THE
# TRADITIONAL
# BUILDINGS
OF
# ENGLAND

# THE TRADITIONAL BUILDINGS OF ENGLAND

ANTHONY QUINEY

*With 193 illustrations, 81 in color*

Thames and Hudson

*For Ginnie*

Who came on the long journey from Dunster to Dedham
and said "whatever you do,
Don't call the bleeders *sheep*."

Key

| | |
|---|---|
| **c** | chamber |
| **c-p** | cross-passage |
| **f** | fireplace |
| **h** | hall |
| **i** | ingle |
| **k** | kitchen |
| **s** | service room |
| **sh** | shop or workshop |
| **st** | stairs |

Modern county names have been used throughout, except in the case of Herefordshire
and Worcestershire

© 1990 Thames and Hudson Ltd, London
Photographs © 1990 Anthony Quiney,
except pp. 35, 74, 98, 102 and 213 © 1990 Thames and Hudson Ltd

First published in the United States in 1990 by
Thames and Hudson Inc., 500 Fifth Avenue,
New York, New York 10110
First paperback edition 1995

Library of Congress Catalog Card Number 89-51819

ISBN 0-500-27661-7

Typeset in 11/12 pt Monophoto Bodoni by Servis Filmsetting Ltd.

Printed and bound in Spain by Artes Graficas Toledo S.A.
D.L.TO: 740-1994

# CONTENTS

# 1 THE MAKING OF A TRADITION

This book is about the everyday buildings of the past. Its special concern is their historical development. Why did a tradition of building emerge in England during the later Middle Ages and what did it achieve? Why did it develop in the 16th century and eventually die during the Industrial Revolution?

Once, it was easy to differentiate architecture from mere building.

A bicycle shed is a building; Lincoln Cathedral is a piece of architecture. Nearly everything that encloses space on a scale sufficient for a human being to move in, is a building; the term architecture applies only to buildings designed with a view to aesthetic appeal.[1]

Although still widely held, that view is altogether too simple. Some animals build shelters, which, to the beholder at least, are of undoubted beauty and can, at a stretch, be called architecture. Man can hardly build otherwise. Despite commonly held opinions about much modern architecture, builders are incapable of avoiding aesthetic quality in their work. Many bicycle sheds have the aesthetic quality of regularity, even though this may be a response to the equal size of bicycles rather than to Man's pleasure in aesthetic qualities. More importantly, there is the middle ground. Most buildings are neither bicycle sheds nor cathedrals, just everyday buildings serving common purposes. These are the buildings in which people live and work. Yet all of them were to some extent designed to have aesthetic appeal, and this makes the line which separates mere building from architecture impossibly vague.

As for tradition, it does not simply mean old. It properly refers to beliefs or customs which are carried from one generation to the next by practice or word of mouth, not by writing. That could exclude architects from tradition, since book-learning has been a major source of their knowledge since their profession emerged from the crafts of the mason and carpenter at the end of the Middle Ages, significantly just at the time that printing became a force in the world. Sir Christopher Wren's great architectural works right up to their summit in St Paul's Cathedral are therefore not traditional. Lincoln Cathedral, on the other hand, is traditional in a sense, because it is the work of masons, and they learned their craft orally and by practice. Nevertheless, while its many parts may have been designed and built by traditional methods, they have deliberately innovatory and ornamental qualities which were intended to give it its essential monumentality, and these set it above the everyday workings of tradition.

If architecture can descend as low as a mere bicycle shed, Lincoln Cathedral reaches a pinnacle of creation for overwhelming religious and cultural reasons. This is the architecture of styles – classical, Gothic, Baroque and so on; yet it is different only in degree from the architecture of a whole range of everyday buildings, which are neither mere nor monumental. For them, aesthetic appeal is still important, but it is not supreme.

These are the buildings in which tradition once worked most strongly. Some architectural historians call this 'vernacular architecture', a term underscoring the difference between their everyday, common forms and the 'polite' architecture of monuments.[2] Further, it suggests the orally communicated local tradition of craftsmanship which gave them their existence; but in England, where the term originated, it is restricted to buildings of one

tradition only, or, more accurately, a series of interlinked local sub-traditions which were born in the Middle Ages, flourished in the 16th and 17th centuries, and died in the Industrial Revolution. A remarkable feature of this particular tradition of building is that it existed at really humble levels, just as a vernacular language does, and, moreover, with a rich variety of forms and an unprecedented ability to survive.

With the high architecture of modernism currently under a cloud of public suspicion, it is no wonder that many architects have turned to traditional forms and decoration as a means of appealing to popular taste. This kind of revivalism is as old as architecture itself. It is not, however, a continuation of a live tradition, just as the Gothic Revival of the 19th century was not a continuation of medieval Gothic, however much the architects of the time asserted that it was.

Ronald Brunskill delimited this range of traditional buildings within what he called the 'Vernacular Zone'.[3] It lay between the superior architecture of monuments and the poor construction of buildings which had no chance of survival beyond a generation or two. The Vernacular Zone originated, he suggested, around the start of the 12th century in the design of great houses which, for the first time, were built well enough to survive to the present. Greater buildings with the most aesthetic appeal – cathedrals, churches and castles – were above what he called the 'polite' threshold; they were the monuments of architecture. Those which were unable to survive were below what he called the 'vernacular' threshold. They really were mere building.

The ability to survive is important, but the causes of destruction are capricious and the reasons for survival multifarious.[4] The vernacular threshold might have been more clearly defined as the boundary between the lowest class of building where skilled craftsmen were employed and those built in a simpler fashion by ordinary people for themselves.

The crossing of this threshold marked a social revolution, and one which carried the seeds of its own eventual destruction: the craftsmen became so learned in architectural ways that local custom was submerged by the written word. It also meant that people had to learn to live in second-hand houses built for someone else and to adapt them to their own usage. Indeed, it is the centuries of adaptation, as generation succeeded generation, that have given many vernacular houses both their irregular shape and their picturesque appeal. By definition, these are not fundamental: the basic architectural qualities of order and regularity were crucial to the initial builders, and the accretions of ages have to be put aside in the mind's eye to recapture the original form.

Over the centuries, according to Brunskill, the vernacular zone widened: while its upper, 'polite' limit fell below the level of the great house about 1600 and below the level of the large house soon after 1800, the lower limit fell more quickly to embrace large houses around 1200, small houses by 1550 and cottages soon after 1700; but by 1900 both thresholds had fallen below these limits – everything, if not polite architecture by then, was subject to the written word. If anything these limits fell more quickly than Brunskill suggests, but did so in a haphazard way around the country. Finally, age-old local ways of building succumbed to materials which were brought in cheaply by the canals and railways, and were erected into shining new buildings by

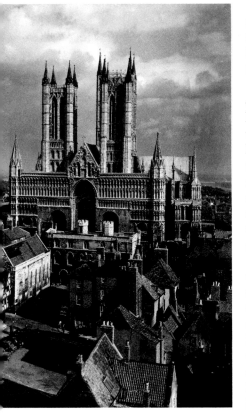

**Lincoln Cathedral surrounded by traditional houses.**

methods explained to once proud, self-confident craftsmen in a host of publications, and as often as not directed by architects and surveyors who came by train themselves.

Specific qualities, therefore, characterize traditional buildings: firstly, they were commonly built in any given locality; secondly, the aesthetic appeal they were designed to have did not raise them up to the level of monumentality exhibited by polite architecture; thirdly, their style did not come from books; finally, overall, their architectural qualities were the result of employing skilled craftsmen rather than their owners' skills and those of friends and neighbours. All in all, despite their everyday qualities, they had a fair chance of surviving.

Common occurrence within their locality, though not necessarily outside it, is of the essence. This nevertheless allowed a wonderful variety; it was a direct response to England's particularly varied landscape as much as to the dictates of style. Similarly, the humble origin of much traditional building was a consequence of historical changes which peculiarly favoured individual initiative among lowly people. This immediately places the heyday of traditional building exactly where Brunskill found it, namely between the 14th and 18th centuries. Topography and history were both crucial to this tradition.

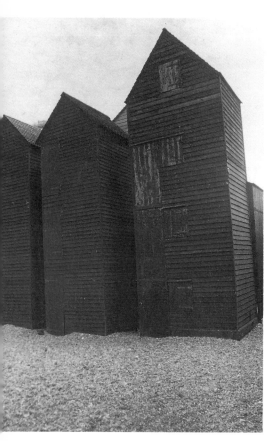

Fishermen's net-houses at Hastings, East Sussex. These are a very localized traditional building type; however basic in form, they nevertheless have the architectural quality of regularity.

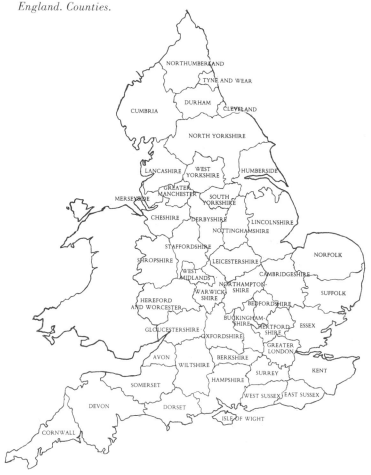

*England. Counties.*

## LOWLAND AND HIGHLAND

Topography affected building in several ways. The most visible effect is the way the land has provided a wide range of building stones, but, long before there was wealth enough to exploit them, topography had had an effect on the distribution of wealth itself. Briefly, the west and north are hilly, the south and east flat. Pushing upwards into the prevailing winds off the Atlantic, the high moors of Devon and Cornwall, the mountains of Wales and the Pennines of the north force the warm, moist air to shed its rain. This makes the western extremities and the north the wettest parts of the land and the eastern lowlands between the Thames and the Humber the driest. The increase in annual rainfall between Essex and Cumbria is more than five-fold, and, while the average increase between east and west is nearer two-fold, that is enough, taken with the cooler temperatures at altitude, to produce an agricultural division into highland and lowland zones.

Until the Industrial Revolution of the 18th century, agriculture was the principal source of wealth. Cattle thrive on the grass made lush by the rains and mild summers of the west; corn needs early moisture to grow and the hot, dry sun of the south and east to ripen. This brought about a highland–lowland division. It was also a division of wealth.

Historically, harvesting grain was the most efficient way of providing food from the land; although this required the most labour, labour was generally

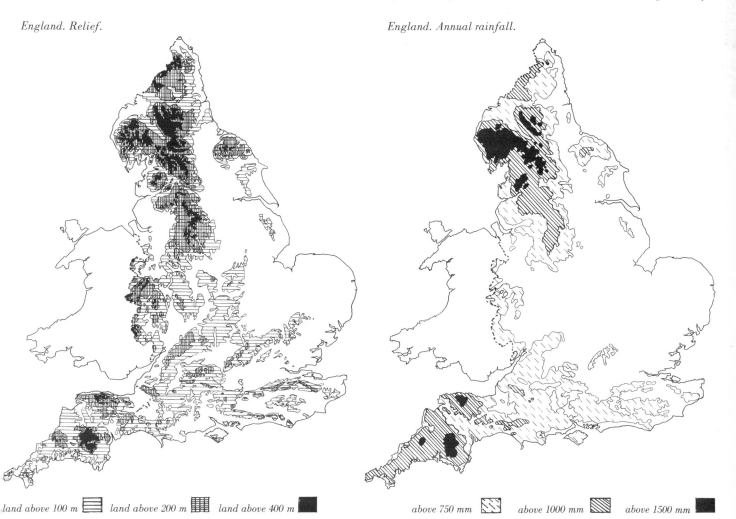

*England. Relief.*

*England. Annual rainfall.*

land above 100 m ▤  land above 200 m ▦  land above 400 m ◼

above 750 mm ▨  above 1000 mm ▩  above 1500 mm ◼

cheap in the past and controlled by powerful landlords. Fertile arable land was expensive, and, again, was controlled by powerful landlords. They could make a good profit from grain. Cattle were expensive too, and, while they needed little labour, they needed plenty of land for grazing; it was harder to store their products – milk, butter and cheese, meat and hides – and to deliver them to market on the same scale as grain, so profit from them was less sure.

The division between highland and lowland was never clear-cut, but it was a strong tendency. The Romans were fully aware of it. They consequently divided the country along the line of the Fosse Way, the road they built between Exeter and Lincoln; to the south and east lay the best arable land and Roman Britain's best source of wealth, while beyond lay poverty.

This divide is one of the most abiding features of England. Nevertheless, its effects varied from person to person: there was little personal advantage in living in the richer lowland zone if one's labour lined someone else's pocket, particularly if a small but adequate living could be made as one's own master in the comparatively poor highland zone. The effects varied historically with changing social and economic conditions, and these, finally, determined the course of traditional building.

**BUILDING AND HISTORY**

By the Middle Ages several traditions of buildings had grown and died in England. The most sophisticated had been imported by the Romans and grafted on to the old Celtic traditions of the Iron Age. The collapse of Roman rule in 410 undermined this tradition and ended an unrivalled civilization. The new order brought by the sword of invaders and, later, by the steadying hand of the Christian Church set off in a very different direction.

The early invasions were repeated with the arrival of the first Norsemen in 787 and the flood, especially of Danes, after 865. Anglo-Saxon and Scandinavian building traditions came, changed and went. Settlements within each locality tended to wander from site to site over the centuries, so impermanent were their buildings. Only after the Norman Conquest did this wandering cease, and permanent buildings, apart from such monuments as churches and castles, arrived on the scene later still.

Fire and pillage swept into many corners of the land, but they did not reach everywhere. This was especially true of Kent.[5] From the time of Hengest's founding of the kingdom of Cantia in the 5th century, Kent enjoyed special privileges and some prosperity. Perhaps uniquely it did not suffer the steep decline that afflicted the rest of England. Nowhere did Roman standards of wealth revive more quickly. One consequence was King Ethelbert's marriage to the Frankish Princess Bertha, an otherwise inexplicable tie between this very small kingdom and a very large one. A second consequence, closely linked, was the choice of Kent for Augustine's mission of 597. The resulting monasteries at Reculver and Minster show the acceptance of Christianity, but they also show the Church involving itself in revived trade, a necessity to its survival, and other monasteries, headed by Canterbury's Christ Church Priory, were to become great promoters of agriculture. All this meant a revival of building.

Kent was a special case. Elsewhere, invasion brought chronic poverty. A crude measure is population. The Roman population of some five to six

million had fallen to around two million by 1086, the time of the Domesday survey.[6] All this was despite the immigrant Anglo-Saxons, then Norsemen and, finally, a scattering of Norman lords. The causes of this depopulation are not hard to find. Violence was one, but not as important as the more insidious social and economic causes of mortality. The ruination of the Roman economy together with its concomitant high standard of civic and domestic hygiene were the major causes.

On the land, vanished markets took away the incentive to repair the breaches made by disrupted cultivation, broken tradition and the ignorance of newcomers. Production fell. So did productivity. This hardly mattered. Demand had fallen. There were no longer the towns. When they were revived and new ones founded in the 9th century, King Alfred's Wessex burhs, for instance, and the Danish Five Boroughs of the east Midlands, they took a long time to reach the size and importance of their Roman predecessors. Their buildings, unlike those of Roman towns, were indistinguishable from country buildings.

**MEDIEVAL WEALTH**
In the 13th century the expansion of both agriculture and the population it fed reached a culminating point. Some people profited from this, and built grand buildings. Manorial lords built themselves substantial houses, the earliest ones to survive in some numbers. As for the masses, their surviving buildings are sparse: much depended on varying social and economic factors from place to place, and most people were not in the habit of employing craftsmen who could build substantially for them.

The beginnings of the expansion are dimly perceptible before the Conquest. Trade, the circulation of money and the foundation of new towns made increasing progress after the 7th and 8th centuries. By the 8th century, London was once again an important market place for foreign traders. It kept its lead and far outstretched other towns in size, despite several devastations by fire. The Saxon Hamwic grew to become the wealthiest town of the south, before Viking raids brought decline, but removal to a new, more easily defended site allowed it to revive as the Norman Southampton. Trade caused other towns such as Lincoln and Stamford to join the most important only to let them fail in an increasingly competitive world. Bristol and Norwich kept their prominence for longer on the profits to be won there and enticed people away from the countryside. This regeneration required agriculture to produce an increasing surplus, both to provide goods for trade and to feed people engaged in other occupations. The comparatively settled conditions of the late Saxon period reduced mortality and allowed the population to rise; more hands in the fields reaped greater harvests, and found a market for them.

After the Conquest, economic activity continued at a greater pace thanks to the Norman settlement.[7] The lowlands of the south, the Midlands and east became rich and populous, as they had been in Roman Britain, the highland Celtic fringes remained poor and empty. Emphasizing this division was a diagonal band of wealth coinciding with the line of the old Roman Fosse Way; then, as in Roman times, it was the frontier between corn and horn. Beyond it were a few patches of wealth: parts of the Welsh Marches and the north benefited from the export of wool from sheep herded on monastic demesnes,

but this was spent on fine monastic buildings, not houses for free peasants.

Indeed, much wealth was the creation of religious institutions, newly revived after the Conquest or freshly created. From the time of their arrival in 598, the Benedictines had led the way. They were to build a series of timber barns in Kent which clearly belong to a definable school, and another stylistically linked series of stone barns in the west. The Benedictines were now joined by new orders like the Augustinians, and none were so active as the Cistercians, who arrived in the 12th century. While their greatest wealth came from granges in the south and Midlands, their fame lies in Wales and the north where their sheep made them synonymous with the creation of wealth from wasteland. This is still evident in the majestic ruins of their Welsh and northern abbeys, but hardly at all from traditional buildings in these regions.

Two other orders, which arrived in the middle of the 12th century, were the Knights Templars and the Knights Hospitallers, the military and chivalrous celibate, monk-like Crusaders who were devoted to defending the Holy Land. They were of far greater significance in England than their numbers, at least so far as buildings go. They became extremely rich through their land and financial dealings, as well as famous for their exploits against the Saracens during the Crusades. Deadly rivalry between the two orders eclipsed their common antagonism to Islam and contributed to their eventual failure on Crusade. The commercial and intellectual rewards of contact with Islam were another matter. One consequence was the rediscovery of Euclid's theorems and their translation about 1120 from Arabic into Latin. This made great advances in building possible. Perhaps it prompted the Templars to ensure that their carpenters were well enough versed in geometry to build the first English windmills, which needed a very strong and, hence, accurately built frame. They also built two innovating barns at Cressing Temple in Essex, and the Hospitallers may have been responsible for another innovating yet significantly different barn at Siddington in Gloucestershire.

The Templars and Hospitallers built extensive preceptories, their equivalent of monasteries, and often these had adjacent farm buildings. Like the monastic orders they also owned manors and granges. Monastic granges were agricultural establishments that usually comprised a group of buildings, often scanty, occasionally grand, and usually with a barn overlooking a house, possibly with a chapel. Many of these barns survive today, at once the first great monuments of agriculture and the earliest indication of new traditions of building. The oldest date from about 1200 when enough wealth had accumulated beyond the needs of the monasteries themselves to pay for their improved construction.

The rise in wealth that made these buildings possible was not continuous. The Midlands were upset by the anarchy of Stephen's and Matilda's contested reign. Civil war in the 1140s and 50s devastated central England, and the only gain was from the misfortune of others. While the Midlands soon recovered, the Conquest and its 13th-century agricultural fulfilment hardly benefited the north and the Celtic fringe. Cornwall's windswept land was not a conspicuous jewel in the Norman crown. Together with the royal forest of Dartmoor, it became the property of the king's heir and what little profit could be gleaned left the region. The rich cornland of the Vale of York should have flourished, but it suffered the disability of being the centre of Danish independence.

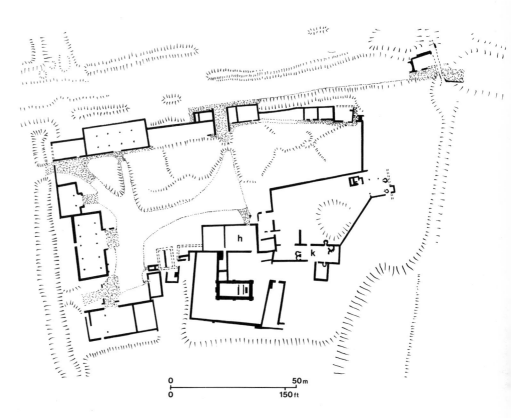

*South Witham, Lincolnshire: plan of the Knights Templars preceptory, showing wide and narrow entrances* (left) *and a third,* main entrance *(top, centre),* domestic range *(lower, centre) with* hall, chapel *(below it) and* kitchen range *(to its right); the two aisled buildings* (left) *were barns, the large building* (bottom, left) *was for carts and ploughs, and other buildings making up the left-hand and upper ranges were for animals; there was also a mill* (top right). *The arrangements were similar to those of a manor.*

William did not tolerate this threat. In the winter of 1069–70 he marched on the Vale and laid it waste, destroying Danish power in England once and for all, and securing the strategic route further north.

This 'harrowing of the north' was not the end of William's demonstration of strength. He gave the land to powerful lords who enforced a policy of resettlement on the peasantry by uprooting them from the Pennines, where they might still have caused trouble, and transplanting them to the ruined lands of the fertile Vale. So the plains, which had received the brunt of the attack, were the first to revive, and the surrounding upland was depopulated to make good the deficit.[8] Powerful landlords reaped the rewards, and York, meanwhile, became a prosperous provincial capital.

What William began his successors continued. Rufus took possession of Cumberland, but Wales caused trouble until Edward I's conquest in the 1280s. From 1277, he based armies of both soldiers and craftsmen at Chester so that what he gained could be consolidated with the construction of a chain of castles around the peripheries of North Wales.[9] Chester became a boom town, and its Rows still bear witness to this. Shrewsbury and Ludlow again did well as frontier towns. Then Edward turned his sword on the north. This time he

failed; Scotland remained a problem as it had done for the Romans, and not even the Union of the Crowns in 1603 entirely staunched the anguish and bloodshed.

The depopulation of the north was not reversed by the establishment of the new monasteries, even though they revived agriculture. The refounding of Whitby within a decade of William's descent began this revival. The Augustinian Guisborough was founded about 1120; then, starting in the 1130s, came the Cistercian houses, Rievaulx, Fountains, Roche, Sawley, Meaux, Jervaulx and Byland. They will forever be associated with huge flocks of sheep. The wool went to market in towns like Beverley, where it was sold and exported to Flanders and north Italy. The proceeds paid for building and glorifying the abbeys; but sheep need little labour or buildings, and their vast runs on the Pennines and North York Moors entailed the continuing desertion of the land. It was a foretaste of what became widespread three centuries later.

Cattle were important for these abbeys as well, but only to satisfy local needs for milk and hides, or to act as draught animals. They were kept in vaccaries or lodges, small and flimsily built, with a group of stalls and living quarters. Apart from earthworks or enclosures at granges, there is little in the way of buildings beyond a barn or two to commemorate this regeneration of northern wealth. The abbeys stand for it all, and they too are ruins. By the end of the 13th century they were largely complete, and the agricultural expansion which had made them possible was faltering.

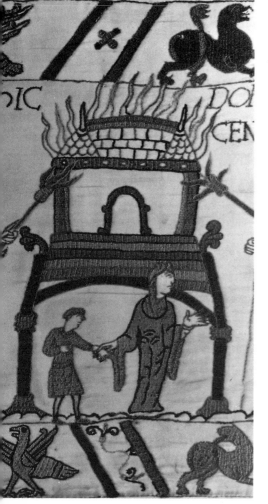

**Bayeux Tapestry. A peasant's house being fired by Norman soldiers; the upper part represents the exterior, the lower part the interior.**

Kent contrasts sharply with Yorkshire. It submitted to William and was never devastated by conquest; nor was it subject to great lords once William's half-brother Odo of Bayeux had fallen from grace. In 1070, while Yorkshire bled, Kent received Lanfranc as Archbishop of Canterbury. He championed Kentish liberties and ensured the future wealth which paid for the county's surviving houses. Lanfranc had every interest in a prosperous Kent. He became its greatest landlord; but a man of Odo's power would have been another matter. The large number of freemen in Kent, as well as the Church, had a common interest in not being subject to a Norman overlord, and gavelkind, a form of partible inheritance, ensured that however rich a man might become, it would not be a stepping stone leading a single heir to overweening power.

The rich cornland of the south and east was divided into manors, much of it owned by the monasteries. It was soon densely settled, but in the Weald, Kent had a reservoir of land, albeit poor, wooded and inaccessible, which freemen could colonize as the population expanded. Here, early settlers had established 'denns' and 'hursts', clearings where they tended swine and, later, cattle. These became permanent, not as nucleated villages, but as single farmsteads, set in the web of lanes that enmesh the Weald still. There were markets and a demand for goods as close as Canterbury and as far as Calais. Enterprise was encouraged by the turnover of land that resulted from the continual splitting brought about by gavelkind, and by the ability to diversify through combining farming with industries like tanning and weaving. Those who succeeded became the richest free peasantry in England, if not Europe. Their houses show it.

Few peasants outside Kent had this freedom. The 13th century brought many of them to a desperate plight. By the end of the century the population

had reached somewhere between 4.5 and 6 million, the same order as Roman Britain's. Some of the rise was accommodated on newly colonized land, but many people had to squeeze in where they could. The increasing demand for grain was ever harder to meet: productivity fell into decline because desperate poverty forced the high population to cultivate land that was utterly unsuited to crops.

Manorial lords exploited the rising grain prices and took the profit. This went into their houses and barns. Free peasants could follow their example only if they had enough land, since labour was cheap and demand high; but their increased numbers caused many of their land holdings to be split into ever decreasing individual lots, which, with falling productivity, gave them less and less profit, and many families failed to maintain their hold on the land.

The house and the family were indivisible. In France the Latin word *domus* applied equally to both. In England a man and woman married so that they might set up house; unless they could afford to do so, marriage was normally out of the question. At marriage, they became a housebondman (husband) and housewife, and, as their circumstances allowed, built up a family of their own children and unrelated teenagers, taken in as servants. These worked alongside their offspring at all the household tasks such as baking, brewing, cheesemaking, spinning, and weaving, or tending the family fields from ploughing to reaping the crops, or as apprentices in their master's trade. Under his headship, the household was a hierarchical but equitable unit, with little distinction between kin and servant, except where inheritance was concerned.

It was the agricultural profits of the 13th century which fulfilled the promise of the Norman Conquest, even if the rich became very rich indeed and the poor became destitute or starved. During the second decade of the 14th century this began to change, and by the 1340s the old conditions of rising grain prices and cheap labour had been reversed; here and there land was even dropping out of cultivation. Foul weather and crop failure in 1314 and 1315 brought starvation and scattered corpses all round Europe. This upset the balance of labour, production, prices and trade by entering full graveyards and empty granges into the account. In the period 1324–6 floods struck, and so ravaged flocks of sheep that their numbers never recovered. Inundation became a continual threat on low-lying coastal marshes.

On top of this natural disruption came the first of the wars with France. These were to last a hundred years. Trade was upset, and poor European silver production aggravated the decline. By the 1340s grain prices had fallen to a half and even a third of their peak about 1320. The population probably started to fall as a consequence of famine and uncertain food supplies. This brought a rise in wages and reduced profits from grain. The great landlords whose income had relied on this profit tried to maintain it by increasing rents. Rather than work their estates themselves, they put them out to farm. Some of the peasantry were able to commute their labour services for payments, and took to buying or leasing fresh plots of land. These changes were not universal, but definite changes were in the air. Before they resolved into a new pattern there came the plague: it would liberate the peasant – in this world or another.

**THE LATER MIDDLE AGES**

The arrival of the Black Death in 1348 marks the great turning point of the Middle Ages. Overall, England lost a third of her population, perhaps more. The survivors had to bear further visitations. Between 1361 and 1485, thirty years saw fresh outbreaks of plague. Twelve affected the whole country, but, as time went by, the plague fed on the crowded, insanitary conditions of the towns, leaving the countryside free; eight visitations were confined to London. About 1500, the fall in the population was arrested at perhaps only half its level on the eve of the plague, and soon there were signs of an increase, particularly where new industries supplemented the profits of agriculture. By the end of the 16th century numbers were approaching the levels of the 13th century. They then hesitated rather than halted, and for a century after 1650 remained fairly static.

Arable farming was threatened: the labour it needed became harder to find and increasingly expensive to keep. The demand for grain dropped with fewer mouths clamouring for bread, so prices fell into a downward spiral. This favoured pastoral farming, which needed less labour, and redressed the balance lost to grain in the 13th century. The Black Death was an economic catastrophe for manorial landlords. Their surviving peasants – the so-called villeins – demanded high wages and hoped to pay a just rent for as much land as they could afford. The difficulty for manorial lords was that rents fell below what they needed to pay higher wages. They used the full force of the law to uphold their manorial rights. The peasantry thought this was a way of keeping them in their serfdom, and did not accept it placidly. Here was a heaven-sent chance of reaping the reward of initiative, rather than supinely filling someone else's purse.

The Peasants' Revolt, sparked off in 1381 by the threat of a new poll tax, was fuelled by a sense of social deprivation. The hedgerow preacher John Ball's appeal to the equality of Adam and Eve was not lost on anyone: 'Who was then a gentleman?'; yet the gentlemen gained the upper hand and Ball, Wat Tyler and many of their peasant followers paid with their lives. Even so, the next two centuries did see the decay of manorial farming and the rise of peasant farming in its place. By Elizabeth's reign most peasants had become copyholders with a firm legal title to land for which they paid rents. These were not usually a strain on their resources, and, remaining fixed through a period of inflation, let them pluck an unearned increment which gave them the wealth to build. Many of the old landlords, 'immobilised in sumptuous appurtenances, at once splendid and unrealisable', and trapped by 'the magnitude of their commitments and the rigidity of their incomes', fell into debt and then to oblivion.[10]

This was not a new Eden. On some manors, especially after the Dissolution of the Monasteries, the lords were new, acquisitive gentlemen who had plundered the old order, and the yeomanry had aspirations in that direction. Indeed the widening division between rich and poor peasants made the very term 'peasant' meaningless. Instead there were the substantial landholders of the yeomanry and the rich burgesses of thriving boroughs, there were the lesser landholders or husbandmen and craftsmen, and the landless labourers and cottagers.

On the arable lands of the south and Midlands, the new conditions imposed by the plague varied greatly from manor to manor. Much of Battle Abbey's

manor of Alciston in Sussex was now farmed by the peasantry, but, though they flourished, they never obtained large holdings nor became noticeably rich. When Henry VIII's minister Sir John Gage took over the manor at the Dissolution, he kept a firm grip of the manorial lands and his family have done so ever since. Unlike Kent, the peasantry remained subservient, and their cottages in Alciston were always small. In the fertile Thames valley at Harwell in Oxfordshire there were no resident manorial lords, and peasants were free to profit from land, which enabled them to build modest but substantial houses.[11]

Some manorial lords were anxious to reduce the effects of dereliction brought by the plague and did their utmost to maintain the housing of their surviving peasants. In the west Midlands, they provided the most costly element of a peasant's house, namely the main part of the timber frames. Other lords ruthlessly tore down what survived of a settlement and enclosed it for great sheep runs. At a blow they disposed of the difficulty of finding and paying labour, since sheep require little, and entered a market that remained buoyant. Desertion ruined villages like Cowlam in Humberside, and it occurred all over the Midlands where corn once ruled men's labours. The result of these varying conditions in the Midlands was that peasants became only sporadic builders of substantial houses. It was a long time before the overwhelming desire to build in the way that is so evident in Kent arrived and, when it did, it was often the result of initiative beyond the ordinary run of things.

Beyond, in the poor pastoral zone of the northern and western highlands, plague and a worsening climate depopulated many hamlets, and their lands have never been reclaimed. Nevertheless there was little change in the pattern of farming. Pastoral farming remained prime. Despite poverty, men could establish a good living for themselves when they held land on favourable terms, so they started to build substantial houses, even though these were small. In Devon and West Yorkshire this began before the end of the Middle Ages; in the Yorkshire Dales it began shortly before the Civil War; further north it was later; in Cornwall, the personal fief of the heir to the throne, hardly at all.

In Yorkshire the changes began at the start of the 14th century. From 1300 the Cistercians began to lease out their estates so that by the Dissolution the order had largely retired from agriculture. Only granges in the immediate vicinity of the abbeys remained as home farms to supply their daily needs. Simultaneously the proportion of sheep to cattle fell. Herds were managed by keepers who, as rent, had to deliver fixed amounts of butter and cheese to the abbey or cash equivalents. By the 16th century they were farming for them-selves, and soon afterwards their profits went into their houses.

The peasantry did best when it combined farming with industry.[12] Weaving was the outstanding route to success. Wool exports were little affected by the Black Death since sheep farming made small demands on labour, and trade was soon back to normal. The Hundred Years War changed this, mostly by disrupting imports of cloth and transforming weaving at home. It quickly became a domestic craft and soon a rural industry, above all in East Anglia, the West Riding of Yorkshire and the West Country. Weaving centres grew up not so much where sheep were herded – land which was generally under strong

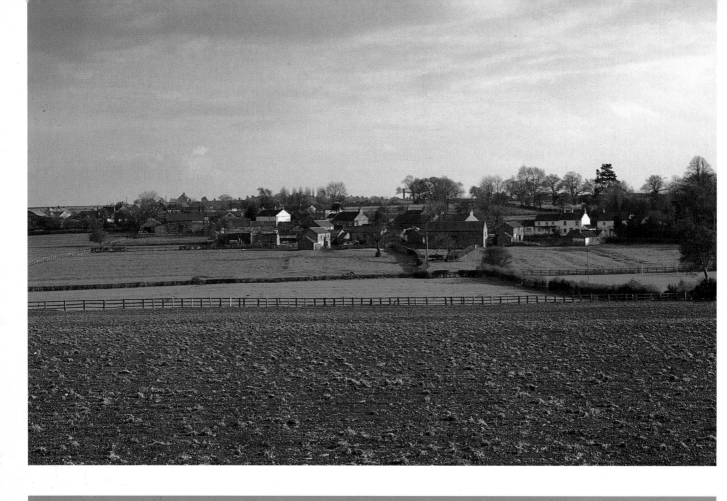

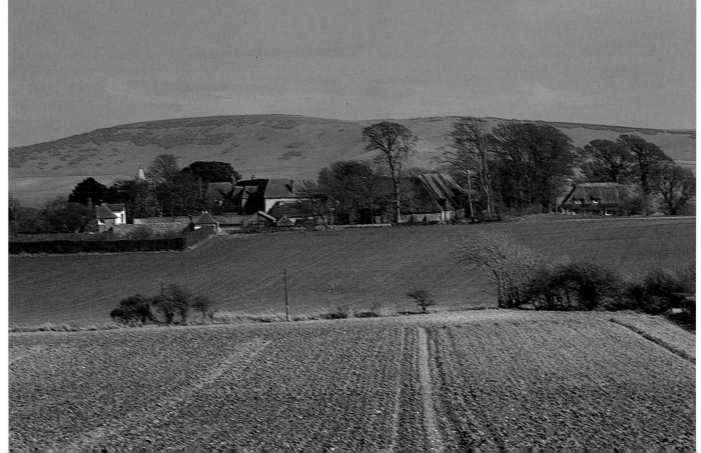

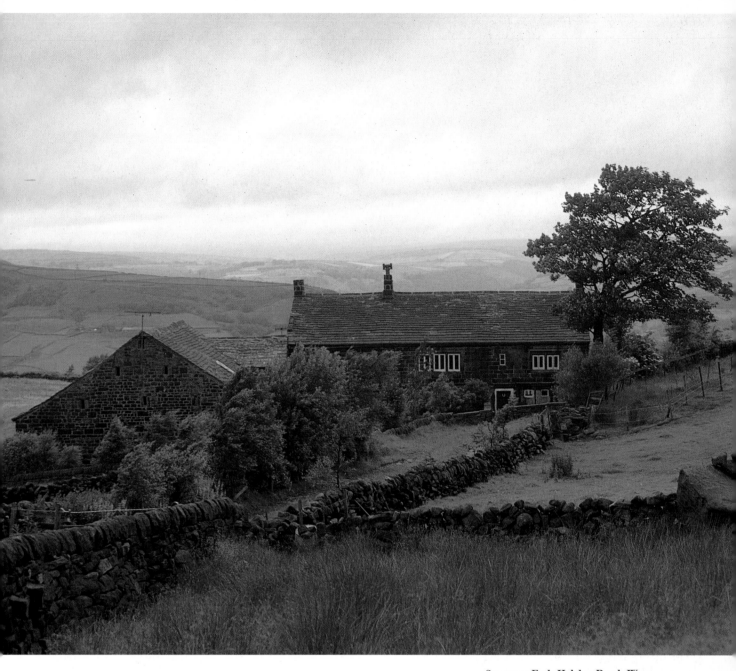

Stannery End, Hebden Royd, West Yorkshire *(above)*. The moorland west of Halifax was ideally suited to pastoral farmers who tended cattle and filled the rest of their time by weaving cloth, so earning the wealth in the 17th century to pay for large houses built of Millstone Grit on lonely sites like this one.

Whixley, North Yorkshire *(above left)*. A lowland village in the Vale of York, with its closely set houses surrounded by fields, which, to the right, still show the ridge-and-furrow of medieval ploughing.

Alciston, East Sussex *(left)*. Once a manor of Battle Abbey, the village is still surrounded by arable land. Windover Hill, in the background, marks the bleak scarp of the South Downs, and has been rough grazing land since prehistoric times. The manor's buildings include, from left to right, the remains of a dovecot, the manor house, and a large barn, overlooked by the spire of the parish church; to the far right is one of the small cottages of the manorial tenants. Despite changes at the Dissolution, the medieval pattern of farming and building is still clearly visible.

manorial control and lacked a good water supply – but in dairying and cattle-rearing country. This had to have plentiful water, a necessity for cattle as it was to be for weaving, and was generally enclosed and owned by family farmers and the self-employed who had the time after tending their herds to give to organizing a home industry. This brought a new agricultural and mercantile class into being, one that distinguishes the late Middle Ages from the era before the Black Death.

Weaving in the Stroud and Calder valleys continued to flourish until the Industrial Revolution transformed them, but in other places, notably East Anglia and the Weald of Kent, there is even more evidence of the prosperity brought by weaving in the 15th century because it did not develop enough in later times to obliterate its past.

**TUDOR AND STUART PROSPERITY**

The ending of the Wars of the Roses and the Tudor succession in 1485 brought more opportunities for making fortunes than there had been since the Roman occupation. The resources of land and industry had been poorly exploited; now, an astute eye for political chance, a crafty pen in practice at law, and a nose for trade in the reviving City of London or a number of provincial entrepôts could lead to fabulous riches. If these were not reward enough in themselves, the Crown could supplement them by offering immense pickings to those whose loyalty it prized, especially from seized monastic estates. This was 'The Age of Plunder'.[13]

An important cause of prosperity was the great Tudor price rise. Following the Wars of the Roses, Henry VII had pursued a strict policy of financial retrenchment. This was not continued by his son: Henry VIII spent heavily on unwise wars in France and splendid living at home. In the 1540s the currency was debased; the worldly riches of the suppressed monastic houses were looted and came on the market as bullion, and later in the century the piracy of Spanish treasure ships loaded with the spoils of America brought more. The value of money was lowered, but other changes played a part. From about 1520 the population began to rise, perhaps as a consequence of improved standards of living, and the increased demands for food and goods attending this rise led to higher prices.[14] Yeomen did well from this: their overheads were often fixed; the prices they charged could rise. Many of them either owned their land or held it for long terms at low rents fixed ages ago. At the start of the 16th century, if one farmer had 'a noble or six shillings in his purse, six or seven other farmers could not muster as much between them,' William Harrison recorded; by the time his *Description of England* was published in 1577,

although peradventure foure pounds of old rent be improved to fortie, fiftie, or an hundred pounds, yet will the farmer . . . thinke his gaines very small toward the end of his terme, if he have not six or seven yeares rent lieng by him, therewith to purchase a new lease.[15]

The price rise touched rents and the price of land as well as yeomen's incomes. Following the Dissolution, monastic land was up for grabs in town and country alike. Only the Crown failed to profit, because, needing political support, it used land as a bribe, and let middlemen fleece it; the old monastic

estates soon went, and even its own estates gradually melted away.[16] Yet, once established, farmers' outgoings did not rise as quickly as inflation. When they employed labourers they paid wages that lagged behind price rises and, similarly, when they invested in new buildings they paid lagging wages to the craftsmen who built them.[17]

When Henry VIII succeeded to the throne in 1509, the prosperity which had filled yeomen's purses in the south-east was spreading to the Midlands. Here, the Wars of the Roses were still a bad memory and the plague was a constant threat, but, with luck, one might enjoy the fruits of wealth, particularly if part of it came from industry.

Iron smelting had a direct influence on Yorkshire farmers. The water-mills of the Pennine streams around Sheffield produced some of the earliest steels in England, and they went into agricultural implements like sickles and scythes which supplied the whole country. The smelters and mill owners worked on a small scale and turned to this industry because they had a stream on their land and access to iron, charcoal and coal. In the north mining and pastoral farming were ancient bedfellows. A combination of limited arable land, endless unenclosed moorland pasture, which attracted young landless immigrants, and partible inheritance, all allowed populations to increase to the point where there was a growing shortage of grain. Households took to mining, quarrying, weaving and stocking-knitting and numerous other specialist industries and handicrafts to supplement their incomes and pay for the food they could not obtain locally. So it came about that, from the 17th century, the Yorkshire Dales were dotted with lead works and field barns.

From Derbyshire to the Borders, and indeed right across western England similar patterns of agriculture and industry evolved. When Celia Fiennes took the road from Elland to Leeds in the last years of the 17th century she passed a

quarrey of stone and pitts of coales which are both very good, so that for fewell and building as well as good grounds for feeding cattle and for corne they are so well provided that together with their industry they must needs be very rich.[18]

Apart from the profits to be made in agriculture, industry and trade through the workings of inflation, the rising demands of the 16th century encouraged farmers, manufacturers and traders in other ways. The number of small market towns serving all the needs of numerous localities declined as larger regional centres took their place, and changing patterns of trade could devastate a town more comprehensively than the plague. Small towns, such as Stapleford Park in Leicestershire, became fossilized or practically vanished, while even such cities as Winchester and Lincoln fell into decline, leaving their medieval buildings as evidence of a lost prosperity. A major consequence was that farmers no longer had to produce all the goods needed in their immediate vicinity, and instead turned to what best suited their fields, with the aim of sending it to a large market where it might be distributed to any part of the land. Similarly, many towns began to specialize in particular trades and industries rather than act as entrepôts for everything. Some old towns failed to find a new niche in this changing world. The once great Stamford fell into a long sleep, its fairs and markets a shadow of their former selves, and only its inns serving travellers on the Great North Road caused a stir. Meanwhile, Richmond, never much of a town although it was the capital of the North

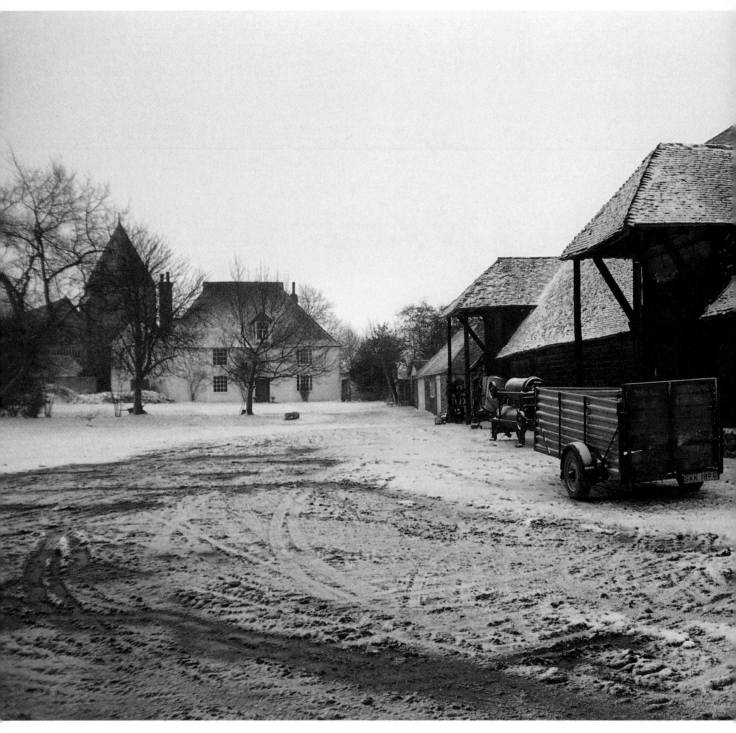

**Court Farm, Mersham, Kent** *(above)*. The medieval church, manor house and barn belonged to the Benedictines of Christ Church Priory, Canterbury.

**Bethersden, Kent** *(above right)*. A hall-house, framed in the typical Kent way, and one of many hundred surviving from the late 14th and early 15th centuries and sited alone in the Weald.

Bishop's House, Norton, South Yorkshire *(right)*. Built about 1500, and extended with a cross-wing, left, fifty years later, the house belonged to the Blythe family, who made their money from pastoral farming, milling and scythe-making, the latter a profitable industry which encouraged nearby Sheffield to become England's foremost steel town. The timber framing combines close-studding with herringbone patterns.

Riding, established a flourishing market for fish, flesh and corn, and, notably, for locally knitted stockings – 'which they make very coarse and ordinary, and they are sold accordingly,' as Defoe recorded in *A Tour Thro' the Whole Island of Great Britain*.[19]

Between 1540 and 1640, London and the larger urban agglomerations like the embryonic Black Country, the Tyneside mining towns and the weaving and clothing towns of West Yorkshire became important markets for food and consumer goods. London's consumption of cereals doubled and redoubled. Fruit and garden produce originally came from abroad, notably from Holland, but Spanish persecution of Protestants in the Low Countries drove them to England, and in the 16th century and especially in the last decade or two immigrants set up orchards and market gardens in the Home Counties, indeed in the suburbs as well, to serve the metropolis.

Kentish pippins, runnets, &c. . . . come up as the cherries do, whole hoy-loads at a time to the wharf, called the Three Cranes, in London; which is the greatest pippin market perhaps in the world.[20]

Chester, Exeter, Bristol and York all sought to emulate this trade with their own markets, though King James I had long since despaired: 'London will be all England.'[21]

The consequences of the growth of this widespread market economy during the 16th and 17th centuries was that the varied landscape of England, with its geological differences, its wide range of soils, and its bewildering microclimates, bore fruit in numerous farming and industrial regions, all characterized by different kinds of buildings, of widely differing materials. The overall division between lowland arable and highland pastoral zones remained, but superimposed on it was a patchwork of farms which could exploit particular local conditions to satisfy a growing national market with a taste for variety. The towns changed in the same way, as they responded to their own singular advantages and developed specialized roles in what increasingly was becoming a national economy.

## AN AGE OF PLENTY

By 1600 the population had reached about four million and was starting to show not just a preponderance in towns but, apart from London, the beginnings of a shift towards the west Midlands and the north, regions that were to become the industrial heartlands of the later 18th and 19th centuries. This was an important new trend.

Once more the rise faltered. Poor harvests brought famine, notably in the 1590s, and outbreaks of plague still crushed settlements. Despite the setbacks, neither disaster nor economic stagnation caused permanent decline as they had done before. There were well over five million people in the country by 1700; and, however slowly, the trend continued upwards. London's population had leaped over the gaping jaws of plague and fire to reach half a million and had carried the surrounding countryside with it. The new metropolis was all set to challenge ancient Rome as the greatest city Western Europe had ever known. This was the real difference from the past. Neither Roman Britain nor medieval England could sustain themselves beyond the levels achieved by the 17th century. The one collapsed; the other survived only through catastrophe.

The 13th century concentrated on one staple, grain, one raw material, wool, and led itself into a cul-de-sac hedged in by demands for products that were less and less efficiently produced.

By the 17th century this had changed. Rising agricultural productivity ensured that the whole economic structure of the nation was well founded, and this was booming. Foreign trade and invention at home supported nascent industries. Agriculture overcame the crisis of supply caused by the rising population in the late 16th century. By 1620 the nation was seldom faced with the old horrors, but, instead, with a new one, strangely familiar today, a mountain of food. 'Plentie hath made us poore' wrote John Chamberlain. This immediate crisis passed, but a lasting consequence was that it was harder to make a profit. The one obvious way through improvement and greater efficiency inevitably led to higher production and lower prices still, and so it remained throughout the 17th century. There was a second crisis in the 1670s. England, Sir William Petty noted in 1676–7, 'doth so abound in victuals, as it maketh laws against the importation of cattle, flesh, and fish from abroad'. Agricultural prices collapsed and went on to languish in a depressed state until 1750. This affected the whole economy. The need to boost production as a means of increasing sales and hence profit became a habit. Where the production of cloth was concerned, this need became so imperative that it spurred along the inventions of the Industrial Revolution, which left little of the old way of life unscathed. Building traditions were a major casualty.

The Barley Barn and Wheat Barn, Cressing
Temple, Essex. These two barns built by the
Knights Templars in the 13th century are
famous for their innovatory timber framing.

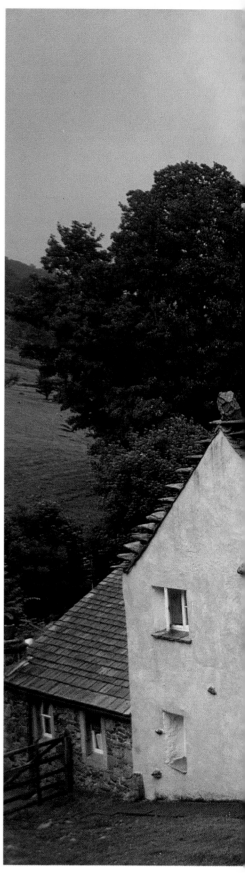

Glencoyne, Patterdale, Cumbria. An
unusually grand 17th-century house made of
dark Ordovician stone and limewashed to
stop rainwater penetrating the walls. The
lonely site overlooking Ullswater is one of
the wettest places in England and only suited
to pastoral farming, hence the range of
cattle-houses built down the slope.

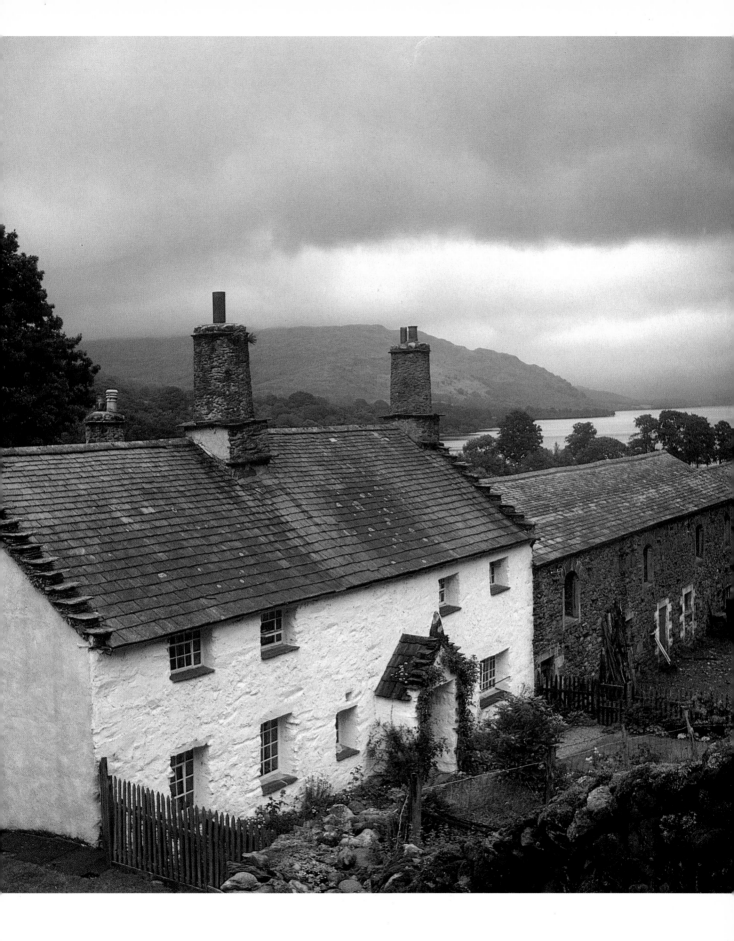

# 2 MATERIALS

When the land was laid bare after the last ice age, England was left with the most varied topography of any country in Europe. Although the differences between Britain and the Continent are subtle, the downs, bournes and scarps of the English chalkland, to take one example, contrast strongly with the broad expanse of their French counterpart. The White Cliffs of Dover seem to be worlds apart from Cap Gris Nez, even though, in the scale of geological time, it is only recently that they were sundered by advancing seas. Britain's varied rock formations occur in Europe in the same variety, but they are marked by a significant difference in scale. The barren windswept scarp of the South Downs has an apparent height out of all proportion to its lowly 200 m (600 ft). Dartmoor and the Fens seem endless, yet both can be crossed in a couple of days' walking. Many geological regions of France and Germany are far larger, and nothing in England compares with the alluvial North European Plain, which stretches all but a thousand miles from the Low Countries to Poland, and on into the Arctic tundra. England has alluvium, and other soils deposited by the retreating ice, but they, too, all vary between localities.

Some of these soils are the direct progeny of the geological formations beneath them. The pallid chalky soil of the South Downs is little more than a living skin stretched thinly over the calcareous bones from which it sprung. The livid red of Devon's fields again is the eroded soil of Devonian Sandstone beneath. In the Midlands and north the land once lay prostrate under the glaciations of the Ice Age. This crushing, grinding, shearing weight transported boulder clays, drifts, tills and brickearths throughout an era of freezing chaos until the warming sun brought them to rest, filling valleys and submerging old plains. Tilting land masses raised up shingle beaches and sandy sea bottoms; ancient rivers choked themselves with the silty refuse of aeons. On the peaks of the north, soil was no sooner broken from its rocky progenitor than it was washed away, leaving rotting vegetation to cover its nakedness with quaggy peat. So rocks and soil sometimes live in harmonious accord, a marriage of kith and kin, but often they are strangers speaking alien languages. Occasionally there is complete divorce: the rocks jut out in lonely defiance or lie so subjugated they might not exist.

**EARTH** These soils provided the oldest of building materials, and in some ways the best. Readily available practically everywhere, cheap and easy for the raising of walls that are warm in winter and cool in summer, soil or earth is full of advantages. Mixed with a binding material of straw, bramble, or animal hair, it was known by several names depending on where and how it was used. The cob of the West Country was the dabbin of Cumbria, the wychert of Buckinghamshire. These were used to build a wall simply by piling up more and more of the mixture until the requisite height was reached, and then by scraping the sides more or less flat. This process needed a little skill, but practical experience supplied that, as the Cumbrian poet Robert Anderson recorded:

That everything might be done in order, and without confusion, a particular piece of work is assigned to each labourer. Some dig the clay, some fetch it in wheelbarrows,

28

some heave it upon the walls. The rustic girls (a great many of whom attend on the occasion), fetch the water, with which the clay is softened, from some neighbouring ditch or pond. When the walls are raised to their proper height, the company have plenty to eat and drink; after which the lads and lasses, with faces incrusted with clay and dirt, take a dance upon the clay-floor of the newly-erected cottage.[1]

This was a method which anyone could use, and for that reason some buildings in this material fell below what Brunskill called the vernacular threshold. If an earthen wall was to last, it was important to ensure that it was kept reasonably dry, first by raising it on a waterproof base, and secondly by covering it with a sound, overhanging roof – a good hat and boots; to complete the job, a coat of lime plaster on the outside reduced the effect of wind-blown rain. Even in England's wet climate these precautions were enough to enable a number of cob-built houses in Devon to survive from the last years of the Middle Ages to the present day.

It was important to avoid the wet mixture slumping, and so walls were built up in layers, each being allowed to dry sufficiently to support the next. Often this layering produced a stratified effect giving a wall a varied texture to add to the local qualities of the particular earths from which it was made.

A different method used the earth preformed into large, more or less brick-shaped lumps, which were laid in courses. This method is of great antiquity, and has been used continuously in Egypt at least since early in the third millennium BC, as surviving monuments show. In eastern England, where it is known as clay lump or clay bat, it was no more than a cheap substitute for fired bricks and, apparently, introduced soon after 1784 when these were first taxed.[2]

Earthen walls are not the strongest: they can easily be raised to the height of two storeys, but above that they start to become inordinately thick. They also need regular attention and maintenance if they are to last, but there is hardly any building material to which that does not apply. Yet, despite all their advantages, earthen walls are synonymous with poverty, and, tragically, nowhere more so than in developing countries, where expensive imports of cement are ruining economies and local building traditions alike.

Earthen walls were sometimes made stronger and thinner by giving them a core of stakes driven into the ground. Archaeologists have found evidence for this in England from as long ago as the Bronze Age – the later second millennium BC – and it has been widely used ever since, but eventually the stakes rot and the wall is doomed to collapse. Another way was to use turves instead of a mixture of earth and straw, and, again, archaeologists have found evidence of such walls from prehistoric times. Because these walls were less compact than cob or wychert and the turf soon died and rotted, their life was even more limited, perhaps to a generation or two at most.

**TIMBER**  Next in the hierarchy of building material comes timber. As the ice retreated across Britain, vegetation advanced, spreading northwards from the Continent. In the vanguard were mosses and lichens, then grasses. As the air warmed, they were ousted by trees; birch, the tree of the tundra, and pine, which still persists naturally in the far north of Scotland, were overtaken by

**Old Hall Farm, Youlgreave, Derbyshire**
*(left)*. A large lobby-entry house built in
1630 of hard Carboniferous limestone and
yellower Millstone Grit.

**Idehurst Farm, Kirdford, West Sussex** *(left)*.
Another lobby-entry house, this one built
early in the 17th century of Wealden
Bedham Greensand by the Strudwick family
from the profits of pastoral farming, cider
brewing, and iron and glass manufacture.

**Dial House, Sulgrave, Northamptonshire**
*(right)*. The quantity of iron oxide mixed in
the fine oolitic limestone of this 17th-century
house gives the courses of stone their varied
colours.

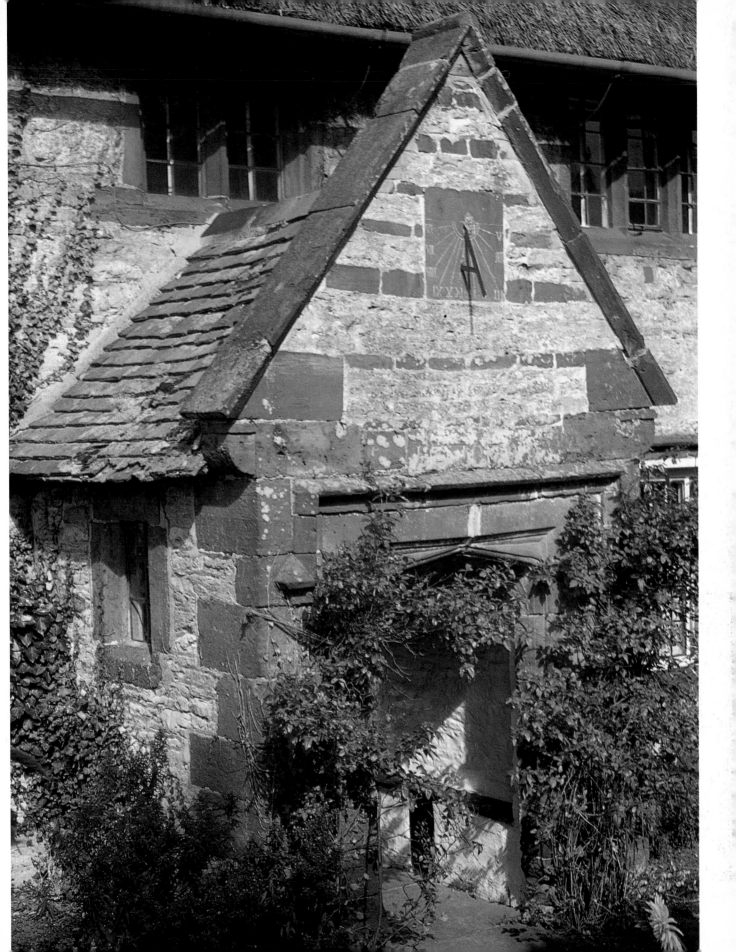

hazel, elm, oak and alder and then by the warmth-loving lime, before the waters met at the Straits of Dover.

England offered a variety of habitats to the new trees, depending on the local climate and soil. Oak flourished wherever deposits of clay gave its roots the heavy, damp soil they need. The Weald of Kent and Sussex, the eastern part of the Thames basin and the west Midlands provided just these conditions, and caused the oak to be known as 'the weed of Herefordshire'. For building, oak became the most important of trees. Its hardness and durability, and its resistance to warping and splitting were to make it highly prized. Other trees were to play their part in building too. Elm was used where oak was scarce, for instance in Somerset, or where its greater length was an advantage. It lasts well when totally submerged in water, and therefore was useful for piled foundations beneath the water table. Ash and sweet-chestnut, which were growing in Britain in Roman times, were other possibilities, and another was beech, a tree which grows best on dry soils. The gracious curve of the black poplar had its uses, and springy hazel made excellent wattles for filling walls with a base to support mud and straw daub.

Even as early as the fourth millennium BC, agriculture was advancing so rapidly that clearances of woodland were already denuding the landscape. Trees were used so extensively in manufacturing and building as well as for fuel that woodland had to be specially managed to ensure adequate supplies. This involved coppicing, a process whereby trunks were cut just above ground, and allowed to regenerate by growing new shoots which could be harvested almost indefinitely.[3] These grew into straight poles, ideal for light building work as well as for fencing and fuel. Heavier timbers came from the whole trunks of standard trees, which could be grown from seed, or, equally, be the product of coppicing.[4]

The water-logged remains of building timber uncovered by archaeologists in the Somerset Levels and the Cambridge Fens show that sophisticated traditions of carpentry had developed by the Bronze Age if not before, in which mortise and tenon joints were common. The Romans, who excelled as builders, brought their traditions of carpentry to Britain, where they probably mingled with native ones,[5] but these largely vanished after the collapse of the Empire leaving new ones to emerge in the Middle Ages.

## THATCH

From the earliest times, roofs were covered with thatch. Reeds from marshy ground, heather from moors and, pre-eminently, straw, a by-product of arable farming, were tightly bundled and bound in horizontal layers to laths. Starting at the eaves and working upwards to the ridge so that each layer overlapped the last, thatch produced a covering at once waterproof and warm. The word thatch comes from the German *Dach*, meaning a roof, and thatch once included other primitive coverings such as fern, moss, brushwood and turf.[6]

Thatch is best laid on a steeply pitched roof so that the rain will easily run off, and the fewer awkward angles there are the better since the thatch tends to obscure them with its heavy coat. In the gale-prone west, a net was often stretched over the thatch to keep it in place, but proper binding and pegging is quite adequate. Some primitive roofs were built up on horizontal beams with a

solid base of twigs rising in the middle to a ridge with the thatch laid directly on top of this, a form still to be seen in farm buildings at Manor Farm, Cogges, Oxfordshire.[7] The ridge has always been an invitation for decoration. In northern France thatched ridges are often planted with irises whose roots stabilize them, but in England crests, sometimes with modelled dollies, animals and birds, and a shaped skirt, are the norm.

Thatch has two distinct disadvantages: it needs to be replaced every generation or so, and it easily catches fire. This was not the problem it seems in the days of high halls with open fires. The smoke coated the under-side of the thatch with soot, which made it less inclined to take fire; and sooty thatch made a potent fertilizer, so thatching gave back more to the fields than it took for a roof. When enclosed fires concentrated the heat and sparks into a chimney, the disadvantages of thatch were aggravated if the chimney cracked, but, by the time this became common in the 17th century, thatch had long been despised for its associations with poverty. Indeed, it would soon start a revival because of its rustic charm.

**BRICK** A completely new building material which the Romans introduced to Britain was brick. The firing of a mixture of earth, clay and other material to make bricks was as old as antiquity, but not in England. Bricks, it turned out, were not only durable, but could be cheaply manufactured in many parts of the country and were light enough to be more easily transported than stone. Despite these advantages, they were abandoned together with other Roman building methods and revived only towards the end of the Middle Ages. Then it was Continental practice and imports of ready-made bricks from the Baltic and Low Countries which spurred the revival. Despite a number of fine brick-built monuments dating from the 14th century, it was only after 1500 that bricks came into common use, and some counties had to wait longer still before they had anything to show. By the middle of the 17th century, at last, brick had made so much headway that it was generally as cheap to build a house in it as in timber; fifty years later a timber house might cost twice as much, so far had fashion allowed the production of the one to advance and of the other to fall.[8]

Like brick, tile was another Roman importation that vanished. The making of tiles, again, was revived towards the end of the Middle Ages, and they came into general use much more quickly than brick. By the middle of the 14th century, both the Benedictines and Cistercians were promoting the manufacture of tiles in Kent,[9] and these found their way on to the roofs of monastic barns and yeomen's houses alike. They might not be as warm as thatch, but that was no disadvantage in a barn anyway, and to improve the insulation of a house they could be laid on a thin covering of straw. With wooden pegs to hold them in place, they lasted far longer than the lifespan of thatch – about a generation – provided they were not caught in a tearing gale. From the 15th century onward, thatch became increasingly associated with poverty as tile took its place.

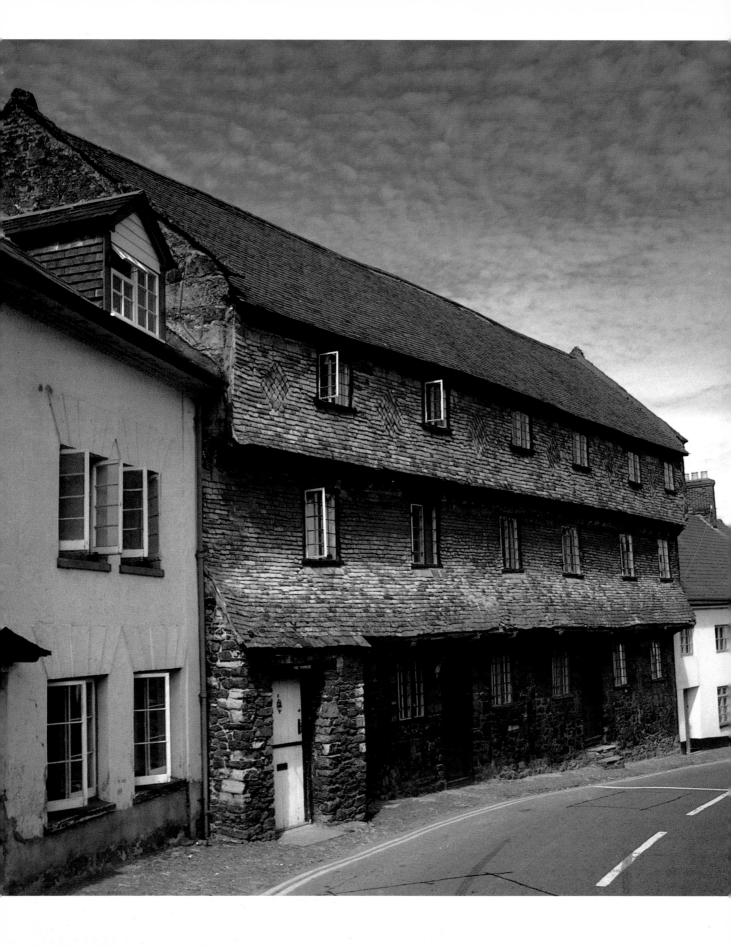

The Nunnery, Dunster, Somerset *(left)*. A row of partly medieval houses, built with a ground storey of Devonian sandstone supporting timber-framed upper storeys hung and roofed with West Country slate.

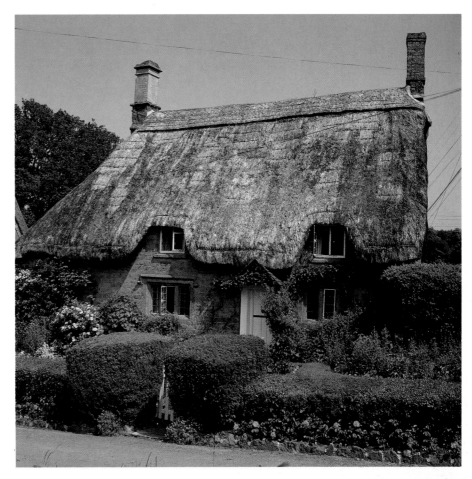

A thatched cottage with finely ashlared Jurassic limestone walls, at Great Tew, Oxfordshire *(right)*.

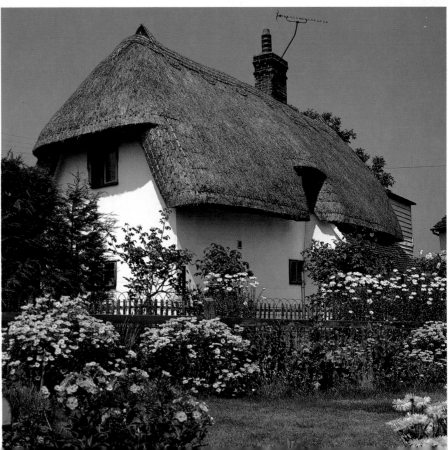

A thatched cottage at Great Dunmow, Essex *(right)*.

**STONE**     Always at the head of the hierarchy of building materials is stone.[10] Generally it is expensive, a characteristic which seems to have brought attractions which blinded people to its disadvantages. It was not available everywhere, it needed skill in the quarry to find the best seams and cut them, it taxed local transport to the limit because of its weight, it took time and experience to raise it into a wall, and even then, despite its structural strength, its ability to last was not necessarily greater than that of other materials. For all this, its appearance was crisp and colourful when new, and the best stones could be raised up into monuments where size matched durability. In short, stone meant status.

One undoubted advantage of stone is its variety, a direct consequence of the great number of geological formations underlying England's landscape from which it was quarried. England is divided geologically into two parts. The break is seemingly only one of many across the land, but dramatic enough as one drops westward off the Chiltern scarp and travels beyond the underlying chalk which characterizes so much of southern and eastern England. The break is caused by the Jurassic formations, which curve diagonally for 300 miles. Starting in Dorset, they run north-east across Gloucestershire and Oxfordshire as the Cotswolds to reach Northamptonshire, then turn northwards through Lincolnshire, and eventually rise up in North Yorkshire for a last dramatic stand in the high moorland of the Cleveland Hills.

To the south and east of this great band, the underlying rock is mainly the younger Cretaceous. Its stones are generally soft and pervious, particularly chalk, which even in its hardest form, clunch, needs a harder stone to protect its edges when used for building. Found in the upper strata of chalk in a union of opposites is flint. As hard as chalk is soft, flint was prized from the earliest of times for making cutting tools. In building, it could be used just as it was found, in small knobbly lumps bound together in mortar, a mixture of sand and lime, itself burnt from chalk. Flint could again be used split – 'knapped' – to make a flatter surface, characterized by its shiny, perceptibly translucent blackness, or as cobbles pounded round by the sea or glacial erosion.

Just beneath the chalk is a thin layer of greensand. This contains some variable building stone, ranging in hue from light buff to a dark purple-brown or murky green, depending on how much iron is present. Particularly in western Norfolk, where it is called carstone, it is difficult to work. When it is used, small chips of the stone are often set into the binding mortar, both to economize in mortar and to decorate the surface of the wall. The best, and oldest, of the Cretaceous formations, the Hastings Beds in the high Weald of the south-east, produce a wonderful golden stone of fine quality, which has the added advantage of being easily split for use as tiles.

The Jurassic band provides the best-loved stone in England. It is as easy on the eye as kind to the mason. Like all limestones, it is damp when quarried and comparatively soft, making it easy to cut; on drying, salts dissolved within the rock crystallize, especially towards the surface, and harden it to produce a long-lasting resistance to weather. In Dorset two fine Jurassic stones were quarried close enough to the sea for easy shipment. Purbeck 'marble', light grey but darker when polished, was widely favoured in the Middle Ages for its decorative effect when placed beside lighter stonework. The brilliant white Portland was always the aristocrat of stones, and was even taken by sea to

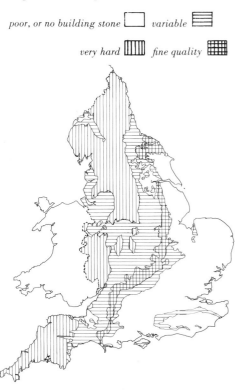

*England. Building stone.*

poor, or no building stone ☐   *variable* ▤

*very hard* ▥   *fine quality* ▦

America. Right across England, the quarries on the Jurassic line up in a distinguished roll of honour: Chilmark, Doulting, Box Ground, Taynton, Weldon, Ketton, Collyweston, Barnack, Clipsham, Ancaster, Hovingham. They are all Oolites, 'egg-stone', so named from their roe-like granular consistency. Depending on the amount of iron oxide in them, their hues range from cream to buff, bistre and brown, greenish grey, gold, orange and all but red and purple. Some of these are monochromatic, but several combine a range of these colours in waving striations. Beneath these oolitic stones is the browner and more variable lias, the best coming from Ham Hill. These are the nobility. Beside them were numberless village quarries which supplied stone of varying quality for everyday buildings from the 16th century onwards.

Emerging on the westward side of the Jurassic band is an extensive area of the older and lower Triassic sandstone with occasional outcrops of Permian sandstone. These stones stretch across the length of the country, but their heartland is the Midlands, particularly the lowland plain embracing the tributaries of the River Trent above Nottingham. South of the River Severn, from Bristol to Teignmouth, the Trias is discontinuous, mingling with Jurassic outliers and other formations. North of Nottingham the Trias runs up to the Vale of York, eventually carrying the lower reaches of the Tees to the sea. A further extensive mass of Trias ranges north-westwards across Shropshire and Staffordshire into the Cheshire and Lancashire plains, the Wirral and Fylde. Another stretch embraces the Vale of Eden in Cumbria and the Solway Coast as far as Maryport. Warm-tinted though not always red, Triassic sandstone renders abundant building stone, easily worked. Sadly, this easy virtue, so seductive to the eye, is soon despoiled by weather.

Pushing southwards toward the centre of England come the Pennines, the backbone of the north. They are formed from Carboniferous stones, breaking up through the sandstones of the Midland plain. Of these, a sandstone, the Coal Measures, forms bulwarks on the Yorkshire and Lancashire flanks of the highest peaks and supports much of Durham and south-eastern Northumberland as well. It outcrops in the Midlands; and a discontinuous chain of Coal Measures runs southwards from that extraordinary humping Shropshire hill, The Wrekin, down the course of the River Severn, eventually to reappear in the Forest of Dean and the Vale of Berkeley.

The other Carboniferous sandstone, Millstone Grit, forms the central Pennines of Yorkshire as far north as the Craven Gap, and flanks the higher Carboniferous limestone further to the north and in the Peak of Derbyshire. In the West Country between Exmoor, Dartmoor, Bodmin Moor and the River Exe is a separate but similar tract of Carboniferous sandstone known as Culm Measures. These sandstones are extremely hard, resistant to both weather and chisel; their light brown colour weathers almost to black, a process abetted in the last two centuries by the soot-laden air of the north. Their sombre tones exactly suit their bleak situation where nature's violence strives against man's violation in a dark landscape. The lighter, steel-coloured Carboniferous limestone of the Peak and the long northern stretches of the Pennines and Cheviots completes these formations. It carries the grandest scenery in England, and complements it with hard crystalline stones.

Older than the Carboniferous formations is Old Red Sandstone, which underlies the Welsh Marches to the south and west of the Severn in Hereford

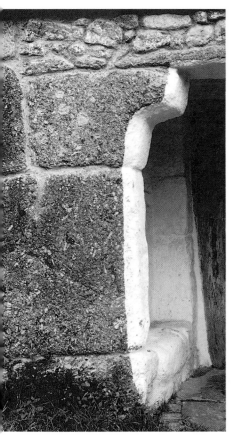

Sanders, Lettaford, North Bovey, Devon. The granite porch, showing the immense blocks of moorstone sometimes used in traditional buildings.

Milburn, Cumbria. A bank-barn built of the red Triassic sandstone of the Vale of Eden and the greyer Carboniferous stones of the Pennines; there are entrances to the cattle-houses at ground level and a doorway above from which straw can be pitched down to the animals from the barn proper, which is reached by way of an embankment at the rear.

Grinton, North Yorkshire. A farmhouse built of Carboniferous limestone in Swaledale in 1663.

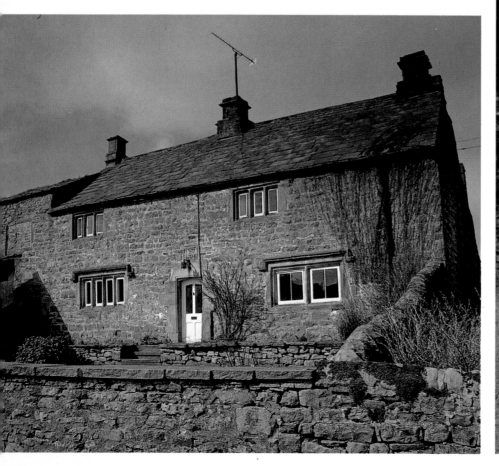

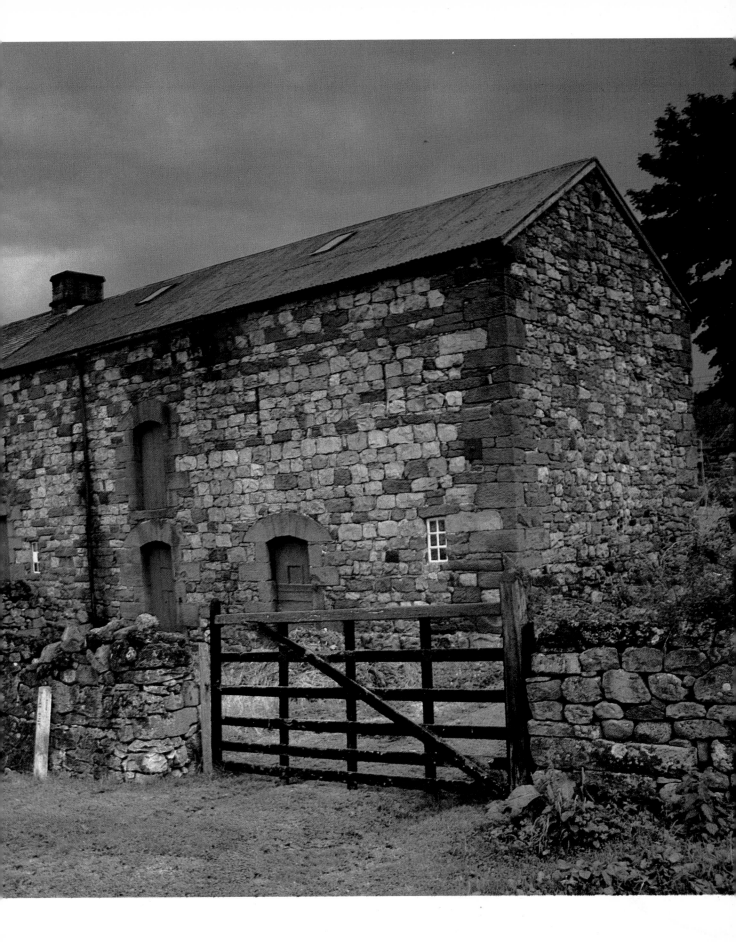

and Worcester. Often dense red, it is marginally better than Trias for building, but still tends to be soft. Rather better is Devonian sandstone, the material of Exmoor, of the Brendon Hills and the Quantocks, and also much of Cornwall and south Devon. Still older in the geological scale are the Silurian and Ordovician stones, which come to the surface in Shropshire and much of Cumbria to render slate and sombre building stones. They make good roofing stone, but, because of their tendency to split and allow water to penetrate them, as much as because they are so sombre, they are often limewashed, distinguishing a house from its surrounding farm buildings and keeping it dry.

These are all sedimentary rocks. They and a few others are typical of the English landscape. The igneous rocks, by distinction, are mostly confined to the west. Formed below the earth's crust, they sometimes rise through the sedimentary rocks in a dramatically frozen burst. The commonest, granite, makes up Dartmoor, Bodmin Moor and much of Cornwall including West Penwith. Together with other igneous rocks, it forms the central mass of the Cumbrian Mountains. Proverbially indestructible, granite is even harder on the chisel than the Carboniferous stones. It can be found as eroded blocks on the surface of the land. This so-called moorstone was used in the Bronze Age for small round houses, and was the first stone to return to common use among peasants in the Middle Ages.

They cleared the stone from the moors to create fields and then used it for miles of dry-stone boundary walling and their houses as well. Astonishingly, immense blocks of moorstone, often weighing a ton or two each, were used for low and humble farms on Dartmoor in the late Middle Ages. The difficulty in transporting and raising such stones must have been matched by the great esteem they brought to their builders.

Metamorphic rock, slate, is often found near granite in the west and in Cumbria. Generally dark, its tones range through browns, pinks and greens to blues and purples. Slate walling, often in conjunction with other stones, is common in Cumbria and the west, and is characterized by a ragged surface, sometimes itself slate hung as protection against the weather. Its ability to split along the close parallel lines of its strata in the way several sedimentary limestones and sandstones can be split makes it ideal for roofing, and with the further advantage that much finer sheets can be formed, making for lighter roofs, and easier transportation. Being impervious, slate is an excellent floor covering too, and can be used as a damp-proof course.

Building stone ultimately crowned traditional architecture with its variety, at least beyond the chalkland of the south-east, and gave numberless villages and small towns their character. The Oolite of the Cotswolds made Chipping Campden, the Millstone Grit of the Pennines made Heptonstall, the granite of Dartmoor made Chagford; but all this required wealth before the skills of masonry could descend below the level of monumental architecture.

# 3 TIMBER FRAMING

The majority of the earliest surviving traditional houses and barns were made of timber, at least in part. This involved a timber frame, which more than satisfied the needs of structure and served decoration as well. Timber framing quickly became central to the development of traditional building, and maintained this position until well after the Middle Ages. The reason is simple. Except in a few regions like Dartmoor, masonry was beyond the means of many everyday builders – farmers, craftsmen and merchants – and remained so throughout the Middle Ages. The art of brick-making was dead and had to be revived anew. Meanwhile, the use of timber was widespread, even in poorly wooded places where supply was difficult, and had longer traditions.

The Roman craft of carpentry may have survived no longer than masonry and brick-laying. Nevertheless, it did not die entirely. Saxon traditions changed it, eventually beyond recognition. Early Saxon buildings of any size had walls built of closely spaced planks, and were both strong and expensive, but they and later Saxon timber buildings had several disadvantages. Their walls were based in trenches or were framed by earth-fast posts; this gave them stability, but it was at the cost of their eventual decay.

The solution to this problem was to frame buildings so that the posts could be set above ground on a waterproof plinth. Archaeological evidence suggests that this did not happen until shortly before 1200. A new royal hall built at Cheddar early in the 12th century employed earth-fast posts. Had there been a better way of stabilizing the structure, the royal carpenters would surely have used it. Significantly, when this hall was rebuilt, possibly in 1209–11 for King John, the posts were set on pad-stones above the ground, so new techniques were seemingly developed in the interval.[1]

There are two strong reasons why the later 12th and 13th centuries should have been the occasion for carpentry to develop in this way. First, the wealth brought by increasing economic activity encouraged building. More and more people could afford to employ skilled craftsmen to build for them, rather than build in a simpler fashion for themselves. In some rich towns timber shops and houses were now built on stone undercrofts; as their posts could no longer be set in the earth, a method of stabilizing them was needed. Secondly, an improved knowledge of mathematics gave carpenters the means of building more skilfully. Contact with Islam through the Crusades improved the mason's techniques so much that they could flower in the Gothic style. This was encouraged by Adelard of Bath whose translation of Euclid's *Elements* from Arabic into Latin about 1120 gave master craftsmen a proper understanding of geometry for the first time.[2] This at last enabled masons to set out their buildings accurately, and carpenters to construct the centering for masonry arches and vaulting with precision. By the last quarter of the 12th century, techniques of roofing great churches in timber were advancing rapidly,[3] together with the introduction of Gothic vaults.

A radical change in the form of early surviving timber-framed buildings shows the consequences of understanding Euclid's geometry. Even as late as the last royal hall at Cheddar, the posts of timber buildings were seldom exactly aligned, either transversely or longitudinally. Euclid and especially Pythagoras's theorem now allowed carpenters to set out right angles accurately, ultimately letting them mount a frame on a timber sill with joinery that increasingly made use of the efficient mortise and tenon rather

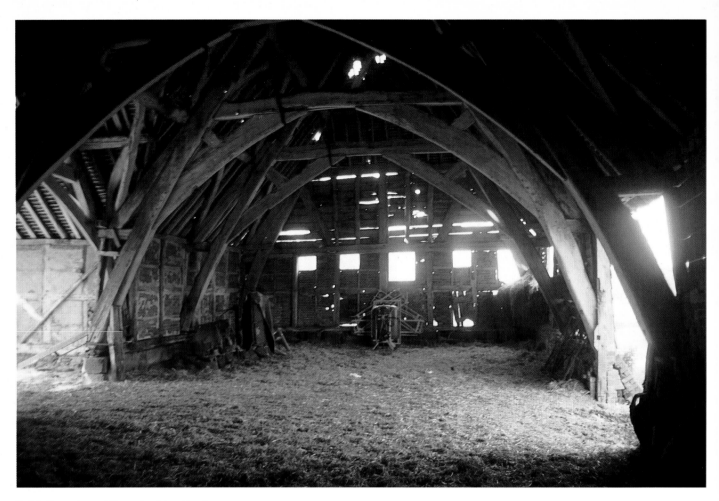

Leigh Court barn, Worcestershire. Pershore
Abbey's unequalled cruck barn.

Abbey Barn, Glastonbury, Somerset. Here,
one tier of arch-braced crucks mounted high
on the stone walls supports a second tier,
and these, together with the curved wind-
braces supporting the roof purlins, give the
structure an ornate appearance matching the
fine stonework of the exterior.

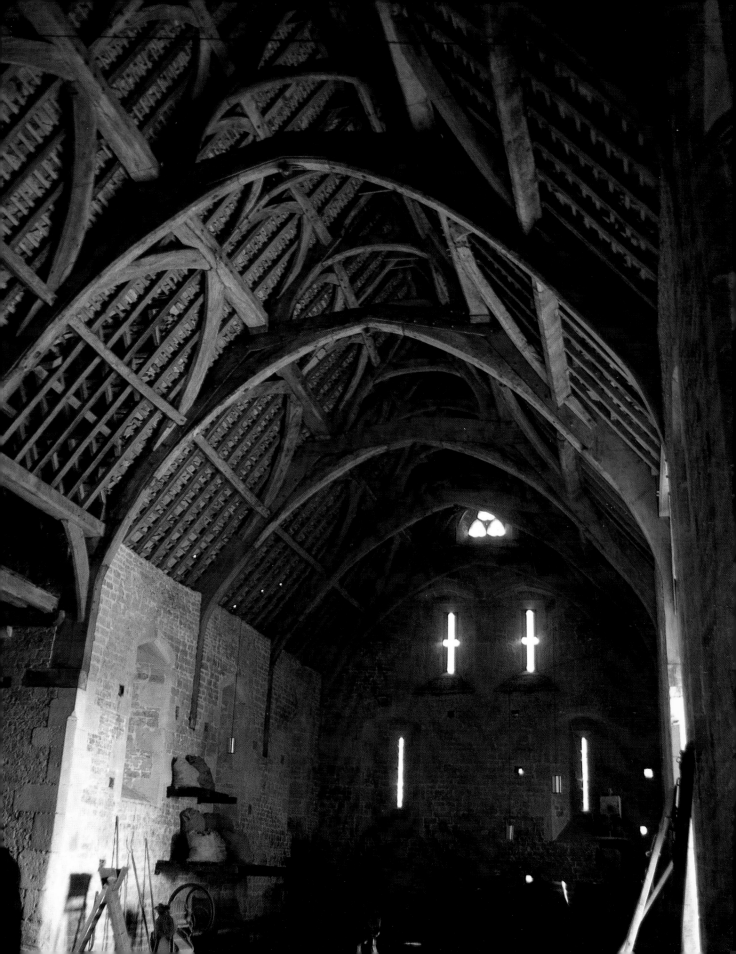

than the simpler lap-joint. This required greater thought in design, greater accuracy in cutting, and precise order of assembly; but, since the joints were drilled with holes to peg the separate timbers together, frames could first be assembled in the carpenter's yard to check their accuracy and fit, before the separated timbers were finally assembled.

By the early 14th century carpenters had solved most problems of building a rigid frame, and had developed various standard joints which remained in use for as long as people built houses and barns with frames of hard wood. The frame was made up of a series of units or bays which were defined by vertical timbers linked together by lengthwise and crosswise beams. Bays were rather

*Anglo-Saxon framing. Chalton, Hampshire: conjectural reconstruction of halls. Early period B1* (top) *has posts sunk in the earth and simple opposed central entrances; later period A1–A2 type* (bottom) *is partitioned and based on posts set in trenches.*

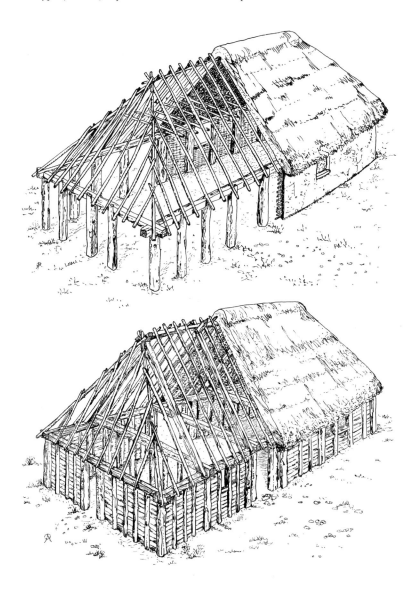

wider than long and normally measured between 4 and 6 m (12 and 20 ft) each way, limits imposed by the length of readily available timber.[4] This was an admirable size for a room; particularly large rooms could take two bays or occasionally more. Large, open buildings such as barns could extend for as many bays as necessary, because carpenters learnt to make each bay self-supporting. Two clearly separate traditions of doing this developed.

In the technically more advanced of these two traditions the larger buildings which promoted these developments were aisled. The weight of their roofs put great stress on their walls and the arcade-posts which defined the bays and separated the aisles from the main central space. Though medieval carpenters were unsure of how this stress operated, the junction between the roof and the wall was critical. If the roof were too heavy and improperly supported, the joints would shear apart and the walls splay outwards under its burden. Since the Norman Conquest, systems of timber buttresses and tie-beams had been used in larger halls, together with arcade-posts, and these were the starting point for this tradition of framing as it developed in the 12th and 13th centuries, perhaps influenced by foreign practice brought to England as a result of the Crusades. Most of the weight of the roof was taken by the arcade-posts, not the walls, and numerous ties and triangulating braces kept them rigidly in place and linked them to both roof and external wall. At first, this involved large numbers of timbers, some of extreme length, and they were mostly joined with simple lap-joints, but, as more sophisticated techniques of joinery were developed, the mortise and tenon joint was increasingly used and the number and length of the timbers were greatly reduced.

There was a simpler, significantly different way of solving these problems, and it was more economical in timber. This was central to the second of these traditions. The weight of the roof was carried by a stable frame, structurally independent of the walls. This comprised pairs of curved or elbowed timbers known as crucks, jointed together to form an inverted V, bowed or cranked outwards. A series of these, linked by lengthwise timbers carried on their backs, formed the basic frame of a cruck building, and, once again, divided it into a series of bays. Unlike the aisled frame, which needed the benefit of extensive bracing or sophisticated joinery, the cruck frame needed neither. This eased assembly: a pair of crucks could be joined on the ground by yoking them together, and then be reared upright, to be followed by a second and then more pairs of crucks as building proceeded, bay by bay.[5]

Because of this simplicity and the consequent widespread use of cruck frames in rudimentary buildings, they were once thought to be of greater antiquity than aisled frames. Their general distribution in the poorer western half of England and Wales, together with their total absence in the east from Kent to the Vale of York, supported this view and prompted the supposition that crucks had a Celtic origin.[6] This cannot be conclusively disproved, even though there is no other supporting evidence. Their origin and the reasons for their distribution, particularly the sharp cut-off along their eastern boundary, remain open to speculation, despite many theories.[7]

Their origin is more likely to be in or shortly before the 12th century. The inverted V-frames possibly used in early Saxon buildings, though like cruck frames,[8] belonged to a different tradition, but might have contributed

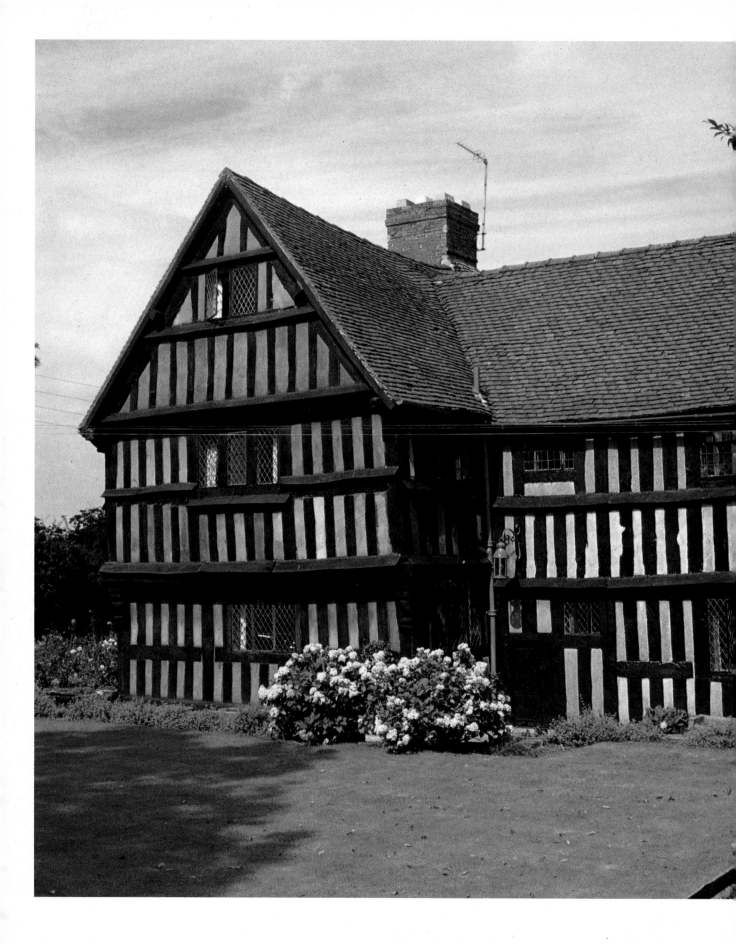

Woodroffe's, Marchington, Staffordshire. In this lobby-entry house of 1622, the close-studding introduced to Kent in the middle of the 15th century is divided, storey by storey, by rails.

Decorative timber framing in Shrewsbury, typical of the west Midlands in that it has small panels enriched by curved braces forming stars.

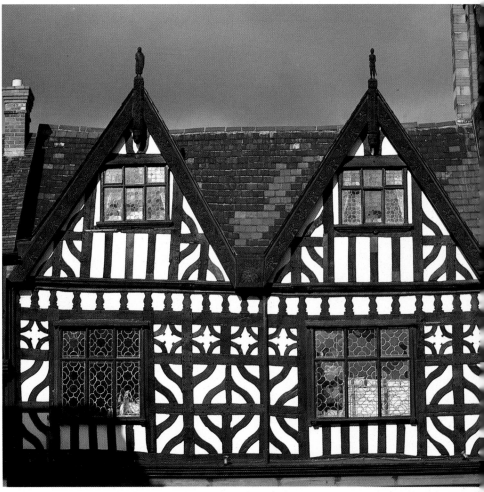

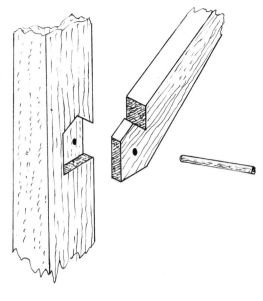

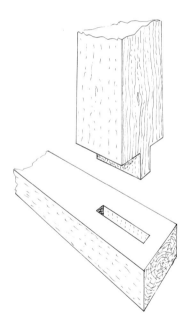

*Lap-joint (top). Detail of arcade post of Cressing Temple Barley Barn, Essex, showing brace with notched lap-joint designed to counter withdrawal, and peg, prior to assembly. Mortise and tenon. Detail of the base of an arcade post of Cressing Temple Barley Barn, before setting in a ground-sill.*

something. The inherent stability of a cruck frame allowed it to be used without post-holes and it would then leave no recognizable archaeological trace.[9] Notwithstanding this, crucks definitely occur in England for the first time only as late as a 12th-century site at Gomeldon, Wiltshire,[10] and, in documents, with the synonymous term *furca* (fork) – once used in Roman times by Ovid, perhaps to mean something similar – in a reference of 1183 to a barn at Glastonbury Abbey.[11] So far as England goes, the two traditions of aisled framing and cruck framing appear to have developed simultaneously from obscure origins.

The reason for the distribution of cruck frames and, for that matter, of aisled frames may depend on what kind of timber was most readily available in the localities where the two traditions evolved. In the Middle Ages, as in prehistory, building timber came from trees in managed woodland, from trees on land also used for pasture, and trees on other farmland including those in hedges. By the time of Domesday, England was one of the least wooded countries in Europe: woodland covered only 15 per cent of the land and was unevenly distributed. The timber which came from it was commercially produced by woodmen, and its supply depended on customary methods of working which were already ancient. In eastern counties this meant coppicing or felling standard trees, usually oak, which were comparatively young but had grown quickly and upright among surrounding underwood trees, which were cut more frequently for other purposes. In wood pasture, the oaks grown for timber tended to be further apart than woodland trees and grew more slowly to a larger girth, while hedgerow trees were as variable as their individual circumstances.[12]

In eastern counties, intensively managed woodland met a demand for building timber so great that no other source could have fulfilled it. Until the end of the Middle Ages, the quickly grown trunks were used whole, not halved or quartered. Even a modest house consumed many trees: a small, three-celled house of two storeys built about 1600 at Swaffham Prior in Cambridgeshire needed seventy-two trunks for its framing and studding, and they had taken from twenty-five to eighty years to grow. A further seven larger and older trunks were needed for floor boards. This was equivalent to the annual production of 27.5 hectares (68 acres) of managed woodland. The larger Grundle House at Stanton in west Suffolk needed over seventy-five trunks for the main frame alone, 251 for smaller studs, joists and rafters, and five and a half for boards. This was an annual production of 116 hectares (286 acres) of woodland. West Suffolk was well wooded, and could have supported the construction of seventy-five such houses every year, or one in each parish every two and a half years. Demand was never that great, but the county had to support its neighbours. Swaffham Prior on the edge of the Fens was almost devoid of woodland, so timber had to travel scores of miles to many villages like it; and a journey of fifty miles by road could double the cost of a load.[13]

The great advantage of managed woodland was the assured supply of good straight building timber it provided. Because oaks grew comparatively close to other trees, their useful growth was upwards; they did not produce branches below the height of the surrounding underwood, that is about 6 m (20 ft). Crucks, by distinction, come from either curved trunks or the natural bend between a trunk and a low branch. By exploiting this bend an oak could

provide a matching pair of crucks, the timber being adzed to shape and then cleft or sawn in two. Intensively managed woodland is unlikely to have produced the heavy curved or elbowed timbers used for crucks, which came from older trees found in wood pasture or hedgerows. These were not uncommon in the south and east. When particularly important buildings or windmills needed especially long or thick timbers, they had to be taken from mature trees in such woodland, for instance from the wooded parts of parks or forests, which were not intensively managed solely for the timber industry.

In those rich eastern counties where aisled frames were to remain common the converse was possibly also true: unless a building were particularly important, large timbers from mature trees were not taken; there were not enough of them to go round. Indeed, by the 14th century mature oaks had become rare enough to jeopardize this supply. Even by 1200, the needs of house and barn builders were already so great that timber from managed woodland trees provided the bulk of their supply. Consequently straight timber of comparatively thin scantling determined the tradition in which the carpentry of eastern counties developed, and curved timbers were confined to small and secondary roles.

Further west and north, both in the area where manorial influence was strong and the peasantry poor, and beyond it in the generally poorer pastoral zone, fewer people built substantial timber buildings. There was consequently

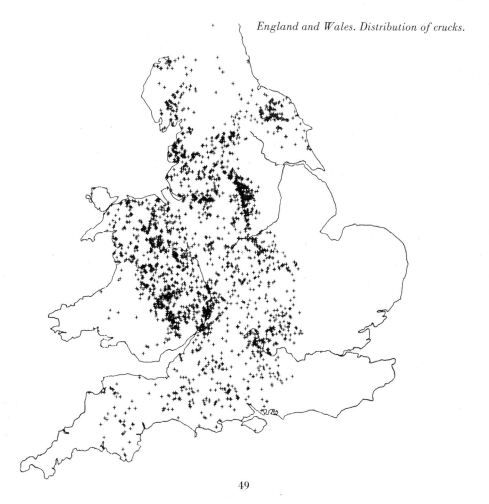

*England and Wales. Distribution of crucks.*

less need to reserve mature trees for only the occasional important building, and so they played a fuller part in the developing traditions of timber framing. Unlike the tall, straight trees of managed woodland, they could supply curved or elbowed timbers for crucks, sometimes of a size so great as to put the rich east to shame.

Meanwhile lighter crucks served to give a modicum of strength to the poorer houses of the peasantry. Woodland was sometimes controlled by manors which refused to give up good timber,[14] and when a peasant could purchase what he needed for a substantial building his funds limited him to as little good timber as might suffice. Here a cruck frame rather than an aisled frame had great advantages: a four-bay house would only need five trees for the cruck pairs and perhaps only another ten straight trees for ties, plates, purlins and a ridge. The walls, bearing no load, could be made of small lengths of light, easily available wood. An equivalent aisled frame would have been not only too expensive, but also beyond what the lord of the manor would make available. Finally, the crucks themselves could be used and used again with far greater ease than other timbers.

For a while, excessively long timbers were a hallmark of aisled framing. Their purpose was to stabilize the roof and the awkward junction of timbers at the top of the arcade-posts and wall-posts. At this point these vertical timbers met the intersecting plates that ran the length of the building and the ties that ran across it, producing points of weakness made the more precarious now that the posts were no longer set in the ground.

The first steps in stabilizing the bottoms of posts set above ground can be seen in Essex. A reused arcade-post in a barn built by the dean and chapter of St Paul's Cathedral on their manor at Belchamp St Paul originally rested on a pad-stone, but an angled mortise near its base suggests that it might have been braced by a short, raking earth-fast strut. This would have saved the arcade-post from rotting, but still allowed it to be firmly held at its base. The post, very roughly dated to the early 11th century,[15] may be nearer the time after 1140 and before the end of the century when the Cistercians of Coggeshall Abbey built their grange barn with arcade-posts which were set on pad-stones and braced instead by horizontal ties to the wall-posts.[16]

Pad-stones remained common among cruck buildings, but soon after 1200 they were giving way in aisled buildings to timber sills or sole-plates which extended inwards from the main wall-sill to the bases of the arcade-posts. The Barley Barn, built by the Knights Templars on their estate at Cressing Temple, Essex, after 1211 and probably before 1220,[17] is the oldest known building to use them. Its arcade-posts are tenoned into sills, and that required the accurate carpentry made possible by a knowledge of Euclid, and skilful use of the block and tackle during construction.[18]

Additional stability came from the horizontal strainer-beams tenoned just below the heads of the opposite pairs of arcade-posts flanking the wagon entrance. There was a similar use of strainer-beams in the Sextry barn at Ely, which was built at much the same time,[19] and again in the remarkable great barn at Bredon, Worcestershire, built on one of the Bishop of Worcester's estates as late as about 1350.[20]

Nonetheless, the characteristic framing member of the two Essex barns is the passing-brace, a very long transverse timber whose principal role was to

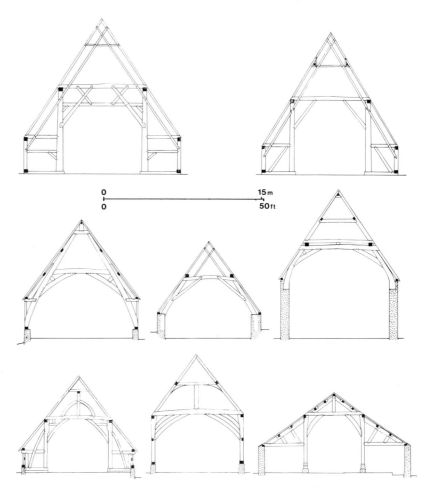

*Transverse sections through medieval barns. The barns at Cressing Temple* (top), *the Barley Barn* (left), *showing its long passing-braces and numerous subsidiary braces joined with lap-joints, notched at their ends; the Wheat Barn* (right), *showing its passing-braces divided on the arcade-posts, and reduced number of subsidiary braces joined with lap-joints, the notches being hidden on inner faces of joints only, and rudimentary purlins held against the rafters by a collar and cleats;* (centre, left to right) *Leigh Court barn, with the greatest span of all cruck frames; Siddington barn showing a pair of base-crucks and tie-beam, and roof framing including scissor-braces but possibly excluding other timbers; Middle Littleton barn, showing base-crucks and double ties (as Siddington may have had) clamping longitudinal roof plates;* (bottom, left to right) *Frindsbury barn, with typical Kent framing and a crown-post roof; Nettlestead Place barn, unaisled, and with roof purlins braced by a collar and central king-strut, and Upper Lee barn, Heptonstall, possibly built in the 16th century, with a low-pitched roof to carry stone tiles, supported by heavy principal rafters and closely spaced purlins and a ridge-piece mounted on a king-post.*

brace the roof to the frame below.[21] It passes over all the main framing members, rising from a pegged lap-joint on a wall-post to be trenched over an arcade-post, over the tie-beam that links it to its opposite number, finally to reach the roof and cross over the opposite passing-brace shortly before being pegged to a rafter with a second lap-joint. Similar timbers were developed in the 12th century for wide church spans, and carpenters probably adapted them shortly before 1200 for the needs of large aisled barns,[22] though it is just

possible that their origin lies in the German highlands in a more ancient tradition of building in fir and spruce, trees that could have provided the necessarily long timbers with little difficulty.[23]

Of forty-one aisled buildings known to have had passing-braces, only Coggeshall barn, the Barley Barn and the Sextry barn were supported by full-length passing-braces.[24] These were up to 15 m (50 ft) in length, and could only have come from very old oaks which had grown straight. They had to be especially sought, and must have been expensive. The Barley Barn and its companions therefore almost certainly mark the end of an experiment in bracing an aisled building. This was probably short lived; thereafter, passing-braces were used either in much smaller aisled halls where they were no more than some 6 m (20 ft) long, and therefore within the reach of managed wood-land, or made up from two similar lengths, meeting at the arcade-post, as occurs in the Barley Barn's companion at Cressing Temple, the Wheat Barn, which was built between 1273 and 1285.[25]

The experimental nature of the carpentry employed in these 13th-century barns is shown by the multiplicity of secondary braces that triangulated the main members of their frames to ensure their security against movement. This did not complicate the process of construction because of the ease of assembly offered by their lap-joints, but the great quantities of timber that they needed added to their expense.

Economy and stability required the development of a crucial part of the aisled frame, namely the junction of the uppermost longitudinal timbers or plates, the vertical arcade-posts and the transverse tie-beams. The purpose was to ensure that the weight of the roof rafters would not twist the frame out of position. In primitive buildings, the tie was usually placed directly on to the posts and the longitudinal plate then rested in trenches cut into the top of the tie. This made assembly easy. Cross-frames could be raised into place in the same way as cruck-frames, and then the longitudinal plates were set down on top of them to secure them in position. The great advantage of this was that it did not require the posts to be set out accurately.[26] A few surviving barns were built like this in the 13th century and later, but, ultimately, it was found to be a less satisfactory way of supporting the feet of the rafters and was not normally employed in most surviving buildings. It has come to be known as reversed assembly,[27] and could be seen in a barn at Belchamp St Paul, and still can be in the great Cistercian barn at Great Coxwell in Oxfordshire, built about 1305–10.[28]

Even by 1200, reversed assembly was being superseded by normal assembly in which the plate is tenoned on to the top of the posts and the tie-beam is placed over it and so helps to counter any twisting action caused by the thrust of the rafters. The barns at Coggeshall and Cressing Temple use normal assembly, but one perfecting development was still to come. This was a joint which would unite post, plate and tie-beam. It is seen in embryo in the aisles of the Cressing Temple Wheat Barn about 1275. The aisle-post has a staggered head. The outer, lower half is tenoned to engage a mortise in the aisle-plate, and the upstanding inner half, rising beside the inner face of the plate, is also tenoned so that it can engage a mortise on the underside of the aisle-tie. Furthermore, the underside of this tie ends in a rudimentary dovetail, which laps on to the top of the plate, thus securing it, firmly uniting all three timbers,

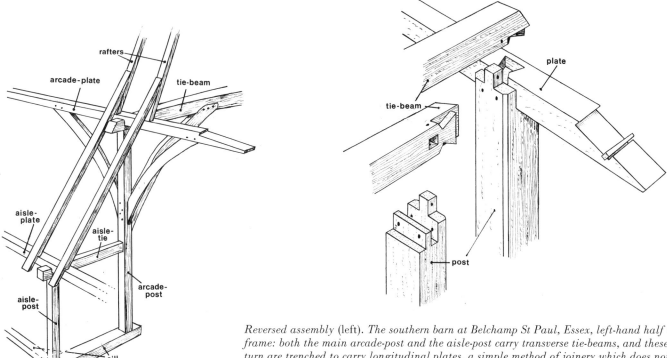

*Reversed assembly* (left). *The southern barn at Belchamp St Paul, Essex, left-hand half of frame: both the main arcade-post and the aisle-post carry transverse tie-beams, and these in turn are trenched to carry longitudinal plates, a simple method of joinery which does not need accurate setting-out or carpentry, but is neither efficient nor structurally strong. Normal assembly* (right). *Cressing Temple Wheat Barn: the tops of the posts are trenched on the outer side and tenoned to carry a mortised plate on to both of which the tie-beam is fitted, with a mortise and tenon to the one, and a dovetailed lap-joint to the other, to resist withdrawal caused by the weight of the roof forcing the wall outwards. The underside of the tie-beam is shown just below, and, below that, the head of the post disengaged from the tie and plate as seen from outside.*

and preventing any tendency to splay outwards.[29] It only remained to refine the dovetail to increase the resistance to outward pressure, and to swell out the head of the post into a jowl, giving it greater thickness and strength to accommodate the width of the plate and the upper and lower tenons. This was usually achieved by cutting the jowelled posts from timbers set upside down, their thicker ends uppermost. This neat solution was reached by 1300, and soon became universal, remaining so with hardly any change until the end of the tradition of framing in hard wood some five hundred years later.

The roof of the Wheat Barn was stabilized longitudinally by timbers, technically plates, but nevertheless embryonic purlins, which rest on collars and are held against the rafters, edge-on, by short vertical cleats. Probably as a consequence, there was no need for the longitudinal stiffness given by full-length passing-braces, as had been used fifty years before in the Barley Barn. Nevertheless, proper purlins, timbers placed flat against the rafters for their support, were already in use in the superior carpentry of great cathedral roofs, for instance in the northern choir transept of Salisbury Cathedral, which was complete by 1237.[30]

The method widely adopted in the 14th century to stabilize the roofs of traditional aisled barns and houses longitudinally was to raise a plate centrally within the roof on posts called crown-posts set on the tie-beams; the so-called crown-plate then supports a series of collars which brace every pair of

rafters and prevent them both from sagging and, resisted by friction against the plate beneath, from longitudinal movement. This so-called crown-post-and-common-rafter roof has a French origin, but was more immediately taken from English parish churches where, from about 1220, such roofs are found resting on stone walls between stone gables.[31] It is first found in the timber-framed hall of the Old Deanery at Salisbury, Wiltshire, built between 1259 and 1274, and Manor Farm at Bourn in Cambridgeshire, built after 1266.

Jowled posts and the crown-post roof made the passing-brace and its many subsidiary timbers redundant, though these remained as a relic for some time, notably in the great barn built by the Abbey of Bec for its manor of Ruislip in Hillingdon, Greater London, probably late in the 13th century or early in the 14th.

Arcade-posts interfered with the internal spaces of a hall, and various ways of removing them were found before the end of the 13th century. One way was to raise up all the transverse framing required by an aisled structure on to a very long tie-beam above head height. This happened at the Warden's House of Merton College, Oxford, in 1299–1300,[32] and on a large scale in a once ornate hall at Church Farm, Lewknor, Oxfordshire,[33] which was probably built about 1335–49 by John de Lewknor, a tenant of Abingdon Abbey.[34] Raised aisles carried by very long tie-beams were also used in Essex, at Gatehouse Farm, Littlebury, perhaps at the same time as the Warden's House, and later at Gatehouse Farm, Felsted, and, spectacularly, at Church Farm, Fressing-field, Suffolk.[35]

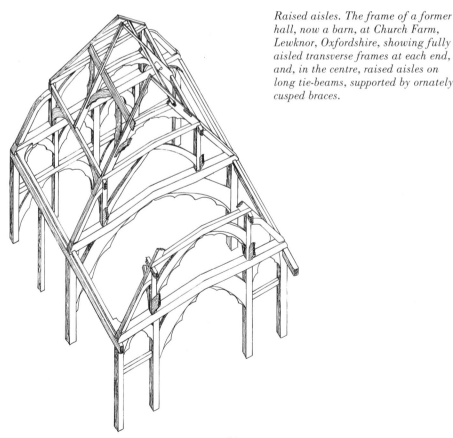

*Raised aisles. The frame of a former hall, now a barn, at Church Farm, Lewknor, Oxfordshire, showing fully aisled transverse frames at each end, and, in the centre, raised aisles on long tie-beams, supported by ornately cusped braces.*

The disadvantage of all these roofs was the need for an excessively long tie-beam. As soon as carpenters realized that the raised aisle-posts could be supported on the inward extremities of cantilevered stub ties, notionally a long tie with the centre cut out, the principle of the hammer-beam roof was discovered. This may not, however, have been a simple process of development. The earliest surviving hammer-beam roof in England was raised over the so-called Pilgrims' Hall at Winchester, with timber felled about 1285–95,[36] that is to say at precisely the same time as the earliest forms of raised aisles; and other parts of this roof are supported by fully aisled trusses, raised-aisle trusses and a form of cruck truss. To complicate matters further, the northern French architectural amateur Villard de Honnecourt drew a form of hammer-beam roof in his notebook c.1235, so the English examples may have come from France. At all events, English carpentry reached its summit with the hammer-beam roof of Westminster Hall of 1394–1401, but this technique was rarely used in traditional buildings.

Always the inordinate length and strength of the tie-beams were against these buildings, so they are rare. In smaller buildings, that is in small houses as opposed to large barns, the box frame became standard. This was no more than an aisled frame shorn of its aisles, and lacking internal load-bearing timbers. Box-framed buildings were the antithesis of cruck-framed buildings. Most of their timbers were short, 6 m (20 ft) being the maximum length, and scantlings of 0.15 m (6 ins) square were usual. Timbers from intensively managed woodland suited these dimensions well, and timbers of more than double the scantling were exceptional, even for posts and tie-beams.

Cruck-framed buildings continued to need much larger timbers. While the earliest dated crucks, in Tiverton Cottage, Wellshead Lane, Harwell, Oxfordshire, were erected after 1262,[37] the greatest of all cruck buildings may be no more than fifty years later, if that. This is the great barn at Leigh Court, near Worcester. Its crucks are 10 m (33 ft) long and have a maximum scantling of 0.53 m (1.125 ft), giving it an internal span of 10.2 m (33.5 ft). This brought the cruck frame to its peak, even perhaps a little beyond it: the great outward pressure of the crucks caused the sills on which they rest to splay outwards and the wall beneath them has had to be buttressed to counter it.

Despite its stability, despite its ease of erection and the freedom it gave builders to use whatever material they liked for the walls, the cruck frame had several disadvantages. Span was one, height another. Neither could be obtained without long stout timbers. Even when they were obtained, the crucks obtruded into the space they spanned. This could be made an attractive feature of a hall, and one conferring status, but unless the crucks were raised high on stone walls they constricted upper storeys. This did not greatly matter in the Middle Ages: halls in the cruck zone seldom reached the great height of those in the south-east, certainly not among the peasantry; when they did, and when large, wide barns were built, the cruck could be combined with the features of aisled framing to produce a hybrid which allowed width without the penalty of excessively long timbers.

So, while aisled buildings tended to keep to the south-east, Essex, East Anglia and parts of Yorkshire, just where crucks are either absent or rare, the cruck and the aisle did nevertheless meet in the south and Midlands in a marriage of convenience to remove the hindrance of arcade-posts.

In these buildings cruck-like timbers, known as base-crucks, curve upwards from the outer wall to support a tie-beam, which, further down the building, may be supported by arcade-posts.[38] To judge by surviving buildings, this first happened in a barn at Siddington, Gloucestershire, where a pair of base-cruck trusses flank the central bay, to be flanked in turn by arcade-posts and aisles, the reduced and partly rebuilt remains of a barn spanning only 4.4 m (13 ft) between the arcade-posts, but an impressive 8.5 m (27.5 ft) between the base-crucks in the middle. In 1193 Siddington church came into the ownership of the Knights Hospitallers, and hard by its west door is the barn. It is tempting to see them building it, perhaps about 1220,[39] with carpenters willing to innovate by marrying arcade-posts and base-crucks. Perhaps contact with Islam and its superior geometry led them to build Siddington barn, and their bitter rivals, the Templars, the two barns at Cressing Temple, as rivals in styles of carpentry yet as partners of great constructional importance in the development of traditional carpentry.

The framing of Evesham Abbey's barn built after 1315 at Middle Littleton, Worcestershire, is similar to Siddington's, though more assured. By then, it was common for halls to use base-crucks to span their open, central frames while still using arcade-posts in the closed frames which partitioned the hall from the flanking chambers. Their use up and down the social scale in the Midlands is well shown in the halls of Leicester Guildhall, Mancetter Manor House in Warwickshire and Til House at Clifton, Nottinghamshire, while the base-crucks of the Boarhunt hall-house, re-erected at the Weald and Downland Open Air Museum at Singleton, serve only to raise the central tie-beam of the hall well above head-height, and there are no aisle trusses at all.

Base-crucks are not invariably associated with aisles, even if they started that way. Glastonbury Abbey barn, for instance, was framed entirely with base-crucks in the middle of the 14th century.[40] Base-crucks achieved marginally greater spans than the crucks at Leigh Court, and employed significantly shorter timbers. Quarr Abbey's barn at Arreton on the Isle of Wight has base-crucks spanning 10.4 m (34 ft) with cruck blades no more than 6 m (20 ft) long,[41] and, perhaps in the 1320s, the base-crucks of the demolished Manor Farm barn at Cherhill in Wiltshire reached a span of 10.7 m (35 ft).[42]

Middle Littleton and Great Coxwell barns are significant for being the first to abandon the common rafter roof in favour of a trussed roof in which stout rafters rise over tie-beams or base-crucks to support purlins. These bear the burden of the common rafters between them, thus removing the need for collars linking pairs of rafters. Because the purlins lie flat against the slope of the roof, they are more effective than the longitudinal plates in the roof of the Cressing Temple Wheat Barn. They herald the alternative to the common-rafter roof, and this form was to become typical of carpentry in the western half of the country and eventually the north; moreover, it steadily encroached on the south-east in the Middle Ages and had become standard even there by 1550.

An important development in framing, made necessary when timber houses grew tall enough to accommodate upper floors, was a means of fixing both ends of the floor joists without interfering with the assembly of the main part of the frame and making this impossibly difficult. It was achieved by tenoning the inner end of the joists firmly to a bridging-piece or bressummer and simply

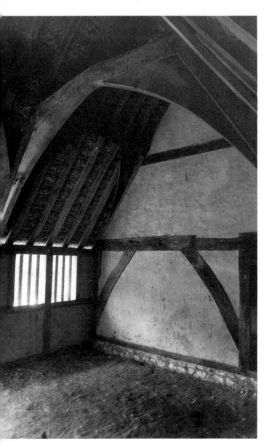

A house from Boarhunt, Hampshire, reconstructed at the Weald and Downland Open Air Museum, Singleton, West Sussex. The base-cruck truss spanning the open hall is designed merely to provide headroom.

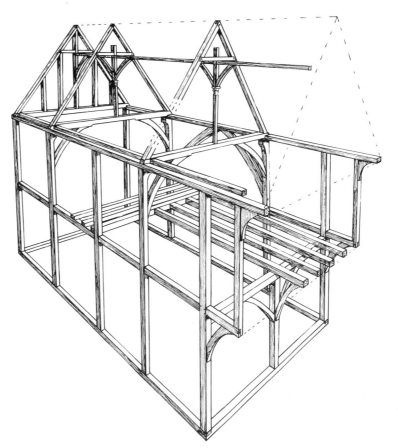

*Tiptofts Hall, Wimbish, Essex. Part of the timber frame of a service and solar bay (the later hall is to the right), showing projecting joists of the upper floor forming a jetty. The roof has an unusual form of crown-post and plate frame to carry the rafters.*

resting them on a second bressummer at the front and projecting them forward from it to produce a jetty. This avoided the difficulty of framing floor joists with mortise-and-tenon joints at both ends, and the projection provided a bit more floor space above. Moreover, the jetty would advertise the existence of an upper floor and, when such floors were still a rarity, they would bring a degree of status as well.

Jetties were probably developed in towns where crowded circumstances made it advantageous to have upper floors, but no early examples survive to prove the point. They appeared in the countryside at the start of the 14th century. The earlier part of Tiptofts Hall, a secondary manor at Wimbish in Essex which owes its name to the tenure of Sir John Tiptoft between 1348 and 1367, shows this well. Tiptoft or perhaps his predecessor rebuilt the hall of an earlier house, but kept the remaining service bay of about 1300 as a wing, framed and roofed at right angles to the hall and so architecturally distinct, and this has the oldest jetty to be recognized.[43]

When the north abandoned the common-rafter roof towards the end of the 14th century, it developed a tradition of its own by favouring a truss in which a king-post rose from the centre of the tie-beam to the apex of the roof to

support a ridge-piece. A few roofs of this type had appeared in halls and churches around the country in the 14th century, but their common adoption in the north is likely to be a response to structural needs brought about when the roofs of traditional buildings were no longer thatched but covered by stone. Clay tiles and thatch were traditionally laid on roofs of steep pitch, with 45 degrees being a minimum and 50 to 60 degrees more usual. With a steep pitch, there is less crushing effect between the rafters where they meet at the apex of the roof, and they could be simply halved together. The heavy slates from Westmorland and the riven Pennine stone tiles were habitually used on low-pitched roofs of 30 to 40 degrees, which made them easier to fix and less inclined to slip. The low pitch produced an obtuse angle at the ridge and, combined with the heavy weight of the stones, made the use of a centre support imperative, hence the king-post and ridge-piece; and they often needed two or more tiers of purlins lower down to prevent sagging, just as had been found when lead was applied to low-pitched roofs of churches. So, in the traditional buildings of the north the king-post roof is mostly confined to the Pennines and Cumbrian mountains where stone tiles were widely used, and they hardly appear in the Vale of York which stuck to clay tile or thatch until well after the Middle Ages.

One of the earliest king-post roofs in Yorkshire was raised in the 14th or perhaps 15th century over the aisled hall of Broad Bottom at Hebden Royd, West Yorkshire, with a pitch of 40 degrees; and the pitch was only 33 degrees in the great aisled barn nearby at Upper Lee, Heptonstall. Here, four tiers of purlins were trenched into the principal rafters, but in the north purlins were never supported by wind-braces as they would have been in the Midlands or west, a traditional regional distinction.[44]

Another northern tradition, again mostly restricted to the Pennines, is less easily explained. The principal posts of numerous cruck-framed and box-framed buildings stand on pad-stones rather than on a timber ground-sill, suggesting that a vestige of the tradition of setting the posts into the ground still survived. In many box-framed buildings the sill is tenoned into the sides of the posts a short way above ground; the plinth is raised accordingly beneath it to fill the space, and the sills carry the framing studs of the wall in the usual way. The resulting interrupted sill, as it is called, does not appear as widely in the north as, for instance, the king-post roof and the specifically northern ways used to fill the panels between the principal posts, the sills and the wall-plates.[45] The distribution of schools of carpentry is hard to uncover, but the general principle is clear: individual carpenters adopted some methods from one local school, and other methods from another, and this produced at times a bewildering variety of forms to enrich the pattern of building.

Nowhere is this more marked than along the curiously sharp boundary in the Pennines between where crucks were widely used and where they were never used. It is likely that the boundary here was partly determined by wealth: the poorer Pennines remained faithful to crucks while the richer Vale of York always chose the more sophisticated but less economical aisled or box frame. There was no simple progress from one form of framing to the other, and what determined the choice for a particular building can seldom be identified. The difference between the two traditions existing in adjacent parishes is highlighted by a lease of 1373, in which John Saunsum agreed to

build eight houses at Pleasley in Derbyshire, 'whereof each house shall have three pairs of crucks or posts [*forcarum vel postarum*], and the said Thomas shall assign to the said John certain trees growing in Pleasley for making the said houses'. Evidently there was a choice independent of the small size of the proposed houses. Maybe it depended on the trees assigned to Saunsum; more likely it depended on which carpenter was employed and the trees he chose. Pleasley lies exactly on the cruck boundary, so a carpenter from the west would probably have built a cruck frame while one from the east would have built a box frame.[46]

The walls of timber-framed buildings show further evidence of traditions of building.[47] In Kent and the south-east it was common to triangulate the lower corners of a frame with a curved brace; elsewhere it was commoner to triangulate the upper corners instead. In Kent, again, the walls were divided into large panels until, taking a fashion from Normandy, they started to be decorated with lines of studs placed so close together that the gaps between them were hardly wider than the studs themselves. This first appeared at Wye College about 1440,[48] and eventually spread quite widely, but with the difference in the west Midlands that a middle rail broke the line of the studs half way up the wall. This may have been the consequence of a marriage of traditions: it was common in the west Midlands and the north for walls to be divided into small panels, purely for their decorative effect; often these panels were further decorated by small diagonal timbers so positioned that they produced an overall pattern of diamonds or herringbone, while in the west minute curved or cusped diagonals set across all four corners of very small panels produced a starry effect.

These patterns were mainly introduced at the end of the Middle Ages, and reached their most ornate a century later. Long before then, indeed, by the 14th century, English carpentry had come of age. It was now thoroughly distinct from Continental practice; and its further development was a process of refinement and ornamentation, not innovation. Soon the new carpentry and the substantial construction it made possible spread to the houses of much of England's yeomanry, as the Elizabethan topographer William Harrison recognized: 'In old time the houses of the Britons were slightlie set up with a few posts & many radels,' he said; 'it is in these our yeares, wherein workmen excell, and are in maner comparable in skill with old *Vitruvius . . .*'

**Bishop Percy's House, Bridgnorth, Shropshire. Decorative framing of 1580, typical of the west Midlands.**

# 4 MEDIEVAL HOUSES

The Romans brought sophisticated planning and construction to England. The almost universal round house which had sheltered prehistoric Britons for at least a millennium was soon abandoned. The old idea that individual rooms were synonymous with individual buildings lost its universal appeal. Roman houses, whether they were built in the new towns or out in the countryside, were divided internally into rooms, each serving a different need.

None of this suited Anglo-Saxon England, neither its purse nor its temperament. There was no longer the money to pay for extensive houses, and the internal divisions favoured by the Romano-British seemed impenetrably labyrinthine. One or more single-roomed buildings became the norm for a family's domestic unit once again, as they had been before the Roman invasion. There was one major difference: now these buildings were rectangular, not round. The poorest had to make do with a single room in a single building. Anyone of substance, however, built a group of buildings with, as its centrepiece, a hall. Doing this was directly to copy the tribal kings.

The hall was simply a room with a fire, organized in a formal way. Simplicity was its strength, for fire symbolized life itself. Bede made this very point, when writing his *History of the English Church and People* in the 8th century. He recounted how, in the previous century, King Edwin and his retinue of knights had reflected on a parable of life and death told by one of their number:

When we compare man's present life with that time of which we know nothing, it seems like the rapid flight of a lone sparrow through the banqueting hall where you sit in winter to dine with your thanes and counsellors. Inside, the comforting fire warms the room; outside rage wintry storms of snow and rain. This sparrow flies in swiftly through one door of the hall, and out through the other. Inside, it is safe from the winter storms; but after a few moments of comfort, it is lost to sight in the darkness from which it came.[1]

However clearly Christianity might enlighten the wintry darknesses of life before birth and life after death, as the parable was meant to show, the hall and the glowing warmth of its hearth embraced corporeal life in the full reality of men's existence.

Excavation has shown that Edwin's hall was accompanied by many smaller buildings, perhaps private quarters or bowers belonging to the queen, the nobles and servants.[2] This arrangement was age-old: Tacitus had recorded a similar centre in Germany six centuries beforehand;[3] and it appeared again in the Old English poem *Beowulf*'s description of Heorot. This mythical hall was the scene of customary feasting to the strains of the minstrel's harp and the epic words of the bard, while the ceremonial passing of the drinking horn of mead fuddled the nobles' minds and freed their tongues to swear to emulate the deeds of past heroes. When finally overcome by drink, the nobles fell asleep where they were, though Hrothgar and his queen retired for the night to their *brydbur* or bower. After the monstrous Grendel's murderous attack on Heorot, the nobles abandoned the hall, and they, too, retired to the safer distance of outer buildings. This still left the hall as far more than a place for drunken revelry: here Hrothgar took the advice of his nobles; here Beowulf swore vengeance on Grendel. Put mundanely, it was a centre of government and justice, like the halls of reality.[4]

For the nobles themselves in their own halls, for the ceorls and free peasants, for their successors, the medieval yeomen, these royal activities existed to be emulated. That idea survived powerfully for a millennium. Feasting and drinking became no more than everyday meals set at a high table in the glow of the open fire where they had been cooked; the performances of the bards and harpers became the repetition of old family tales and local gossip; affairs of state descended to the level of a discussion of market trends and farming activities, justice was only to settle the quarrels of the serfs: but for all these they needed a large, open hall, and so came to build like the king.

Royal halls increased in magnificence, as wealth and craftsmanship allowed, to reach a zenith late in the Middle Ages in the incomparable Westminster Hall. Meanwhile, knights built smaller halls. Many of these were manor houses. Because they acted as a court where manorial law was administered, it was sensible to build them as halls, like the king's but on a small scale. Similarly, they were residences for their lords, again using the royal hall as a suitable model, and one that would confer a degree of status. Finally they were places from where the agricultural efforts of the manorial land were run, namely farmhouses.

The remains of one of these halls, at Sulgrave in Northamptonshire, indicate a timber hall with a central hearth and opposed doorways at the west end, a service room beyond and perhaps a balancing chamber at the east; further west was a separate structure with a hearth and a soakaway which may have been a kitchen. These structures were probably built before 1000, and a rebuilding shortly afterwards marks the start of a process of assimilation of secondary domestic buildings under one roof which was to continue until after the end of the Middle Ages.[5]

By the 14th century all classes of people were building halls, and they satisfied a need for all kinds of accommodation. They lay at the centre of royal palaces and peasant crofts. They served equally as inns and clergy houses, guildhalls and court-houses. Only size, decoration and minor adaptations differentiated them for their various uses. Long after the advent of chimney-stacks had removed the practical need for height, this very quality still gave them their essential status.

## PRIMITIVE AISLED HALLS

This development is witnessed by many seemingly primitive halls dating from soon after 1200. For the most part their construction relied on the use of an aisled timber frame. William Rufus's Westminster Hall, smaller royal halls at Cheddar, and at Hertford and Ludgershall Castles, aristocratic halls at the castles of Leicester and Sandal Magna, and ecclesiastical halls at the bishops' palaces of Exeter, Farnham and Hereford established aisles in the 12th and early 13th centuries as features to be associated with the buildings of the rich and powerful.[6] These were the greatest of a series that included numerous manor houses and, before long, the farmhouses of several yeomen. In this way monumental architecture gave birth to a tradition.

A series of aisled halls whose successive construction straddles the Conquest was built at Netherton Manor on the Hampshire Downs at Faccombe. The last of these was built against a two-storeyed chamber block, which provided private accommodation, and at its further end was a screened passage

between the front and back entrances. Beyond this were two service rooms, perhaps a pantry – that is a *panetrie* or bread room – which was regularly used for storing any kind of provisions in cool, dry conditions, and a buttery or *bouteillerie*, literally a bottle room, though, once more, it might be no more than a general store. By 1350, after the long process of build and rebuild that must have preceded many surviving manors, this manor and its hall had reached the fully developed pattern.[7]

Aisles helped to span any hall over 6 m (20 ft) wide, but increasingly it was the status that aisles conferred which was paramount. Nevertheless aisles and the arcade-posts that divided them from the main body of the hall were hindrances and sometimes removed, as shown by successive halls built between about 1175 and 1300 at Wintringham on the east side of St Neots, Cambridgeshire. Here the aisles of the earlier halls were abandoned in the last two manor houses of a series of four whose width progressively increased from 6 to 8 m (20 to 26 ft).[8]

## UPPER HALLS

Several of the earliest manor houses were built quite differently of stone with their hall apparently placed on the first floor of a storeyed building. These 'upper halls'[9] were possibly a Norman importation, though a few upper halls, such as King Harold's at Bosham as depicted in the Bayeux Tapestry, may have been the centrepiece of royal palaces before the Conquest.

After the Conquest, halls were widely built in the upper storeys of castle keeps. Towards the end of the 12th century a similar room appeared in royal and episcopal palaces, monastic lodgings and small manor houses, and in the town houses of rich merchants and Jews. Possibly this was for reasons of defence,[10] though status played its part too: the richest men could now afford masonry, and here was a particularly visible solid, upstanding means of showing off its use.

These storeyed houses are remarkably uniform. Boothby Pagnell Manor House in Lincolnshire, of shortly before 1200, is the classic example.[11] The hall, or, at least, a heated room, and a secondary room stand over a similar pair below. The hall has no high or low end. The entrance is at the top of an outside stair on a long wall with the hearth nearly opposite, and the adjacent room is reached by a doorway in a transverse wall, though in other houses it may also have an external stairway of its own, and a second hearth. Often there are window seats and a garderobe in the thickness of the wall or extending out from it. The lower rooms, a reflection of those above, seem to bear the same relationship to each other; less grand, they are not merely store-rooms and may have served privileged retainers.[12]

Although many of these upper halls belonged to manors, they could belong to rich churchmen, as the late 13th-century Rectory at Westdean in East Sussex shows. Less usually, the upper hall at Temple Manor, Strood, Kent, was probably a lodging belonging to the Knights Templars and had no manorial role at all.[13] Possibly these upper halls had no hall in the full sense of the word, that is with a semi-public, formal usage, but were blocks of chambers on the lines of the Saxon bower and, like them, dependent on an ordinary open hall.[14] The difficulty with this interpretation is that, if these ever existed, most of them have been lost.

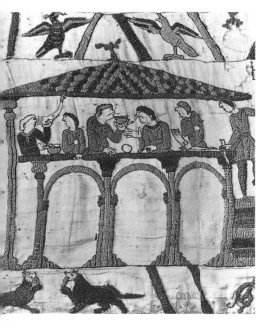

**Bayeux Tapestry. Harold's hall at Bosham, showing the king and his retinue dining in the great upper hall.**

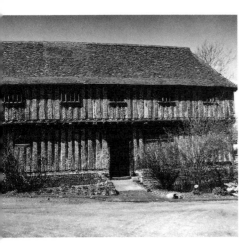

**The Court-house at Colville Hall, White Roding, Essex.**

A different form of upper hall, which appeared at the end of the Middle Ages and was usually built at least in part of timber, had no domestic function and served as the court-house of a few manors. In Essex a two-storeyed court-house was attached to Widdington Hall with a long upper hall reached by two staircases; one rose from a wide doorway and was for the presiding lord, while the second rose from a narrower doorway and was for the commoners attending his court. The use of the ground floor is unclear, although one room may have been for the private use of the lord. A completely detached but otherwise similar court-house apparently served Colville Hall at White Roding; its upper hall had an entrance staircase for the lord at one end and a second entrance and stair for the commoners in the middle.

Yet another form of upper hall commonly built in the last years of the Middle Ages in Essex and East Anglia housed village guilds. These had few craft associations and generally served to promote the religious welfare of their members. Crawley House at Elmdon and Clavering Guildhall were both similar to the houses of their day, except that their open upper storeys served a communal function rather than as storage.[15]

The halls of guilds, which served trade or craft interests and, later, local administration, often took the form of an upper hall, sometimes as grand as the hall built for the Guild of the Holy Trinity at King's Lynn in 1421, which has an immense, church-like Perpendicular window entirely appropriate to its religious origins, and a timber roof with archaic scissor-braces. Market halls, by distinction, were usually built over an open arcaded ground storey, which could shelter stall holders. The much restored and misnamed Guildhall at Thaxted, Essex, was originally called the 'Moot Hall' or 'Market Cross', and, unusually, has a third storey.[16]

## AISLED HALLS

The earliest surviving manor houses date from the 12th century, but far more belong to the heyday of manorial farming in the 13th. In the south and east many of these houses depended on an aisled hall. Their construction developed in parallel with the aisled barns whose products provided the money for both. Passing-braces and the similar scissor-braces which cross over each other within the roof space to link pairs of rafters gave way to the standard forms of crown-post roof or trussed rafter roof of the 14th century. Like aisled barns, these manorial halls were built in great numbers in the same places, the south-east and east and, later, in parts of Yorkshire, and, similarly incorporating base-crucks, in the Midlands and south. Simultaneously, the plan of the manor house developed by the inclusion of, first, a service bay with an upper chamber or 'solar' at the low end of the hall, and then a chamber bay at the high end.

One of the earliest survivors, Battle Abbey's manor house, Old Court Cottage at Limpsfield in Surrey, was built between 1200 and 1250 with foliated capitals to its arcade-posts, a direct copy in timber of the decorative forms of stone churches, and an archaic scissor-braced roof. The hall at first had two open bays and perhaps no more, but there might have been a detached private chamber or bower for the manorial bailiff.[17]

If survivors are a measure of past achievement, Essex, with a fifth of England's aisled halls, adopted them as nowhere else.[18] Half of them belong to

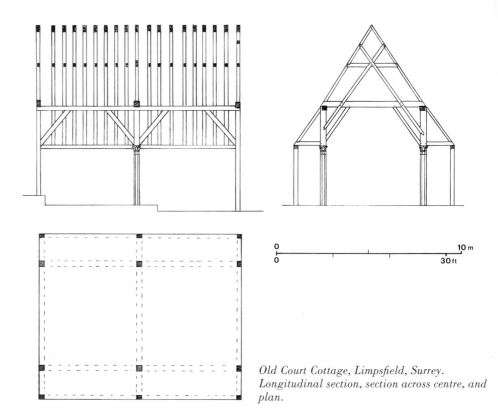

*Old Court Cottage, Limpsfield, Surrey.*
*Longitudinal section, section across centre, and*
*plan.*

manor houses of the 13th and 14th centuries.[19] Slade's Farm, probably the original manor house of Beauchamp Roding, was built as an aisled hall between 1250 and 1330,[20] and the neighbouring Fyfield Hall was no more than a two-bay hall at first, with an open central truss supported by scissor-braces and passing-braces.[21] The Bury at Clavering, built in the early or mid-13th century,[22] went further in having a hall with a narrow bay for an entrance and cross-passage, screened from the hall by short partitions known as 'speres'; and beyond the cross-passage, a further storeyed bay originally contained a service room, perhaps with a solar over it, and even another storeyed bay at the high end.

This fully developed plan was often the result of two or three stages of building. Stanton's Farm at Black Notley, perhaps built as a secondary manor house by Thomas de Staunton about 1306,[23] had a two-bay hall with an oriel window to light the upper end. At the low end, three doorways, two of them still with fine two-centred arches and cusped foils in their spandrels, led into service rooms and perhaps a passage that went between them out to a detached kitchen.[24] The room above was probably Staunton's private chamber or solar, while a storeyed block at the high end of the hall probably belongs to a later stage of building.

By the end of the 13th century the three-celled manor house with chamber and service blocks flanking the hall was well established. Sometimes the three parts were clearly defined outside in their separate constructional form; sometimes all three were housed within a barn-like house and only defined internally. Essex has many of these variations, but came to prefer separately expressed storeyed ends in gabled wings, such as the jettied and gabled earlier wing of Tiptofts Hall, which is framed and roofed at right angles to the hall.

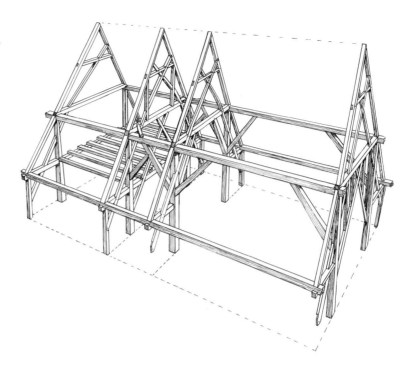

*The Bury, Clavering, Essex. Perspective of part of the timber frame, showing the narrow central bay containing a cross-passage (shown in broken outline), flanked by a storeyed service and solar bay (left) and open hall beyond a short partition or 'speres'.*

**Stanton's Farm, Black Notley, Essex. The arched doorways to the service rooms.**

When the Augustinians of Little Dunmow Priory built Priory Place just outside their precinct, perhaps as an elaborate lodging for important guests, they gave it an H-plan with separate, jettied and gabled blocks at both the service and chamber ends.[25] At Little Chesterford Manor, separate ends were adopted piecemeal. The le Bretons, who owned the manor in the 13th and 14th centuries, added an aisled hall to a stone upper hall or chamber block and then a balancing block of timber at the other end of the hall to form a chamber with a floor over it, thus giving the house an H-plan with separate roofs.[26]

By the time Little Chesterford Manor House reached its final shape in the middle of the 14th century, Nurstead Court had already shown the alternative Kentish way of roofing the three cells of a manor house. It was built about 1314, perhaps by Sir Stephen de Gravesend, or one of the de Gravesend Bishops of London, with low flint walls which gave it the appearance of a large barn. Only the tall cusped windows of the hall breaking above the eaves with small dormers indicated its central role. Internally huge circular timber arcade-posts with foliated capitals divided the immense hall from its aisles and from the two end bays. These were apparently without upper floors, the one at the surviving high end perhaps serving as an antechamber, the other at the demolished low end for services. An earlier stone block, perhaps in the form of an archaic bower attached to the high end, probably contained the lord's private quarters.[27] The overall hipped roof, which was to become characteristic of hall-houses and barns in Kent and the south-east, did nothing to differentiate the divisions of the house, but it had the great advantage of easy construction, stability under longitudinal wind pressure and, unlike the separate Essex roofs, had no awkward angles or gullies to trap rainwater.

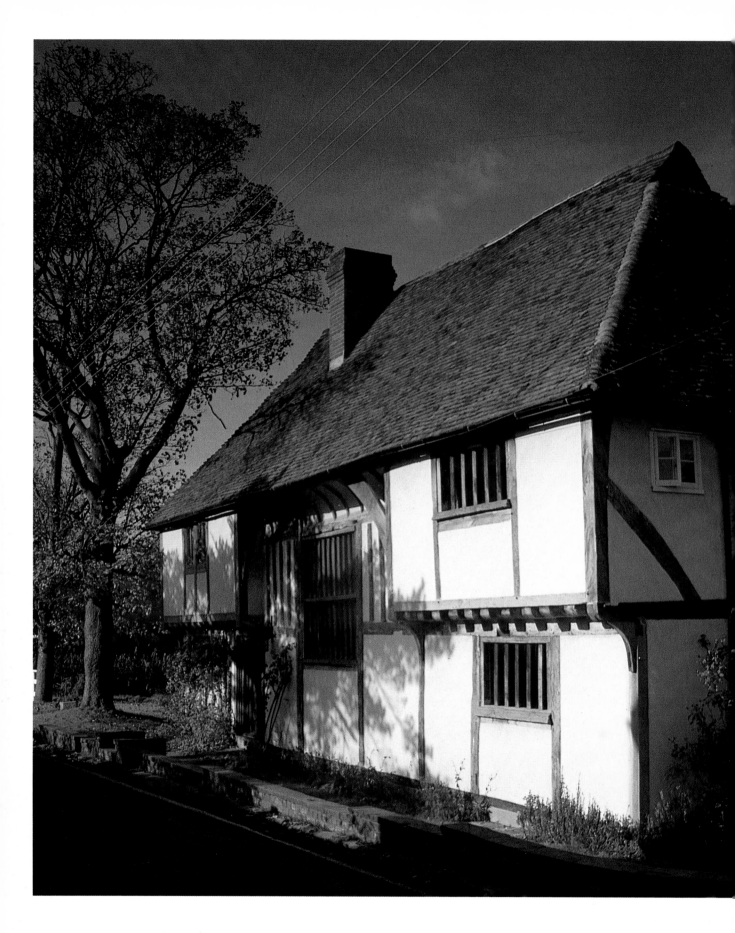

A Wealden house, Southfleet, Kent. Built in their hundreds for innkeepers and clergymen as well as yeomen, these Wealden hall-houses are instantly recognizable by their characteristic jetties at each end and recessed central hall, yet many more are hidden behind later accretions.

Ostbridge Manor Farm, Olveston, Avon. Built early in the 16th century with the same three-part hall-house plan, this time in stone, the left-hand end contained a chamber or parlour served by a projecting garderobe, the open hall was in the centre to the left of the entrance, and there was a service room or kitchen to its right.

**Fairfield, Eastry, Kent. An aisled hall with prominent end bays.**

The disadvantage of such roofs was that they swept so low over the aisles that they impinged on the upper storeys in the end bays. This was not a problem for the single-storeyed Nurstead Court, but Fairfield, Christ Church Priory's timber-framed manor house at Eastry, has both aisles and a three-part plan; to overcome the problem of the low roof, the storeyed end bays were given separate roofs in the form of large hipped dormers which embraced the end of the main roof and reached its ridge. This unusual compromise between the traditions of Kent and Essex was distinctly old-fashioned, for, when the house was built about 1400, aisled halls had been superseded by a standard form of hall-house which had developed from them. Yet even the slightly later Hogbrook at Alkham, a farmhouse rather than a manor, had a similar form,[28] and so did a few other houses in Kent.

Unlike the earliest northern barns, aisled halls in Yorkshire were generally built after the decline of manorial farming in the 14th century, and were a special response to rising local prosperity in which status was expressed by a means already old-fashioned in the south, but given new life by the sturdy forms of northern framing. With a low-pitched, king-post roof, the aisles could be given adequate height without the hall becoming inordinately high. Aisled halls were occasionally built in the west, for instance Plowden Hall, Lydbury North, and Upton Cressett Hall, two manor houses built in Shropshire in the 14th century,[29] and Thringhill Grange at Withington in Herefordshire is another, which also has a spere-truss.[30]

*Nurstead Court, Kent. Interior of the hall looking towards the entrance and triple doorways at the service end, as recorded about 1837 before alterations.*

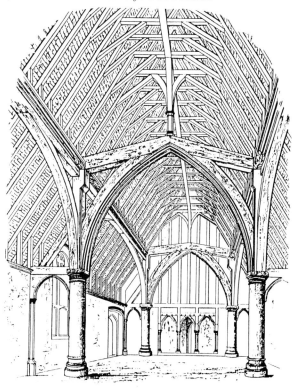

**BASE-CRUCK HALLS**  Generally in the Midlands and the south the intrusion of arcade-posts into halls had fallen into disfavour by 1300 and base-crucks were used instead for the open truss at the centre of the hall. This was an actual substitution at Lime Tree House, Harwell, Oxfordshire, when John Moygnes, a yeoman, repaired the house.[31] At the same time, a narrow bay to contain a cross-passage between front and back entrances was often formed at the low end of manorial halls by two aisled trusses. One of these carried short partitions or speres, which screened the front and back entrances, the other a partition between the passage and the service rooms in the form used at Little Chesterford Manor. The speres are commonly said to have prevented the draught from the exterior doors from penetrating the hall, but halls must have been draughty anyway because of their unglazed windows, and the main purpose was to block the view from the entrances for the sake of privacy.

Halls with a base-cruck truss and a spere-truss first appeared about 1300 when, apparently, William de Marnham built West Bromwich Old Hall, West Midlands,[32] and Coventry Priory built their grange, Manor Farm, at Wasperton in Warwickshire.[33] The Knights Hospitallers, who, at Siddington barn, were apparently among the first to use base-crucks, used them in their granges as well, for instance Cubbington Manor House, again in Warwickshire, and in the demolished Moor Hall at Harefield in Hillingdon, Greater London. Their great rivals the Templars seem to have remained faithful to arcade-posts: not far from Cubbington, at Temple Balsall, West Midlands, they built a preceptory with an aisled hall, though this was as early as 1250–60,[34] when base-crucks were not yet in widespread use.[35]

Manorial lords built several houses in Herefordshire between 1350 and 1425 with base-crucks and spere-trusses of such uniformity that they appear to belong to the work of a definable school of carpenters with well-established traditions. Amberley Court at Marden, typically, has a hall flanked by storeyed cross wings, roof trusses decorated with cusped foils, and purlins all supported by heavily cusped wind-braces.[36] This form spread into Wales after Owain Glyndwr's uprising in the second decade of the 15th century. Rectory Farm at Grafton Flyford in Worcestershire,[37] presumably built by a clergyman, again has a base-cruck truss and a spere-truss. Elsewhere in England they appear together only sporadically in manor houses, such as Handsacre Hall at Armitage in Staffordshire and Old Hall at Tabley in Cheshire, two lordly houses in the north, and in the south at Long Crendon Manor in Buckinghamshire and Chennell's Brook Farm at Horsham in West Sussex.

Lesser men built similar halls, though without speres. Til House at Clifton outside Nottingham[38] and Pear Tree Farm at Yoxall in Staffordshire[39] both have imposing base-cruck trusses in the centre of their halls, at once conferring status and removing the inconvenience of arcade-posts, while aisled trusses carry the partitions between the hall and the rooms at the ends.

While aisled halls became increasingly unfashionable in the manor houses of the 14th century, yeomen continued to build them after the Black Death, either with base-crucks or full aisles. This descent from manor to yeoman might have continued to a greater extent had not the development of box frames made arcade-posts redundant in spans of less than 6 or 7 m (20–23 ft), and this embraced the width of most farmhouses.

Westdean Rectory, East Sussex. Built in the 13th century of flint with Greensand quoins and window frames, the upper hall and chamber are served by a fireplace with a chimney-stack on the end wall (right), and a projecting garderobe (left); beyond this is a 19th-century addition.

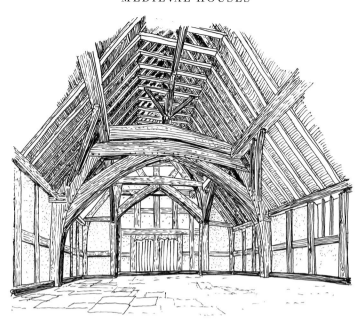

*Rectory Farm, Grafton Flyford, Worcestershire. Restoration, showing the interior of the hall looking through the central, base-cruck truss towards the spere-truss and paired doorways into service rooms.*

## STONE HALLS

As manors reached a peak of profitability in the 13th century, their houses began to adopt expensive stone for their construction, and ascended into the realms of polite architecture. A handful of manor houses built of stone with unaisled open halls survive from these early years. Around the middle of the 13th century, the de Greys built Cogges Manor, near Witney in Oxfordshire, with an open hall, lit by two pairs of lancet windows cut into its stone walls, and a service block and a cross wing for private chambers.[40] By the mid-14th century similar unaisled halls were becoming common, at the high level of the Archbishop of Canterbury's palaces and the lower level of manors like Sir John de Clevedon's Clevedon Court in Avon. This has a complicated outline, broken by projecting porches and wings, but Christ Church Priory's Court Lodge at Mersham has a tall overall hipped roof in the Kentish way; built in the middle of the 14th century when the manor was probably already let out to a tenant farmer, it was given only a two-part plan with an open hall and a storeyed bay for services and a solar, but the size and decoration of its fine traceried windows graphically demonstrate this arrangement to the outer world. Stone gave all these houses a degree of status, traceried windows more still.

The clergy reached similar levels on occasion. The three-part hall-house, which Muchelney Abbey built of stone outside its precinct for the vicar of this Somerset parish soon after 1308, has fine traceried windows adding status to each side of its open hall. Otherwise it is fairly modest; both the chamber and services blocks are contained under a single roof, but they are heated by fireplaces in enclosed hearths, perhaps to allow the vicar and a female servant to live apart but with a fitting degree of luxury. Nevertheless, this innovation did nothing to detract from the status of the open hall, which still retained its hearth.[41]

**The Angel Inn, Grantham, Lincolnshire.**

## GROUND-FLOOR HALLS

The days of the open hall with an open hearth were nevertheless slowly drawing to a close. Perhaps as early as the middle of the 14th century, The George Inn at Norton St Philip in Somerset already had what appears to have been a ground-floor hall with a fireplace enclosed within a chimney-stack on its rear wall. This was adjacent to a parlour on one side and an archway and service room on the other. Over all these extended a large chamber which may have served as a store for the great quantities of wool that passed through Norton's two annual fairs, and, during the rest of the year, as a lodging for travellers. The George seems to have been built under the auspices of the Carthusians of Hinton Priory, who owned the manor and controlled the fairs, but, for the sake of the monks' privacy, would not house travellers near its precinct. Like many later inns, The George's archway leads to a rear courtyard where, no doubt, there were always ancillary buildings, and, later, stables and first-floor chambers reached by a gallery in what was to become the standard way.[42]

A century later, these trends were becoming well established, particularly among large or particularly ostentatious inns where the status of an open hall could be replaced by other architectural qualities. The Angel at Grantham was designed with the great bay windows and chimney-stacks of its architecturally equal ground-floor hall and parlour symmetrically arranged across the front, each side of a fine archway. It probably took this arrangement from great abbey gatehouses, and that became standard for many inns.[43]

Some of the best priests' houses were now following the halls of the great and mighty in the prominent way they placed chimney-stacks for enclosed hearths on their front walls. Chantry houses, colleges and other lodgings followed a parallel course and, similarly, came to abandon the open hall in favour of a full upper floor.

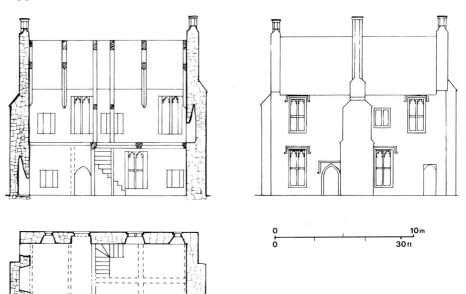

*The Chantry, Trent, Dorset. Elevation, section and plan, showing* (left to right) *a service room with fireplace, cross-passage, and hall with fireplace and stairs to chambers above.*

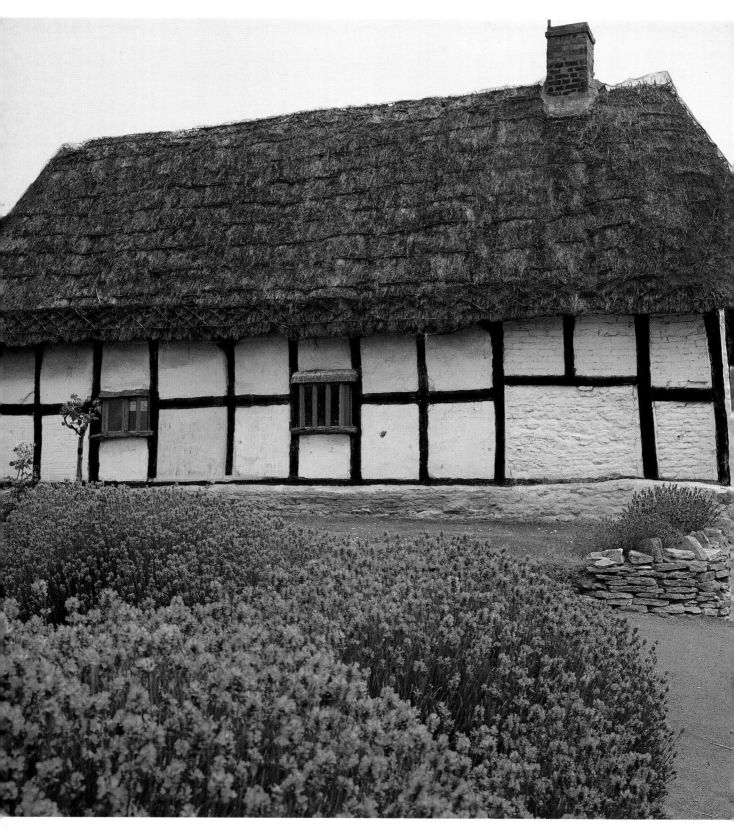

**A small timber-framed yeoman house at
Bishop's Cleeve, Gloucestershire.**

**Mersham Court, Kent** *(right).* A hall-house built in the 14th century with an open hall marked by the large traceried window, and a solar chamber with the smaller traceried window set over a service room.

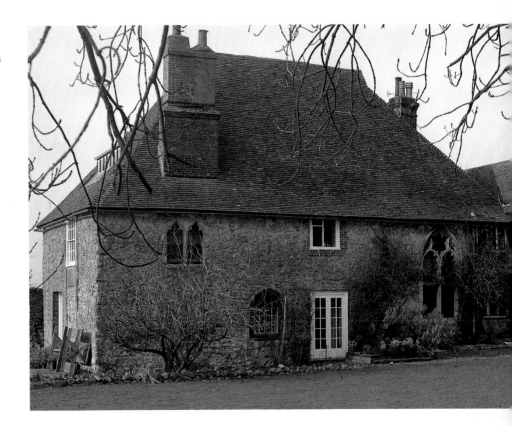

**Boothby Pagnell Manor House, Lincolnshire** *(right).* The classic example of an upper hall, built in the 12th century of Jurassic limestone.

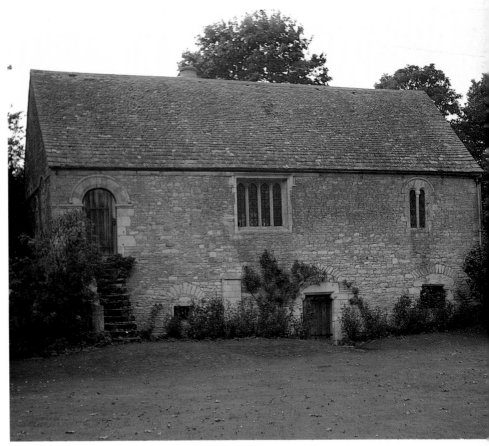

The manorial guest lodging at Ewelme, Oxfordshire, achieved this through the improving hands of the Earl and Countess of Suffolk sometime after 1430, and had two storeys of heated chambers, the upper ones reached by an external gallery like those similarly used to reach the chambers of large inns. These abutted a small open hall, but there was a full end-to-end floor at The Chantry at Trent, Dorset, built soon after its foundation in 1441.[44]

**KITCHENS**  Eventually, the medieval manor house was designed to stand complete in itself, and could serve most domestic needs. Even so, many manor houses were soon surrounded by a number of accretions, which might serve all number of temporary uses. Most were swept away during the processes of modernization and extension that assimilated many of their functions into the house itself. Among these subsidiary buildings none was so important as a free-standing kitchen.

Since so much food was prepared at home, including farm produce that was sent to market, a kitchen relieved the pressure on the hall fire. It also was a safety precaution. Animal fat could turn lazily glowing embers into a rush of flame and sparks that might ignite a soot-encrusted roof.

Separate kitchens were favoured architectural features of grand establishments, as the famous monks' kitchen at Glastonbury shows, and a few manor houses such as Stanton Harcourt in Oxfordshire had equally grand detached kitchens of their own.[45] More typical of the many kitchens that once served major houses is one at Little Braxted Hall in Essex. Its timber frame is about

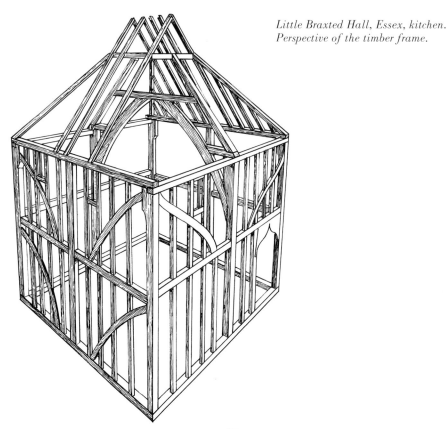

*Little Braxted Hall, Essex, kitchen.*
*Perspective of the timber frame.*

7 m (22 ft) square and 4.5 m (15 ft) up to the eaves. A pair of small unglazed windows on each side provided light and ventilation, and in one corner there was an ornate door with an ogee head. Above is a hipped roof with small gablet openings to let out the smoke. Inside, the hearth was at the centre and there are ranges of holes along the walls for pegs that were once used to hang up irons and utensils out of the way. It was probably built towards the end of the 14th century, and such kitchens were still commonly found beside important Essex houses two hundred years later.[46]

Often the only evidence for a kitchen is no more than a third service door in the low end of the hall, which once opened into a passage between the two service rooms. This led to an exterior door in the end wall, with the kitchen placed conveniently nearby. There was a passage like this at Stanton's Farm, Black Notley, Essex, but a third door is not conclusive evidence of a detached kitchen, as it may have led to stairs; conversely, many kitchens were simply reached from the back door, not through a third door at all. This was usual in Herefordshire in the way still evident at Swanstone Court, Dilwyn, where the kitchen has now been physically joined to the back of the house.[47]

## YEOMAN HALLS

Throughout the Middle Ages, most peasants lived in houses of one or two rooms. These were too small to be called hall-houses. Archaeological evidence shows that they often had walls made of cob supported by studs; their floors were of beaten clay, and the roofs were thatched. They were often very small and only occasionally reached the 68 sq m (720 sq ft), which is about average for today's small houses. The Bayeux Tapestry shows four of these houses well: they have a single room, a rounded doorway and no windows. Such houses must have been ubiquitous in the 11th century and only died out in the poorest parts of England a hundred years ago.

Nevertheless, well before the Black Death reached England, the profits from the high agricultural prices of the 13th century enabled a few peasants to build substantial hall-houses. In the changed economic conditions after the Black Death, far more of them had money for building and the newly developed techniques of carpentry were readily available. The attitude of peasants to building consequently changed. No longer were they so willing to build their homes themselves, but instead engaged the professional skills of the carpenter to provide a ready-made frame, and of other tradesmen to complete the house by filling in the panels with wattle and daub, by thatching or tiling the roof, flooring the upper rooms, and fitting doors and shutters.

Some peasants made use of the new carpentry before it was completely developed. Archaic passing-braces and lap-joints put Songers at Boxted, Essex, on a par with the Cressing Temple Barley Barn. It was much smaller than Old Court Cottage at Limpsfield, but still contained an aisled hall, service room and solar.[48] Several other similar houses in Essex date from the century before the Black Death, for instance Hales Farm at Fyfield.[49] In Suffolk yeomen again built aisled halls from at least the end of the 13th century. Purton Green Farm at Stansfield shows them or perhaps a bailiff pressing hard down the path taken by manorial lords a few decades before.[50] The larger Edgar's Farm, now partly rebuilt in the Museum of East Anglian Life at Stowmarket, was probably the work of John and Asclina Adgor who

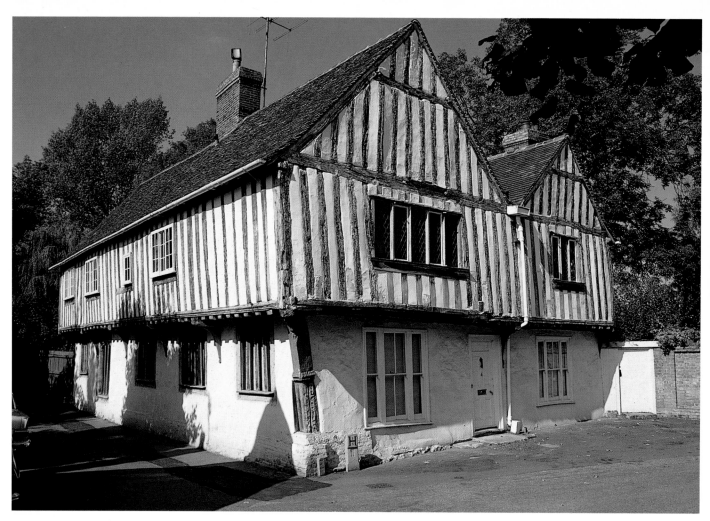

Trinity Guildhall, Linton, Cambridgeshire. A
large court-house, framed with close-
studding, and jettied over the ground floor.
A second range at the right forms a double
pile of the whole building.

Edgar's Farm, Stowmarket, Suffolk. Detail
of one of the arcade-posts, showing its
moulded capital and, above it, the bracing
for the arcade-plate and tie-beam which it
supports, together with the passing-brace,
which runs diagonally across the post and
the tie, just beneath the roof rafters.

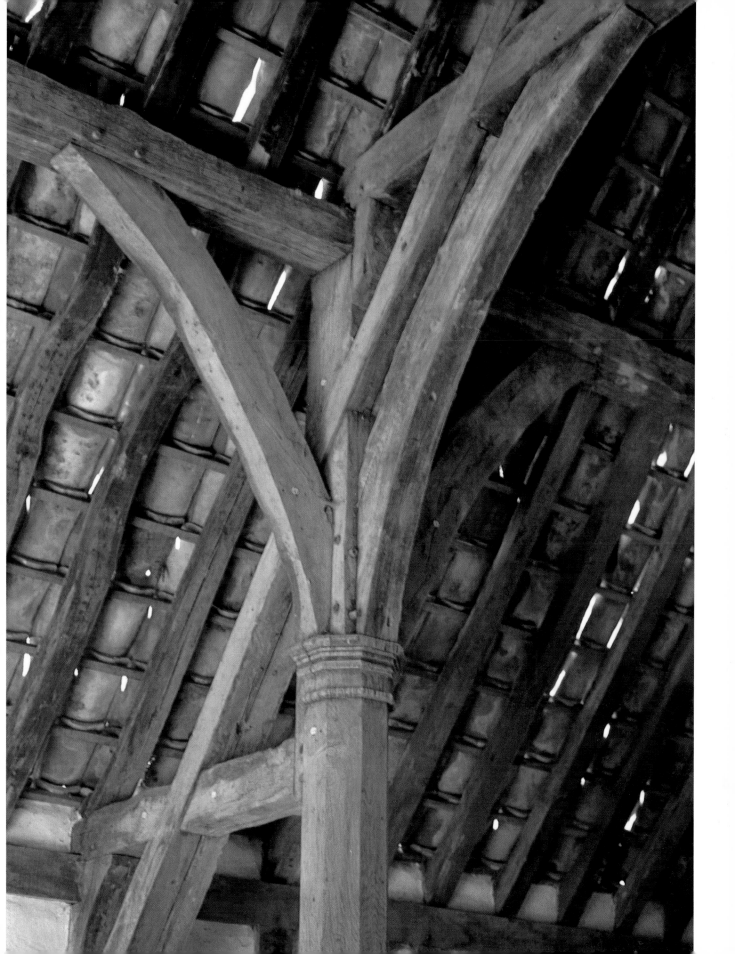

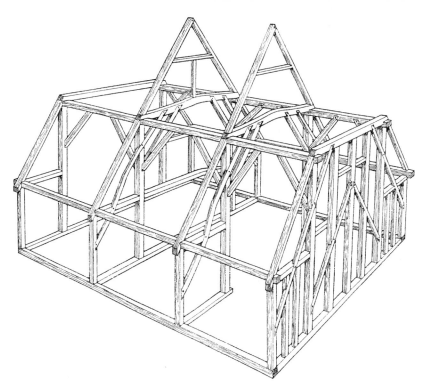

*Songers, Boxted, Essex. Perspective of frame: the left-hand bay contains a service room with a solar above; the central and right-hand bays contain the hall.*

were buying land nearby in 1342 and 1346.[51] Its aisled form became traditional in eastern counties, more for status than construction: even around 1500 a similar aisled house was built at Depden Green.[52]

In other counties, yeomen preferred to build with base-crucks instead of aisle-posts in the centre of their halls. Tickeridge at West Hoathly in West Sussex has base-crucks, front and rear, and a few more farmhouses were built like this in counties as far away as Nottinghamshire and Worcestershire, while others in Sussex, like Dunsters Mill House at Ticehurst, have a base-cruck to span a single aisle on one side only.[53]

By the end of the 14th century, the main communal living room of any substantial house was called a hall. In 1422 Richard Goveway guaranteed to replace a cottage in Worcestershire with a hall (*aula*) of only two bays.[54] Even the two-roomed cottage of Chaucer's poor widow contained a hall as *The Nun's Priest's Tale* shows:

> Ful sooty was hir bour, and eek hir halle,
> In which she eet ful many a sclendre meel.

Only for houses of a single bay does the word *aula* not appear because these were too small and poor.

The halls of 15th-century cruck-framed houses in Worcestershire were about 5 m (15 ft) high, probably a little higher than the lowest acceptable limits for a hall. A high hall, as well as a large one, reflected the status of a manorial or royal hall; but height had the further, practical advantage of ensuring that the smoke from the open hearth did not collect so low that it would choke the inhabitants. In a really low cottage where the roof might be no more than 3 or 4 m (9 to 12 ft) high, smoke was a more trying problem, but it could be avoided. According to Langland's *Piers Plowman*, three things made a man flee his house – a wife with a wicked tongue, a leaky roof, and

. . . whan smoke and smolder · smyt in his eyen,
Til he be blere-nyed or blynde · and hors in the throte,
Cougheth and curseth · that Cryst gyf hem sorwe
That sholde brynge in better wode · or blowe it til it brende.[55]

In the north, where old words lasted longer, but where, significantly, houses were poorer and lower, the principal living room was called the house, or, since many houses did contain more than a single room, it was called the firehouse, house-place or house-body; and other rooms had names indicating their subservient role such as nether-house or backhouse.[56]

Bowers, chambers or backhouses were private rooms for sleeping, and were storerooms as well. Privacy did not matter at all, as Chaucer's *The Reeve's Tale* makes clear, for whole families and their guests might sleep in the same room. While some chambers were upstairs, this was because money often limited space, particularly in towns, and the only private room had to lie above the service rooms. In the countryside sleeping in downstairs chambers remained the norm, at least for the master and mistress of the household, until the 17th century, and in the north for much longer.

After the Black Death the majority of peasants either built a small house, or built in stages. Crofton Farm, now 161 Crofton Lane, Orpington, Bromley, Greater London, was built as a simple open hall of two bays, box-framed in the Kent manner. To this were added a storeyed service bay and then a chamber bay with a jettied upper room. So the house finally gained the characteristic medieval three-part form, but it took time. The house remained small, but

*Crofton Farm, Orpington, Bromley, London. Sections showing five phases* (left to right, top to bottom) *in its development. First there was a two-bay hall with a moulded central tie-beam and octagonal-section crown-post for decoration, possibly with ancillary buildings. To this was added a pair of service rooms in a single bay with a chamber over them. Then came a larger chamber block at the other end of the hall with a jetty to the front. In a later phase the hall was partly floored over with heavily moulded beams to support the joists and, perhaps some time later, the cross-passage was also floored over to carry the partitions of a smoke bay. Even later a chimney-stack was built into the smoke bay and dated 1671 (later still the wall framing was largely replaced in brick).*

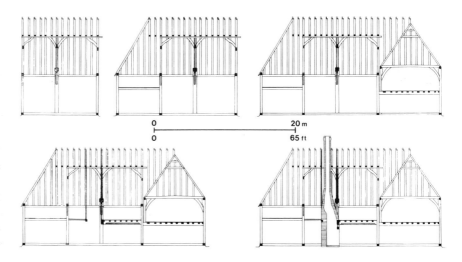

81

halls came in all sizes, the attached chambers and service rooms in all kinds of ways. Large hall windows, front and back, had shutters to keep out the weather. This was a strong reason for building a house no more than one room deep; so further rooms were added in a linear fashion at the ends, not at the front or back. In this way, leeward windows could remain open to light the house when wind and rain put up the shutters on the other side.

Colour as well as carving had its place. Timber houses were often limewashed overall to deter the effects of weathering, and when they were colour-washed, perhaps with redding or reddle on the timbers and yellow ochre on the infilling, they satisfied the medieval delight in bright colours. Faded hints are still commonly found in northern France, but in England only an examination of the timber grain and the lowest coats of plaster reveals signs of this colour, such as the reddle that once brightened the frame of a hall-house at Foots Cray, Bexley, Greater London, now re-erected at Singleton.

Large numbers of small timber-framed hall-houses were built in Essex and East Anglia after the Black Death. White Cottage at Wacton in Norfolk has a two-bay hall and flanking service and chamber bays aligned down its length, with neither jetties nor cross-wings. This simplest of forms that a fully developed hall-house could take is widespread throughout the country. Here the roof is carried by raised aisles above its tie-beam, but normally there was a crown-post roof, like the one raised about 1400 at Water Hall, Little Baddow, Essex,[57] and the simplest roofs made do with no more than common rafters linked by collars, pair by pair. Finally, Hole Farm at Great Warley differs

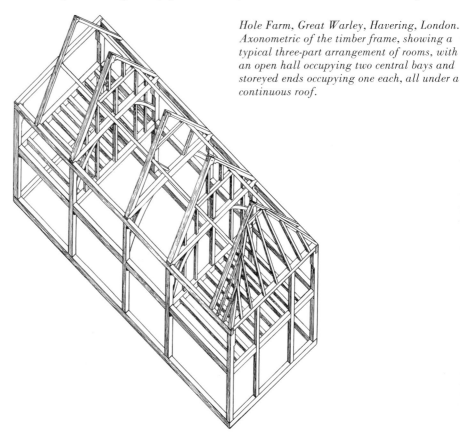

*Hole Farm, Great Warley, Havering, London. Axonometric of the timber frame, showing a typical three-part arrangement of rooms, with an open hall occupying two central bays and storeyed ends occupying one each, all under a continuous roof.*

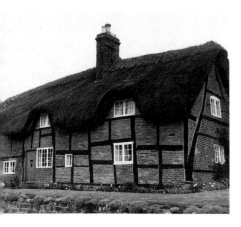

A cruck-framed hall-house in Birmingham Road, Stoneleigh, Warwickshire. Once one of the poorest sort of houses with any chance of surviving, it was improved by having its walls replaced by brick nogging set in timber panels.

Hill, Christow, Devon. A small hall-house, built of cob; the hall lies in the angle of the two wings, and is continued to the left by a cross-passage and later medieval parlour, while the even later right-hand wing contains a kitchen.

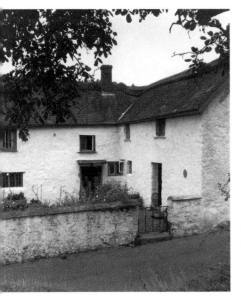

mainly in the later form of its roof framing, the old crown-post and common rafters giving way to trussed rafters and side purlins.

The peasants of the west Midlands lived in similar conditions.[58] Their houses were often too roughly finished to survive unaltered, though plenty of modernized cruck-framed hall-houses do remain. They are now fully framed, and have usually been extended. White House at Peopleton, Worcestershire, was first built as a two-bay hall with a cross-passage beside a service bay, and was later given a cross-wing for chambers, much as Crofton Farm was; the more altered Box Tree Cottage at Defford was similar, and Lower Norchard Cottages at Peopleton had four bays from the start, with both a service room and a chamber flanking its hall.[59]

These cruck-framed hall-houses of three and four bays lie well above the divide between what craftsmen built, and was therefore good and large enough to survive for some time, and what was literally home-made and so would last for only a few generations. At the poorest level of surviving houses are the handful of cruck-framed hall-houses built in the 15th century at Stoneleigh in Warwickshire by the tenants of the Cistercian Stoneleigh Abbey. After the Black Death a few tenants found that their economic position had improved just enough to enable them to start building the poorest sort of substantial houses. These are roughly framed; their halls never take more than one bay, and in Croome Cottage and 2 Church Lane there was only one further bay for a chamber. The others had a third bay for a service room, but only in the best of the houses, 8–9 Vicarage Road, was there possibly a partition dividing the services into buttery and pantry, and here the chamber at the high end of the hall was floored over to provide a solar. Nearly all the rest of the houses were open to the roof from end to end, and their entries opened directly into the halls, never by way of a screened cross-passage. Even their cladding was not the patchwork of brick-nogging they have today, but wattle and daub set into flimsy studding.[60]

In Devon many hall-houses are again noticeably small, a straightforward reflection of the poor conditions. Hill at Christow on the edge of Dartmoor and its namesake at Loxhore in the steep tight country of north Devon to the west of Exmoor both retain their open halls, but have floor areas of only about 80 sq m (870 sq ft), little more than typical for the uplands. In the more fertile east of the county yeomen again built very small hall-houses when they were subject to the control of strong landlords. Among the smallest to survive is Cotmead at Pinhoe, which has a standard three-cell plan, but a floor area of only 70 sq m (765 sq ft). The house is traditionally said to have belonged to St Nicholas's Priory, though the yeoman who built it paid only ground rent. This may be why he could build at all: he was, after all, significantly wealthier than the tenants of the Bishop of Exeter at nearby Bishops Clyst, of whose insubstantial cottages nothing now remains.[61]

At the other end of the scale are the large halls of the richest yeomen. At Condover in Shropshire the grandest houses set the pattern for others to follow. Condover Court, which was probably built about 1400 for the Gosnell family as the home farm of the manor, has a four-bay range, equally divided into a hall and services, framed by massive crucks that reach 0.6 m (2 ft) at their greatest breadth, while the chamber wing is box framed so as to provide the requisite height for a jettied solar. Cruck frames were used for nine other

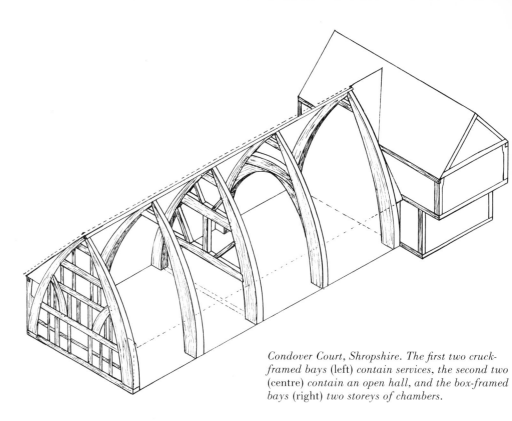

*Condover Court, Shropshire. The first two cruck-framed bays* (left) *contain services, the second two* (centre) *contain an open hall, and the box-framed bays* (right) *two storeys of chambers.*

hall-houses in the parish, a notable reflection of the wealth of its yeomen.[62]

Around Sheffield in South Yorkshire, where crucks are densely concentrated right up to their boundary, 15th-century farmhouses were as likely to have crucks as box frames, however grand. The cruck-framed Pond Farm at Stannington and the similar but box-framed Green Farm at Stocksbridge clearly show this;[63] nevertheless, West Yorkshire, particularly in the upper Calder valley near Halifax, showed a distinct preference for the aisled hall, and this was to influence the form of its post-medieval houses in a direct way.

White Hall at Ovenden, among the earliest of the series, had aisles on each side, but many later ones followed High Bentley at Shelf with only a single, rear aisle, and, by the 16th century, they were built in greater numbers. These houses demonstrate the early wealth of yeomen who, from about 1475, were branching out into cloth manufacture, and this probably accounts for the aisle. The halls often had a cove marking the high end and a smoke hood over the hearth at the lower. This served for cooking and was probably already being fired by the abundant coal of the region, so the hood ensured that the acrid, indeed poisonous smoke was safely removed from the room. At the same time, the hood turned its back on the large, single service room beyond it, an inconvenience were this room to be used for storing and preparing food; but the inference is that it was used instead for storing wool and finished cloth, that is for industrial purposes, leaving the aisle, conveniently adjacent to the hearth, for the storage and preparation of food. Not only would a single aisle do this adequately, but it left the south-facing front side of the hall unencumbered so it could have a large window. All this is visible at Bankhouse, Skircoat, despite alterations, and well over thirty other survivors show that such houses were commonly built between 1475 and 1575.[64]

The full, three-cell arrangement comprising a hall flanked by a chamber and services gave medieval yeomen their highest standard of house. This did not always provide the full range of domestic accommodation they needed. Some yeomen followed the wise manorial precaution of building a separate, external kitchen; and often they also built a number of impermanent rooms for special purposes to do with the work of the household.

Most kitchens were far from substantial. Of the few to survive in East Sussex, those at Chateaubriand, Burwash, and at Slatters in Mount Street, Battle, typically measure about 7 m (22 ft) square and are placed well to the rear of the houses they served so as to avoid the risk of fire. Two unusually large and commodious kitchens at Beestons, Warbleton, and at Wardsbrook, Ticehurst, have three bays and may have accommodated servants as well as storage for food.[65] The two bays of Winkhurst Farm, formerly at Chiddingstone in Kent and now re-erected at the Weald and Downland Open Air Museum at Singleton, may again have been built as a large kitchen before becoming an integral part of a farmhouse.[66]

By the end of the 16th century, hearths were being enclosed by chimney-stacks, making indoor kitchens safer; this and reasons of convenience caused detached kitchens to be demolished wholesale or converted to other uses.[67] The same reasons saw the end of numerous other ancillary service rooms that were built as more or less temporary structures, either attached to the house or standing free. Brewhouses and bakehouses were similar to kitchens except in their fittings, and such ancillary buildings as weaving sheds were widespread. Many Wealden yeomen kept looms in their halls, but others kept them in a special room set aside for weaving. William Kidder had looms and other weaving tackle in two of the ground-floor rooms of his hall-house at Cranbrook in 1576; one of these rooms, perhaps a chamber, was called the 'Olde Shoppe', while another, simply called the 'Shopp', may have been a specially built outhouse.[68]

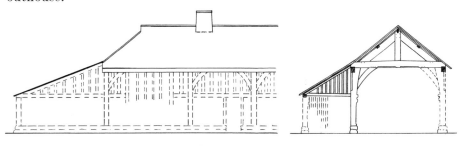

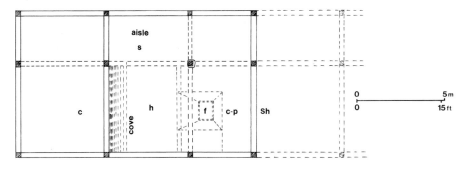

*Bankhouse, Skircoat, Halifax, West Yorkshire. Plan, section and partial restoration of front elevation, showing the central housebody with aisle (to left on section), flanked by a parlour and workshop or woolstore (left to right, respectively, on plan).*

## THE LONG-HOUSE

Some houses went much further than this and had stalls for cattle rather than a domestic service room at their low end. On the Continent a farmhouse properly sheltered animals as well as man, and regularly had done so in north-western Germany and the Low Countries since the Iron Age. In England it was different. Man and beast lived under the same roof in what has come to be called a long-house only when special conditions brought them together.

The earliest long-house yet found was built at Mawgan Porth in Cornwall, probably in the 10th century. At one end, its living-room was marked by a hearth and nooks for fixed beds in the corners, and, at the other, a cattle-house had a drain venting from one corner.[69] This form, which is found in other long-houses on Orkney and Shetland, all close to the western seas, suggests a common origin among Scandinavian settlers, necessitated by high rainfall where the protection of cattle from the weather and their summer pastures from trampling were strong motives for keeping animals indoors over winter.

The concentration of long-houses in the west at first suggested a Celtic origin and gave them their name, a literal translation of the traditional Welsh *tŷ hir*,[70] but their eventual popularity was, instead, a response to the deterioration in the climate which brought wetter and colder winters in the 14th century. By the 13th century the long-house had appeared in some numbers in many English counties outside Kent, East Anglia and parts of the Midlands where there was plenty of straw to sustain cattle out of doors over winter. Since then there has been a contraction back to the poor uplands of the west and north, just those regions where the effects of the worsening climate were harshest.

This killed off numerous settlements which flourished high on Dartmoor in the 13th century. One of them, Houndtor in Manaton parish, had four long-houses, and they provided a pattern for the surviving long-houses which were built lower down the slopes of Dartmoor at the end of the Middle Ages.[71]

They were built of stone taken from the moor, and laid in rough courses with soil to pack the gaps and make the walls proof against draughts. The walls stood about 2 m (6.5 ft) high, and often had opposed doorways front and back, set in the middle of the house and sometimes protected by porches. The upper end of the house contained a living-room with a hearth, while the lower end, marked by a drain, was the cattle-house or 'shippon' as it is called in the west. Some houses had an inner room serving as a private chamber and store.

The increasing prominence of cattle farming in the late Middle Ages was attended by the building of large numbers of long-houses outside eastern England, where cattle were traditionally housed in yards over winter. These insubstantial houses do not survive, although several are recorded in documents.[72] Only in Devon and parts of Wales are there several medieval long-houses, and they are not poor. Those on Dartmoor were built around 1500, when there was an upsurge in Devon's economy. They are similar to their predecessors at Houndtor, but have higher, mortared walls, and roofs carried by crucks or two timbers jointed together to form crucks. Outside Dartmoor the few long-houses like Higher Brownston at Modbury and Arnolds at Harburton have walls of cob, as nearly all the rest of Devon's medieval houses do. Like their predecessors, these long-houses had a cross-walk wide enough for cattle, often 2 m (6 ft) wide. The hall was usually up a step, and beyond a partition came the inner room. In the other direction, the

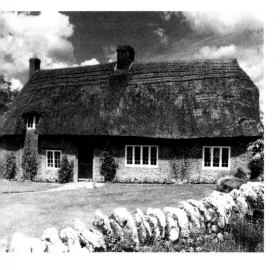

**Spring Cottage, Chetnole, Dorset. Possibly a medieval long-house.**

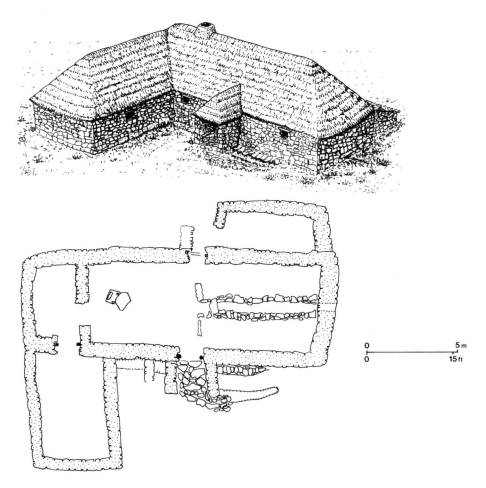

*Houndtor, Manaton, Devon. Reconstruction and plan of House 7, showing inner rooms and main living-room with hearth* (right), *and* (left) *shippon with drain.*

cross-walk opened directly into a cow-house, or shippon. Usually the shippon lay down a step and, to aid drainage, its floor sloped towards a vent in the end wall.

The first process of improvement, complete by the time the earliest surviving long-houses were built and the most efficacious in improving conditions within them, was the erection of a partition between the hall and the cross-walk and shippon. This was followed by a second partition, added between the shippon and cross-walk, so turning the latter into a passage. Stone walls had already done this at Houndtor, where external porches were also added before the houses were abandoned, but in surviving houses, the first partitions were made with upright planks slotted into grooved studs. Sanders at Lettaford, a long-house built about 1500, was given a low stud partition to divide its hall from the cross-walk, probably as an original feature,[73] and, south of Dartmoor, Higher Brownston at Modbury still has a low timber partition in the same position.[74] The partitioning of the cross-walk from the shippon was generally a much later improvement, one that remained unachieved at Foxworthy, Widecombe in the Moor, until 1945.[75]

*Sanders, Lettaford, North Bovey, Devon. Section and plan, conjectural restoration, showing a structurally separate porch, a partly lofted shippon with separate external door, a partition between the cross-passage and open hall, an inner room with a jettied floor to loft over it, and a roof hipped at the shippon end and gabled at the other end.*

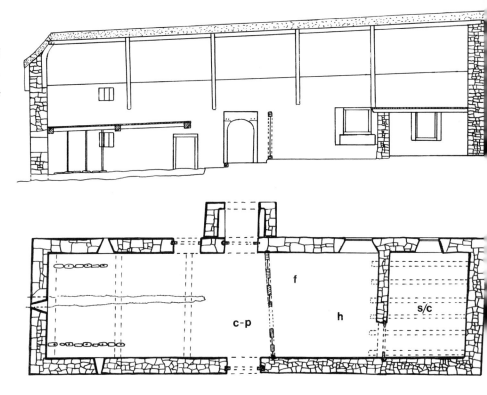

All surviving long-houses have an inner room, which had to serve as a chamber and a dairy and store room. The inner room was sometimes separated from the hall by a partition of the kind still to be seen at Colliehole Cottage. It is probable that this inner room, like the hall, was open to the roof, but the partition was strong enough to carry floor joists, and either in the first instance or soon afterwards the room was floored over, the joists projecting beyond the partition out into the hall to form an internal jetty.[76] At Sanders and Higher Brownston, the inner room was divided by a solid wall matching the exterior walls, suggesting its greater importance and earlier origin than the partition between the hall and the cross-walk. The inner room was sometimes very small, Higher Brownston's only measuring 2.5 by 4.5 m (8 by 15 ft). Long-houses themselves were hardly spacious, 65 sq m (700 sq ft) being typical for cross-walk, hall, inner room and its upper floor, all combined.

Like inner rooms, shippons were eventually floored over to provide a small loft for hay, straw or bracken. At Sanders, part of the shippon might have been floored over from the start. The majority of Devon's long-houses have now been converted entirely to domestic use, and several more are solely in agricultural use. Some never had a shippon and so were not really long-houses at all, despite their form. Townsend Farm at Stockland had this form, but there is no evidence of a drain in its lower room, and it may always have been used to store barrels of cider as it still was within living memory.

Many other medieval houses in Devon were built as conventional three-cell hall-houses, and outside Dartmoor this was true of the majority. This gave the long-house a reputation for being confined to the uplands, but this is because

the land in those places did not produce a great profit and yeomen seldom became wealthy enough to improve their houses beyond all recognition. Elsewhere in the pastoral counties, for instance at Yetminster in Dorset, the lower room of three-cell farmhouses may have been designed to function as either a shippon or a service room, leaving particular usage for individual occupiers to decide. The evidence of low ends rebuilt to incorporate new service rooms and upper ends used as stores as well as private sleeping rooms suggests that some of these houses, such as Chetnole Farm, were once long-houses.[77] At Stocklinch in Somerset, only Johnson's Acre, one of the several hall-houses built around 1500, has evidence for a cow-house at its low end, while others had a store for apples, implements and fuel instead, but never cattle.[78] By the 17th century a long-house might express local wealth when substantially built, but in a wider context expressed comparative poverty brought about by a combination of poor soil and harsh climate. The long-house, reflecting these conditions, was increasingly confined to the uplands.

## LARGE HALLS IN KENT AND SUSSEX

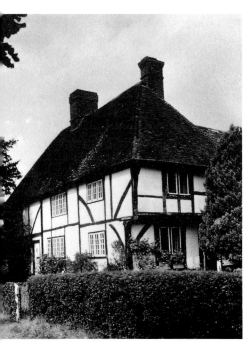

A hall-house at Chilham, Kent, with an end jetty.

Kent soon led the country with its fine yeoman houses. Like the West Country, much of Kent was devoted to pastoral farming, but yeomen here also supported themselves with the profits of weaving and tanning, to name two industries, and there were good markets close by. The wealth this brought began to show in the second quarter of the 14th century with base-cruck halls like Hamden at Smarden, which may have been built by John Hamden or an ancestor, one of the yeomen who cleared parts of the Weald for new settlements.[79] However grandly these yeomen built in the earlier 14th century, their sons and grandsons built so many fine houses after the Black Death that they transformed and nearly obliterated all that had gone before.

Somewhere between two and a half and four thousand of their fine hall-houses are standing today. Possibly, five times as many hall-houses were built in all. Each one would have accommodated about five or six people, so about 35,000 to 90,000 people, or somewhere between a third and well over three quarters of Kent's late medieval population of around 100,000, were living in one of these fine new houses. Such was the proverbial wealth of the yeomen of Kent at the end of the Middle Ages. In 1697, two centuries after this great outburst of building was at its peak, Celia Fiennes reported that the inhabitants of the Weald were 'a sort of yeomanly Gentry, about 2 or 3 or 400£ a year and eate and drink well and live comfortably and hospitably'; Goudhurst, she continued, was full of 'old timber houses'.[80] Evidently, most people here as in the rest of the county had satisfied their need for good, substantial houses a long time beforehand and done so very thoroughly. Hardly anyone needed a new house.

This is still obvious today. Many parishes contain a handful of large, easily recognizable hall-houses, not to mention a great number of smaller ones, and ones so altered as to escape immediate notice. If this is remarkable, so is the size of these houses. The larger ones measure about 6 by 15 m (20 by 50 ft) and, including the upper floors at each end, have a total floor area of 100 to 130 sq m (1100 to 1400 sq ft). Many contemporary manor houses were no larger, and the average three-bedroomed house built for similar-sized families today does not match up to this size.

All of these large hall-houses have jetties. Mostly the jetty is along one end only, usually the service end, extending the house sideways, and occasionally there are jetties along both ends, as in Burstead Farm at Upper Hardres. A more distinctive group of houses has prominent jetties extending the front forward at each end. Often these houses have a further jetty along one end as well, and occasionally at both ends as at Chessenden in the centre of Smarden, and the unusually lavish Yardhurst at Great Chart.[81] The biggest of them have more jetties at the back, so that apart from the hall in the centre, they are jettied all round. Pattenden at Goudhurst, probably built about 1470 by the Pattenden family, is one of these,[82] and even more spectacular is Headcorn Manor, built after 1516 as a parsonage house.

The principal effect of the front jetties is to leave the hall recessed between them, and, because the characteristic overall hipped roof extends forward to cover the jettied ends, the hall is recessed beneath the eaves as well. This produces an elevation which at once differentiates the hall from its flanking rooms, and, through the overall roof, integrates them as well. Moreover, the jetties and the overall roof give a strong feeling of symmetry, the more surprising since complete symmetry was an architectural ideal of the Renaissance and seldom realized even in far grander houses at the time.

The form of these houses is so distinctive that they have come to be known as 'Wealden' houses, although they are found all over Kent in great numbers, and many more are scattered across Sussex as far as the Hampshire border. About 350 of them were counted in the 1960s,[83] and a close scrutiny could double that number. Many are hidden behind additions, and some, like Furnace Farm at Lamberhurst, are totally obscured.

*Yardhurst, Great Chart, Kent. Front elevation, cross section of hall, ground plan showing the position of the floor joists, and elevation of the internal cross wall at high end of hall.*

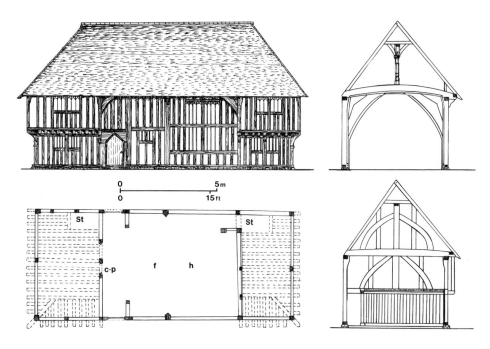

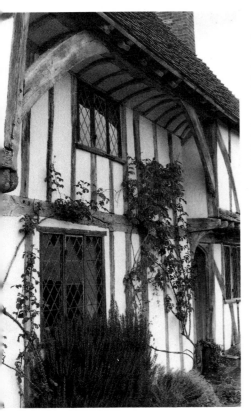

**Upper Bush, Cuxton, Kent. The recessed hall at the centre of a Wealden house.**

The concentration and variety of Wealdens south-east of Maidstone suggest that they may have originated there.[84] A feature of early Wealdens is the graceful, two-centred arch formed by the large curved braces supporting the central tie-beam of the hall. Wardes at Otham, south-east of Maidstone, has an arched tie-beam like this and there is another right outside Kent in East Sussex, spanning the hall of what are now Post Office Stores at Boreham Street, Wartling. This house was associated with the Colbrands, a family known there from the 14th century, and they could have built it as early as the middle of that century.[85] By the last two decades of the 14th century the Wealden had reached the fully developed form of Brishing Court at Boughton Monchelsea, south-east of Maidstone, whose lavish frame includes jetties at both ends as well as the front, and eaves bracketed out all round.[86]

Though Wardes ultimately had the typical Wealden form with a hall flanked by jettied service and chamber blocks, it was first built with the older form of a hall with services and solar combined in a single bay. Post Office Stores at Boreham Street, which also began in the same way without a chamber block, could still have served a small family quite adequately.

A row of 'two-thirds' Wealdens like these form a terrace nearby at Battle,[87] and other urban Wealdens possibly indicate an origin for the type in towns, perhaps Maidstone.[88] What evidence there is points in the other direction. A unified row of 'two-thirds' Wealdens would require a long frontage in single ownership, and an owner willing to speculate. It was easier to lease out individual plots for building individual houses; indeed, most Wealdens in small towns and villages are like the seven 'full' Wealdens in Robertsbridge, East Sussex, which were built between about 1390 and 1440.[89]

One of the oldest Wealdens was built by the Church as a clergy house at Alfriston in East Sussex, probably following the rebuilding of Alfriston church about 1360. Its arrangements are unusual in that the high end cannot be reached directly from the hall, perhaps because it was reserved for a guest, such as the Archdeacon of Lewes, or a female housekeeper, and decency had to be preserved.[90] This suitability for double occupancy is significant. Later Wealdens built by the Church, Durlock Grange at Minster-in-Thanet, apparently of 1413–14,[91] and Deanery Farm at Chartham, of soon after 1495,[92] were once again designed for multiple occupancy, and with status in mind. This must account for the frequent use of the Wealden design for inns, on occasion far away from the south-east. Both factors appealed to yeomen, possibly because the custom of partible inheritance favoured a partible house, and this could be achieved within the Wealden's prominently jettied twin ends.

This characteristic had the advantage of allowing a Wealden house to be built in stages and yet still have in its incomplete form an arrangement of rooms that was both useful and architecturally articulated to demonstrate their status. Bayleaf at Singleton, built by Henry Bayly about 1405, had a solar over the pair of service rooms clearly defined by jetties to both front and side. This satisfied a need to demonstrate status no less than the rooms themselves satisfied the basic requirements of a small household, even without an older chamber block on the site. The remarkable thing is that the concept of the Wealden design was so strong that when Edward Wellys and another generation of carpenters came to complete Bayly's house over a

century later they did so as faithfully to the original as though they were the first builders,[93] even though the roof framing was extended internally, in the form of a cross-wing.

In Sussex many Wealdens were small, reflecting the lesser wealth of its yeomen. Here the end-jetty is commoner still. The finest house of this type is the massive Maypole Farm at High Hurstwood. Its roof is unusually steep, and nearly doubles the overall height of the hall. The main timbers rest on a plinth of sandstone and are of great size, the posts being 0.33 m (13 ins) square, but they are not lavishly carved, and even the octagonal crown-post has only a crudely carved base and capital.[94]

Hampshire Wealdens are again small, and uncommon. In a curious variant of the type the jetties at each end continue across the front of the hall and project internally to provide a gallery between the two upper chambers. This is fairly common among those remaining urban hall-houses of the west which were built end-on to the street, and access between the upper rooms flanking the hall was clearly the purpose. Galleries serve the same purpose in such Hampshire Wealdens as The Curio Shop, Wickham, and Perry's Acre, Micheldever, but this is not the case everywhere. The Blue Boar, St John's Street, Winchester, has diagonal braces blocking any possible entrance from its gallery to the upstairs end rooms, and the same happens at The Crease, Micheldever. All these houses were built along the street, so the jetties would add visible status, and that might apply to the gallery too, especially if it overlooked the public hall of an inn as it perhaps did at The Blue Boar.[95]

In general, few Wealdens are highly decorated. Their crown-posts were occasionally carved with bases and capitals, and the tie-beams might have carved mouldings. A few houses have traceried heads to their windows; the restored hall window of Corner Farm at Langley has rows of four lights, each with a tiny arched head. Old Bell Farm at Harrietsham and Yardhurst have conspicuously embattled hoodmoulds over their front doors, perhaps as symbols of a chivalrous age and tokens of the yeomanly rank of their builders, though this had long since ceased to imply military service. Despite the general paucity of their decoration, however, these medieval houses have come to symbolize English rural building at its traditional best.

# 5 NEW HOUSES FOR OLD

Dowle Cottage, Pluckley, Kent. A 15th-century hall-house, modernized about 1600 by the subdivision of its open hall to make a continuous upper storey, and the insertion of glazed windows.

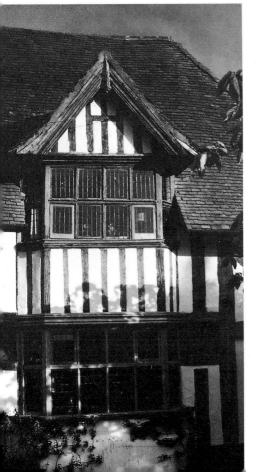

'There are old men yet dwelling in the village where I remaine', wrote William Harrison in a famous passage in his *Description of England* (1577), who, looking back at the 16th century, could see many things 'marvellouslie altred in England within their sound rembrance':

One is, the multitude of chimnies latelie erected, wheras in their yoong daies there were not above two or three, if so manire . . . but ech one made his fire against a reredosse in the hall, where he dined and dressed his meat.[1]

This increasingly common use of chimney-stacks to remove the smoke from an enclosed hearth made the open hall redundant and allowed the hall to be subdivided to make a continuous upper storey. This was indeed a marvellous change, one which Harrison rightly ascribed to the new wealth of yeomen farmers brought by the Tudor price rise. As a consequence of this, builders began to devise new house plans which would rationalize the introduction of the enclosed hearth and the chimney-stack.

The new demand for chimney-stacks is less understandable than it seems. Greater comfort, convenience, space and privacy are obvious reasons,[2] but all must be qualified. Space is doubtful: in the countryside, where stacks were a novelty, a hall-house could be built to whatever size money would allow, and was hardly more expensive than a house of the same floor area with a continuous upper floor and a stack rising through it. Convenience is harder to assess: the enclosed hearth played havoc with the formal arrangement of the hall-house plan, but formality was not an imperative. An enclosed hearth was cleaner, but it concentrated the heat, roasting people's faces while their backs froze, and produced a rattling draught at the same time. This caused a fire to burn excessively fiercely and the stack might let smoke billow out into the confined space of a single-storeyed hall. Conservative minds disliked all this, as the mathematician Edward Howes wrote in 1632:

I like well the old English . . . buyldinge where the roome is large and the chimney or herth, in the middest [i.e. where an open hall has a hearth in its centre]. Certainly thereby ill vapour and gnatts are kept out, lesse firinge [fuel] will serve the turne, and men had then more lusty and able bodies than they have nowe.[3]

Finally, privacy was low among people's needs, and the usage of rooms was at first little affected by the decline of the hall; if anything, usage became confused and privacy might be jeopardized. It is no wonder that it took two full centuries for the process of modernization to be completed, even in the rich south-east.

Nonetheless, privacy and convenience were not ignored. Langland had complained as long ago as 1370 of how the rich aristocracy retired to eat in the privacy of a chamber instead of in the communal hall as was the ancient custom,[4] and ideas of how the aristocracy behaved slowly permeated society, eventually to become the fashion among yeomen and burgesses. Secondly, in towns, where space was at a premium, the open hall was an encumbrance that many households were forced to shed in their pursuit of the best use of the space available to them. Necessity in town became fashion in the countryside.

Here were two powerful factors working on taste, and it was perhaps this importation of novel ideas, however little their practicalities and limits were understood, that helped to bring change. In the end that meant accepting a

radical rethinking of the form that a house should have if it were to exploit the use of chimney-stacks and a continuous upper floor to the best advantage. By 1600, this had been done for rural houses, but the achievement of the definitive urban terrace-house plan took a century more. Thereafter, the history of the traditional English house is concerned with the acceptance of these new plans across the country from rich south-east to poor north. This, as always, depended on fashion and status, and how far people would go beyond utility to show off their wealth and taste; it depended finally on the diffusion of knowledge about the new plans and the resistance of old traditions.[5] The pattern of building consequently became very complicated before tradition finally failed.

## EVOLUTIONARY PLANS

It was the more conservative and evolutionary plans into which the stacks and rooms were disposed which were most widely disseminated in the 16th century. This was well suited to the widespread adaptation of existing medieval houses. So their three-part plan continued in use, despite the inclusion of a chimney-stack, and the hall remained, though in attenuated form and floored over by an upper storey, which linked together the upper rooms at its high and low ends. The linear arrangement of rooms again continued, because it was familiar and it was easier to construct using the bay-by-bay forms of timber-framing. Moreover, until windows were generally glazed (by about 1600), the need for lighting on both sides of the house remained.

Rook Farm, Cressing Temple, Essex. The ornate chimney-stack of 1575.

There was a price to pay for the changes, and this accounts for the slowness of their acceptance. The first was cost itself; second were difficulties with space and circulation; third was the chimney, the feature that made it all possible. Bricks for a chimney-stack were relatively expensive before the 17th century and the stack took up a lot of space and impeded circulation. Because of this, houses at first only had one stack, and, while the earlier ones usually served only a single hearth, much effort went into placing the stack in such a position that there could be back-to-back hearths, two per storey. This brought obvious economies, though it was difficult to achieve. The stack had to be carefully placed, and ultimately that involved a break with tradition, but chimney-stacks were eventually accepted and became lavishly decorated objects of esteem, conferring status on a house.

In Essex and Suffolk brick making was flourishing by the end of the 15th century, and in towns brick chimney-stacks were becoming fairly common, if only in timber-framed shops and, more especially, in the larger inns where a high standard of accommodation was needed. Merchants and clothiers started to build chimney-stacks at the same time: the front range of Thomas Paycocke's house at Great Coggeshall in Essex, which his father built for him shortly before 1505, has a stack that allowed a continuous upper storey to be built over the hall, and its floor joists were then jettied out at the front, end to end, to support a fascia which was richly carved with foliage as an ostentatious demonstration of this novelty.

A few yeomen in Essex and East Anglia adopted these new features fairly quickly. Probably by 1530, Jenkyn's Farm at Fordham had been built with its chimney-stack added during construction as an afterthought, but allowing

Hilders Farm, Boughbeech, Chiddingstone, Kent. A yeoman's timber-framed house converted to a lobby-entry plan early in the 17th century. The oast house in the background came two hundred years later.

Houchins Farm, Feering, Essex. A lobby-entry house of about 1600 with a multi-flued chimney-stack providing for two hearths on each of the three floors.

a continuous upper storey. Apparently the builder had no clear idea of what would result from adapting the old medieval arrangements, so the central truss in the chamber over the hall is more grandly treated than the others, as though it were still decorating the hall itself.[6] It was the same in Kent and Sussex. A contract of 1500 specified the erection at Cranbrook in Kent of 'a newe house . . . to be lofted over with 3 particions beneth and 3 above . . . and a chymney with 2 fyres', perhaps serving a fair-sized hall and a chamber.[7] In all likelihood this house was similar to Morefootes, built about 1518 in the Sussex iron town of Robertsbridge. This had a tripartite hall-house plan, and was fully floored with a jetty. It is almost exactly the same size as the Cranbrook house, but differs in the position of its stack, which is placed externally, opens into the rear of the hall, and does not heat a second ground-floor room as well.[8] At Small Hythe in Kent, two timber-framed houses built shortly after a disastrous fire in the village in 1514 have the immediate appearance of Wealdens, but again with full-length jetties like Morefootes.

At Cheam, Sutton, on the Surrey side of London, Whitehall demonstrates the difficulties encountered by the builders of these first houses with chimney-stacks. It was built no later than 1520 and possibly before 1500 with a typical three-part plan and a full upper storey jettied out to both front and back. The stack is placed at the high end of the hall and has a single hearth, which was certainly for cooking. This immediately played havoc with the medieval arrangements. If the room at the low end of the hall were the service room, both servants and prepared food would have to go back and forth to this hearth past the high table. This table could then no longer be at the high end of the hall, but would have to be in the middle or at the low end near the screened entrance. That would have been uncomfortable and have upset medieval ideas of propriety, but, in fact, the service room was almost certainly in the room beyond the high end of the hall. The evidence for this is two niches let into the back of the chimney-stack, which, being warm and dry, would admirably serve for salt and spice jars. That would ease the problems of cooking and serving food in the hall without putting the high table in the centre of the bustle, but it still placed the table uncomfortably between the hearth and the entrance, and the chamber to which the head of the house would retire was now inconveniently at the low end of the hall beyond the entrance.

All of this would have been awkward if the old-established hierarchy of rooms mattered more than having a new status symbol. Privacy did not come into it at all. Not only was the chamber less private because it was at the low end of the hall beside the entrance, but it also had the only staircase in the house to give access to the upper floor where the rest of the family and the servants slept among the stores. These arrangements did not last for long: a second chimney-stack with a single hearth was inserted into the chamber at the low end, which then became a kitchen, and the former service room at the high end could then have become a parlour with the benefit of radiant heat from the back of the hall chimney-stack. This gain in convenience was costly. It took a second building campaign and more bricks and space, but there was obviously money to spend. The old stairway was removed from the former chamber and a staircase tower was built on the back of the house to serve the upper floor, and a loft was formed by inserting a new floor at eaves level.[9]

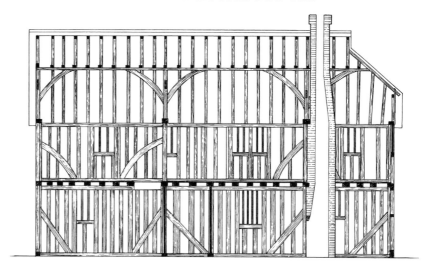

*Whitehall, Cheam, Sutton, London. Transverse section, showing the fully storeyed, three-part form with (left to right) a large chamber or service room with a gap in the joists for a staircase, an entrance passage, a hall with hearth at the further end, and a small chamber or service room with a chimney-stack projecting into it.*

**Crofton Farm, Orpington, Bromley, London. The hall at last completely floored over and given a chimney-stack with a bressummer dated 1671.**

A second position for the chimney-stack, rather less widely adopted in the south-east than Whitehall's original position, was at the low end of the hall, backing the cross-passage. This did not upset the medieval arrangements, and the stack could continue the screen or spere, making the division between the hall and passage greater than before and so adding to the sense of privacy. Because the stack backed against the cross-passage, it could not contain a second hearth and that was an inefficient use of bricks; and there was no question of providing warmth for the parlour, either through radiant warmth or a second hearth, so that limited the amount of comfort which the stack could provide. Nevertheless this position was chosen in several new timber-framed farmhouses in the south-east, and in nearly half the open hall-houses that were converted.

In perhaps a third of the hall-houses of Kent this process was not undertaken all at one go. Instead, the hall was partly covered over by inserted floors, thereby reducing the open portion through which the smoke could still escape, and providing a reasonably large upper room that might receive some warmth from the open fire beneath. This was a way of avoiding both disadvantages of the enclosed hearth and chimney-stack, the increased draught and the disarray which befell the old arrangements at the high and low ends of the hall.

These first smoke bays appeared at the end of the 15th century, although extremely grand Wealdens such as Headcorn Manor were still being built with open halls after 1516. A third of a sample of halls were progressively modernized by the provision of a smoke bay before a brick chimney-stack was inserted into them. Payne Street Farm at Charing, Barrow Hill House at Upper Bush, Cuxton, and The Old Farm House at Dean Bottom, Fawkham, all had the additional advantage of a gallery to link the new floors over the high ends of their halls with the original upper floors at their low ends. Tonge Corner at Sittingbourne was unusual in having galleries across both sides of the smoke bay, and in all these houses there was a partition fitted into the formerly open truss to keep the smoke from penetrating the new upper room.[10]

This division of large halls by the insertion of a floor to form a smoke bay was also applied to such small ones as the hall at 82–84 High Street,

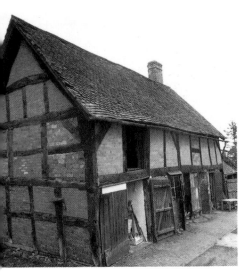

**Old Saddler's, Snitterfield, Warwickshire. The hall is at the further end and now has a chimney-stack inserted into the smoke bay.**

Westerham. A narrow smoke bay was created at Crofton Farm, Orpington, and this remained in use until 1671 when a brick chimney-stack was finally inserted. The whole process from the first build to the insertion of this chimney-stack could have taken as long as three hundred years.

The more radical form of carrying away smoke, the timber and plaster chimney-hood, was apparently a convenient way of removing the poisonous fumes of a coal fire from the open halls of West Yorkshire houses at a time when stone had yet to come into regular use, but by 1600 the hood was generally a cheap substitute for a fireproof brick or stone stack. It was consequently common in Somerset, where brick-making developed more slowly than in the south-east, and stone was too cumbersome. Timber and plaster hoods remained common in the poorer parts of the north and west of England, but there is widespread evidence of their former existence, even in the south, before brick became cheap enough for all to use.

By the mid-17th century open halls in large houses had mostly vanished and even the term 'hall' itself was slowly falling out of use. Fifty years later, just about everyone in the south-east had a chimney-stack. Crofton Farm had to wait until 1671 before its owner finally built a single-flued stack for his hall and emblazoned the date on its bressummer together with a fleur-de-lis and some very old-fashioned carving. The latest date recorded in Sussex for a chimney-stack inserted into an open hall was at Chodd's Farm, Handcross, where it is inscribed 'Bilt 1693',[11] and Hoggeshawes, a fine Wealden hall at Milstead in Kent, did not get its chimney-stack until 1700. It is easy to see why Celia Fiennes had been impressed a few years earlier by how old the houses of Kent looked.

## CHIMNEY-STACKS IN THE MIDLANDS

In the west Midlands rich yeomen were fewer and innovations took longer to take root. Storeyed houses were built early in the 16th century, but they often started with smoke bays or hoods rather than chimney-stacks. While there was plenty of clay for brick and good building stone in many parts of the Midlands, they were applied to house-building very slowly. Stone is less adaptable to the construction of stacks with multiple flues as the stack tends to become very thick, so this imposed further restrictions on the placing of enclosed hearths until houses were commonly built of stone in their entirety.

Meanwhile, timber remained the basic building material in the west Midlands until the end of the 17th century. Middle Beanhall Farmhouse at Bradley in Worcestershire, which may date from the first half of the 16th century, was one of the earliest houses with a floor over its hall; beyond it was a kitchen with a hearth placed within a smoke bay. A plainer, Warwickshire version of Middle Beanhall, Manor Farm at Stoneleigh, was built much later, probably after 1597 by junior members of the Leigh family, who came to Stoneleigh in 1567 when Sir Thomas Leigh, a successful Levant merchant and once Lord Mayor of London, bought the major part of the estate of the now dissolved Stoneleigh Abbey.[12] Smaller houses in Warwickshire were often similar, for instance Old Saddler's at Snitterfield, which had a parlour and hall, both with chambers over them, and a smoke bay serving the hall at the end of the house, which soon had a chimney-stack inserted into it, but otherwise grew no further.[13]

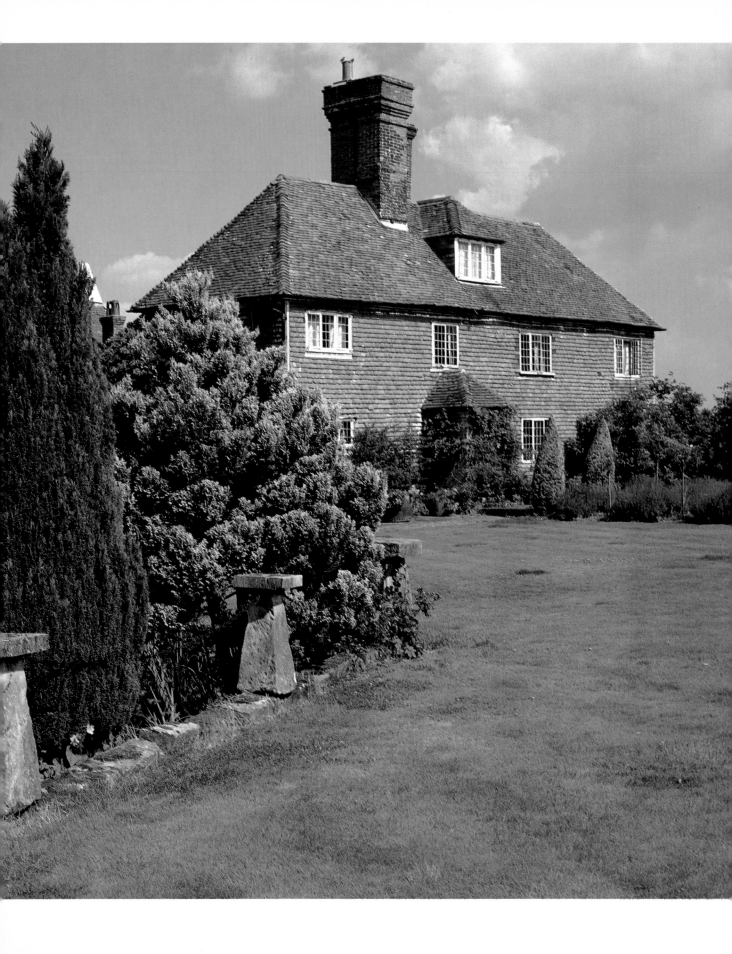

A timber-framed hall-house at Uckfield, East Sussex *(left)*, now tile-hung and heated by fireplaces set within an immense brick chimney-stack.

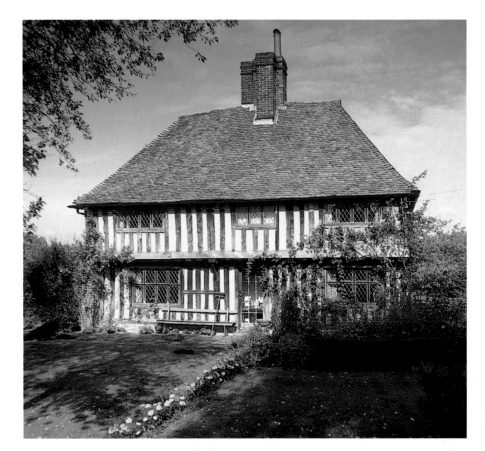

Skeet Hill Cottage, Plaxtol, Kent *(right)*. A 16th-century lobby-entry house with the typical close-studding of the period and a jetty advertising the continuous upper floor.

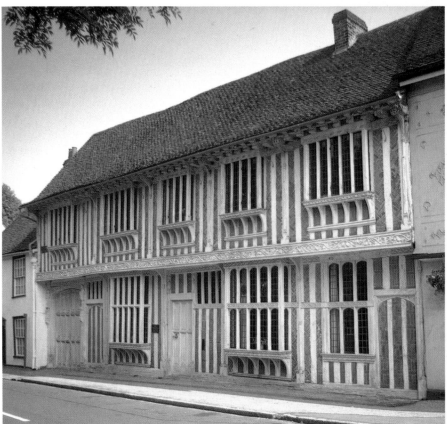

Paycocke's, Great Coggeshall, Essex *(right)*. The famous clothier's house, resplendent with a continuously jettied upper floor, made possible because the use of a chimney-stack rendered an open hall redundant.

## HEARTH-PASSAGES

It eventually became common to place the chimney-stack so that it backed a cross-passage to form a 'hearth-passage'. In the west, this may be due to the prevalence of the long-house and the needs of dairying. The preparation and storage of butter and cheese had to take place in an inner room at the high end of the hall because the lower end contained a shippon. Since a dairy should be cool, the inner room could not be heated, not even by the radiant heat from the back of a chimney-stack at the high end of the hall. A stack at the low end of the hall solved this, and also helped to block off the cross-passage, an increasing desire in the 16th century when the direct link between man and cattle was being reduced for comfort's sake.

These changes are clearly seen in Devon. At first, the stacks were added to the front wall. This economized in stone by making use of the wall, and the stack could be well seen, so giving the house some status. Stacks had appeared on the front walls of superior houses around England in the later Middle Ages, but only in the West Country were yeomen to follow them. Manorial lords added a chimney-stack to the front of the medieval hall of Bury Barton at Lapford, probably in the first half of the 16th century,[14] and a particularly successful yeoman added another to the front of Poltimore at Farway, and dated its fireplace 1583.[15] The grander, fully storeyed Boycombe, also at Farway, has two prominent stacks on the front wall to heat both a hall and an adjacent chamber. Front stacks are particularly prominent in Otterton, for instance the one dated 1587 fronting the hall of the cob-built Pinn Farm.[16] This is equally true among long-houses. Sanders at Lettaford, North Bovey, had a stack added to its front wall before a floor was ever inserted over the hall;[17] and so had the cob-built Higher Brownston, Modbury.[18]

The front chimney-stack was superseded by one backing the cross-passage. At Sanders this took place when the front stack was rebuilt as a staircase to serve a new floor over the hall which linked the old floors over the inner room and shippon.[19] This new position was adopted in many of the older long-houses and in a majority of the new ones.[20] The back of the chimney-stack took up most of the cross wall dividing the hall from the cross-passage, leaving just room for a door. Shilston at Throwleigh was given this form in 1656. It was one of the last long-houses to be built, but the process of modernization went on at least until Lower Tor Farm at Widecombe was given a porch in 1707.

When at last Devon yeomen separated their dairies from their inner rooms, and put them in extensions, the comfort of a heated chamber involved little cost since they could save stone by building another stack against an existing wall. In this way they avoided the wasted space of large multi-flued stone stacks in the centre of their houses, and a need to change the traditional use of rooms as happened in the south-east.

The hearth-passage was not confined to long-houses. Late in the 16th century Higher Stiniel at Chagford was completed with two full storeys, a hearth-passage, hall and unheated inner room following the usual long-house arrangement, but in place of a shippon is a service room.[21] In Herefordshire, one of the last open halls, Old Plaistow at Ledbury, was converted in this way, and later houses, Manor Farm at Leinthall Earls, for instance, followed the same pattern.[22] Indeed the three-part hearth-passage plan is very common among stone farmhouses built or modernized between about 1550 and 1650 along a great arc embracing the west and the north.

**Shilston, Throwleigh, Devon.**

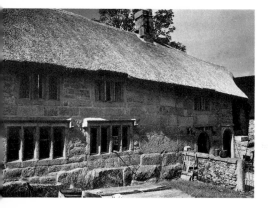

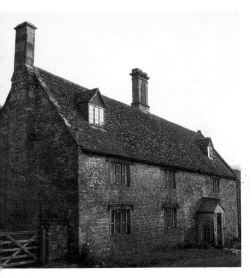

**Farm House, Ford, Temple Guiting, Gloucestershire.**

If the popularity of the three-part arrangement of these houses was due to conservatism, the hearth-passage conserved space and materials, and made the best of the restrictions that stone imposed on the building of stacks. While a single multi-flued brick stack in a timber-framed house was the most economical way of building, and a new arrangement of rooms was devised to exploit it, in a stone house everything was different. More stacks could comparatively cheaply be built into the gables to serve further rooms such as private chambers or kitchens, and they would not only benefit from the stone of the walls, but also give the walls further stability by buttressing them.

When the excellent Jurassic stones came to be exploited in the later 16th century, many of the traditional houses built of it during the following hundred years were given hearth-passages, and by the 17th century many houses included further stacks on their gable walls, one for the parlour at the high end and another at the low end for the service room, which now usually became a kitchen, leaving the hall as a rather more private living- and dining-room than it had been. The hearth-passage plan was used in houses of all sizes, in Gloucestershire from the comparatively modest Farm House at Ford, Temple Guiting, to the grand Warren Farm at Stanton, which has a mullioned hall window of six lights as opposed to the universal three lights at Ford, and two prominent gables for the garrets at the front.

One consequence of the spread of enclosed hearths was a change in the age-old process of smoking meat to preserve it. Smoking required an open fire and a hook in the roof above, where the meat could be cured by the smoke, yet not get hot enough to cook. As soon as open hearths were displaced by chimney-stacks, separate curing chambers were introduced in the West Country to stop the meat from burning. Most chambers were about 1 m (3 to 4 ft) in diameter, and placed on one side of the stack in a position where smoke could be directed into them from smouldering wood chippings or sawdust, independent of the main hearth, and so avoiding the full heat of the fire. The smoke was returned to the stack by way of a narrow flue at the top of the chamber, which had an access door and hooks for hanging the meat inside.[23] Most curing chambers have been found beside farmhouse chimney-stacks in Somerset and nearby, and there are a few more elsewhere in England. These progress from a

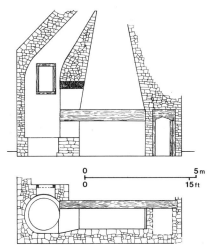

0       5 m
0       15 ft

*Somerset curing chamber at Pendyn, Nailsbourne: section looking outwards and plan, showing the main hearth with a chamber to its left, open to smoke from the main fire but shielded from its heat, and a warm cupboard to its right.*

101

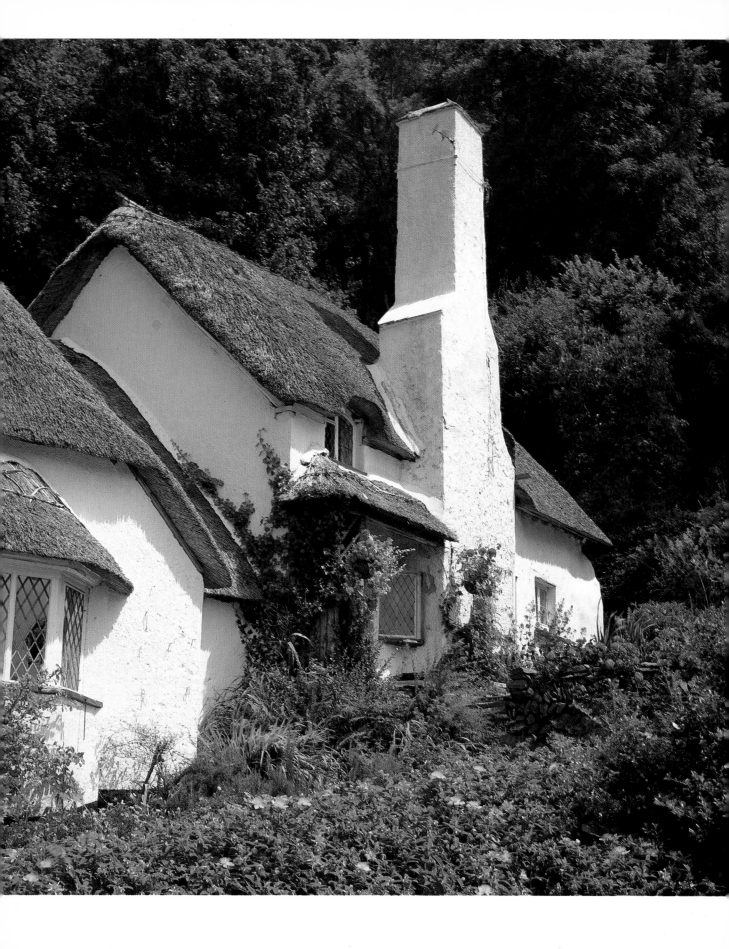

A house at Selworthy, Somerset *(left)*, with a typical, prominent chimney-stack on the front wall.

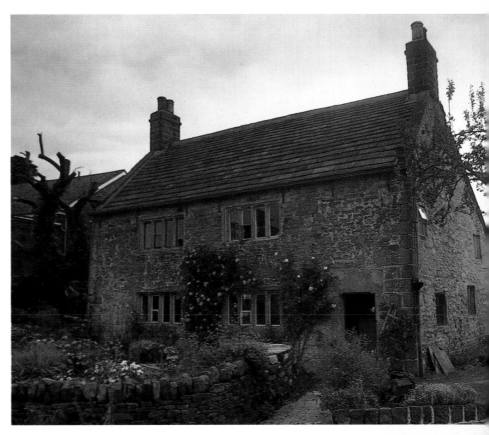

Whitehouse Farm, Stannington, South Yorkshire *(right)*. Built on the eastern Pennine slopes about 1630, with two main rooms at the front and service rooms in a rear outshut, which is descended from the aisles of a hundred years beforehand.

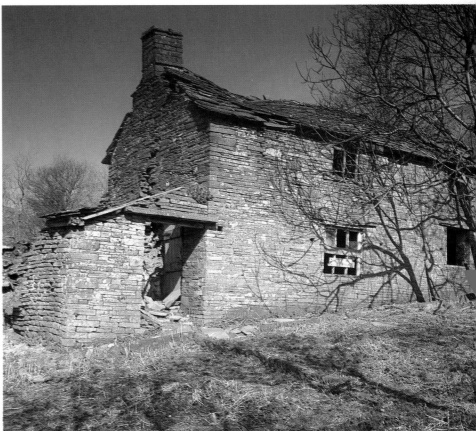

Blaen, Llanveynoe, Herefordshire *(right)*. High above the Olchon valley in the Black Mountains, this little house has only two rooms on each floor, and the entrance is in the gable end, shielded by an added porch.

primitive open chamber beside the hearth that takes smoke from the fire, to an enclosed form with a small fire of its own, a type that seems to have remained in use until the middle of the 18th century.[24]

## SMALL HOUSES

Lesser yeomen, husbandmen and craftsmen made do with four-roomed houses with two rooms to a floor. Many of these were reduced versions of the three-cell houses with a hearth-passage, and a few appear to have links with the long-house, which after all had only two domestic cells itself. One such house in Kings Sutton, Northamptonshire, had a hall and hearth-passage beyond which there were a small service room and an upper chamber, providing a total floor area of only 60 sq m (640 sq ft).[25] At Northend in Warwickshire another, probably contemporary, house of this type was built in 1579 and surprisingly became the oldest house as well as one of the smallest in the area to be given a datestone.

In the north of Northamptonshire some of the 17th-century two-celled houses are contracted versions of three-celled houses and have a hearth-passage, but these little houses are a cut above nearly half of the peasant houses in this part of the county, a continuing reflection of strong manorial presence and little yeoman wealth. Most houses comprise just two small rooms on the ground floor with direct entry from the street and a single hearth in a stack rising up one gable wall of the hall.[26]

The houses of Foxton in Cambridgeshire built by the villagers between 1550 and 1620 in the main consisted of two rooms, a heated hall with a chimney-stack, and an unheated parlour with a storage loft over it. There was usually room for a small brewhouse behind the chimney-stack, for these were timber-framed houses with brick stacks and so were differently planned; but the significant point is that their small size and limited number of rooms were again a direct reflection of continuing manorial control. Peasant wealth increased slowly, and any capital gathered after the construction of a new house went eventually into the insertion of a floor over the hall.[27]

After 1560 the common two-room arrangement of an open hall and buttery found in the east Midlands at Wigston Magna in Leicestershire was amplified by a third room, usually a kitchen, and by the construction of upper rooms, both as additions and as integral parts of new houses. This reflected a doubling of peasant wealth in the second half of the 16th century. These houses were built within the confines of a village which, typically, was still surrounded by its open fields. Because plots were restricted, as houses were extended their plans had to be modified, often resulting in an L-shape.[28] Many houses were built end-on to the street, again to save both space and valuable frontage, so that there could be a front entrance to the farmyard. Space was sometimes so tight that a house and its farm buildings eventually coalesced, but this never prompted the building of long-houses.

Nevertheless, in the west Midlands, unlike the east, some two-celled houses were built as though they were long-houses shorn of their cattle-house and cross-walk. This produced the unusual feature of an entrance in a gable wall, precisely where a doorway led into the hall from the cross-walk of a long-house. A similar position could result from descent from an ordinary hall-house, but most gable-end entries occur where there was a strong tradition of

**One of the small timber-framed and plastered houses at Foxton, Cambridgeshire.**

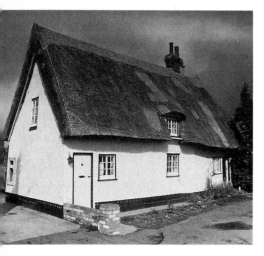

building long-houses, particularly in upland Herefordshire around Wigmore and overlooking the Olchon valley. Among the earlier houses is Ford Farm at Wigmore, while Blaen at Llanveynoe belongs to the late 17th or 18th century.[29]

**UNIT-SYSTEM HOUSES**

At the opposite end of the scale were those houses with doubled sets of accommodation which suited families where partible inheritance had effectively divided them into two separate households. This seems to be the explanation for structurally independent ranges in a number of superior houses in Cheshire and Lancashire, such as Livesey Old Hall, Blackburn.[30] This so-called unit system, which provided two separate but contiguous houses, was not confined to the affluent nor to the north-west. In Somerset, Blackmoor Farmhouse at Cannington is an early, grand example of what appears to be a double unit-system house, and Yatford Farmhouse at Broadway a modest one, looking like a semi-detached pair dating from about 1600.[31] In West Sussex, Hole Cottage at Billingshurst comprises two adjacent houses on one plot, once separate but now linked, of the smallest size. Again, this may well be a consequence of partible inheritance; their overall similarity to each other strongly suggests it, and makes other explanations such as separate hall and chamber block or house and kitchen or small barn rather less likely.

**THE LOBBY-ENTRY PLAN**

Occasionally a chimney-stack at the low end of the hall was built within the cross-passage to provide a second hearth in the room beyond it, reducing the passage to no more than an entrance lobby. This was seldom more than 2 m (6 ft) square, but it provided separate access to each of the flanking rooms and screened them from draughts. A tight newel staircase could then be fitted into the remaining space at the rear of the stack, though occasionally it was placed at the front to rise from the lobby itself.

This at once produced a new and more convenient form of plan. Both the principal ground-floor rooms opening off the lobby have fireplaces in the centrally placed chimney-stack, and corresponding upper rooms can be similarly heated, requiring the stack characteristically to have four flues. The space over the lobby may contain cupboards or a closet opening off one or both of the upper rooms, and sometimes the closet extends above an open porch to make a fair-sized third room. In many houses the roof space was used as a loft or garret and sometimes was tall enough for fully fledged rooms with dormer windows and even fireplaces of their own.

*Yatford Farm, Broadway, Somerset. Plan, showing (left to right) a probable chamber, first cross-passage, first hall with joists forming a panelled ceiling, second chamber, second hall with a panelled ceiling and surviving hearth, second cross-passage, and kitchen with a large cooking hearth.*

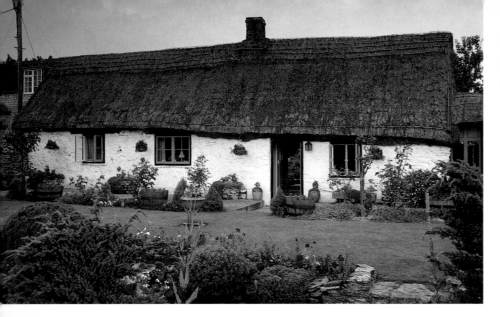

**Daleside, Pockley, North Yorkshire** *(left)*. A converted long-house on the lower slopes of the North York Moors, the room down the slope to the right of the entrance once being used as a byre.

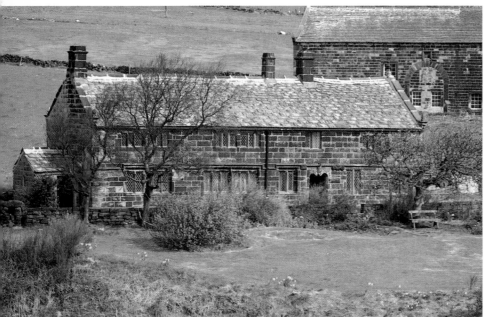

**Hippins, Blackshaw, West Yorkshire** *(left)*. Dated 1650, this is one of the prosperous houses built on the slopes above the Upper Calder, where weaving augmented the profits of pastoral farming; behind the house is a converted laithe, part barn, part cattle-house, now with windows in place of doors in the main wagon entrance.

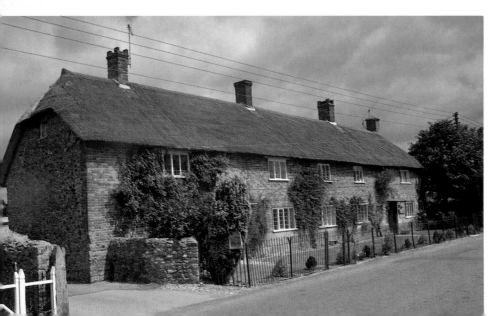

**Yatford Farm, Broadway, Somerset** *(left)*. Not a terrace, but, apparently, a double house, possibly for two heirs living under the same roof.

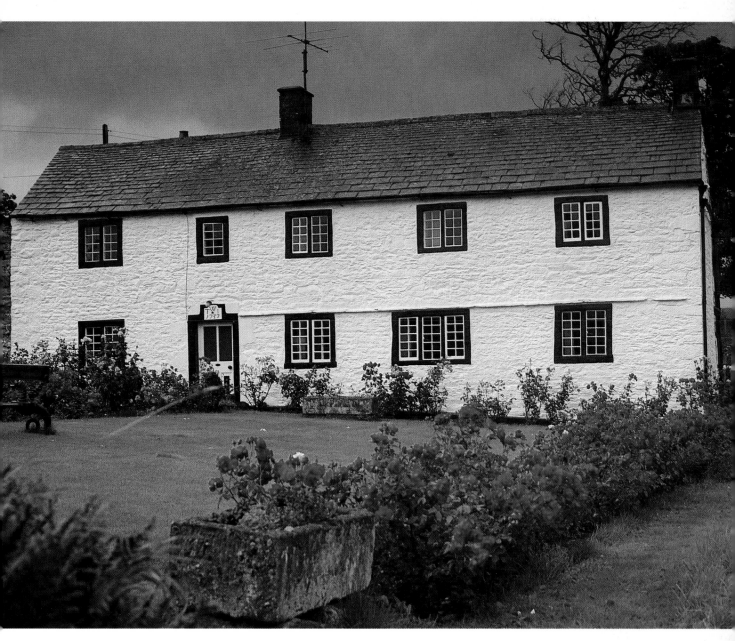

Sourlandgate, Dacre, Cumbria. Built in 1737 with an old-fashioned hearth-passage plan and a heated parlour.

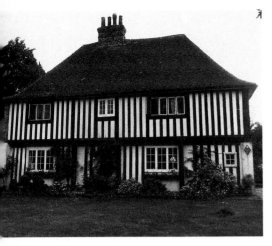

Cobb's Hall, Aldington, Kent.

Fairbanks House, Dedham, Massachusetts.
Built about 1637, this is recognized as the
oldest lobby-entry house in New England.

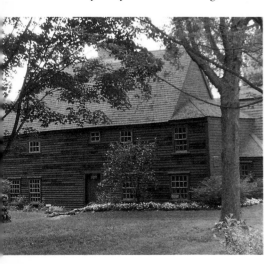

Often the third, unheated room of these so-called lobby-entry houses was omitted, leaving the remaining two to share the functions of the three in traditional houses. The hall, or kitchen as it came to be known, took on some of the attributes of a service room as well as being used for cooking and eating. Smaller service rooms for special purposes like brewing or cheese-making were often partitioned from it or housed in complete bays of their own. The chamber on the further side of the lobby, increasingly called the parlour, took on some of the functions of the high end of the hall as a formal place where a yeoman could conduct his business or eat in private; otherwise it was a sitting-room, bedroom and general storage place for household goods, clothing and linen, and again might have an inner room partitioned from it. The upper rooms served as before, and, if the house had a garret, it again was used for storage; no one slept there, not even servants, who commonly slept in garrets in towns.

The compact plan of the lobby-entry house is well suited to box-framed construction. The stack, entry lobby and staircase neatly fit into a narrow bay, framed by two trusses, and give each other mutual support, and, with the adoption of trussed roofs with side purlins instead of the medieval crown-plate and collared rafters of the south-east, the axial stack does not interrupt the roof framing.

Apart from its fashionable symmetry, the great advantage of the plan is that no space is wasted: individual access to each room required no passages. Only when more rooms were added to one end or at the rear had they need of their own chimney-stack or remained cold, and could only be approached through one of the other rooms. This hardly affected privacy so long as the upper rooms were used by children and servants; but a later, more fastidious age had to erect partitions and form passageways.

The majority of early lobby-entry houses were built in the south and east where there was already a long tradition of timber framing, attention to fashion, and the wealth to pay for it. The earliest were built all of a piece, so the plan must have been an invention. Its origins lie in lodgings and inns where necessary high standards of accommodation and comfort were provided by enclosed hearths in several rooms on at least two floors, each with its own access. The lobby-entry plan itself was developed quickly at the start of the 16th century, probably for lodgings. Apparently the earliest survivor, Cobb's Hall, was built at some time between 1509 and 1526 as the combined lodging and court-house of Thomas Cobbe, the steward of the Archbishop of Canterbury's Aldington estate. It was followed about 1536 by Old Hall Farm at Kneesall in Nottinghamshire, built as a brick hunting lodge by Sir John Hussey,[32] but yeomen accepted the lobby-entry plan slowly, partly through conservatism, and the plan remained for a generation or two as little more than a local curiosity.[33]

When it was at last widely accepted towards the end of the 16th century, its undoubted advantages gave it a remarkably long life span of over four hundred years and an almost universal appearance in England and in many eastern counties of Wales. It was even exported to Ireland, where it failed, and to New England, where it was an even greater success than at home.

Many hall-houses in the south-east were converted to the lobby-entry plan, but the number of completely new houses built to this plan from scratch is

small because few new houses were needed. North of the Thames there were fewer good houses and so the advance of the lobby-entry house was quicker. Rook Hall at Cressing Temple in Essex, of 1575,[34] is among the first, and by 1600 the plan was widely used.

This is shown by Bells Lane Farm at Stanningfield, Suffolk,[35] and many others. They are well documented by a building agreement in the Suffolk Record Office whereby John Cage, an Ipswich carpenter, was to build a lobby-entry house at Holbrook by Michaelmas 1577.[36] Overall the house was to be 15 by 5.5 m (50 by 18 ft), giving a spacious floor area of 165 sq m (1800 sq ft), with three rooms on the ground floor. The hall and parlour were to be heated by the single stack, and a buttery, unusually, was to be partitioned from the parlour. The windows were to be of the new type, with a large, glazed, main window, flanked at the top by wide, shallower, so-called clerestory windows. They could stretch almost end to end in a timber-framed house, only being broken by the load-bearing vertical timbers. They not only were an overt sign of status at a time when to have glass in a window was still a novelty, but also provided a great flood of light, something that would not be equalled until the architects of the Modern Movement re-invented long bands of windows for more ideological reasons in their reinforced-concrete buildings of the 20th century. The long windows of the 16th and 17th centuries lasted only as long as glass was a novelty and houses remained framed; solid wall construction in brick or stone and the desire to incorporate classical proportions into a facade soon combined to eliminate them.

During the first quarter of the 17th century the lobby-entry plan was adopted wherever timber-framing still flourished. In the west Midlands,

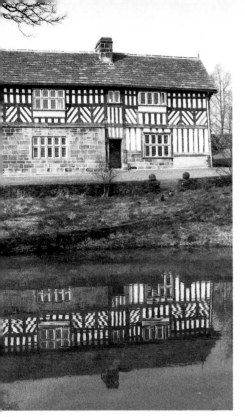

The timber-framed wing of Houndhill, Worsbrough, South Yorkshire, built as a lobby-entry house, possibly by Roger Elmhirst in 1566.

*Wood Farm, Redisham, Suffolk. Partly restored section, interior of east end and plan, and (bottom right) plan of house for Toly's Foundation. Wood Farm has a typical lobby-entry plan, except for the staircase placed between the entry and chimney-stack, and unheated room, perhaps a buttery, beyond the parlour, as also shown in the Toly's Foundation plan and agreement.*

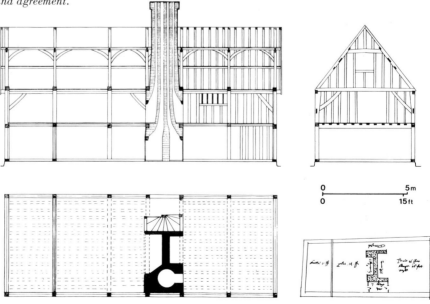

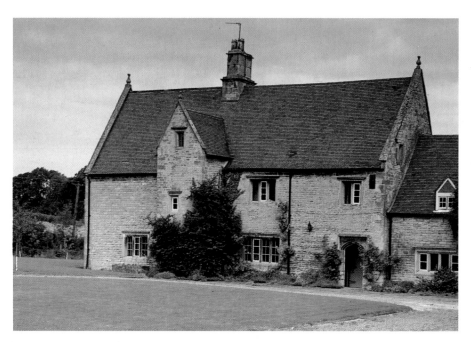

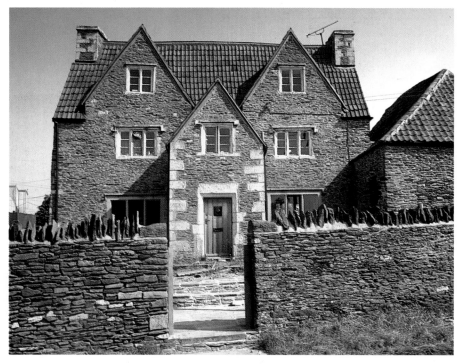

The Priory, Heydour, Lincolnshire *(top)*. Built in the middle of the 17th century, this was never a priory, but a grand farmhouse with an entrance into a service room, and a heated hall and chamber with a prominent staircase in a tower set between them on the front wall.

Brook Farm, Westerleigh, Avon *(above)*. A gabled house typical of the plain north of Bristol, with a central entrance vestibule and chimney-stacks on the end walls.

Warren Farm, Stanton, Gloucestershire *(right)*. One of the grandest 17th-century hearth-passage houses, built on the edge of the Cotswolds of fine-quality oolitic limestone.

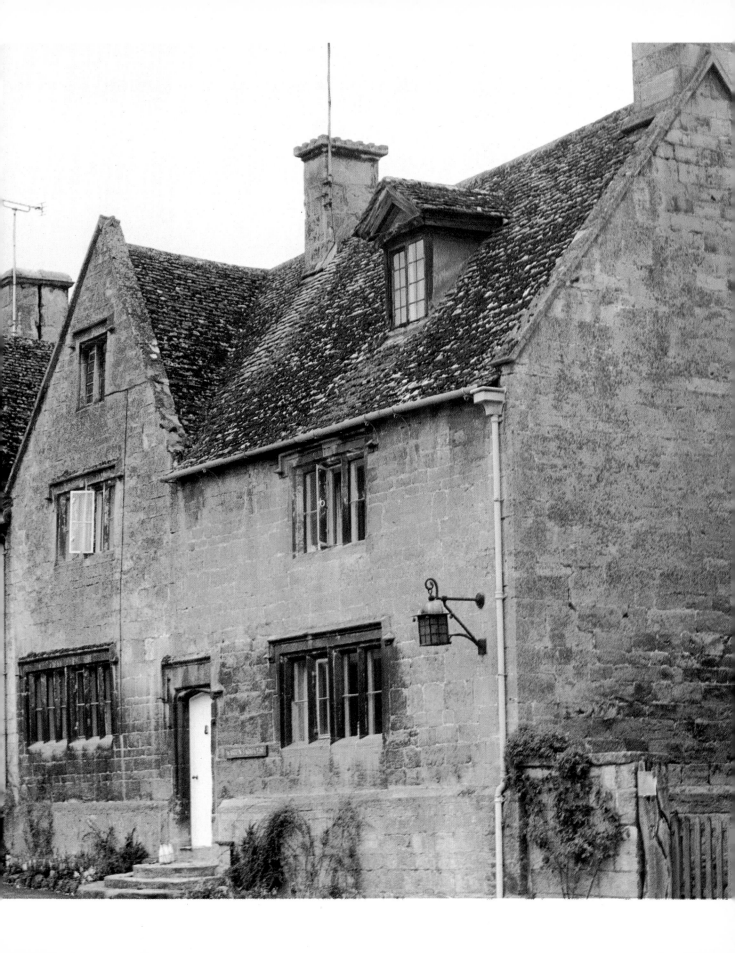

where the old tradition of including a cross wing continued, the entrance lobby and chimney-stack were often placed where the two parts joined. Keys Farm, Bentley Pauncefoot, Worcestershire, was given this form about 1600,[37] and it appeared as late as 1658 when Richard Blakeway remodelled Berrington Manor in Shropshire.[38] The regular form of lobby-entry house with wings confined to the rear arrived with The Ditches at Wem in Shropshire in 1612, and Woodroffe's at Marchington in Staffordshire in 1622. The plan reached the north well after 1600, if Houndhill at Worsbrough in South Yorkshire is discounted. It belonged to the Elmhirsts, a progressive family of yeomen who may have built it as early as 1566, but it was little copied in Yorkshire houses until stone took the place of timber in the 1620s.[39]

## BRICK AND STONE HOUSES

As fashion turned to brick and stone, the cultivation of building timber decayed and its price rose so much that by the middle of the 17th century it was no longer the cheapest building material. Ashlared walls of local Bedham Greensand and a roof tiled with Horsham stone give Idehurst Farm at Kirdford, West Sussex, unusual quality. From about 1600 it belonged to the rich Strudwick family who owned at least 1750 acres and half a dozen farms. Rents paid for this fine lobby-entry house, and so did the profits of their furnaces, both iron and glass; in fact they were one of the greatest glass-making families in the Weald.[40]

In Norfolk, where timber framing had always been poor, plaster rendering on a particularly strong mixture of daub made up for it, and many houses were built of unbaked earth with little or no framing for support. So, while brick was used at a comparatively early date in the county, it made slow headway. Mary's Farm at Tacolneston was made of unbaked clay in 1628, and only at the end of the century was brick commonly used. Long before that, the first brick lobby-entry house, White Loaf Hall at Freiston, had been built in Lincolnshire with crow-stepped gables and dated 1613 and 1614. Here, small houses were invariably built from unbaked earth or with the poorest of frames. The few survivors in villages like Thimbleby and Mareham le Fen show that it was as common for the entry to be directly into the hall away from the chimney-stack as into a lobby against it. A husbandman's cottage from Withern on the coastal marshes near Louth, now re-created at Church Farm Museum, Skegness, had a heated parlour and kitchen each side of a lobby entry, and a narrow third room, partitioned off the rear of the kitchen, with a boiler set into the rear of the chimney-stack. The loft is floored below the top of the walls and contains just one room with the stack rising through it. At least its solid earthen walls and thickly thatched roof ensured a warm retreat from the biting Lincolnshire winter.

Dressed in brick or stone, the lobby-entry house conquered new ground. On the better seams of the Jurassic, they went up by the hundred until well into the 18th century. Stone central stacks would have been too large with more than two flues so they were usually built of brick instead, or further stacks were built against the gable walls.

In Lincolnshire, the Old House at Leasingham is dated 1655, and a row of three more at Kelby, two dating from the later 17th century, the third perhaps a century later, are a very far cry from the poor, clay lobby-entry houses of the

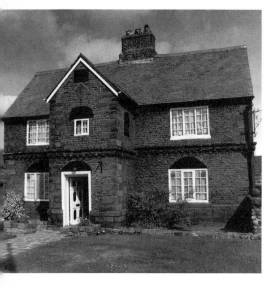

**Manor Farm, Greasby, Merseyside.**

The Old House, Leasingham, Lincolnshire.

Fens. In Nottinghamshire the Cartwright family built their Manor House at North Wheatley of brick in 1673, while Hall Farm at Woodborough, which is tall and has a full-height garret lit by large gabled windows, is clearly a house for a gentleman farmer, and, to prove it, is inscribed 'PHILIP LACOCK ESQUIRE 1710'.

The lobby-entry houses built in the Wirral, Merseyside, in the 1680s, such as Manor Farm at Greasby, are similar, and less distinctive than their cousins on the Lancashire plain, where the plan was used for several houses built of russet-coloured brick with sandstone quoins, and basket-arches and brick cogging courses over the window openings. Old Gore Farm at Lydiate carries the unlikely date 1596, while a house in Cobbs Brow, Newburgh, has a far more credible plaque of 1691. In the Derbyshire Peak there are several lobby-entry houses, but numbers decrease across the Pennines of Yorkshire and all but stop at the Craven Gap.

By 1700, the lobby-entry plan was no longer at the height of fashion and had started its descent down the social scale to smallholders and labourers. It came to be used for small farmhouses set up by the enclosures of the late 18th and 19th centuries, for instance in Cambridgeshire for Hall Farm at Bottisham, which followed the enclosure of 1808. Of much the same date is a small weatherboarded farmhouse in Pike Lane, Upminster, Havering, Greater London, which is so small that the whole house and the two-bay barn that continues the building under the same pantiled roof could be entirely contained within most lobby-entry houses of the 17th century. Yet the lobby-entry house still retained an aura of ancient wealth, and so came to be revived by 19th-century architects of the Old English style, who used it until Clean Air Acts and other forms of heating caused a decline in the need for several hearths in multi-flued chimney-stacks.

## END STACKS AND CENTRAL VESTIBULES

A central stack wastes little radiant heat, but it consumes space and materials, and restricts circulation. The lobby is small, the staircase tight and usually reached only from one of the rooms. Hearths built into the external walls of a stone house solved this problem by freeing its centre so that the lobby could extend rearwards to become a fully fledged vestibule giving individual access to all the rooms, to a wide staircase and to one or two service rooms within the main body of the house or in a rear outshut or a separate wing. The cost might be the loss of some heat from the exposed backs of the chimney-stacks, but the gain in convenience was more than recompense. A stylish staircase effectively decorated the vestibule, and the front of the house could again be symmetrical. Status and efficiency were served in equal portions.

Though the principal room was at first still called the hall, it eventually became known as the kitchen or dining-room depending on its use; meanwhile the vestibule became known as the entrance hall or staircase hall and in the end simply as the hall. Its only connection with the medieval hall is that, by lying at the centre of the house with all the rooms opening off it, it reflected changes in great houses where the hall had become simply a ceremonial place of welcome lying between the entrance and the reception rooms.

A few houses with end stacks had been built before the end of the Middle Ages, but these were at a high social level. The Priest's House at Muchelney in

Netton Farmhouse, Bishopstone, Wiltshire, built in a chequer-work of flint and clunch in 1637, with a central entrance and chimney-stacks on the gable walls.

Dairy Farm, Tacolneston, Norfolk.

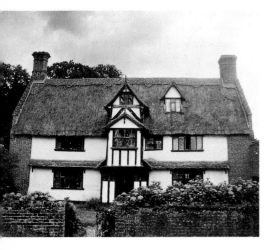

Somerset, probably built soon after 1308 as a standard three-part hall-house, has heated end rooms with enclosed hearths set into stacks built in the thickness of the end walls.[41] This area offered ideal conditions for these houses in later centuries, because of its good building stone and the emergence of wealthy yeomen who wanted fashionably new houses. Thomas Miller was among the first of them, building Iles Farm at Leigh in north Dorset when he married shortly before 1600. His family's unusual wealth and status might be the reasons for both the advanced planning of this house and its size. A floor area of some 140 sq m (1500 sq ft) allows space for two large rooms each side of a vestibule and corresponding rooms above. A plank and stud partition with an open balustraded grille at the top for ventilation separated the vestibule from a buttery, well placed at the rear since it faced north and was furthest from the fires.[42]

By the middle of the 17th century there were similar houses with central entrance vestibules and end stacks built all along the Jurassic band from similar kinds of stone, so it was the architectural tradition of the locality that made the most visible difference. In Dorset, where houses were usually thatched and as a result roofs had to be simple in shape, gables were generally reserved for the end walls and used to terminate the main roof. This is where the garret windows were placed. In Gloucestershire the houses often had full garrets and were roofed with stone tiles. This provided an opportunity to build imposing gabled dormers so the garrets could be lit not only at the ends but at the front and back as well. In Northamptonshire, where the Civil War disrupted the economy for a decade, the revival of the locality's fortunes is marked by Poplars Farm at Chacombe of 1654, the earliest house hereabouts to use this new plan.[43]

Further east, central vestibules and end stacks came into their own only in the 18th century, despite the example of Moor Farm at Humby in Lincolnshire, which is dated 1631. Local tradition stuck to the plan of the adjacent farmhouse, which has an entrance directly into its milk-house with access to a hall and parlour that share a chimney-stack with back-to-back hearths, and the so-called Priory at Heydour, which has the same plan and a prominent stair turret at the front. Most other farmhouses in the Midlands continued in the medieval tradition up to the middle of the 17th century by having variations on the three-part plan, the larger ones with one or two cross-wings and a central hall entered at one end, as exemplified by Harecastle Farm at Talke, Staffordshire, built soon after 1600, and Manor Farm of 1635 at Clipsham in Leicestershire.[44]

The central vestibule plan came to be used even in timber-framed houses, for instance in Norfolk for Crossways Farm at Chedgrave, where the stacks are built into brick gable walls, which are tied to the frame by iron rods that terminate in figures making up the date 1669. The similar Dairy Farmhouse at Tacolneston has crow-stepped gables rather than shaped gables, and the brick end walls wrap round the house like book-ends to support the framing. The planning of the house is unusual because there are two staircases, one in each of the brick ends beside the chimney-stack. The staircase rising from the parlour leads only to the chamber above, which is partitioned from all the other four chambers. These are reached by the other staircase, which rises from the kitchen and continues to the garret. This might be a farmhouse

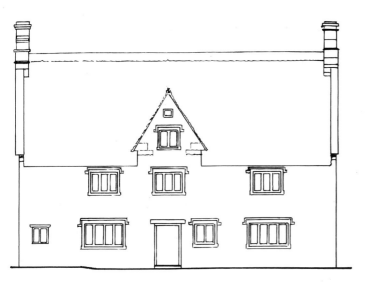
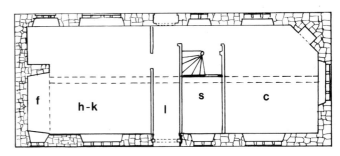

*Poplars Farm, Chacombe, Northamptonshire. Front elevation and plan before extension, with a hall-kitchen to the left, a central partitioned entrance vestibule, a staircase compartment and service room, and a parlour to the right with a corner fireplace which allows a window in the end wall, repeated on the floor above and in the garret.*

divided between master and servants,[45] but, with only a single chamber opening off the parlour, it is more likely that the master wished to have a private apartment separated from the rest of the household or that the two rooms were devoted to the use of a dependent relative.

In both the south-east and the Midlands the plan made some headway well before timber framing was finally abandoned. Rushbury Manor in Shropshire was built to this plan in the mid-17th century with stone stacks and a timber frame. Never a manor, the house was a farm that later became a drovers' inn and then cottages. The Red House at Lydbury North, built only a bit later, was entirely of brick; it started life as a drovers' inn on the road between Bishop's Castle and Ludlow, but the entertainment of a cockpit was not enough to stop the inn failing and it became a farmhouse.[46] Glutton Grange, Earl Sterndale, Derbyshire, was built in 1675 with a full third storey. This means of obtaining extra accommodation from a restricted ground plan without the trouble of digging out more extended foundations was widely adopted in the south and Midlands and generally gave houses an untraditional urban appearance, but generally yeomen preferred to have more than two rooms on each floor rather than multiply the number of storeys in their houses and consequently the number of flights of stairs. The type therefore was soon extended by the addition of a third main room, either in line with the other two or in a wing, or, more commonly, by adding extensive outshuts at the rear.

**THE DOUBLE PILE**   All the plans widely adopted for rural houses before the Civil War were only one room deep, in conception at least. The linear arrangement of rooms might be angled to form an L-plan, or have cross wings forming a T or H; a porch with a room over it or a staircase tower were other additions; and a rear

outshut could give depth for further rooms at the rear of the ground storey. Modified or not, all these plans eased construction and served usage.

The disadvantages were not felt at first. The draughty passage was accepted long after it was an anachronism. The lack of privacy resulting from one chamber opening into the next offended few. The meandering plan of a large house hardly mattered at all; space never constrained countrymen as it constrained merchants and traders in towns. Nevertheless, the urban method of building two blocks together, making a 'double pile' in the words of the architect Sir Roger Pratt (1620–84), invaded the countryside in the 17th century. It produced a compact building, roughly square in plan, which allowed a set of rooms to the front and another to the rear, hence the name. A hierarchy of rooms could be established too, with formal rooms at the front, service rooms at the back.

Until the advent of bricks for chimneys and glass for windows, heating and lighting these double piles were problems, and so was the roof. When the need to build bay by bay that dominated the timber frame had been superseded by construction in brick and stone, the compact double-pile plan could be more easily built. The widespread use of chimney-stacks and glazed windows, common after 1600, solved further problems, and several roof patterns to cover the double span were devised to facilitate drainage.

Then the advantages of this compact plan were appreciated, as, about 1675, Pratt noted: 'we have there much room in a little compass . . . and there may be a great spare of walling, and of other material for the roof'. In fact a large double-pile house might use only half the material for its walling that would be needed by a linear house of the same floor area.[47] There were other advantages too. A vestibule could link the front door with four ground-floor rooms and the staircase, and similarly a small landing could serve four chambers upstairs and a further flight to the garret: easy access and privacy went hand in hand. In larger double-pile houses there was space for a servants' staircase, greatly increasing both the privacy and the social divisions within the house, although this was uncommon at the social level of most traditional houses. The house was easy to heat and less draughty. A pair of internal chimney-stacks between the front and back rooms could help to support a spine wall as well as to provide hearths in all the four main rooms of each storey; nor would they cramp circulation as happened in a lobby-entry house where only a narrow bay was devoted both to this and to containing the chimney-stack. With glazing, no room had to be lit from opposing sides, though most rooms could have windows in two adjacent walls.

Where fashion was concerned, the plan offered all the potential symmetry of the lobby-entry and central vestibule plans, nor was this jeopardized if further rooms were needed. The plan already provided for a hall and parlour at the front, later known as a front kitchen or dining-room and living-room, while there was space for a back kitchen and a service room or two at the rear. Still more rooms could be fitted in at the back without affecting the design as seen from the front. That mattered most: to be seen was often the main objective of the builders of these houses, because status was as important as convenience and any constructional advantage. Fashion soon took the place of tradition. Only around the Pennines is this not generally the case: here the double pile became popular because, uniquely, it did develop a local tradition.

**An earthen house at Thimbleby, Lincolnshire.**

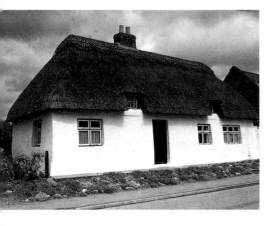

The double-pile is better suited to brick or stone construction than timber, and hardly at all to cob, but when brick and stone had been fully established in the countryside by the middle of the 17th century, many places already had a fair number of houses. Demand for new ones was only enough to scatter double-pile houses around, with most of them going up wherever prosperous yeomen wanted status and thrifty landlords wanted economy.

Several double-pile houses in Kent stand out because they are timber framed, early in date, and, exceptionally, do follow the local tradition of house building. Among them are Marle Place at Brenchley of 1619, Anthony Honywood's house at Lenham, of 1621, and the undated but contemporary Bilting Grange near Wye. There must be a common link between them, since they were an overt demonstration of their builders' status, and they are all built as lobby-entry houses, but two rooms deep as well as two rooms from side to side. Bilting Grange has been extensively altered, but the other houses are resplendent with close-studding, jettied gables, carved finials, and long ranges of windows with bracketed oriels under the gables.

While some builders expanded the lobby-entry or the central-vestibule house into a double pile, others saw the double pile as a house where the outshut was increased to two full storeys, and yet others as a house where two rear extensions could profitably merge to make the rear pile. The Grange at Ipstones, Staffordshire, has an outshut raised almost high enough to form a double pile, and Lavender Hall Farm at Berkswell, West Midlands, has two back extensions so nearly touching as to produce almost the same result.[48]

The internal planning of these early double-pile houses may belie their exterior symmetry. This can be seen in a small double-pile house built in Middlesex in 1700 by Richard and John Hatchett at East Bedfont, Hounslow, Greater London. The Hatchetts were the second largest landowners in the parish after the lord of the manor of Pates, who lived in an old-fashioned timber-framed house, but they were clearly yeomen not squires and their house was modest. It has a gabled front, but the two piles run backwards from the street. The shorter one contains a single, long parlour. The longer pile contains the front entrance and a passage leading backwards to the stairs and a kitchen and service room, laid out like a lobby-entry house with back-to-

*Two double piles, one irregular, the other regular. Hatchett's Farm, East Bedfont, Hounslow, London (left), 1700, where the two piles run backward from the street, the right-hand one facing the farmyard, with overtones of the lobby-entry plan; and North Holton Farm at Lytchett Minster (right), built at least fifty years later, with a regular plan, the spine wall dividing front and back bearing the chimney-stacks.*

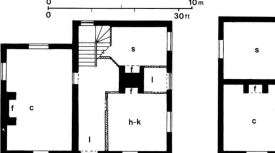
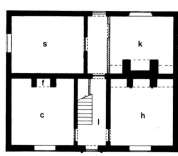

back hearths between them and an entry lobby with a doorway opening into the farmyard. Tradition got the upper hand here, leaving the shorter pile as an afterthought, yet ends of the two piles facing the street make an impressively symmetrical though rather old-fashioned facade.[49]

Architecture in front, convenience at the back are typical qualities of many double-pile farmhouses in the south and Midlands, so much so that it is not always possible to discover whether the two piles were built together or, if not, which was first. Brick House at Wicken Bonhunt in Essex shows how successive generations of the Bradbury family achieved a comparatively regular double-pile house through the progressive rebuilding in brick of what was perhaps a timber-framed house of about 1600. Image House at Berkswell, West Midlands, shows what happens when the process failed, for this is three quarters of a double-pile, planned with an entrance lobby and central stack, but without a fourth quarter.[50]

By the time of the Restoration in 1660, the heroic age of English house design was nearly over. There were many plans to exploit, and a single modification would give the terrace house its ultimate form. Much building was needed as the population grew or moved to the towns, but all the new architects could do was to take what they were given and dress it up to suit their clients' taste. Luckily the traditional plans which had evolved over the previous centuries were designed to suit all occasions, all materials, all purposes. Dressing-up had a point. Increasingly books and travel spread ideas of fashion round the country, and, as always, people wanted to keep up with fashion, even though that meant breaking down local traditions as they did so. Only in the north was it different. Less wealth and greater distance from London promoted independence marvellously.

## YEOMAN HOUSES IN THE NORTH

When yeomen started to build in stone on the bleak Pennines, they remained faithful to the medieval hall. A 'firehouse', 'house part', or just 'house' was still the centre of their houses in the first half of the 17th century. To this, poorer yeomen simply added an inner room in a distinctively local way with lofts above, and the richer added a 'nether house' as well, making three ground-floor rooms. By adding a firehood or chimney-stack, they could form a loft or a complete upper storey to achieve the fully developed form of Bent Head, Old Edge, and Hippins of 1650, three fine farmhouses built of hard Pennine Millstone Grit.[51]

They were built around Heptonstall, a thriving West Yorkshire township high on the moors overlooking the tree-choked valleys and rushing waters of the upper Calder. Here weaving had been augmenting the profits of dairy farming for well over a century and, if only at second hand, now brought the wealth that enabled yeomen to build substantial stone houses in large numbers. These hills were in the process of becoming the richest part of West Yorkshire: between 1600 and 1740 nearly half the county's surviving dated houses were built here, all thanks to the stimulus of domestic industry.[52] In some places pastoral farming declined as it became less and less profitable when set against weaving, and houses took on the aspect of small factories as they were extended to accommodate spinning jennies and weaving looms.[53] All this wealth erased the desire for long-houses, but in Cumbria and on the

North York Moors, where domestic industry was slighter and profit harder to find, they remained in common use right through the 18th century.

Most Pennine yeomen did without a cross-passage in their new houses; the entry was directly into one of the rooms, and some houses had a second, independent door at the back. Often the entrance is adjacent to the side of the ingle formed beneath a wide firehood. The screen or 'heck', which shields the ingle from the entrance to form a distinctive 'heck-entry', became one of the most abiding features of northern houses. The heck-entry has a direct parallel in the lobby-entry developed among the timber buildings of the south. In Derbyshire there are numerous 17th-century houses where heck-entries to one room and lobbies to two are intermixed. In general, the poorer houses had a heck-entry into the hall alone, the richer a lobby into both hall and parlour or kitchen. Further north, even grand houses usually had heck-entries. In 1634 Cat Hill Hall was built on the hills above Penistone in South Yorkshire with the symmetrical front elevation of a lobby-entry house, but the lobby opens into the hall only, and the planning is anything but symmetrical.[54]

In the Yorkshire Dales, where monastic land was quickly sold after the Dissolution to extensive landowners and by them to the tenant farmers, it was a matter of only a few generations before these men were rich enough to start building in stone.[55] In Bishopdale building in stone began with a remarkable series of houses. The first, New House, was built in 1635 from Millstone Grit taken from a small quarry cut into the fell just above the house. It is typically of three cells with a heck-entry into the firehouse. At Dale Foot, built nearly opposite on Wasset Fell in 1640, the entrance is into a service room instead. At the further end of the firehouse is the sole hearth, set inside a wide ingle with a window adjacent to the fire, a 'fire-window', at the front and a heck at the back which divides the ingle from a short passage leading to a parlour and a newel stair projecting from the rear wall. An upper window, like the fire-window below it, lights a closet beside the chimney-stack.[56]

*Plans of three Pennine houses. Daisy Bank at Hebden Royd (left) has its entrance, traditionally, leading directly into a central firehouse, which is flanked by a parlour and service room; Bradshaw at Langsett (centre) has a gable entry into the firehouse beside a heck and ingle, and a parlour, and the rear outshut for services and stairway are unusually interrupted by the corner of an adjacent barn against which the house was built; and Lower Birks at Todmorden (right), of 1664, is a double pile with, on the left, the firehouse and twin service rooms behind it, and, on the right, the parlour and a dairy house containing the stairway at the rear.*

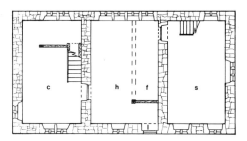
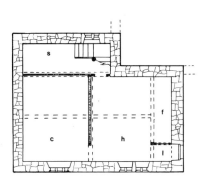
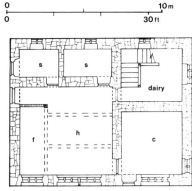

**HOUSES OF
TWO CELLS**

Especially in the western Pennines there were many lesser houses which lacked a service end. This might leave a cross-passage with front and back doors to separate the end wall from the firehouse as happened in 1631 at Higher Red Lees at Cliviger in Lancashire. The inner room had to double as a parlour and service room, which might itself be partitioned to make two rooms, one, a dairy, on the more northerly side. In a few larger houses these rooms were in a cross-wing, perhaps balanced by an entrance porch at the other end, in the manner of Jackson's Farm at Worsthorne of 1627, where the wing was built a generation earlier.[57]

A still more curtailed plan omitted the cross-passage, leaving just a firehouse and an inner room, but, when their upper storey is high enough to contain chambers rather than mere lofts, they comfortably exceed 120 sq m (1300 sq ft). The entrance may be in either the gable wall or the front wall, and nearly always adjacent to a heck and ingle.

This plan arrived in wealthy parishes on the western side of the Pennines early in the 17th century, and remained current for well over a hundred years on the moors from Derbyshire to Cumbria. Scholefield House at Little Marsden is dated 1617 on the large projecting porch of its front entrance, and Jackhouse at Oswaldtwistle came soon afterwards with a gable entrance.[58] In the West Riding township of Saddleworth, now part of Greater Manchester, the oldest survivor is Henry Shaw's Windy Nook at Grotton of 1648. Here the internal partitions are timber framed, but in later houses they would be of stone; again, Windy Nook originally had a timber and plaster firehood over the ingle, as a majority of these yeoman houses had in the early 17th century, but this was replaced by a stone stack to bring it up to the standards of the 18th century. Typically, there were no openings apart from the entrance on its north-facing wall so as to keep out the piercing winter weather, and Boothstead, dated 1728 and one of the last of these houses, has no north-facing openings at all. A few houses, for example Holden Farm at Exwistle in Lancashire, were built with extra rooms from the start, usually in an outshut.[59] Many others, for instance Pinfold Farm at Saddleworth, were extended and raised in height time and again to make room for looms and spinning jennies as weaving augmented the profits of farming.[60]

*Windy Nook, Saddleworth, Greater Manchester, of 1648. Plan and section, showing the entry by a heck and, over the adjacent ingle, a timber firehood which carries the smoke to a stone chimney supported on corbels.*

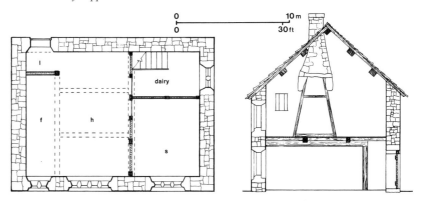

Further east on the Pennines a significantly different indigenous tradition gave rise to similar houses with only two cells, but they also had a rear outshut with space for a staircase and service rooms. The outshut was descended from the rear aisle, common in medieval halls, which was now progressively partitioned from the hall to provide separate rooms. On the rich Pennines of West Yorkshire, the yeoman-clothier Richard Wade ceiled over the open hall of High Bentley at Shelf, and partitioned off the aisle to make a service room during a general remodelling which included the addition of a new kitchen and the recasing of the house in stone in 1661.[61] Similar changes affected the smaller houses of the Vale of York, such as Well End Farm at Great Ouseburn and Home Farm at Scriven.[62] At the same time, fully storeyed houses of similar form were appearing on the Pennines, but with rear aisles built from the start as outshuts to accommodate separate rooms. One of these, Whitehouse Farm at Stannington in South Yorkshire, was built shortly after 1627,[63] with a firehouse and heck-entry, a parlour, and an outshut containing a service room, the staircase and a dairy.

Once again, the internal divisions of these houses were at first of timber, often heavily framed, though by the 18th century they were usually of stone instead. The outshuts were more lightly partitioned from the body of the house. The early Bradshaw at Langsett in South Yorkshire had no more than plank partitions, and this continued to the last quarter of the 17th century, when, at Fairhouse, Lower Bradfield, the two service rooms were divided at different depths from the main body of the house, thus making a wide firehouse, but a narrower parlour, and consequently losing the idea of a continuously partitioned rear aisle.[64]

## NORTHERN DOUBLE PILES

The direct entry of the north is typical even of the new double piles on the Pennines, despite the accent on privacy in double piles further south. Uniquely, the northern double pile developed along traditional lines and was not an imposition on the countryside in which the only differentiating feature was in the building materials used. While the hard carboniferous stones of the Pennines do stamp them indelibly with their origins, so do their elevational features. Long bands of low, mullioned windows, the upper ones hard under the eaves of low-pitched, stone-flagged roofs, were the norm regardless of southern fashions, and symmetry had a low priority. The plan, again, was a derivation from the long-established line of aisled halls, with outshuts enlarged into fully storeyed rear piles, or it was formed like a linear plan doubled back on itself.

Cat Hill Hall at Penistone is all but a double pile, and other houses with the complete double-pile form were first built on the Pennines about 1630. Heaton Royds Farmhouse outside Bradford is among the earliest and shows the effects of a prosperous clothing town that rivalled Halifax. The house is dated 1632, and, like the houses with outshuts from which it is developed, has its entry direct into the firehouse, and a rear pile separated only by a framed partition as though it had been conceived as an aisle.

In the Dales, Old Hall Farm at Thoralby has a stone partition between the piles, and had a nearly symmetrical front with a storeyed porch, added either as an afterthought or soon after the house was completed in 1641. The entry

was directly into the kitchen at first, but soon changed to open into the firehouse in the traditional way, even though the house was a cut above what yeomen had just started to build in the Dales.[65] Arncott House Farm at Chatburn was built in the 1670s just on the Lancashire side of the Pennines, but with the usual single gabled roof, rather than the double, M-roof of Old Hall Farm, and it again has a projecting, storeyed porch bearing a datestone. Lower Birks at Todmorden, built in 1664 across the border in West Yorkshire, has the traditional gable entrance of two-cell houses; the firehouse, entrance and service rooms, instead of running across the front of the house in a linear arrangement, run down the west side of the house, with the hall to the front and the entry beside the gable-end stack, with a heck to screen the ingle from the cross-passage, and two small service rooms to the rear. The parlour is on the east side, and this eastern pile is completed by a dairy or 'deyhouse' in the cool north-east corner, reached from the hall. It is as though the old three-part medieval plan was bent into an L and the remaining angle filled by the dairy, with the main front given over not to the entrance but to the long windows of the hall and parlour.[66] Many double piles were similarly built with heck-entries in the gable wall, and took the form of a complete two-cell house at the front with a pair of service rooms at the rear. These, the largest houses to be built by the Pennine yeomanry, might have a floor area of anything between 150 and 250 sq m (1550 and 2700 sq ft).

Whatever social status the owners of these houses claimed, they often attached combined barns and cattle-houses to the sides of their houses. The depth of these so-called laithes corresponded well with a double pile, so the union of the two was easy to achieve. The earliest dated laithe-house, Bank House at Luddenden, was 'Built by Gilberte Brokesbank' in 1650, and they continued to be built until the end of the 19th century. The Pennine double-pile houses went on just as long. There was enough wealth, particularly when the Industrial Revolution increased the size of northern markets, to ensure that yeomen could continue to build, and build better than their northern neighbours. They stuck to tradition and kept sturdily independent from the fashions that spread elsewhere in England.

## NORTHERN LONG-HOUSES

By 1700, the long-house was just a memory on the Pennines, but it was very much in evidence elsewhere in northern England. Between the Vale of Pickering and the Tees, all classes of farmers built long-houses in the later 17th and early 18th centuries, whether they were the smallest of smallholders or yeomen of substance; and there was little to differentiate those who built near the open moorland, for instance at Laskill or in the upper reaches of Farndale, from those who built lower in the dales that run up into the moors or right at their foot in villages such as Harome or Wrelton.[67] In Cumbria it was the same; the long-house found a place on the edge of the fells and equally on the plains of the Eden valley, the Solway estuary and the Lancashire coast.[68]

The earlier long-houses were cruck-framed and had earthen walls. This continued where stone was unavailable, but good building stone was widespread and became cheap enough to prompt a thorough rebuilding. Size went with wealth, but long-houses were never large and most were low. The smallest had two bays of about 5 m (16 ft) each, but others extended to four

bays, occasionally more. The need for a byre was almost universal, but neither wealth nor large herds raised yeomen's sights above a long-house very often.

On the moors of North Yorkshire between the Vale of Pickering and Eskdale, smallholders built long-houses of only two bays, one for the dwelling, one for the cattle, divided at the position of a cruck truss by a cross-walk. These little houses were very small, the house-body serving all domestic functions as a kitchen, dairy, living-room and bedroom. Rebuilding often provided a separate bedroom in a raised upper storey, though even then the houses had a floor area of little over 50 sq m (540 sq ft). Later still, these houses were either abandoned or, if they remained in domestic use, the cow-houses were converted to living rooms, and the houses generally lengthened. Though once common, the only survivor in anything like its original form is Ivy Cottage at Keldholme, Kirbymoorside. More commonly surviving long-houses such as Orchard House at Harome and Cruck House at Wrelton still had only one bay for the cow-house, but a framed partition with an infilling of wattle and daub covered in limewash divided an inner room from the house-body, and, typically, the hearth backed the cross-walk.[69]

Most surviving northern long-houses are larger, a consequence simply of being more useful. They were built by the most prosperous yeomen everywhere in the north. They also have the greatest variation, with two or three bays given over to the dwelling, invariably partitioned into a house-body or firehouse and inner room, and a similar number of bays for the cattle. White House at Cropton, North Yorkshire, is equally divided into two pairs of bays, and Venoms Nick, Thorgill, Rosedale East, had three of its five bays for domestic use and, at 24 m (80 ft), was the longest of these houses.[70]

The long-houses of the north-west were much the same. The more sub-stantially built ones are inland in Cumbria, especially in the higher reaches of the Eden valley, for here were the best building stones and men of substance to use them. They were the Westmorland yeomen, locally known as states-men, who, as customary tenants since Queen Elizabeth's reign, paid low rents for their land, and held it securely. The accession of King James I in 1603 and the Union of the Crowns secured peace of sorts on the border, and, within a decade or two, substantial building in stone was fully under way.

This continued a long tradition, just as it had done a century beforehand on Dartmoor, but poverty was still limiting its use. Stone was used even for the impermanent dwellings called sheilings, built on upland commons to accommodate herdsmen in summer. When Celia Fiennes travelled between Windermere and Penrith in 1698 she saw

villages of sad little hutts made up of drye walls, only stones piled together and the roofs of same slatt; there seemed to be little or noe tunnells for their chimneys and have no morter or plaister within or without . . . .[71]

Nevertheless domestic conditions were slowly improving, though West-morland statesmen continued to build long-houses almost to the end of the 18th century, and poorer men elsewhere in Cumbria were building the last ones only in the 19th century. In some of the better and later long-houses the inner room did not double as a dairy and sleeping room, but was a proper parlour. In these better houses, the dairy was placed at the rear in a small projection, as had already happened in Devon, usually in small outshuts with

pentise roofs, locally known as 'toofalls' or, more anciently, as 'turf whols', to reflect their poor construction.[72]

Many Cumbrian houses reached their present appearance as a result of a continuing process: first they were built in earth, timber or dry stone, and then, as money became available, they were rebuilt in mortared stone, first the house, then the cross-passage and byre. That was followed by a further process of raising first the house and then the byre into two full storeys and perhaps converting the byre into a domestic down-house. This left many houses showing a marked break between the house part and the byre.

Often the byre was converted to domestic use and others always had a service room in the downhouse. Glencoyne, Patterdale, of 1629, was among the first houses to have this form, and others were later converted to it, as long-houses dropped out of favour among the well-to-do in the 18th century. Glencoyne has the luxury of a heated down-house that serves as a kitchen, and a full upper storey. Further grand houses followed, but, while their plan was typical of much of England when Glencoyne was built, it was old-fashioned by 1737 when it was used again for Sourlandgate at Dacre, and it went on and on in ever smaller houses.

The few surviving long-houses on the Lancashire plain are largely confined to the Fylde and greatly altered. They were poorly built of cobbles or clay with stakes for support, a form of construction called 'clay-and-clatt' or 'clam-staff and daub'. Other houses on the Lancashire plain took the heck-entry plan of the western Pennines, though they might still be attached to shippons. Adamson's Farm at Eaves, which had a carved doorhead dated 1620 and walls of clay-and-clatt, was like this, and so was Bunting's Farm at Ainsdale though it lacked a shippon.[73]

## PELES AND BASTLES

The northern Border country is the home of several extraordinary stone houses. They were the product of the last years of Queen Elizabeth, but, while other houses owed much to the increasing wealth and stability of the Tudor period, the form of these houses was a direct consequence of poverty and appalling lawlessness. Like many other poor houses, they contained only two rooms, but here the similarities stop.

Uniquely they accommodated people above their beasts, an arrangement common in Continental Europe, but not in England. It was a direct response to a need for security not felt elsewhere in the kingdom. Unlike the Welsh Marches, which were pacified by Edward I's conquest at the end of the 13th century, the Scottish border suffered outbreaks of warfare and cattle-raiding throughout the Middle Ages. This had led the gentry into building a number of large defensive towers. Village headmen and vicars built smaller versions called pele towers. They took the form of miniature castle keeps with a ground floor for cattle, farm produce and general stores, and two storeys of living accommodation over that.[74]

These towers were to be the model for a future generation after a renewal of violence which became particularly nasty in Elizabeth's reign. Some raiding was simply between the English and Scottish confederate groups known at the time as 'surnames', with the Scottish gaining the better of it, especially in the west. Between 1586 and 1590 the Grahams, the most successful of all, rustled

as many cattle and sheep as the English had taken throughout the whole century in the Western and Middle Marches. In theory English, but in fact owing allegiance to neither crown and beyond the reach of the law, the Grahams were 'bold and brought up in Theft, spoyle and bloode . . . Neither have they anie other trade nor any other meane (manie of them) to live by, but stealinge'.[75]

Already the men of this surname had enriched themselves far beyond the resources of their own poor husbandry in the Debatable Lands each side of the River Esk and had built themselves a few stone houses. These had been widely built on the Scottish side of the border as a secure base for the unruly and an essential defence against retribution. They were very small, 'one little stone tower garretted and slated or thatched'.[76] Along the border itself, in a band about twenty miles wide, there are even smaller houses, two-storeyed versions of the pele towers that had been built here in the 14th and 15th centuries.

These small houses were variously called 'bastles', 'stronghouses', or 'pelehouses', and in Cumberland they were called 'stonehouses' to distinguish them from the mud or timber houses that previously prevailed. They were especially designed, like their predecessors, to keep small herds of animals and their owners safe until raiders had ridden on in search of easier meat. They are remarkably homogeneous in plan and size, their two storeys being built up with solid stone walls, around 1.2 m (4 ft) thick, and roofed with heather or slate. In all, their accommodation matched that of a small long-house. Each floor measured about 11 by 8 m (36 by 26 ft). The byre had a single door in the gable wall, opening inwards and held fast by a pair of stout timber drawbars; a few narrow slits provided ventilation. Internal access from the house was by stair or ladder. In Cumbria the floor of the house was supported on heavy joists, while a stone tunnel-vault generally took its place in Northumberland, a contrast well shown by Hole, Bellingham, Northumberland, and

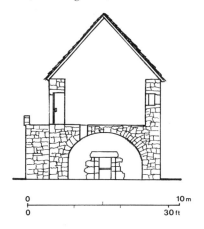

*Hole, Bellingham, Northumberland. Plans of the byre, below, and house, above, and a section through them, showing a small internal ladderway linking them; there was probably a firehood at the left-hand end of the house and perhaps an inner room divided from it by a partition towards the right hand; the form of the roof is unknown.*

0                 10 m
0                 30 ft

125

**Elsdon Tower, Northumberland. This pele tower was built for the rector of Elsdon about 1400, probably with three storeys of domestic accommodation above a tunnel-vaulted ground floor store.**

Whitehouse Farm, Glassonby, Cumbria.[77] External access to the house was usually on the more southerly long wall and, at first, probably by a ladder that could be drawn up at the approach of raiders. Nearly everywhere there is now a stone staircase, added after the owners were confident that peace along the border was permanent. The doorway near one end of the long wall opened into the main room, which had a fireplace against the further gable, originally with a hood over it, though most were replaced by stone chimney-stacks. Sometimes there were one or two extra rooms, and the few small windows were heavily barred in iron.

Such houses remained the usual homes of Border farmers right into the 18th century. Only occasionally do superior stonework, a loft or the provision of a fine, stone-arched fireplace such as the one at Townhead, Ainstable, Cumbria, suggest a particularly wealthy owner. Although some pelehouses are solitary and sited on their own enclosures, the aim was to build them in scattered groups within at least hailing distance of each other, like those at Gatehouse, Tarset, Northumberland.

Three inscribed dates, 1594, 1602 and 1604, give a rough idea of when most pelehouses were built.[78] The unsettled peace which followed the Union of the Crowns allowed profit enough for building, but fear prompted defensibility. By 1640 everyone who could afford a pelehouse must have built one; the wealthiest landholders had been building undefended houses for at least thirty years and the first undefended farmhouses had been built.[79]

Only in the later 18th and 19th centuries were pelehouses widely replaced by ordinary storeyed houses; and the long-house that replaced the pelehouse at Whitehouse Farm, Glassonby, in 1723 is unusual. When an optimistic view of a peaceful border came to be accepted later in the 17th century, the sturdy build of the pelehouses was not immediately abandoned, nor was the plan of their domestic rooms. Both reappeared in the Cheviots of Northumberland when William and Fanny Read built Corsenside Farmhouse beside lonely windswept Corsenside church in 1680, and added a second storey of domestic rooms and a garret, and its tall, gabled outline and small mullioned windows are strong reminders of its predecessors.

In the far north of England, apart from pelehouses, earthen houses with hardly more than two rooms and a loft open to the roof were the norm until they were replaced by new houses owing nothing to tradition in the 19th century. After Celia Fiennes had visited the Roman Wall near Haltwhistle in Northumberland in 1698, she had to spend a night in one of those old houses, as she explained:

I was forced to take up in a poor cottage which was open to the thatch and no partitions but hurdles plaister'd; indeed the loft as they called it which was over the other roome was shelter'd but with a hurdle; here I was forced to take up my abode . . . but noe sleepe could I get, they burning turff and their chimneys are sort of flews or open tunnills that the smoake does annoy the roomes.[80]

# TOWN BUILDINGS

Towns imposed two major restrictions on building. Because of demand, land was comparatively expensive, so it had to be used as efficiently as possible. Open space became a great luxury and could only sparingly be provided. Expense put an even heavier premium on frontage since shops were best placed facing the street, and profits depended on this. Buildings, therefore, often ran backwards along narrow sites to the disadvantage of both lighting and circulation.

In the countryside houses, workshops and agricultural buildings were usually built with convenience in mind, and space was not a major restriction. Houses usually had a long frontage and the planning was adjusted accordingly. Early buildings in the new and refounded towns of the 8th and 9th centuries followed suit, and, indeed, many were hardly distinguishable from rural buildings, although they might be grouped more compactly. As towns filled up with people in the later Middle Ages, this changed: the luxury of the detached, linear form of rural houses increasingly became the preserve of a few wealthy town dwellers, and even their houses had to concede to the limits of space. When awkward sites twisted a hall and its attendant chamber and service blocks out of their rural alignment into new patterns, the difficulties began.[1]

A second important distinction between town and country that affected building was that urban populations were more shifting than rural ones. This created a demand for rented property, and opened the way to speculators. If little was expected, less was given. In many places, consequently, building was haphazard. People of small substance were forced to live close together and speculators built accordingly. Well-lit shops at the front and stores at the back with chambers to one side or above might be the aim, but it was hard to do this within the confines of many sites. The most frequent solutions to these difficulties, to build upwards and rearwards, had their hazards; nevertheless, a speculative builder was looking for rent, and, within the limits of a town's economy, the better the building the greater rent it commanded.

Shifting populations and great concentrations of wealth quickly brought fashion to town, with the result that local traditions were never so marked as in the countryside. Nevertheless, the small size of all towns but London and the fact that only a small proportion of the population dwelt within their walls meant that until well after the Middle Ages many ideas about how to build were developed in the countryside and then adapted to urban use.

UNDERCROFTS    The most enduring, specifically urban type of building resulted from digging downward to form an undercroft. The Anglo-Saxons had introduced a type of building from the Continent characterized by a sunken floor, the so-called *Grubenhaus*. It has been found in great numbers in town and country alike. Possibly developed from it are the larger, deeper sunken buildings which were apparently first built in London and other towns in the 10th and 11th centuries. These could measure 15 by 6 m (50 by 20 ft) and were dug over 2 m (7 ft) into the ground. Substantial undercrofts built with stone imported from Normandy appeared soon afterwards. A fragment of the earliest survivor in London dates from about 1140 and is rib-vaulted just as a church crypt might have been.[2]

Similar building skills went into the construction of undercrofts which survive in great numbers in several towns, as well as beneath castles and grand houses.[3] They often have vaulted roofs – barrel vaults for the plainer ones, rib-vaults for the more ornate – and others had timber roofs. In Chester many undercrofts have massive timber cross-beams, some supported by longitudinal arcades, and these carry floors up to 0.6 m (2 ft) thick comprising flags and a packing of rubble laid on thick boards. Fireproofing seems to have been a major aim, and, significantly, many of Chester's undercrofts were constructed shortly after a devastating fire in 1278.[4] Stone undercrofts are particularly common in such prosperous towns and cities of the Middle Ages as Coventry, Southampton and Norwich, where the earliest survivors date from the later 12th century, but less so where marshy ground or a tendency to flooding might jeopardize their use, such as at Hull and at York. Undercrofts were not cheap, and stone had to be imported to build them in many places. Their fireproof qualities were prized everywhere, and they provided a damp-proof base for timber buildings set over them.

Some undercrofts, for instance one below the Angel Inn at Guildford and The Crypt at Coventry, were nearly square in plan and so wide that they needed a central column or an arcade to support the vault. One Chester vault had two arcades forming three aisles, but most vaults were narrow enough to avoid arcades altogether. From the late 12th century onwards, Southampton's many undercrofts were built to a standard width of about 6 m (20 ft), but could be from two to nearly three times as long and from 2.5 to 5 m (8 to 16 ft) high. Typically, they were sunk 2 to 3 m (6 to 10 ft) below the level of the ground, and so might be either more than half visible or almost totally submerged. The fronts of Chester's undercrofts were hardly 1 m (3 ft) below the level of the main street, but their further ends were almost entirely below the level of the back lanes.

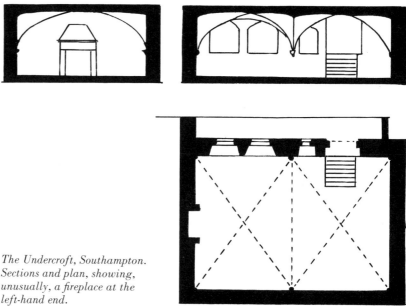

*The Undercroft, Southampton. Sections and plan, showing, unusually, a fireplace at the left-hand end.*

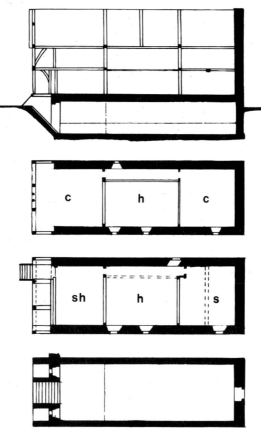

*No. 58 French Street, Southampton. Section and plans, showing* (left to right) *a shop with a chamber above, an open hall with a gallery, a service room with a chamber above, all built on an undercroft.*

Generally undercrofts run back from the street, but when they fronted a particularly wide plot in the manner of the undercroft of Tackley's Inn in High Street, Oxford, they could lie along it. They were all designed to carry buildings at a higher level than the street, and these were approached up a short flight of steps. Most undercrofts in towns were self-contained and had a separate entrance from the street with a wide doorway and a flight of steps leading down into them, and only in special cases was there access from the buildings above. Often the entrances and the steps were treated ornately, and the decoration might extend to the vaulting, which was sometimes given moulded ribs and decorated bosses.

The provision of windows was always difficult. Light could enter through the wide doorway, and sometimes windows were placed beside it. If the sides of the undercroft were unrestricted by adjacent buildings and it was high enough above ground, there might be windows set just below the vault. The undercroft of Tackley's Inn had windows along the side that faces the street, and The Undercroft built on the corner of Upper Bugle Street and Simnel Street, Southampton, was similarly lit. Here the decoration extends to corbels, carved with heads, from which spring moulded ribs intersecting at carved bosses, and, unusually, there is a hooded fireplace and lamp brackets terminating in ball-flower ornaments.

The individual use of these undercrofts varied. Their lack of direct communication with the buildings they carry shows that they were often in

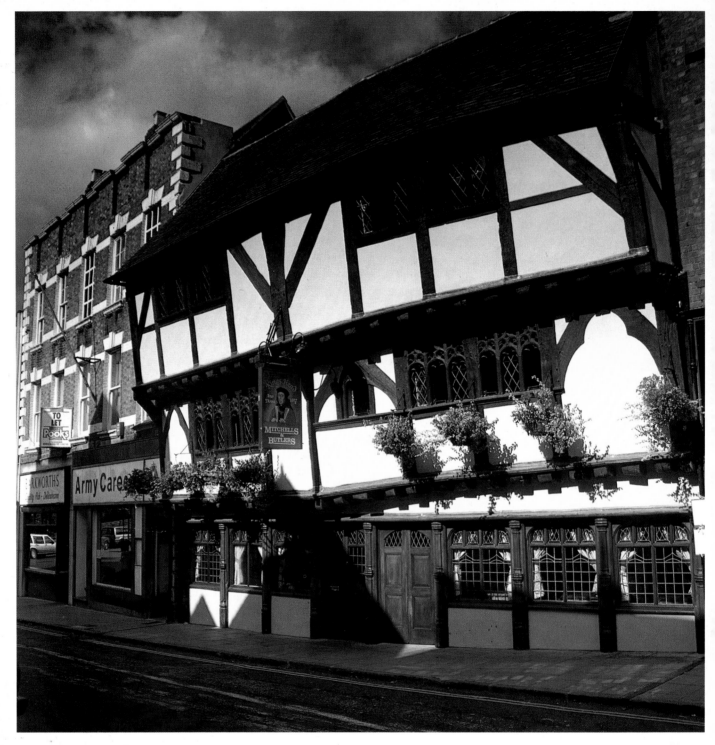

The King's Head, Mardol, Shrewsbury.
Formerly a merchant's house of the late
14th century, its two jettied storeys
originally carried a pair of gables.

17–19 Stonegate, York. This row was built in
the 15th century, probably with shops on the
ground floor and a single floor of chambers
above, and then, about a century later, was
given a further jettied floor of chambers on
top.

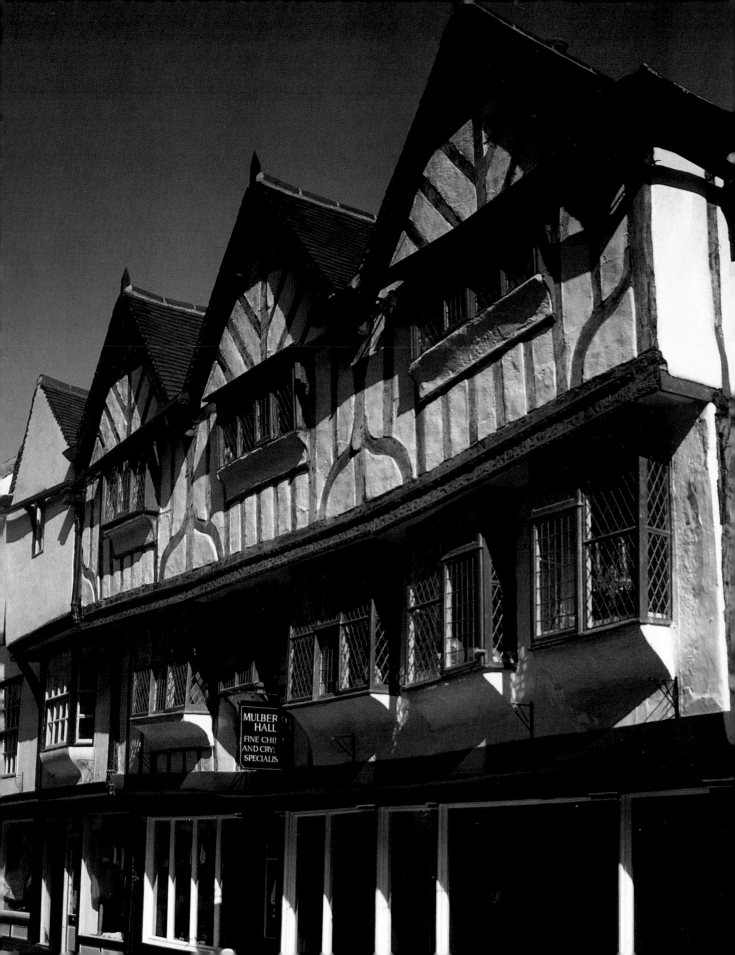

separate occupation and probably let out to tenants for all kinds of commercial use. Quilter's Vault in Southampton was divided into two parts with one part entered from the High Street, the other from a back lane, suggesting a double tenancy. Those with direct access from the building above were probably stores, and others may have had a similar use. Castle Vault at Southampton, which had direct access to the castle quay, was well placed to be a warehouse for goods in transit between sea and land. Nevertheless, the steep stairway of most undercrofts would impede this use, despite the wide doorways, and the dog-leg stair of Quilter's Vault would make the entry of bulky goods particularly hard.

Undercrofts were particularly suited to the storage of various types of goods, where security from fire and theft were paramount. The undercroft at 36 High Street, Canterbury, is traditionally said to have been the city's mint, and undercrofts could have suited jewellers and silk merchants. Again, the cool, even temperature and shade of the interior were advantageous to the storage of wine. Despite the steep stairways, barrels could be rolled inside down removable runners, just as they are today; undercrofts often served in exactly the same way as the French *cave* continues to do, and both their fireplaces and decoration were entirely appropriate to taverns. This use is well documented in London, where the remains of vintners' undercrofts have been uncovered facing the Thames,[5] and is known again in Coventry.[6] It was widespread elsewhere: many undercrofts, for instance several in Rye and Winchelsea, are associated with the wine trade and this may have prompted the construction of inns above them.

Despite this evidence, unless the Middle Ages were unbelievably bibulous, there were too many of these undercrofts placed too close together for them all or even a majority of them to have been taverns. In Norwich, where there are over sixty late-medieval brick undercrofts, and in Chester, where long lines of them form the Rows, their efficacy in supporting timber-framed buildings must have been matched by their suitability for commercial uses well beyond the needs of drinkers. Most of them are likely to have been combined shops and warehouses devoted to a wide range of goods.

Retail trade was not conducted in quite the same way as today. Merchandise was either sold at market or in shops; these were usually single rooms where goods might be manufactured or finished, then put into stock, and finally sold. An undercroft went one stage further by reason of its size, and could have provided surroundings which matched the luxury of the goods on sale, silks for instance, and any sort of cloth whose bright dyes would last longer away from strong light. The subdued lighting may have been an impediment, though the area immediately behind the entrance was probably well enough lit for displaying luxuries to discerning customers, and lamps made up some of the deficiency further inside.[7]

What kind of people and institutions built undercrofts is not always clear, but they were certainly wealthy. The Church, urban manors, the guilds and their richer members are likely candidates. The Church had extensive estates in medieval towns and was always ready to exploit them to increase its income. Its influence reached into many corners of life, particularly where power and revenue might result. It was allied to the wealthy guilds who were likely builders of undercrofts, their members likely users. The Church was

involved in the control and sale of liquor too, and could well have built undercrofts for leasing to licensed victuallers. Tackley's Inn, Oxford, was built by a parson of Tackley, and its undercroft was used as a tavern, at least after Adam de Brome, chancellor of Durham Cathedral, had acquired the property so that he could make it the home of his foundation, Oriel College.[8]

In Chester, the rebuilding of the city within the Roman walls almost certainly followed a disastrous fire in 1278 and was spurred on by the wealth brought by Edward I's armies. The rubble of Roman Chester facilitated the formation of a grid of streets based on Northgate Street, Eastgate Street, Bridge Street and Watergate Street. Rows of fireproof undercrofts facing on to these streets and containing rows of shops were dug into the rubble so that they were entirely below ground at their backs. The buildings which they supported were all set back at the front to allow a continuous, public walkway with room for stalls on its street side. Further shops lined the inner side of the walkway and behind them was domestic accommodation which had direct access to back lanes, which, because of the build-up of rubble, were at a level roughly a storey higher than the main streets at the front. The walkways were arcaded and supported upper storeys built out over them, thus forming the distinctive covered Rows of Chester. The comprehensive way this was undertaken and the unique public rights of way which it brought into being suggest that it must have resulted from the requirements of a civic Act, now lost, which prescribed the form of rebuilding.[9] Where the idea for the scheme came from is unknown. Trajan's Market in ancient Rome had a similar

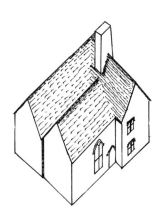

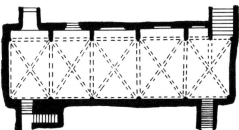

*Tackley's Inn, Oxford. Plan of the ground floor and undercroft, and a restored perspective, showing a range of shops with chambers above built over an undercroft, and an open hall* (left) *flanked by a chamber block.*

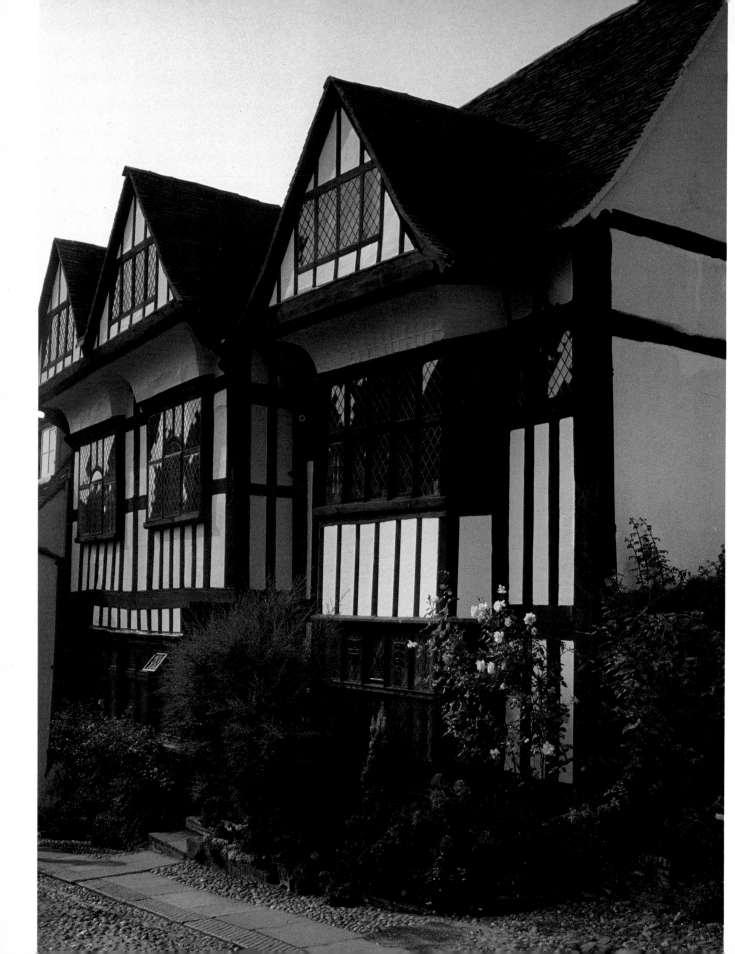

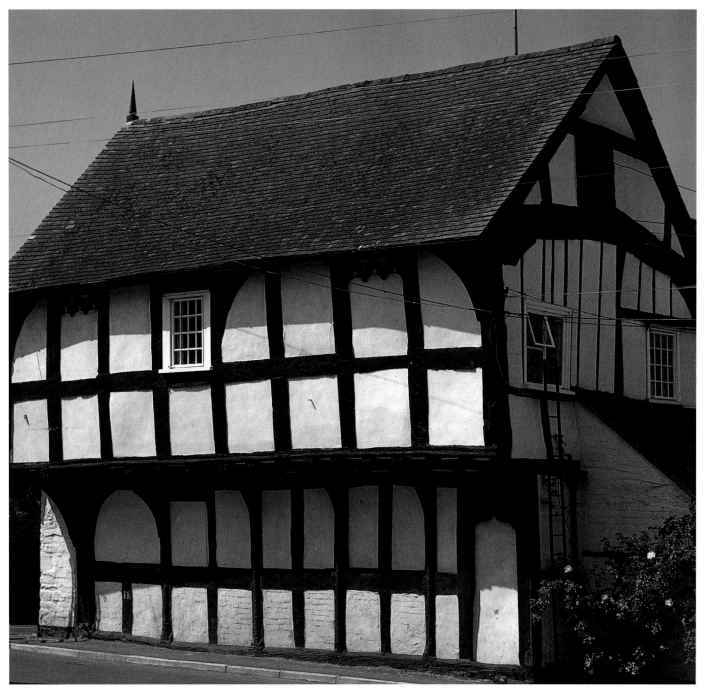

The Red Lion, Broad Street, Weobley. Built about 1400 with an ale room beneath the jetty and a chamber above to accommodate travellers.

31 Mermaid Street, Rye. Built in 1576 over an undercroft, the main entrance lies between an office (left) and a ground-floor hall (right), with chambers and gabled garrets over them.

arrangement of shops at two levels, but to trace a line stretching across Europe and over two thousand years is hardly possible, despite the wealth of international talent which Edward I's craftsmen brought to Chester. At all events, civic rather than Church wealth spent for mercantile profit seems to have given Chester this unique form of building.[10]

By contrast, several individual undercrofts may owe their origin to the wealth of the outcasts of the Middle Ages, the Jews. It was probably one of the most influential Jews of the day, Isaac or Jurnet *Ha Nadib*, who in the 1170s built The Music House in King Street, Norwich, with two aligned undercrofts, one of two bays with moulded ribs, the other of three bays and simply groined. Like the even more successful Aaron of Lincoln, he loaned money to Henry II, but, unlike Aaron, part of his stone house survives.

**EARLY STONE HOUSES**

Jurnet's house was a two-storeyed stone building based on the twin surviving undercrofts. These and a heated chamber above may have been reached independently by stairs in a forebuilding, suggesting a parallel with the upper halls of the countryside, but the forebuilding may have been part of an aisled hall instead, producing the more usual hall and chamber block arrangement.[11] Either way, such a house would have protected Jurnet's wealth.

The house in Steep Hill, Lincoln, wrongly called Aaron's House, and, lower down in The Strait, the Jew's House, which was at least occupied by a Jewess in the late 13th century, were similarly built in the later 12th century, though, in their case, of local oolitic limestone rather than imported stone, and they have two storeys. This far they mark the same innovation that led to the building of upper halls like Boothby Pagnell Manor House, also in Lincolnshire, with strength, safety and status made concrete in their form. They were once common; indeed large numbers of such houses survived in Lincoln until they were swept away in the 19th century, and they probably housed the city's extensive population of Jews and successful Christian merchants alike. These houses were not confined to Lincoln either, though the good Jurassic stone on which the city was built made their large numbers possible.

These two houses were both double piles. This was another innovation, and one, more significantly, that specifically responded to the crowded situation of a once-prosperous city. Furthermore, the fall of the ground required the front range of Aaron's House to be built on a vaulted undercroft, typically with its own entrance. Over it, a passageway from a central entrance at street level gives access to two flanking shops occupying each side of the front range, and to the entrance into the rear range. Jew's House, though greatly altered, had a similar plan, with both of their upper storeys reached by stairs in their rear ranges. These comprised a chamber at the rear and a hall at the front, with a doorway between them at one end of the dividing internal wall. The fireplace in the hall was built into the centre of the front wall where its chimney-breast was plain to see and conferred a little esteem on the building.[12]

Similar houses, some single pile, some double, survive in other prosperous towns and cities that went into decline in the late Middle Ages. While records and archaeological remains demonstrate that London once had several of them,[13] to see their remains one must turn to a town like Southampton, which fell from its medieval eminence. The romantically named King John's Palace

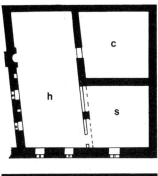

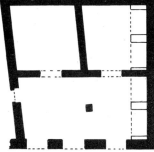

*The Norman House, Southampton. Plans of upper and ground storeys, showing a double-pile arrangement of rooms with a hall and two subsidiary rooms on the upper storey.*

of about 1150–60 and the slightly later Canute's Palace both had an upper hall or heated chamber built over separate ground storeys with a commercial use. This pattern of building is repeated in other haphazard survivals, such as Marlipins (once called Malapynnys and possibly the customs house of the de Braoses, Lords of Shoreham, serving New Shoreham harbour in West Sussex) and St Mary's Guild in High Street, Lincoln.[14] Similar houses were built with a timber upper storey. The large number of undercrofts of many towns like Chester and Southampton, now supporting modern buildings, probably started by supporting timber-framed upper halls or heated chambers like those at 48–50 Stonegate at York.[15]

These wood and stone houses with their domestic accommodation built over ground floors or undercrofts in separate commercial use have strong parallels in France, just as the architecture of contemporary English castles and cathedrals has. If they were principally a Norman importation, this may explain why they remained commonest among the well-to-do, and why, ultimately, the ground-floor open hall dominated urban building. It had a longer pedigree in England and was better suited to timber construction; and, if this did not please Jews because they needed the security of stone, it was more attuned to the purses of ordinary merchants and craftsmen. They, ultimately, won the day.

**URBAN HALLS**  The first urban halls were built for kings, the rich and the powerful. By the 13th century urban halls were also the product of ordinary mercantile wealth. Despite the great destruction caused by urban redevelopment, much evidence of these early halls survives, even though their tall open spaces were poorly suited to the increasing pressures on urban land. Survivals are nevertheless so scattered that it is harder to trace how the plans of urban hall-houses

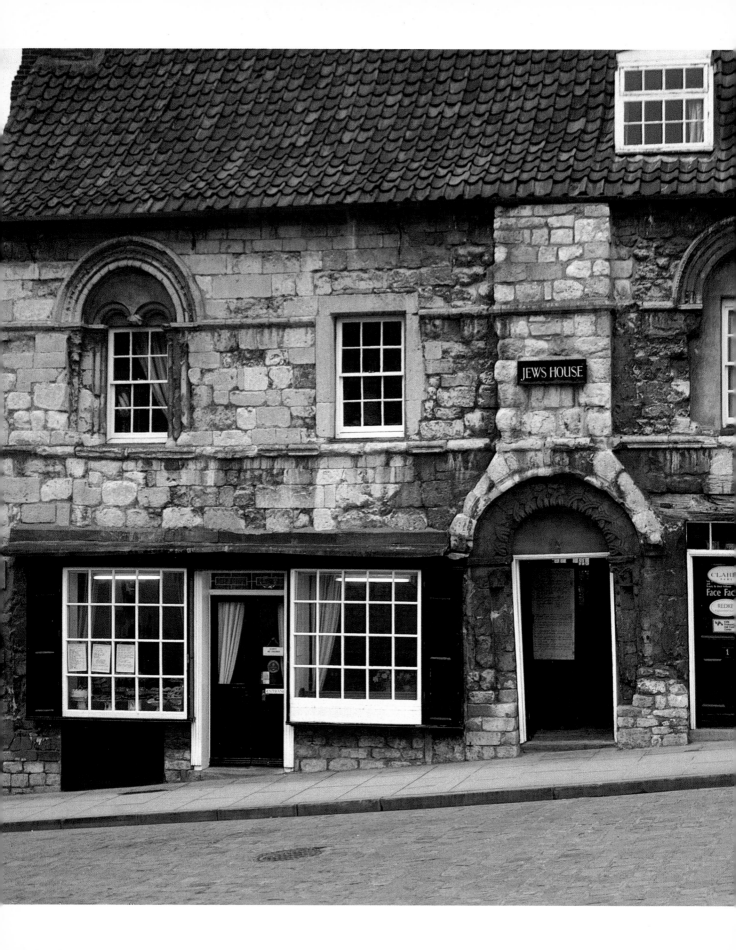

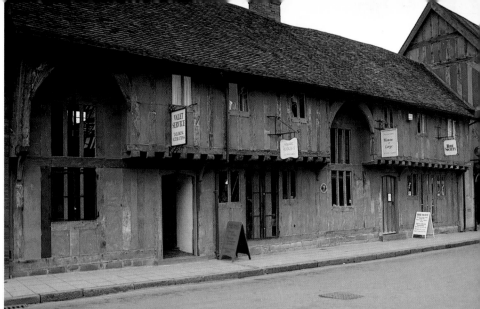

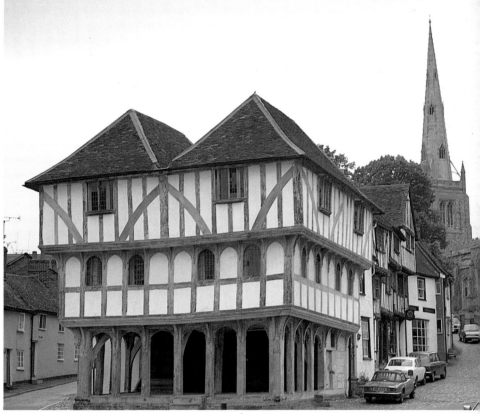

Jew's House, The Strait, Lincoln *(left)*. Built in the 12th century, perhaps for a wealthy merchant rather than a Jew, there were shops on the ground floor and principal rooms above, with a fireplace whose chimney-stack rises prominently up the front wall and, today, carries the house's nameplate.

Spon Street, Coventry *(top)*. Some of the restored 'two-thirds' Wealden houses which were once common in this flourishing medieval town.

The Guildhall, Thaxted, Essex *(above)*.

developed than to describe them. Many ideas came from the countryside, yet others from the cathedral close and the cloistered monastic precinct, where space was restricted and buildings were forced to abut each other. Even so, urban pressures were never so great that they destroyed all traces of halls laid out in the three-part rural manner, namely with a hall flanked by service and chamber bays and aligned along the street.

Survivors are most commonly found in those small towns which have developed little since the Middle Ages, or in the side streets or suburbs of larger towns where time has passed them by. Nos 19, 21 and 23 Bradford Street, Bocking, and The Woolpack Inn at Great Coggeshall, typically of Essex hall-houses, have their end blocks treated as gabled wings, and many similar houses still survive in small towns whose prosperity rose and fell with cloth. These urban hall-houses suited all kinds of people with money, not just clothiers and inn-keepers. Among them was Richard Curteys, the beadle of Battle Abbey, who, between 1406 and 1414, built himself a full Wealden hall-house fronting the High Street at Battle in East Sussex;[16] and in Robertsbridge there were a dozen hall-houses of which five were built in the period roughly 1390 to 1430 as Wealdens with standard measurements, probably through the auspices of the Cistercians of Robertsbridge Abbey and the craftsmen of a single carpenter's yard.[17] Several of these Wealdens were or became inns, but there was little to differentiate this particular usage architecturally. Occasionally one of the end rooms contained a shop, or a shop might be built out from it, as happened at Pollard Cottage, Lingfield, Surrey.

Given the premium on frontage, it is hardly surprising that the more compact single-ended arrangement of solar chamber set above service rooms was favoured for lesser houses in towns where land was expensive. Westerham in Kent, for instance, has a single-ended hall-house with services and solar in a cross wing at 84 High Street as well as a full Wealden hall-house. These contracted hall-houses are almost ubiquitous in the once prosperous medieval towns of the south-east, and they are not uncommon in the Midlands. Some are two-thirds Wealdens, that is with services and jettied solar flanking a hall recessed under the roof eaves. A few of these were again inns, despite having little accommodation for travellers. The Woolpack Inn in Stodman Street, Newark, is a two-thirds Wealden, said to date from 1489, and there are others in Coventry's inner ring of suburbs where impermanent settlements were redeveloped during the prosperous years of the 15th century.

A more specifically urban, contracted form had no service room as such and a solar, serving as part chamber, part store, was perched over the entrance passage and jettied out into the hall in the manner of two Coventry houses in Much Park Street and Spon Street, again in the inner ring of suburbs.[18] This was so restricted a form that additional rooms were invariably added at the rear to take the pressure off the solar. Sometimes the services and solar block was built behind the hall in the first instance to reduce the pressure on frontage even further.

A more likely way of building was to accept the concomitant difficulties with lighting and build a complete double pile in the first instance, usually with the hall placed behind a row of shops fronting the street. Tackley's Inn had this form: a front range comprising five individual shops with solar chambers over them was built over the undercroft, and a rear range, reached

A full Wealden serving as an inn, Spon Street, Coventry; the gabled oriels are unusual.

through a passageway between the shops, comprised an open hall and chamber built directly on the ground. The front block could be lit only from the north, the rear from the south, but this was an expensive stone building, and, with glazed windows, lighting from one side only was not the greatest impediment. Nos 38–42 Watergate Street, Chester, is a direct parallel, though here the hall is built over the rear part of two undercrofts, and the chamber block extends forward along the whole length of a third. This general arrangement of hall and chamber block set behind shops was common among cheaper timber-framed houses too, for instance in Jordan Well and Gosford Street, Coventry, and it appeared again, though possibly with private rooms rather than shops at the front, in Colston's House, Bristol (probably not the house of the city's famous merchant), and in Tudor House, Southampton.[19]

A grander and at once better lit arrangement was when the front and back ranges were separated by a courtyard, and linked either with further buildings or the party walls. Many of the commoner buildings which could afford to rise to this plan were large inns. The northern part of Marshall's Inn in Cornmarket, Oxford, had this plan by 1380 when it was still a house, but New Inn at 26–8 Cornmarket was built as such after 1386 by John Gibbes, a vintner.[20] A fragment of the aisled spere truss of a similarly placed hall survives behind the Nag's Head in Wyle Cop, Shrewsbury.

In probably a majority of courtyard plans, the hall was not set parallel to the street on the further side of the yard, but perpendicular to the street along one side. This was particularly favoured for large inns because the hall was not of prime importance and could do without the status of a central position in the plan; the front was then left free for a wide carriage entrance set between ale rooms, and the rear for stabling. This arrangement is widespread in towns situated on major coaching routes, for instance in Oxford, where The Golden Cross and The Star (latterly The Clarendon) had this plan, and at Gloucester's New Inn.[21] Merchants often had reason to use this plan too. The clearest example of this is Hampton Court at King's Lynn, which fronts Nelson Street with a row of shops and a central archway leading to a courtyard. This is flanked by a fine 14th-century hall with service rooms adjoining it at the street end and, at the other, private rooms comprising a parlour and counting-house or office with solar chambers above. The reason for the disposition of the hall range along the side of the plot is that the further end of the courtyard faces on to South Quay, and this was given over to warehouses set above an open arcade designed for the sorting of goods awaiting shipment. The fourth side of the yard was probably taken in from an adjoining plot for further buildings, perhaps a kitchen among them, which, after a series of building campaigns, completed a singularly grand version of a widespread arrangement.[22]

Only a short way from Hampton Court, a narrower courtyard served Lynn's Steelyard, one of four which Hanseatic traders established in England following a treaty in 1475 to foster trade with the Baltic (Steelyard, incidentally, derives from a mistranslation of the Middle High German word *Stâlhof* which meant a yard or house for samples or patterns as well as steel, and hence warehouse). This was essentially a long narrow courtyard with warehouses down both sides as well as the end, leaving the front for domestic accommodation.[23] London had a similar Steelyard,[24] and there were probably similar ones at Boston and Hull.

**The Music House, King Street, Norwich. One of many undercrofts in the city, this one was constructed about 1170 as a foundation for what was probably the house of a prominent Jew.**

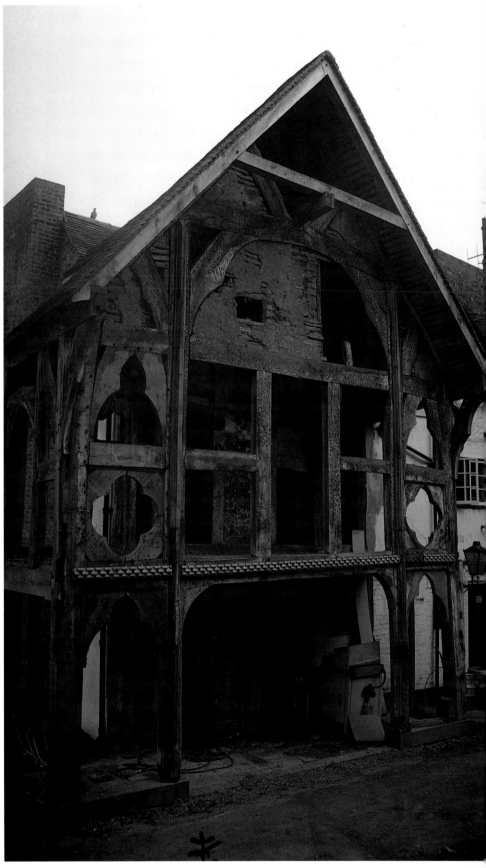

The Nag's Head, Wyle Cop, Shrewsbury. The surviving end of an ornate hall built in the late 14th century behind the street.

*Hampton Court, King's Lynn. Plan, showing an arcade beneath a warehouse* (left), *a later range* (top), *hall range* (bottom) *with counting-house and chamber flanking an open hall and services, and* (right) *shops flanking the entrance from the street.*

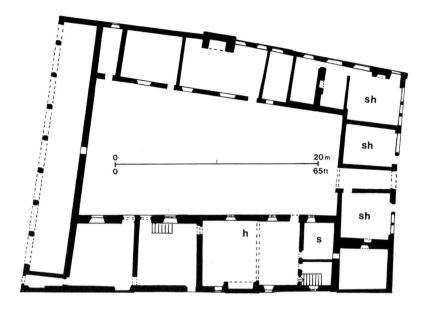

When the plot was very narrow, the hall was built perpendicular to the street and the courtyard shrank either to an access lane entered through an archway in the street frontage, or to no more than an internal passage through the front range. Because this plan particularly suited the numerous towns whose streets were divided up into characteristically narrow-fronted but deep plots, the so-called burgage plots, it had the greatest significance in the development of urban house plans from the Middle Ages until the start of the 18th century when the standard terrace house plan finally emerged.

In West Country towns this plan was used for houses which had stone party walls dividing them from neighbouring houses and timber-framed walls spanning them. There would usually be a shop at the front with a storey or two of chambers over it, usually with prominent jetties, oriel windows and a gable; behind these came the hall, which had to rely on windows high above an alley for lighting, and the sequence would end with service rooms, again with a chamber built over them; often there might be a separate kitchen further to the rear beyond a small yard. Two adjacent houses built over undercrofts in North Street, Exeter, had this form. Similar houses survive in Southampton at 58 French Street and on a grand scale in The Leche House at 17–19 Watergate Street, Chester. The stone house in Redcliffe Street, Bristol, which belonged to the celebrated merchant William Canynge, builder of St Mary Redcliffe and five times mayor of Bristol, again had this arrangement of rooms and may owe its construction in the middle of the 15th century to him too.[25]

This plan is widespread, though mostly in houses entirely built of timber and therefore lacking enclosed hearths. Nos 49–51 Goodramgate, York, for instance, comprises shops with two jettied storeys of chambers above fronting a complete hall-house of Wealden design running backwards from the street beside a narrow alley.[26] No. 126 High Street, Oxford, was a highly compressed version of the same idea, with a shop and chamber block rising through three full storeys into a garret fronting an open hall.[27]

*No. 38 North Street, Exeter. Section and plan, showing* (left to right) *a shop with chambers above, an open hall, services with chambers above, and, linked by a gallery across a courtyard, a kitchen.*

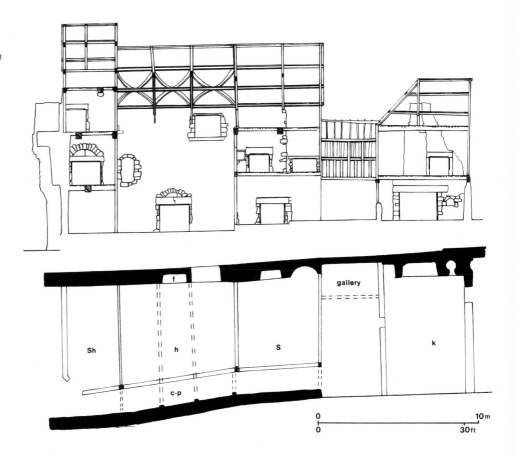

*Leche House, Chester. Sections and plan of the main floor, showing* (left to right) *a row and shop with a chamber over them, an open hall, and a service room with chambers above, all set over an undercroft; a kitchen, not shown, lay beyond a yard, further to the right.*

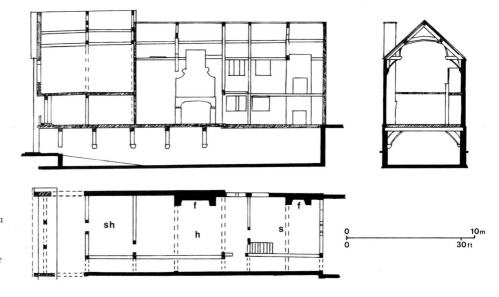

## MEDIEVAL TERRACES

Rows of such houses were once common, but their individual qualities and separate construction set them apart from the comparatively rarer medieval terraces of uniform houses. They were built by speculators willing to invest in an extensive building, standing alone and divided up into individual units. The Church seems to have been the earliest speculator to build terraces, possibly because it was used to the idea, for instance as exemplified by the rows of small lodgings set around cloisters for the accommodation of Carthusian monks, who were devoted to individual seclusion. Soon after their foundation in 1232, the Carthusians of Hinton Priory in Somerset built themselves fourteen identical houses, each with a main, heated room and a subsidiary room set in a regular way around a cloister, and these may have set a precedent for things to come.

At all events, terraces were going up in London early in the 14th century, if not beforehand, but the oldest dated survivor is Lady Row, built fronting Goodramgate, York, in 1316. It is as modest as the rows of shops with solar chambers built over them that fronted the halls of large establishments like Tackley's Inn in Oxford, though here it was not attached in any way to a hall, nor built of imported stone, but of timber. Lady Row, typically, came about through Church money improving Church land for the benefit of the Church, in this case part of Holy Trinity's churchyard being improved to provide rents which went to the endowment of chantry priests. Again typically, Lady Row is simply a long building fronting the street and divided into bays, originally more of them than now and with a bay turning the corner of the north end to run back along the side of the churchyard. Seven of these bays survive, each of which comprises a room measuring about 5 m deep and 4 m wide (16 by 13 ft) on the ground floor and slightly deeper on the jettied floor above.

This was limited accommodation in all conscience, although the southern bay is a bit larger and the next three bays to the north were grouped together to form a larger house. This simple arrangement of terrace planning with one bay per house became standard for the Church's speculations in York with the construction of two more terraces, one in Coney Street in 1335, significantly described in the surviving building contract as *domus rentales*, the other in Newgate Street in 1337, while a larger, three-storeyed version of the same single-bay terrace plan was built at 54–60 Stonegate at much the same time as Lady Row.[28]

These were modest houses, modestly treated (their jetties apart), and suited to traders and craftsmen who were well enough established to want the comforts of substantial quarters, however small, but who had yet to strike gold and move into fully-fledged hall-houses. Presumably they kept warm with winter braziers, for a fire in an open hearth was out of the question, and took their food to York's bakeries to be cooked, just as the urban poor used to do until well into this century.

Evidence for such terraces is scattered because both their age and their small size went against their chances of survival. They were probably widespread and built in varying degrees of quality. An unusual terrace of four such houses was built about 1310–20,[29] back to back against a second similar terrace to produce the eight shops with two storeys of jettied chambers above them forming Middle Row in Watling Street, Dunstable. This arrangement exploited an open site taken from the market place, and consequently had

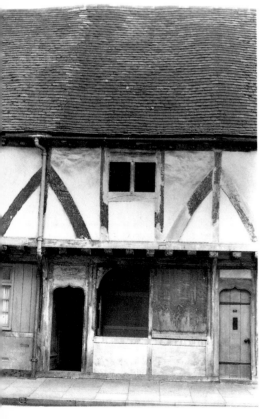

**Church Street, Tewkesbury. One of the restored houses of this long terrace, now open as a museum.**

good access each side. Constructionally, the group is treated not as two abutting terraces, but four abutting pairs of opposed houses, each with a gabled roof to emphasize its individuality, and a staircase built against the back party wall.[30]

The back-to-back was not to come into its own until the 19th century, and then only in northern weaving towns; lighting was always a problem, just as here, and they could only be one room deep. Their notoriety is not always justified, but the one-roomed plan is reasonably associated with poverty. Nevertheless, it was put to spectacular use with walls of stone and openings carved with pointed Gothic heads to form the two facing terraces of the Vicars' Close at Wells. Here, Church money was spent on its own, and the rooms had the additional advantage of enclosed fireplaces, with the chimney-breasts and stacks becoming a proud feature of the forty-one houses.[31]

The lower room presumably acted as a hall, the upper as a chamber, but in most surviving medieval terraces with halls, the construction was of timber, the hall open to the roof. The most widespread survivals have the hall and the service and solar bay aligned with the terrace itself along the street. This was not the most economical use of frontage, but it avoided problems with lighting since all the rooms could be lit from front and back. Six two-thirds Wealdens form a speculative terrace in Spon Street, Coventry, and there are pairs of 'semi-detached' Wealdens in the city's inner suburbs as well.[32] The longest terrace of Wealdens is in their south-eastern homeland at Battle, where the abbot built a row of nine adjacent to the abbey's precinct in Upper Lake at some time between 1460 and 1477. The central house was a full Wealden and leased out at 16 s. per annum as an alehouse, and the remainder, of which two more were also used as alehouses, brought in 10 s. and 8 s. per annum because of their smaller size.[33]

*Urban Wealdens in Spon Street, Coventry* (left), *and Upper Lake, Battle* (right). *Front elevations and plans. Two of the Coventry houses are shown in which a cross-passage and hall comprise the lower storey, and a chamber and upper part of the hall comprise the upper storey; the wider Battle house has additional room for a shop at the front and services at the rear to the right of the cross-passage.*

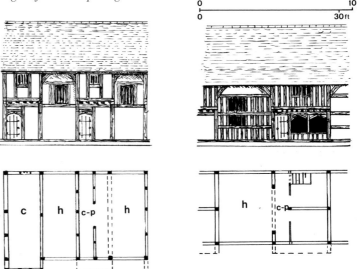

This lengthwise planning of the houses, parallel to the street, made only one concession to the premium on frontage by compressing the three-part arrangement of a hall-house into two parts. The more urban perpendicular arrangement placed the hall behind the front rooms within the confines of individual bays ranged down the length of the terrace set along the street. The difficulty in lighting the hall was aggravated by its low rear wall, and this could be made even worse when additions were built out from it rearwards. All this is evident at Tewkesbury in the terrace of sixteen houses fronting Church Street and backing the abbey. Here, the front part of each bay is storeyed with a shop below and a jettied chamber above; a passage beside the shop leads to an open hall at the rear, which is lit by a window in the rear wall, but extensions added to the rear of some houses reduced the lighting of the halls to what filtered through open partitions between it and the front and new back rooms.

Despite its disadvantages, this perpendicular arrangement was the springboard for the post-medieval terrace, so it must have been common once. Yet surviving examples are rare, and limited to fragments such as those of 39 and 41 High Street, Kingston upon Thames, which originally had this arrangement. Other terraces, such as the one probably built shortly before 1390 by the draper Simon Basse in Abchurch Lane in the City of London, with their two rooms aligned perpendicularly to the street frontage were a lesser breed and had no halls, but instead comprised shop and warehouse, with two storeys of chambers above and a kitchen beyond a narrow yard.[34]

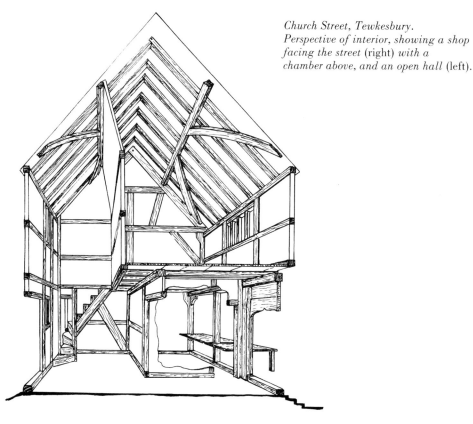

*Church Street, Tewkesbury. Perspective of interior, showing a shop facing the street* (right) *with a chamber above, and an open hall* (left).

**POST-MEDIEVAL HOUSES**

The wholesale introduction of chimney-stacks and continuous upper floors to town houses, together with the reduction of the hall to no more than one heated room among several others, generally went in step with similar developments in the countryside. The reasons for making these changes were all the more pressing because the concomitant savings in space were needed so much more in towns. Even while the rapid growth of many towns and particularly London forced the pace in the 16th and 17th centuries, a greater awareness of fashion ensured that the towns eventually left the countryside behind in the search for innovation.

Tradition started to crumble in the 17th century as fashion turned to foreign books of architecture for the design of speculative housing. This began when Inigo Jones brought back classical ideas and a copy of Palladio's *I Quattro Libri dell' Architettura* from Italy and used them on a grand scale for the fourth Earl of Bedford's speculative development of Covent Garden in the 1630s. Following the Great Fire of London, the Rebuilding Act of 1667 killed off traditional building in timber in the City at a stroke, and the Building Acts of 1707, 1709 and particularly 1774, hand in hand with fashions expressed in a growing flood of books, eventually established new standards throughout London. These defeated the traditional builder, artistically, technically, and commercially. Where London led, other towns followed, then the countryside.

Another powerful cause of change was the decline in timber framing. This has been attributed spuriously to the growing needs of the navy and the wholesale consumption of trees by the iron industry. In fact the cultivation of timber slowly fell into desuetude as brick and stone rose in general esteem and fell in relative cost. Imported fir from the Baltic states ousted oak in the London building world, and soft wood of various kinds completed the conquest of traditional hard wood by the start of the 19th century.

All this took time. For a century or two after the Middle Ages, tradition adapted rather than tradition overturned was the rule. Piecemeal change was more easily assimilated, and left people well satisfied. Large inns, in the widest sense of grand town houses and lodging houses for academics and lawyers as well as public lodgings for travellers, were in the vanguard here, particularly in the use of multi-flued chimney-stacks to heat many rooms. The best chambers in the comparatively modest Golden Cross at Oxford and The George Inn at Dorchester on Thames seem to have had fireplaces, some set back-to-back in single stacks, by about 1500, and larger inns, such as The New Inn at Gloucester, may have had them some while beforehand.[35] The brick chimney-stack with two or more storeys of back-to-back hearths became common in urban timber-framed houses more quickly than in the country-side, and, similarly, was often fitted into a narrow bay of framing and associated with a staircase.

The saving in space that this efficient arrangement made possible brought changes to the planning of town houses, just as it was doing in the countryside, and it was only the particular needs of large coaching inns like The George at Stamford or the desire for luxury proper to an important dignitary or institution that allowed the courtyard plan to continue for the largest urban establishments. The double-pile, now with a full complement of heated rooms, was widely adopted for all but the largest of individual urban houses, and, significantly, was the first major incursion into the countryside of a plan

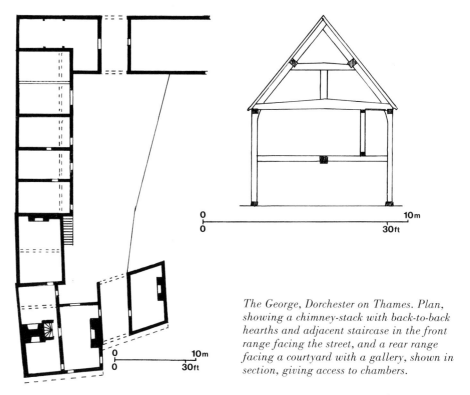

*The George, Dorchester on Thames. Plan, showing a chimney-stack with back-to-back hearths and adjacent staircase in the front range facing the street, and a rear range facing a courtyard with a gallery, shown in section, giving access to chambers.*

evolved in town. Either way, it was readily adapted to the new classical taste of the 17th century.

The rural three-part hall-house plan continued briefly in small towns; it was easily adapted to take a chimney-stack, as Paycocke's House at Great Coggeshall showed as early as the first years of the 16th century, and its alignment parallel with the street was particularly appropriate here as the rear of the plot was already taken up by ranges of workshops devoted to weaving. The surrounding countryside soon followed its example, but modernization was not a one-way process. The countryside continued to affect urban planning. For instance, the more developed lobby-entry plan and the central-vestibule plan with gable-end stacks came into urban use where crowding was not a great problem.[36]

The linear arrangement of rooms perpendicular to the street held greater promise for crowded towns. Totnes, which enjoyed a century of high prosperity lasting until the Civil War, adapted the local hall-house plan with timber-framed transverse walls set between stone party walls containing chimney-stacks simply by removing the central open hall and using the rear, ground-floor room in its place. The separate kitchen in a rear outhouse was retained and linked to the main part of the house by an enclosed gallery. One house, 70 Fore Street, now restored as The Museum, had another gallery beyond this leading to a second back block.

This arrangement was adopted wholesale in Totnes and appeared widely elsewhere. Similar houses with stone party walls and framed end walls went up in Taunton. Many had a passage down one side to provide access to the rear room and back yard, and, as early as the 17th century, this passage was made

*No. 54 Fore Street, Totnes. Section and plan, showing* (right to left) *a shop facing the street with chambers above, a staircase, a hall with chambers above, and a courtyard leading to a detached kitchen.*

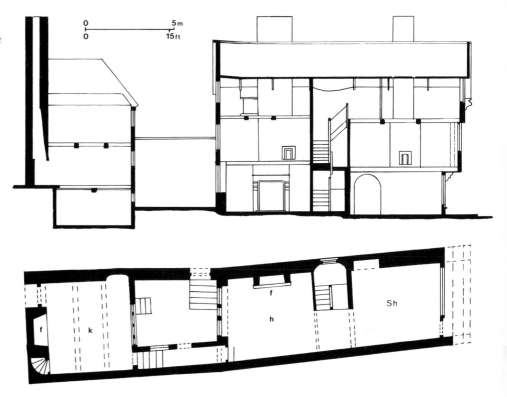

common to pairs of houses to produce the semi-detached plan of 25–6 High Street.[37]

Where plots were wide enough to allow the retention of a fully open passage running between the main street and the back lane, the same arrangement of rooms had the advantage of side lighting for part of the house as well. No. 31 Mermaid Street, Rye, known variously as the Old Hospital and Hartshorn House, was built in 1576 by an unknown but important citizen of the town with a double front set over an undercroft in the age-old local way, and a main entrance placed between an office and the hall, which was divided by a chimney-stack with back-to-back hearths from a rear wing containing a parlour.[38] The similar house at 25 Court Street, Faversham, probably built soon after 1608 by the ship-master John Trowtes, has a shop in place of the office and a kitchen and buttery in place of the rear parlour, but these are differences in nomenclature rather than in planning.[39]

A grander variant of the same idea allowed the house to be entirely detached from the front range of shops facing the street to provide a secluded residence of the kind built in 1637 for the Oxford mercer Alderman William Boswell. This house, Kemp Hall, has three storeys of heated rooms, with hearths set in stacks rising against the stone party wall, and placed either side of a central entry lobby containing a staircase, also built against the party wall.[40]

No. 31 Mermaid Street, Rye, has its secondary entrance from the back yard to both hall and parlour opening into a lobby in front of the chimney-stack, as though derived from the rural lobby-entry plan. When a lobby-entry house was denied the access of a side passage as well as turned sideways, it could no

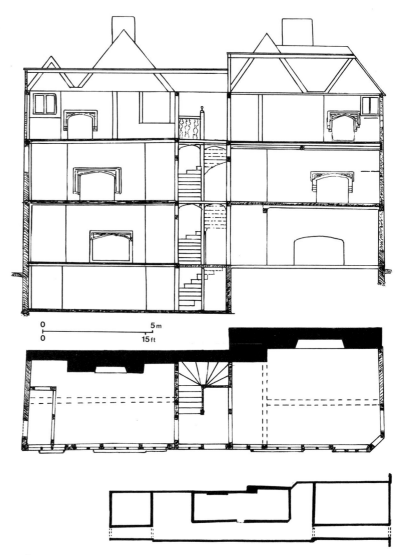

*Kemp Hall, Oxford. Section, plan and site plan, showing chimney-stacks built into the party wall, and three storeys of heated rooms flanking the staircase.*

longer retain its lobby entry, but the association of chimney-stack and staircase could continue, even while the entrance had to connect with them through either the front room or a passageway. This happened when the fisherman Robert Meriland built his house between 1556 and 1560 at 4 Watchbell Street, Rye, with his ground-floor hall over an undercroft and backed by a narrow bay containing a staircase and chimney-stack also heating a rear parlour and the chambers over them.[41]

It is a short step from here to the lost contemporary houses in the City of London. The appearance of many of these was caught by the topographical artist J.T. Smith at the end of the 18th century;[42] and, to this day, the three jettied and gabled storeys of the Holborn front of Staple Inn, which Richard Champion, the Principal of the Inn, built in 1586, shows what the best of them

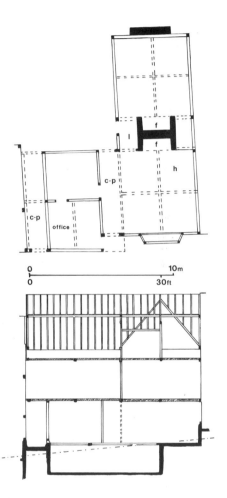

*No. 31 Mermaid Street, Rye, of 1576. Section and plan, showing an office and the hall with a passage between them, built over an undercroft running the width of the front range, and a rear range with a parlour, all with chambers above.*

were like far more accurately than is generally recognized.[43] As the capital expanded in the 16th century, gardens were taken for building and, following the Dissolution, monastic land similarly succumbed to the speculative builder. Terraces of houses, such as those recorded in West Smithfield, were built of timber with two rooms divided by a stack with back-to-back hearths, and smaller houses with a single room on each of their two or three storeys, such as those of 1537 which once stood in Billiter Lane, had stacks simply built against their back walls.[44]

Many of these humbler houses probably had the appearance of 57–65 Broadway, Stanmore, a terrace of timber-framed houses in the north London suburbs of Harrow. The front is regularly arranged with doors and windows alternating beneath a jetty and the windows in the storey above aligned with those below; but the planning is fairly haphazard and includes one double-fronted house which is only one room deep and several others may originally have only had a single room on each of the two floors. The chimney-stacks are mostly placed on the party walls between the houses rather than at the rear, and most of the smaller houses have been extended rearwards, at least on the ground storey.

This terrace survives, but most of the City's timber houses were consumed by the Great Fire of 1666, and practically all the remainder have long since gone. Oddly, the earliest surviving brick terrace in the London area follows the same traditional two-room arrangement of the West Smithfield houses. The four houses at 52–5 Newington Green, Islington, were built in 1658 as a uniform terrace, two of them apparently for a mariner, John Pidcock. In a naive way, their exterior shows the new Renaissance fashion which Inigo Jones used first at Covent Garden. This has nothing to do with English traditions at all, but the planning, by contrast, takes tradition to absurd

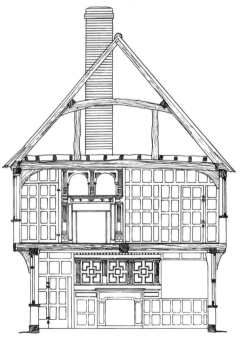

*Nos 57–65 The Broadway, Stanmore, Harrow, London. Section showing a two-storeyed arrangement of single rooms, with jetties front and rear, and lavish panelling and chimney-surrounds.*

*Houses at 4 Watchbell Street, Rye, of about 1558–60, Newington Green, Islington, of 1658, and Buckingham Street, Westminster, of 1673–6. Plans showing the arrangment of chimney-stacks and staircases.*

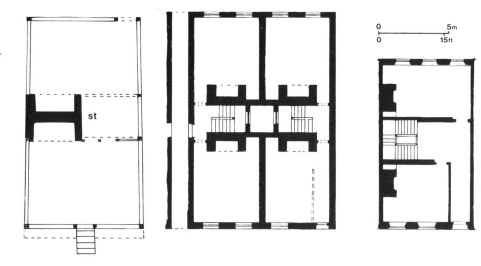

lengths. The walls of the houses are all of brick, yet the brick chimney-stacks are still built separately across the middle of the houses as though set between transverse timber frames. Worse from the planning point of view, the stacks are split into front and back halves to make space for staircases, which they support. While the front and back rooms, storey by storey, are well lit, the staircase is not, and to remedy this an inefficient light-well is inserted across the party wall.

All these problems could have been solved at a stroke if the builder had built the stacks against the party wall, as happened in the brick terraces of Bloomsbury Square in 1664, and widely in London's terrace houses after the Great Fire, for instance in Buckingham Street and Essex Street in the 1670s. By 1680, the problem of lighting the staircase was also solved by removing it to the back wall adjacent to the rear room with an approach from the front door by a passage adjacent to the front room.[45] From that moment, the standard terrace plan of later years had arrived: there was nothing left to invent. It remains the point of departure for terrace houses to this day, despite the arrival of modern services.

By 1700 the London speculative builder was abreast of all the current fashions. The Deptford bricklayer Thomas Lucas, for instance, worked for such architects as Nicholas Hawksmoor and Thomas Archer, and his own speculative development of houses shows it. Well outside London, tradition continued. Oxford persevered with timber framing well into the 18th century, but there was more than a whiff of decay in this old craft. New types of roof frame based on mechanical principles and soft-wood techniques covered reams of publications as well as acres of new building as the Industrial Revolution demanded a new scale in the country's life.

*House built about 1710 as part of Thomas Lucas's speculative development in Albury Street, Deptford. Plan showing the standard terrace-house arrangement of ground-floor rooms, with chimney-stacks on party walls, a closet in a small rear extension, and a staircase at the rear of the entrance vestibule.*

# AGRICULTURE AND INDUSTRY

The largest of all traditional buildings and, apart from houses, the one with the longest history is the barn. It was the centre of agricultural activity, and so soundly built that it was likely to outlast all other farm buildings. This was also because it was the most adaptable. Its main function was to store harvested corn, so it had to be large. Corn must be threshed to separate the grain from the straw and chaff, so a space had to be made for threshing and for storing the grain and straw. All farms had an animal or two, a milking cow or a plough team, and they were often kept over winter in a stall inside a barn, with further space made for their fodder. As well as crops, logs for fuel, barrels of wine, salted meat and fish were stored there too, so it served as an agricultural warehouse. The pounds and presses for making cider and the tubs and kilns needed for brewing were often installed at one end, so it could be a factory as well.

Barns are the greatest monuments of English agriculture, and the earliest survivors owe their existence equally to the progressive farming vigorously pursued by the monasteries, and to the new constructional techniques introduced in the 12th and 13th centuries. The largest surviving barn was built by the Cistercians at Great Coxwell in Oxfordshire. A glance shows that it was designed to be a monument to its builders, yet it was a house of toil at the same time, and, on at least one occasion, the peasants who worked there rebelled against their masters, so arduous were the impositions of the bailiff who managed it for the monks.[1]

Many barns were so extravagantly built that they emulated the monasteries themselves, and this raises them into the levels of polite architecture. Great Coxwell barn and, for that matter, the great stone-walled barns at Bradford-on-Avon in Wiltshire and Glastonbury in Somerset are no mere barns, but among the finest buildings of their age.

Great Coxwell barn is aisled and divided into bays, a constructional necessity turned to advantage which allows the interior to be partitioned for separate crops, for stalls for wintering cattle or calving cows. The centre bay has an entrance large enough for laden carts to enter, and a second, lower doorway opposite, enabling the emptied carts to be drawn straight out. This was not important in the Middle Ages as carts only had one pair of wheels and were easily manoeuvrable, but, when four-wheeled wagons appeared in the 17th century, the doorways on each side of the bay were to prove their worth. More importantly, the opposed doorways produced a draught for winnowing threshed grain from the chaff.

The bay between the entrances, the so-called 'middlestead' or 'midstrey', was flanked by further bays or 'side steads', where unthreshed corn could be kept before being threshed in the middlestead, after which the straw and the filled sacks of grain could be placed on the other side. Many large barns had two middlesteads and in exceptional cases more. The bays between them and at each end could then house different crops, or crops belonging to different owners. The Archbishop of Canterbury's barn at Headstone, Harrow, Greater London, has two middlesteads of which the western one and the two end bays beyond it were reserved for his own crops and the remainder for his tenant's.

The middlestead was floored with clay, hardened with ox blood, or with tightly fitting elm or poplar planks. Armfuls of corn or untied sheaves were laid out on the floor and threshed with sticks until the grain had been beaten

155

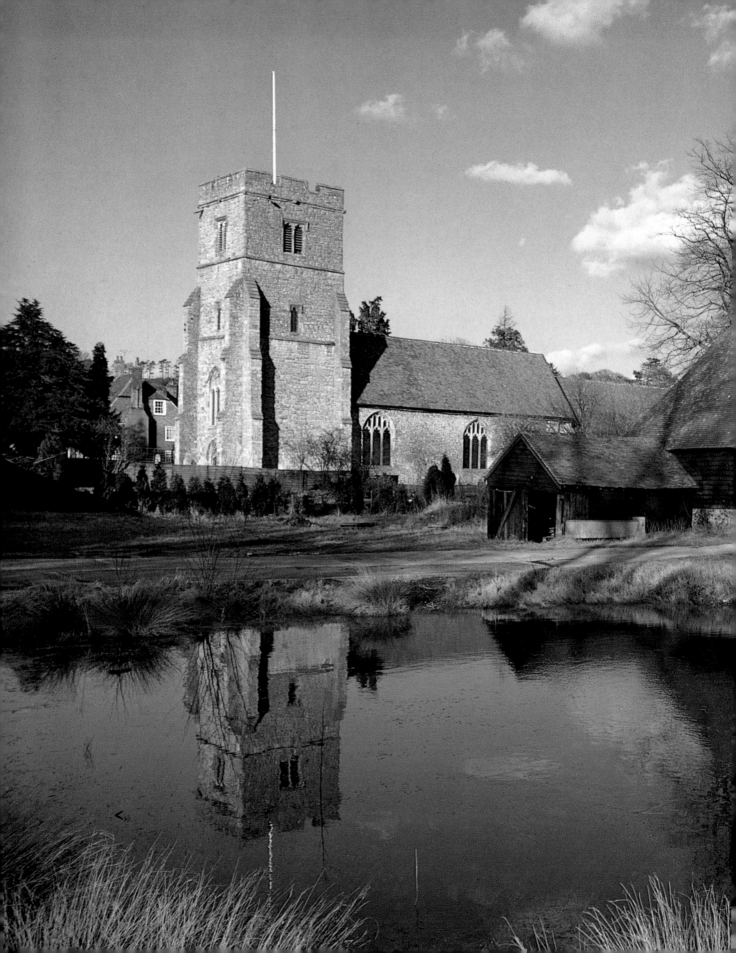

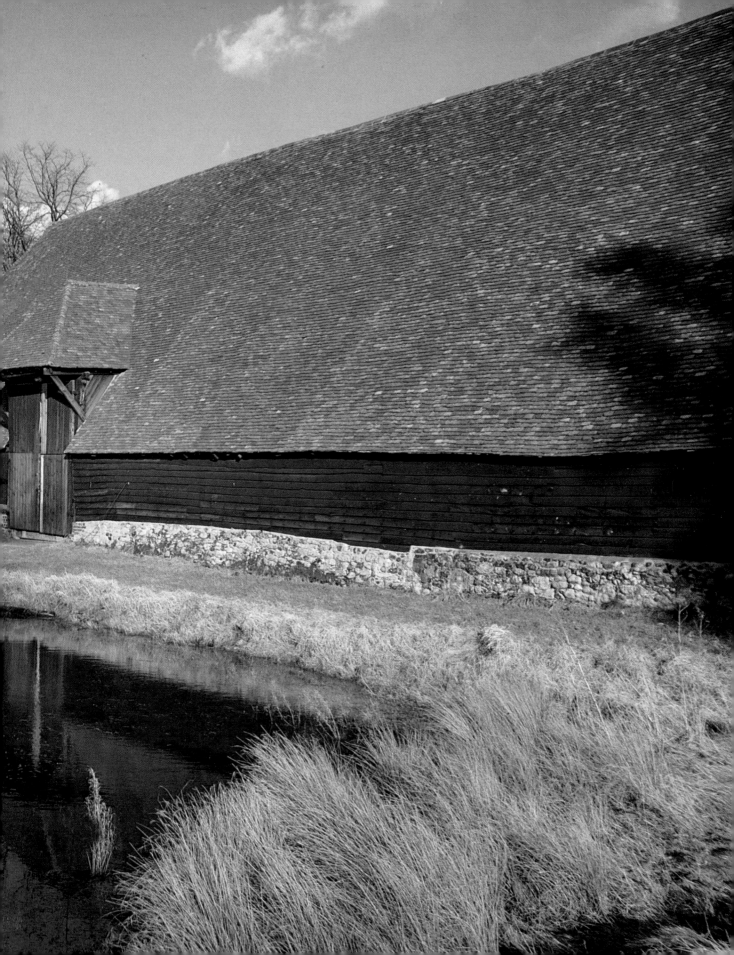

from the husk. Then came winnowing: the opposed entrance doors were opened to let a strong draught rush across the threshing floor into which the grain and chaff were cast; low striking-boards were placed across the doorways to prevent the grain from bouncing out into the yard, while the draught blew the chaff outside.

The standard plan of middlestead flanked by storage bays continued until the last barns were built late in the 19th century, when traditional methods were at last giving way to mechanization and engine power. When advancing constructional techniques made aisles obsolete, they still remained common in the south-east and the north because they were useful. Coggeshall Abbey barn probably dates from the last years of the 12th century and is the oldest in England. It is big, though well short of Great Coxwell's capacity of about 5860 cu m (207,000 cu ft), but even this is less than the capacity of the Cistercians' partly destroyed barn at Beaulieu St Leonards in Hampshire which reached 14,900 cu m (526,000 cu ft).

## AISLED BARNS

The many aisled Kentish barns have remarkably uniform timber construction, from the earliest survivors like Frindsbury, which at 64 m (210 ft) is the longest, and Lenham, with a capacity of 3510 cu m (124,000 cu ft), the largest.[2] Their aisles account for between a third and a half of the total width. The arcade-posts are buttressed by curved, raking shores which rise across the aisle-ties. The aisles are carried round the ends so that the roof is fully hipped in the traditional south-eastern way, and based on crown-posts with collared common rafters.

Two middlesteads are usual in Kent, although Frindsbury's thirteen bays were served by only one. Many barns, like Brook, had hipped porches added to the larger entrances. Some early barns were clad with boards, butted together. At Frindsbury much of this miraculously survives. The boards are set vertically and housed in grooves in the horizontal timbers of the wall framing. This made the walls very firm, but they were harder to construct as the cladding had to be fixed during the framing of the aisles, and it could not be replaced without removing the wall-plate and the whole roof as well. Later barns like the smaller barn at Lenham had horizontal boarding pegged into rebates in the vertical framing timbers, and so the cladding could be added after the frame had been erected and be easily replaced without disturbing the frame.

The boarding had to keep out the weather and deter farm animals and vermin, but the cladding was not designed to be airtight and gaps below the eaves were left to enable air to move freely through the barn. The earliest barns were roofed with thatch as Littlebourne still is today, but tiles soon superseded them. These were at first more expensive than thatch, but needed less renewal and had the great advantage of assisting the flow of air.

Later barns in Kent were built in the same form, although by the 18th century far thinner timber was used, sometimes elm or chestnut, and trunks might be quartered to make four posts rather than be squared, one per post, as a barn built at Yalding in 1759 and rebuilt at Rachel McMillan College, Wrotham, well shows. There were changes in the roof framing: principal rafters were used with purlins and collars without vertical supports at

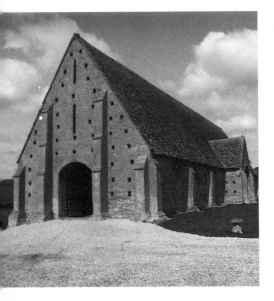

**Great Coxwell barn, Oxfordshire; the large doorway in the gable wall was forced through in the 18th century.**

Willesborough and Mersham in the later Middle Ages, and with a pair of queen-struts supporting collars, probably in the 16th century, at Teynham. Later barns still, like Austin Lodge barn at Eynsford and the Yalding barn, have various struts, posts and collars, and were clad in horizontal, overlapping weather-boarding.

The reason for this uniformity and continuity lies in the traditions of craftsmanship of the great Benedictine monasteries of Kent. Their influence was felt widely in the south-east. Upminster Hall barn in Havering, Greater London, which the Augustinians of Waltham Abbey probably built in the 15th century, belongs to Kent by type although its location is old Essex. Its cladding was like Frindsbury's, though the boards were set in rebates rather than grooves. Hertfordshire barns such as the ones at Parsonage Farm, Abbots Langley, and at Croxley Hall Farm, Croxley Green, which were built in the 14th and 15th centuries by the Benedictines of St Alban's, again show the influence of Kent, but have archaic passing-braces rather than shores across their aisles.[3]

The alternative way of framing a roof, common in the south and Midlands but not in the south-east before the 16th century, was to employ purlins supported by collared trusses of the type used for Harmondsworth barn, which was built after 1432,[4] and for a similar barn at Drayton St Leonard in Oxfordshire. These barns show that by the middle of the 15th century the trussed-rafter roof was superseding the common-rafter roof of the south-east and pressing the frontier between the two types eastwards, finally to embrace all Kent in the early 16th century. By 1550 principal rafters, usually supported by queen-struts and collars, were used almost exclusively. They appear in the Archbishop of Canterbury's large barn at Headstone, which was completed in 1506 with a similar frame to one in a barn built for £32, again in 1506, for the Bishop of Winchester at Harwell, Oxfordshire.[5]

The Kentish aisled barns form the densest concentration in the country, a direct reflection of high agricultural production.[6] Only in the north do they become common again, but there are not nearly so many of them and few are medieval. Whiston Hall barn near Rotherham in South Yorkshire, by far the oldest survivor, was built after 1214[7] when the manor of Whiston was part of the vast estate of the lords of Hallamshire. Its typically early framing is an exceptionally tantalizing fragment of primitive forms, probably widely in use before a northern tradition of framing was established, well over a century later.[8] Its common rafter roof appears in other medieval barns in the north,[9] for instance high in the Pennines at Shore Hall, Penistone, and at Dean Head, Hunshelf.[10] Both of these originally had aisles, but, with only four bays, were very small, a reflection of their damp, cold location.

Just a few monastic barns survive in the north. The Augustinians built a large aisled barn in Wharfedale, North Yorkshire, to the south of the monastic buildings at Bolton Abbey. They built another within the precinct of Carlisle Cathedral, reputedly at the end of the 15th century. Its capacity of less than 2000 cu m (70,000 cu ft) reflects the poor conditions for growing corn in Cumbria, and this barn was used for storing all the produce from the Priory estates, rather than for threshing.

The traditional Yorkshire barn, as established well before the Dissolution, had aisles and a trussed roof with king-posts and principal rafters. This

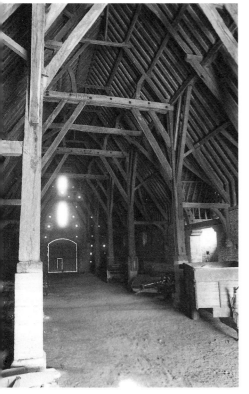

The interior of Great Coxwell barn.

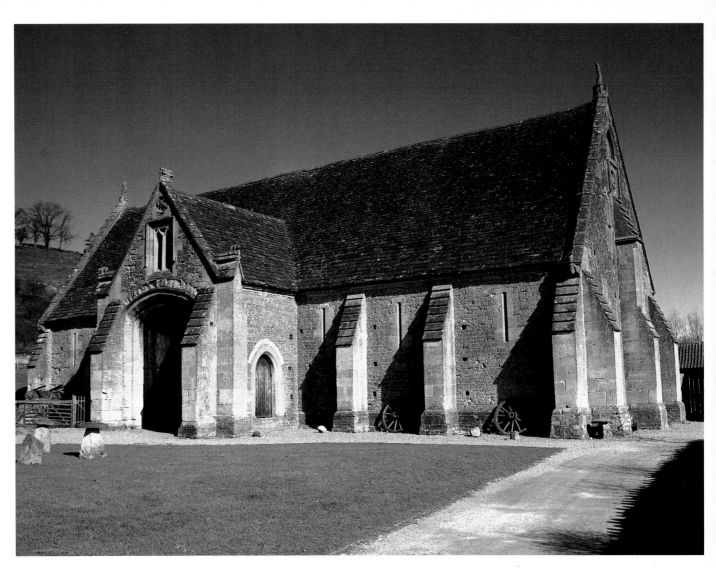

**Abbey Barn, Glastonbury, Somerset.** Built in the middle of the 14th century, the barn rivals the abbey itself in the quality of its carved oolitic limestone masonry. The decorated end wall *(right)* depicts an eagle, symbol of St John the Evangelist.

remained the norm until the 18th century, with aisles increasing in width during the period to accommodate ever larger numbers of cattle. About a hundred of these barns are known between northern Derbyshire and the Dales of Yorkshire, right across the Pennines from the arable of the Vale of York to the edge of the Fylde in Lancashire.[11] Typical of the earlier barns is Stank Hall barn in the southern suburbs of Leeds, which has a single aisle[12] and East Riddlesden Hall barn, with two.

### STONE BARNS

Along the geological formations of Jurassic stone from Lincoln to Dorset and beyond it even as far west as Cornwall there is an extended group of barns that served the same purpose as those in the south-east, but are dramatically different in appearance. With great gabled walls and pinnacles of immaculate masonry, with sturdy buttresses, narrow ventilation slits and spreading, arched porches, these barns immediately reveal their monastic origins and a singular desire for monumentality. Some of the earliest, like Cherhill in Wiltshire, were partly aisled; nearly all have their roofs carried by some form of cruck truss, and the exceptions were generally built in the last century of monasticism. Most have imposing gabled porches, often on both sides. The porches have heavy, double doors, and also small, single doorways in the sides of the porches to enable individual people to go in and out when the main doors were closed.

No builders were more assiduous than the Benedictines. Among the earliest of their surviving barns is Middle Littleton barn, built shortly after 1315.[13] They adopted the base-cruck roof construction possibly first used at Siddington, but followed their own magnificence in masonry and carving, and so made their barns rival the finest of their abbeys. Their barns at Bradford-on-Avon in Wiltshire, Glastonbury in Somerset, Stanway in Gloucestershire and, above all, at Abbotsbury in Dorset, itself partly a ruin like the abbey it served, glorify their builders as well as Mother Church.

The stonemasons of Glastonbury Abbey brought decoration to a peak with the exquisite carving of their barn outside the precinct: the four gables of the end walls and flanking porches have traceried windows and panels depicting the Evangelists. The roof is magnificently decorated with two tiers of curved wind-braces springing from two tiers of crucks. This is unsurpassed anywhere, yet the Benedictine monks of Bath Abbey built lavishly at Englishcombe in Avon, the monks of Sherborne at Wyke, Bradford Abbas, in Dorset, and the nuns of Shaftesbury built on a magnificent scale at Tisbury in Wiltshire as well as at Bradford. The Cluniacs built at Preston Plucknett, the Augustinians at Ashleworth Court,[14] and Premonstratensian canons built a great barn at Torre Abbey, Devon. Clerical lords joined in: the Bishop of Exeter at Bishop's Clyst, Sowton, Devonshire, and further afield at Cargol, Newlyn East, Cornwall. So did the occasional laymen: the powerful Berkeleys at Beverstone Castle, the earls of Hereford at Southam Manor in Gloucestershire, and the Holands at Dartington in Devon.

Although most medieval barns on and beyond the Jurassic band were built in stone, there were the exceptions. Pershore Abbey gave Leigh Court barn timber-framed walls as well as its gigantic crucks. Other medieval cruck-framed barns in the region are pale reflections, Rectory Barn at Letcombe

**Abbotsbury barn, Dorset.**

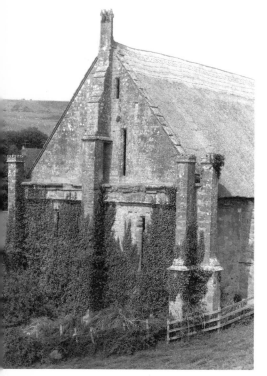

Bassett in Berkshire and Middle Farm barn at Harwell, Oxfordshire, built after 1400,[15] being among the best of them.

**ACCOMMODATION IN BARNS**

Some monastic barns accommodated sleeping rooms and offices for the monk or granger in charge. At Bredon, the granger's lodging over the southern porch is reached by a covered external stair which led to a main room with a fireplace; a gallery, leading to a garderobe, overlooks the middlestead, and from here the granger could direct the unloading of wains and keep an eye on threshing and winnowing as he prepared his accounts. Abbotsbury barn had a granger's room too, and so did Great Coxwell, where it was in the form of a loft over the west porch.

The upper part of these porches had a further use: in the east gable at Great Coxwell, opposite the granger's room, is a dovecot, and a few other medieval barns have them. In Gloucestershire Sudeley Castle barn has two tiers of large windows at its south end and may have contained a lodging with a chute to drain a garderobe, although this might have been a grain floor with the chute used to fill carts below.[16]

*Bredon barn, Worcestershire. Perspective with cutaway of parts of the roof showing some of the aisled frame and the lodging over one of the two wagon entrances.*

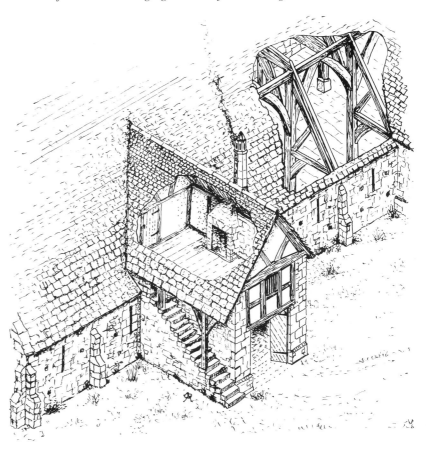

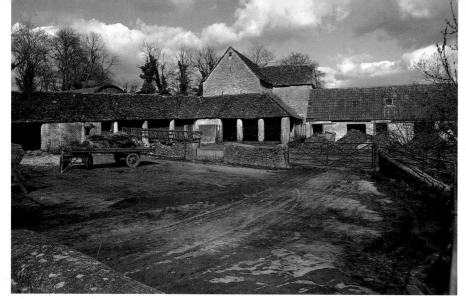

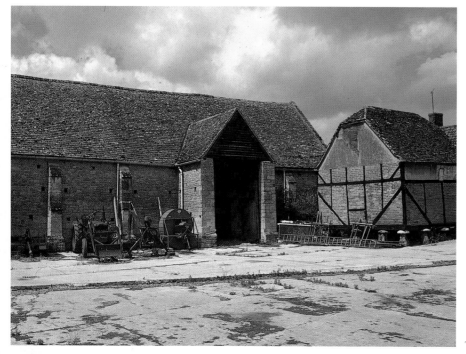

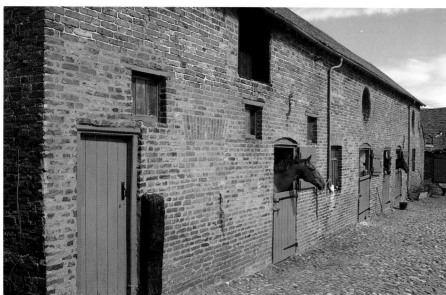

Irongate Farm, Rodmarton, Gloucestershire *(top left)*. Shelter sheds attached to a grain barn and cattle-houses, all built of oolitic Cotswold stone.

Upper Heyford barn and granary, Oxfordshire *(centre left)*. One of the greatest cruck-framed barns in Oxfordshire with

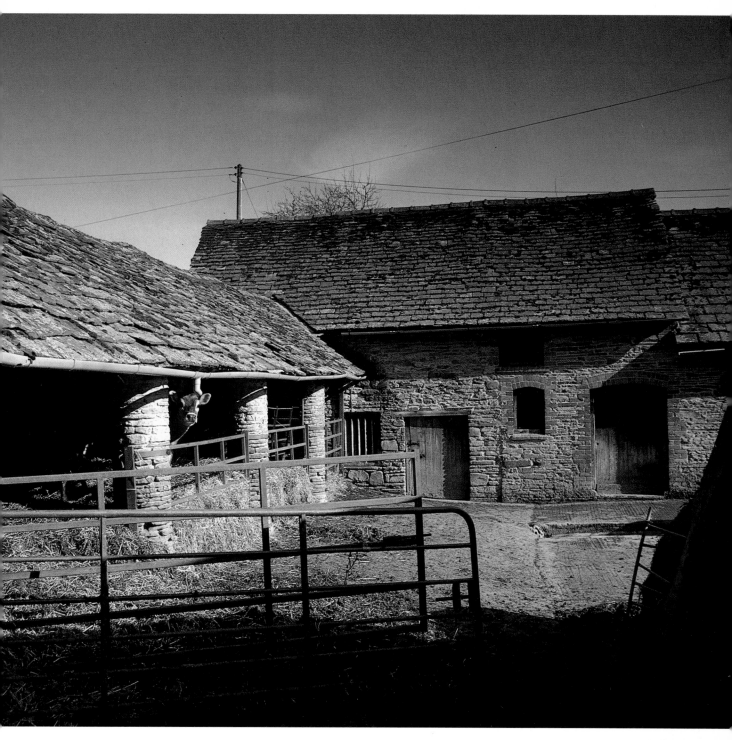

Shelter sheds, Bodcot Farm, Herefordshire *(above).* The supporting piers, constructed in Old Red Sandstone, are circular so that they will not scrape the sides of cattle pushing their way in and out.

buttressed walls of oolitic limestone, accompanied by a sizable 18th-century timber-framed granary.

Stable, Stanwardine in the Wood, Shropshire *(bottom left).* A range of brick stables with a hayloft above them.

## BARNS AFTER THE MIDDLE AGES

The new men of the Tudor settlement often displayed their aggrandizement by following their monastic predecessors with the construction of imposing barns whose architectural quality went much further than the mere needs of usage. One of them was Thomas Josselyn, who was knighted in 1547 at Edward VI's coronation. He bought the manor of Broomhawbury in 1544 and in 1554 the adjacent manor of High Roding in Essex where he built himself a manor house, with a court room and gatehouse, all now gone, and, to serve the new estate, a large barn that survives. For show, he clad those parts of it most likely to be seen from the approach to the house with brick nogging rather than the cheaper wattle and daub used for the rest.[17]

In Norfolk the major landowners built a remarkable series of barns, starting about 1500 with James Hobart's great barn at Hales Court and ending nearly four centuries later with a barn that the Townshends built in 1870 on their estate at East Raynham.[18] Hobart, Henry VII's Attorney General, set the pattern with the red bricks, crow-stepped gables and varied roof trusses of his long barn at Hales Court. Among his friends were the Pastons, the great Norfolk family of letter-writers, courtiers and lawyers. They also built fine barns, the one on the coast at Paston being their only surviving architectural monument; it is dated 1581, and inscribed: 'THE BILDÎG OF THIS BEARNE IS BI SIR W PASTO KNIGHTE'. Unusually, hammer-beam and queen-post trusses alternate to span its flint walls. Apart from flint, the few building stones in Norfolk are limited to dark lumpy carstone and clunch. These materials, never used alone because they weather so poorly, were usually combined with brick. Dersingham Hall barn, which is dated 1671, has the distinction of being the most decorative barn in the whole county. It has the crow-stepped gables so often seen in Norfolk, but it is the combination of materials used in its construction that make it special: purplish carstone forms the gable walls, a high plinth and a band beneath the eaves; the rest of the walls are of creamy-grey chalk, with red brick quoins and surrounds for the openings and, finally, for the crow-stepped gables. Yet the most poignantly decorated of these barns is at Hall Farm, Hunworth. Here flint, cobble and brick make up a pattern of hearts, the date 1700 and three more hearts bearing the initials of Edmund and Rebecca Britiffe, already married for many years when they erected this symbol of their passion.

Lesser success brought into existence many a small but unusual barn, such as a closely studded timber barn at Court Farm, Throckmorton, Worcestershire. In the western and northern peripheries barns continued using traditional forms of framing, often with crucks, or with jointed crucks in the south-west, and sometimes with aisled frames and king-posts in the north. The pair of great cruck barns at Rivington Hall in Lancashire show how the cruck tradition flourished in the north, with stone superseding framed and panelled walls of a type still seen a little further south in the pair of aligned barns belonging to Little Morton Hall at Astbury in Cheshire.

## YEOMAN BARNS

The yeomanry built small and plain versions of their grander monastic and lordly relatives. Their capacity could be as little as 40 cu m (1400 cu ft), but survivors are usually four times as large, and a few are much larger still. Many lacked opposing entrances since poorer peasants seldom had wagons of their

The south-east corner of Broomhawbury barn, High Roding, Essex, complete with its brick nogging.

Dersingham barn, Norfolk.

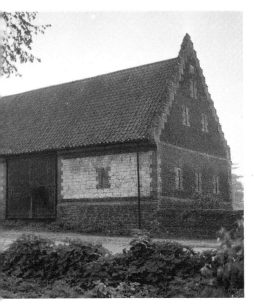

own and were not disposed to leave up to a third of the space free for threshing and winnowing. Their barns were general-purpose buildings, but, however used, the ownership of even a small barn which formed a yard with the peasant's house gave his croft the satisfying appearance of a tiny manorial farmstead and the greater practical advantage of removing many agricultural activities from his house. Such a man was clearly on the way up.

A minute timber-framed barn of three bays at Valley Farm, Ubbeston, Suffolk, with a capacity of only about 45 cu m (1600 cu ft) must have been built as a labour of love by a peasant whose desire to improve his farmstead was greater than what his expected harvests would warrant. In the old county of Middlesex a three-bay barn at Smith's Farm, Northolt, Ealing, Greater London, built in 1595 had a moderate capacity of 700 cu m (24,500 cu ft), but still followed the Archbishop of Canterbury's large barn at Headstone in its width, and standard queen-strut roof. Surrey barns increased in size as London and other markets grew. Three bays were common in the 17th century, five in the 18th, and these had aisles for secondary uses. They also had opposing doors to facilitate winnowing and the passage of carts, unlike barns in Middlesex. An aisled barn on the Downs at Effingham uniquely recorded the names of the four men who raised its frame in June 1742 as well as the landlord and farmer for whom it was built.[19] Where arable farming dominated agriculture, the old interdependence of landlord, tenant and labourer continued from the Middle Ages, and this barn showed it.

Many barns were built of cob before stone or brick became cheap. In Northamptonshire, Hall Farm at Teeton was built in the 17th century of passably good Upper Lias, but cob was still used for its barns and one of them survives. Small cob barns such as those at Washingford Farm, Bergh Apton, Norfolk, and Flint Street, Haddenham, Buckinghamshire, are typical of a long tradition of peasant building that was centuries old when they came to be built. Another hint of the appearance of early peasant barns can still be seen in East Sussex at Foxhole Bottom, Westdean, in a 19th-century barn, which, like so many others around here, is made of flint with brick lining the wagon entrance and the ventilation holes. The usual practice is also to have brick quoining to square off the corners, but in this barn they are continued in flint and rounded, like the wall base of a much older barn on which it rests, and whose age-old form it continues.[20]

It was in brick that most medieval peasant barns in the Midlands and East Anglia came to be replaced. Their builders exhibited great imagination in the way they omitted bricks in the barn walls to provide ventilation opening: crosses, lozenges, chequers, and many other patterns made up a wide vocabulary with little expense.

On the Cotswolds, high grain prices in the 17th century and ever cheaper Jurassic stone brought into being numerous fine stone barns which took their great monastic predecessors as models. With three or five bays, they are smaller, and their decoration is restricted to a well-turned arch over a gabled wagon entrance, and perhaps a datestone and some ornate finials. Their solid, flagged roofs are often carried on trusses that look a little like crucks, but instead have graceful arch-braced collars supporting the principal rafters, and sometimes curved wind-braces as well. Among the earliest is a barn at Taddington, dated 1632 in the gable of the wagon entrance. Its fine elliptical

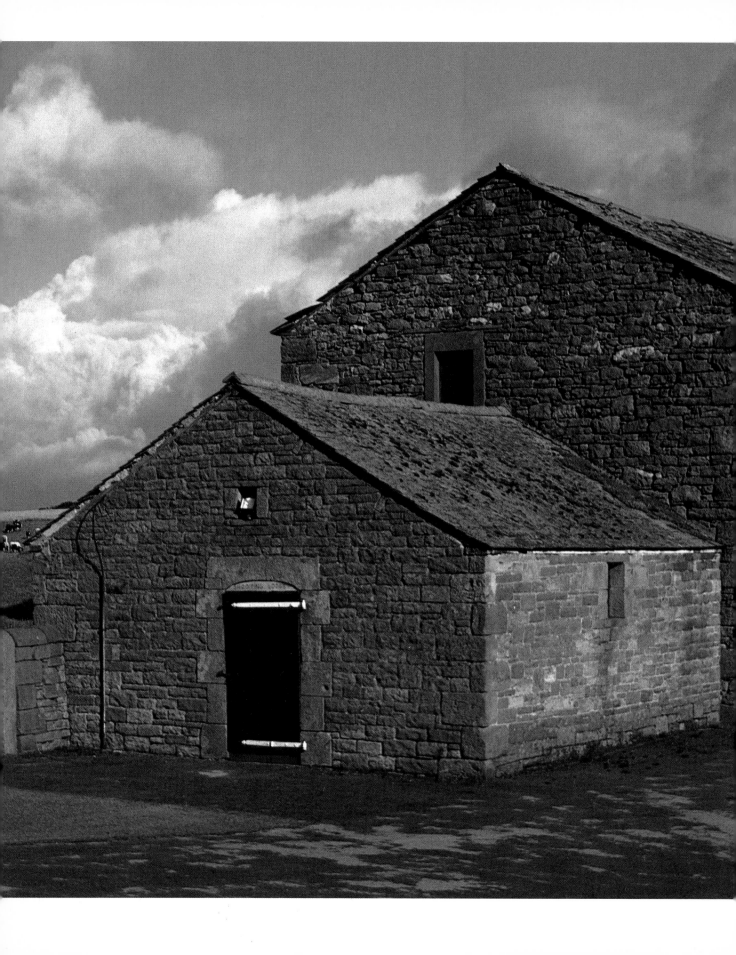

A stable and cartshed, Newton Reigny, Cumbria *(left)*.

Peper Harow granary, Surrey *(below)*.

Warehouses on the bank of the River Nene, Wisbech, Cambridgeshire *(bottom)*.

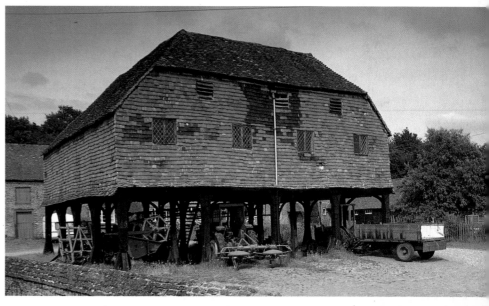

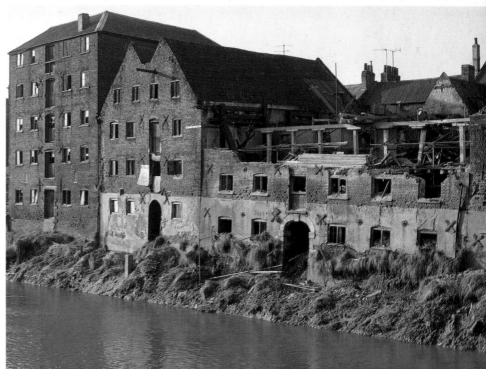

arch with a keystone is a reminder of the new secular architectural taste that followed the Dissolution, but most of these Cotswold barns were built in the 18th and early 19th centuries. Pinchpool Farm at Windrush has a barn dated 1833, but this was by no means the last, and they continued to be built until the depression of corn prices in the last quarter of the 19th century. They do not vary much, except in detail. The greatest, at Lowesmoor Farm, Cherington, is the exception. Its seventeen bays and two middlesteads bring it up to monastic dimensions, and on the west side is a dovecot in the form of a tower, and while this is again the grandest in the region, many barns on the southern Cotswolds have dovecots in their gables.

## IMPROVED BARNS

Long after the Dissolution, when Henry VIII rewarded Sir John Gage for his services as vice-chamberlain with the grant of Battle Abbey's Alciston Manor, his descendants extended the present barn and gave it its present L-shaped plan. During a rebuild of 1750, they formed a stable with a hayloft in its east end, and made the interior of the barn more useful by introducing a method of framing that did without tie-beams and allowed crops to be easily piled right up into the roof space. This relied on sling-braces, pairs of curved timbers that rise between the arcade-posts and the principal rafters to stop them from splaying outwards. A primitive form of sling-brace was used for the secondary trusses of Newhouse Grange barn at Sheepy, Leicestershire, early in the 16th century,[21] and these became popular in the 18th century, especially in granaries. A barn at Owlett's Farm at Cobham in Kent had the greater part of the tie-beams of two bays removed and the stubs on each side bolted to sling-braces. A different way of increasing the unencumbered height of a barn used in the north was to replace the tie-beam and king-post by yoking the principal rafters together a short way beneath the ridge and mounting a short king-post at this level, in the way used in the central trusses of a barn at Falthwaite Grange, Stainborough.[22]

*Alciston Manor barn* (left and centre) *and Birling Manor granary, Eastdean* (right), *East Sussex. Cross sections, showing how, in the barn, the late medieval frame relying on a tie-beam and two tiers of collars was replaced in 1750 by sling-braces which cut short the tie-beam and provided a higher open span; the granary, meanwhile, is apparently similarly framed, but here the lower collar is supported on struts rising from a bridging-joist, a different structural method which achieves the same end, a clear space.*

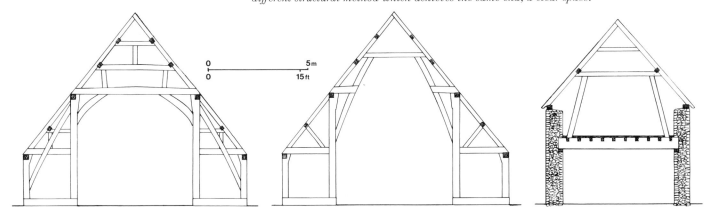

0        5m
0       15ft

A few barns provided some kind of rudimentary accommodation at one end or in a loft. This was not a granger's room in the medieval way, but probably a bedroom for farm hands, even though they were usually treated as part of the household on yeoman farms until the 18th century. A 17th-century barn in the Sussex Weald at Park Farm, Mountfield, with unglazed windows on three levels, all fitted with sliding shutters, suggests this use, and a similar barn at Mill Cottage, Salehurst, was possibly used in the same way.[23] In the north the aisled barn at Hopton Hall in West Yorkshire had a room built into one end, and a barn of 1689, at Smith's Farm, Dalton, Lancashire, had a second storey over its south bay reached by external steps and lit by a mullioned window. It lacked a hearth and may again have been a bedroom.[24]

## GRANARIES

Grain was important to everyone, for daily bread, for seed corn, for market and for animal feed. Whatever its destination, it needed special attention. Grain was stored successfully underground in the Iron Age, but that had been forgotten. Yeomen put their money into houses, and their grain went into their houses as well, or into their barns. They seldom built granaries, and this was left to important landowners, men who were apt to build grand barns.

Customarily yeomen stored grain in upper chambers or garrets. Weight rather than space was the determining factor. A bushel weighs about 30 kg (70 lbs), so it only needed about thirty bushel sacks to impose a weight of one tonne on a granary floor. An upper chamber in a solidly framed house could cope with weights of this kind, and indeed fulfilled every requirement of a granary. It was secure and not easily raided by thieves, nor could rodents attack the grain undisturbed. It was watertight yet airy.

When grain was stored in sacks, no more was needed. When it was stored loose, the floorboards would have to fit tightly together and a closely fitted skirting was needed as well. Just such a room occurs in the gabled garret of Richard Blakeway's Berrington Manor in Shropshire. Its tongue-and-grooved boards and plastered walls were evidently designed to stop grain from falling through. Better than tightly fitting boards was a floor plastered with gypsum as commonly found in parts of the northern Midlands, especially in the Trent valley where gypsum is readily obtained. Woodroffe's at Marchington in Staffordshire has upper floors finished in gypsum plaster and any of its garrets could have served as a granary.

When grain was stored in barns, the sacks could stand directly on the ground, but in some barns, notably at Widdington Hall and at New Hall, High Roding, Essex, raised floors were constructed in the end bays to ensure that the grain stayed dry. To protect grain from rodents, there were farmyard cats and dogs, and small holes like those high in the gables of the barn at Dersingham in Norfolk encouraged owls.

These raised floors were distinct from the individual granaries that were occasionally built on large estates. A granary at Navestock Hall Farm in Essex was so well built that two hundred years later it could be taken down and re-assembled in the farmyard, as an inscription records: 'J.C. J788 Re. Built'. It remains, remarkably, as it must have been when new, raised on low brick piers to promote airflow and to deter rats; its floor is solidly joisted and boarded, and the walls are closely set with solid, grooved studs into which

Foxhole Bottom barn, Westdean, East Sussex *(right)*.

A field-house, West Witton, North Yorkshire *(below)*.

A medieval granary at Colville Hall, White Roding, Essex *(bottom)*.

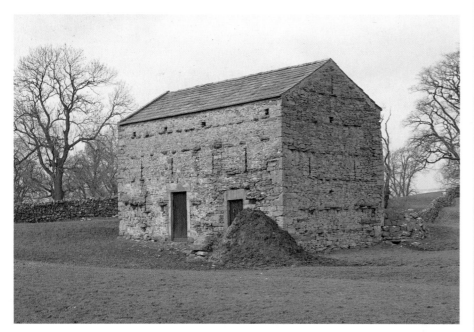

thick, tongued panels were slid and then held fast by the sills and top-plates, thus providing an extremely strong container able to bear the outward pressure of the grain.[25] The granary at Colville Hall, White Roding, is again similarly constructed, though the boarding, instead of being tongued into grooved studs, is more simply halved and lapped, one board over the next, and pegged top and bottom into the plate and sill. It was later fitted out with rough partitions so that grain of different kinds could be stored loose.

Most granaries were small, box-framed structures with a gross capacity of 80 to 90 cu m (640 to 3200 cu ft), or 500 to 2500 bushels. Although their useful capacity was less than half this, they provided enough space for two or three separate crops. By the late 17th century their plinths took the standard form of a series of mushroom-shaped staddle-stones, which efficiently countered damp and rats. These staddle-stones were usually spaced in three or four rows of three or four, making nine, twelve or sixteen stones in all. Small granaries made do with five staddles, one at each corner and a fifth in the centre. A removable ladder provided access through a narrow door.

The solid vertically grooved studding of the Navestock granary soon gave way to brick nogging or wattle and daub. A granary built beside the great barn at Upper Heyford in Oxfordshire is so large that it needs closely set staddles, arranged six by six, and solidly framed walls filled with brick nogging, only giving way to light lath-and-plaster at the top. Later granaries, right until the 19th century, were weather-boarded, but they did not have to withstand the pressure of loose grain. Typical of hundreds is a weather-boarded granary at Blaxland Farm, Sturry, Kent, which rests on nine staddles and has two sizeable bins on one side of a gangway and space for sacks on the other, making room for about 500 bushels in all.[26]

## RAISED GRANARIES AND CARTSHEDS

A different type of granary, exemplified by one at Birling Manor, Eastdean, East Sussex, was built of flint with a raised floor over a cartshed and external steps to reach it. Its roof is supported by raking struts that rise from the floor but leave the interior relatively unencumbered. This form of framing is common among stone and brick granaries on the Downs and also in Herefordshire where yeomen had typically stored their grain in upper chambers. Near the end of the 17th century, better yields of corn caused them to build large numbers of granaries with two low storeys reached by a ladder and plastered inside to seal them and facilitate shovelling. Instead of struts rising from the granary floor to support the roof, there might be sling-braces or crucks, so reduced in size that all they did was to strengthen the angle between wall and roof rather than bear much weight. They were built over a ground storey that was sometimes dug out to form a semi-basement for a back-kitchen, wash-house or dairy, or more occasionally for a cartshed. Some granaries were built as cross-wings, like one at Wormbridge Court, where the early 16th-century house was refaced in brick and the projecting granary wing made to match a symmetrically placed domestic wing in everything but its use of ventilation holes instead of windows. Architectural considerations were usually less in evidence, and most granaries followed the example of a brick granary added in 1730 to the timber-framed Mintridge Farm at Stoke Lacy, which had been built a generation beforehand.[27]

Granary at Birling Manor, Eastdean, East Sussex.

Raised granaries were less easy to fill than the lower granaries set on staddles, nevertheless a majority of later granaries were in the form of lofts, and so were all the largest. Lifting sacks by the hundredweight up steps into a granary, or, worse, up a ladder, was after all only one exhausting job among many, and the space underneath could be utilized as a shelter for cattle, although this was not greatly favoured because of the damp, fetid air that rose from the animals. It was better to put a granary over horses than over cows, because they were not stalled so closely; better still, the lower part of the granary was kept open and used as a general shelter.

One of the oldest raised granaries, at Brenley Farm, Boughton-under-Blean, on the fertile soil of north Kent, probably goes back to the 16th century, if not the Middle Ages, and originally had a series of posts down each side to support five massive beams that carried the floor over a space that would have served carts well. The entrance to the granary was up a ladder to a doorway in full view of the farmhouse, and the interior was set out with bins, which have vertically grooved timbers to hold the planks that form their sides.[28]

Yeomen had only a few carts on their farms at the end of the Middle Ages, and these were generally kept in barns when not in use. When farm equipment increased, implement sheds that kept off the rain and let a steady flow of air dry out everything sheltering beneath became a sensible proposition. If they were made to face north, they would keep the sun off the carts and implements as well, and stop them from warping. Most raised granaries could provide space for a pair of carts, each in a separate bay. A large granary at Queen's Court Farm, Ospringe, took advantage of the slope of the land in such a way that it could be entered easily from the top of the slope, while the sides were supported by flint walls and, down the slope, the undercroft could be entered by carts or wagons.[29]

The largest and finest of all granaries stands like a proud market hall in a position of honour at the centre of Peper Harow Farm in Surrey, surrounded by attendant farm buildings and labourers' cottages. This vast granary has been dated to about 1600, but the complexity of the internal arrangements and details of the framing and tile-cladding are more compatible with the early 18th century. Its twenty-five massive posts form a square grid, four bays by four, with enough space for wagons, tractors and other modern implements between them. Were the granary's floor area of 130 sq m (1450 sq ft) filled to only half its height, it would have a capacity of over 5000 bushels, or 6 tonnes per bay. Two bays have trap doors with sack hoists over them, thus easing loading and unloading from wagons stationed under cover, and the equivalent of a further bay contains a staircase with a sack store under the stairs. Five bays comprise complete bins, another three bays are for storing grain in sacks, and three small bins occupy parts of two more bays, altogether providing space for 2000 bushels. The roof is floored over for yet more storage, making in effect a huge warehouse where all kinds of grain could be brought in, stored and despatched with great ease and efficiency.[30]

At the other extreme was the hovel or helm, a form of raised granary or general store, common among both smallholders and prosperous farmers in the arable Midlands, again with space beneath for implements. Sometimes this was no more than a stand high enough to shelter carts and support a

Dawson Fold, Crosthwaite, Cumbria *(left)*. The pentise roof of this bank barn in the Lyth Valley shelters the entrances to the cattle byres, while above it is the barn door from which straw can be pitched down to the animals.

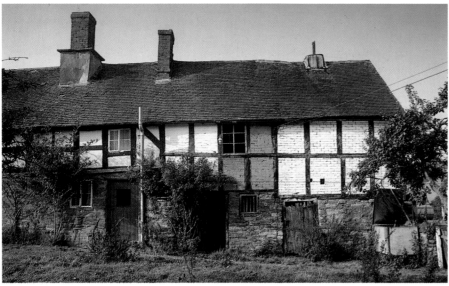

Winley Farm, Tedstone Delamere, Herefordshire *(left)*. Only the remains of a later cowl and, inside, a treading hole, identify the 17th-century extension at the right-hand end of this 16th-century house as a kell.

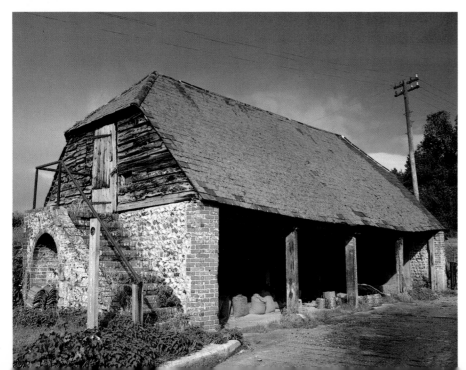

Church House Farm granary, Litlington, East Sussex *(left)*. The flint of its walls is readily found here on the South Downs, but the roofing slate probably came by boat from north Wales. The arched recess beneath the steps probably sheltered a kennel for a dog who guarded the grain upstairs and kept rats at bay.

Priory Farm dovecot, Stoke sub Hamdon, Somerset *(right)*.

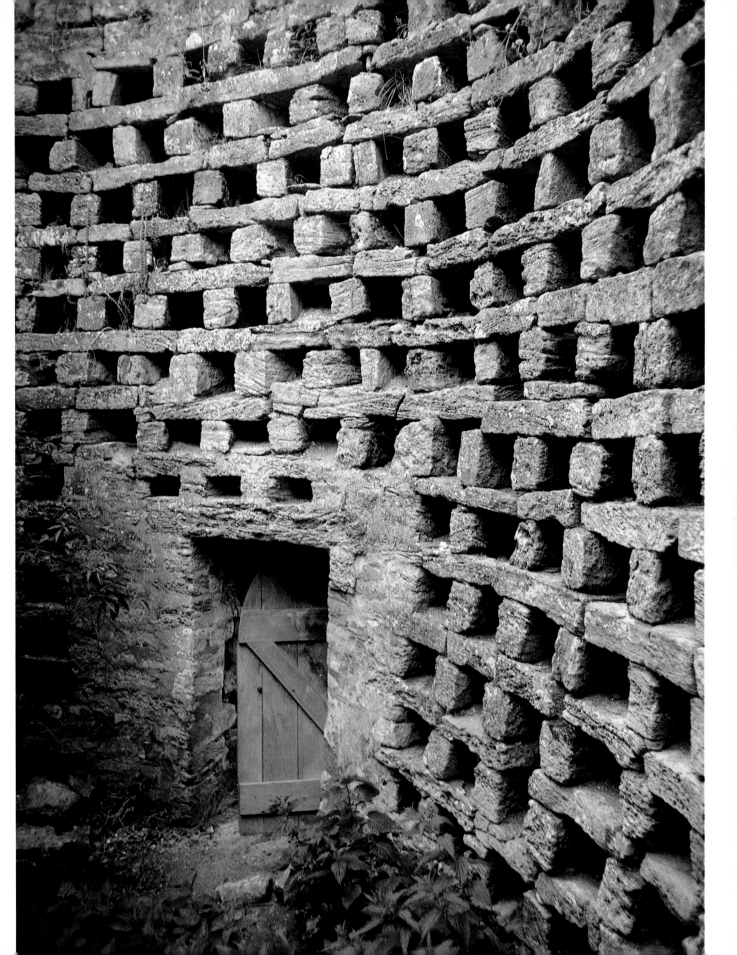

thatched stack of hay, peas or grain clear of the ground. In east Yorkshire these structures could be taken down and moved, but often they were as strongly built as the weight they had to bear implies, and large enough to protect half a dozen wains or carts underneath.[31]

**WAREHOUSES**

Granaries were, in effect, specialized warehouses, just as barns were general warehouses devoted to farm produce, but also normally used for threshing, winnowing and other farming activities. Apart from their opposed entrances and threshing floor, there was little architectural difference between them and many other warehouses which had no agricultural function. Indeed, the Vicars' Barn within the precinct of Lincoln Cathedral, which was designed only for the storage of tithes and not for threshing, and similarly Carlisle Cathedral's tithe barn were warehouses in all but name, and are hardly distinguishable from many early warehouses which had no immediate agricultural connections.

For instance, the wool from Beaulieu Abbey's estates was despatched to Southampton where it was stored in the Wool House at the low end of Bugle Street facing the quayside to await shipment. This was built about 1400 in the form of a wide barn with stone walls, buttressed down the sides to counter the thrust of a fine arch-braced timber roof. Significantly, it was entered at one end rather than at the side because the restrictions of its urban site necessitated its building end-on to the quay. A similar though later warehouse on South Quay at King's Lynn has its entrance, just like a barn's, in the centre of the long side facing the water. Both of these buildings have far larger windows than the ventilation slits of a barn since goods needed to be clearly seen when they were sorted for shipment, but the windows had to be shuttered and barred for security.

Many kinds of goods were better stored in cool, dark spaces, and undercrofts fulfilled this purpose, as well as serving as shops for manufacture and sale. Undercrofts nevertheless suffered from restricted access and height, and, as the needs of efficient trade increased, multi-storeyed warehouses became the norm. A rare early survivor was built about 1400 at Faversham on Quay Lane facing Faversham Creek. It looks like a hall-house with characteristic Kentish framing and an overall hipped roof, except that jetties run the full length of both sides as evidence of its full upper storey.

The jettied warehouses of the Steelyard at King's Lynn, built soon after 1475, again provided two storeys for the storage of goods, which could be sorted inside or on the quay, but the two-storeyed warehouse built of brick about 1500 to terminate the quayward end of Hampton Court had an open ground storey to ease the process of loading, unloading and sorting. A fine surviving arcade of four-centred arches supports the upper floor and gives access to the sheltered space below, and, at once, status to the building, making it immediately recognizable from the river.[32]

Later warehouses continued these patterns, usually without the luxury of an arcaded open space beneath them, and the number of storeys grew with trade and the increasing restrictions on quayside space. The warehouse built in the 16th or 17th century on Standard Quay at Faversham, apparently from material taken from the suppressed abbey, is 49 m (160 ft) long, with a main,

central range of twelve bays divided into two lofted sections.[33] Rather later, another surviving warehouse was built on North Brink at Wisbech with a barn-like form, similar to the warehouse on South Quay at Lynn, and its interior is fully storeyed.

By the 18th century, warehouses were following houses by adopting the double pile plan and even multi-piles as well. The three-storeyed Grist Mill built on The Strand at Rye in East Sussex is a double pile with walls of stone imported from France; The Great Warehouse, which the Corporation or its tenant built nearby about 1736, is a triple pile with internal arcades four bays deep, and two main floors with a high loft built into the roof space over them.[34] In many ways it is very like the granary at Peper Harow, excepting its enclosed ground floor. This became a common pattern, to be repeated in a double-pile warehouse facing the Nene at Wisbech, which was built on an undercroft opening directly on to the river itself without an intervening quay.

Just as the double-pile house lent itself to standardization and the formality of classical forms, so did these warehouses. They also needed new methods of framing for their wide-spanning roofs, as often as not made from timber imported through the ports they served. Before the end of the century, iron was introduced into their construction, and expressed the new traditions of the Industrial Revolution. Nevertheless the old patterns remained. Nowhere were they better expressed than in the great iron arcades of Telford's St Katharine's Dock, which once stood adjacent to the Tower of London. At Jesse Hartley's Albert Dock in Liverpool, which has happily survived the changes which have reduced so many English ports, they still remain.

## CATTLE HOUSES

Houses for animals have an endless variety of forms. Farm animals have differing needs and ideas about how animals should be kept changed over the years, and even more so from place to place. The earliest cow-houses, the so-called shippons of Devon long-houses, had the most important feature of any cow-house, a drain running downhill to carry off urine. Surviving shippons follow ancient practice, with a manger on both the front and back walls, an arrangement that still remains at Sanders and in a deserted long-house at Pizwell. In a long-house at Chapple, Gidleigh, cattle were unusually tethered in two rows across the shippon rather than down its length. In some excavated houses the holes where vertical tethering posts were driven into the ground have been found close to the side wall; in surviving shippons the tethering posts were slotted into granite base-stones or curbs and held at the top by a rail or tenoned into a beam, but with a means of quick release for the yokes in case a cow fell and had to be rescued in a hurry. The drain was covered over with stone slabs as it was meant to take urine only, the dung remaining behind mixed with the litter of straw and bracken to be used later as manure. Many shippons had small holes near the drain so that the manure could be raked out. Eventually floors were inserted into shippons to provide a small loft for hay, straw or bracken.

Detached cattle-houses were generally similar though seldom built as well. Later cattle-houses, such as one at Mintridge, Stoke Lacy, Herefordshire, had two passages along a row of tethered cattle, a narrow one at the front for feeding, a wider one at the rear for access to the cattle and for mucking out, but

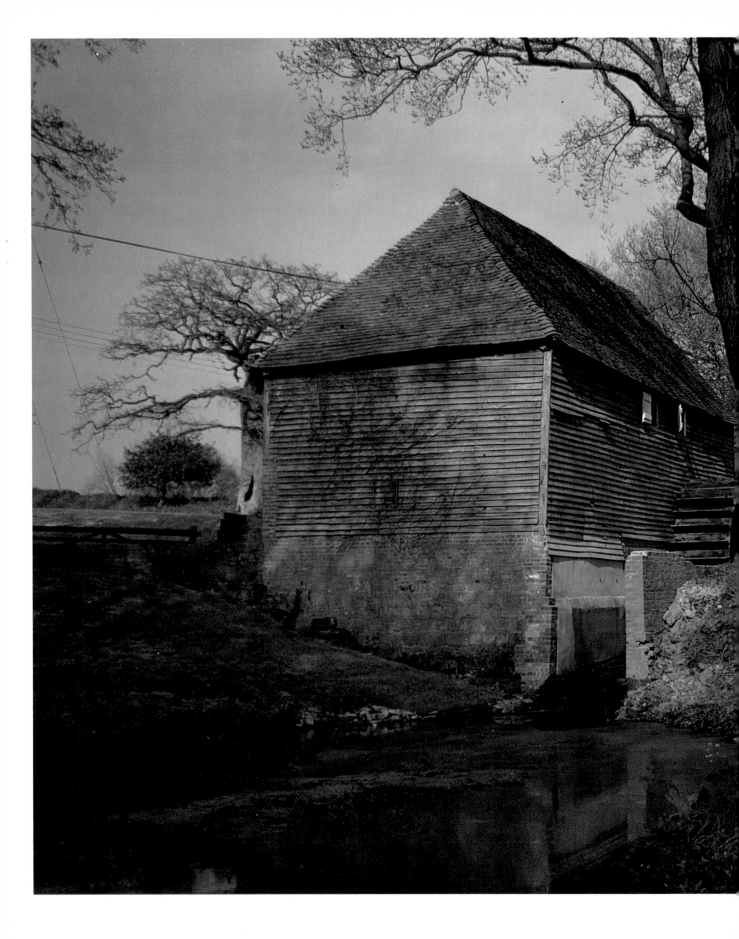

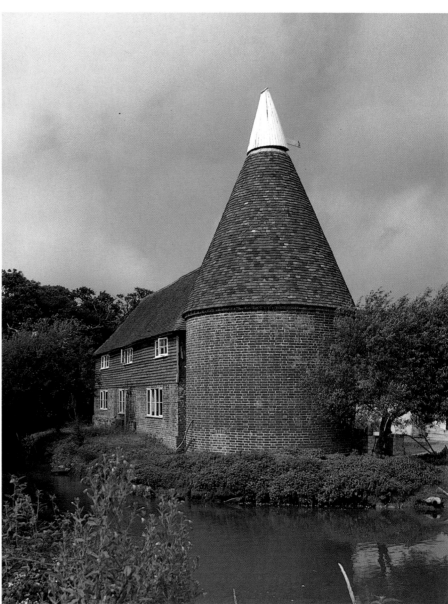

An oast, Great Sprays, Penhurst, East Sussex. The original oast of about 1700 is the weatherboarded building behind the roundel, but when the latter was built in the 19th century the earlier part served as the stowage.

A watermill, Mickleham Priory, Arlington, East Sussex.

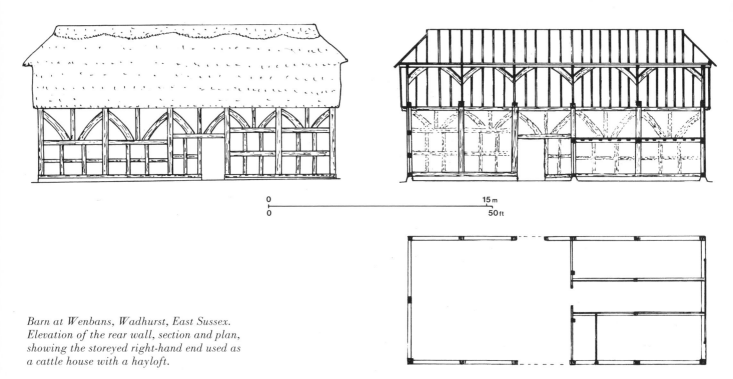

0            15 m
0            50 ft

*Barn at Wenbans, Wadhurst, East Sussex. Elevation of the rear wall, section and plan, showing the storeyed right-hand end used as a cattle house with a hayloft.*

this form did not become universal in pastoral areas, and in the east far simpler accommodation was the rule.

Valuable milking cows and draught oxen were penned with tethering rings or posts to keep them in their stalls, pair by pair, so that they would not disturb each other, particularly when they were milked from one side. A sick beast or calving cow was usually confined within a large stall known as a loose-box, where it would not be disturbed nor need tethering. In wetter areas hay was kept in a loft conveniently placed over the stalls so that it could be dropped down to the cattle, often through openings directly into mangers. These lofts were placed just above the cattle and the windows were small in the false belief that light and air were detrimental to the animals.

Where cattle were secondary to crops, yeomen did without specialized cattle-houses and if they needed indoor accommodation they adapted whatever buildings were already available when they increased their herds. In the south and east this was common, even in pastoral areas like the Weald. Here the barn was the main farmyard building because of its overall usefulness, and the ease with which cattle could be kept inside it. The two southern bays of a lavish five-bay barn of about 1600 at Wenbans, Wadhurst, were floored over and fitted with two rows of stalls arranged so that the animals faced inwards to a central feeding passage with access to the rest of the barn and the loft above, where hay and straw were stored. The stalls varied in width, maybe because the two dozen cattle housed there were of two types.[36]

Stalls for cattle, whether kept for beef, dairying or draught, were ubiquitous in barns all over the country at this time. Only their haylofts survive now, since the stalls themselves were insubstantial and meant to be: the cattle

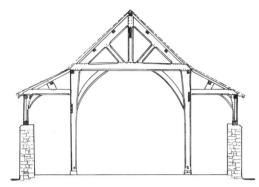

*Gunthwaite Hall barn, Penistone, South Yorkshire. Part elevation and section, showing the decorative framing of the south side, and the chamfering of the aisled trusses inside, ostentatious decoration which may be due to the marriage in the middle of the 16th century of Godfrey de Bosville, lord of the manor, to Jane Hardwick, sister of the Countess of Shrewsbury, who built Hardwick Hall.*

needed no more, and flexibility in the usage of space was more important than solidity. In the north cattle were generally stalled in the aisles of barns, rather than under a loft. The early barn at Shore Hall, Penistone, South Yorkshire, had its aisles widened to accommodate byres; later barns, like the ornate one at Gunthwaite Hall, had wide aisles from the start, that is about 3 m (10 ft) as opposed to 1.5 m (5 ft), and some late barns, like those at Low Hall and High Farm, Horsforth, and at Mock Farm, Mirfield, have aisles nearly as wide as their naves, so important was the stalling of cattle on the West Yorkshire Pennines.[37] The same arrangements were used on the Lancashire side of the Pennines in barns at Great Mitton Hall, at Gate House, Hurstwood, and at Dry Gap Farm, Shuttleworth, where aisles were incongruously added to a cruck barn, both at the side and at one end as well. Small barns without aisles often followed the southern practice of having a byre at one end. To aid drainage, the byre at Onesacre, Bradfield, South Yorkshire, was built down a slope, so the trusses at the lower end of the barn had to be raised on plinths, and the cattle faced up hill so that their mangers could be easily filled with straw. In some late 17th-century barns the end containing the shippon was significantly wider, giving them a lop-sided appearance, By the end of the 17th century the end containing the stalls was treated as a shippon in its own right, the aisles extending inwards for the animals and the nave shrinking to no more than a feeding walk.

**SHELTER SHEDS**  Wintering cattle in foldyards was common in the dryer eastern counties from the Thames to the East Riding.[38] Foldyards, or crew-yards as they were called in Lincolnshire and the East Riding, were formed by barns and simple sheds or 'hovels'. Hovels were widely used in the south-east from at least the 14th century as shelters for swine or other beasts, two hundred years before the word assumed a wider, derogatory meaning. They were usually no more than a

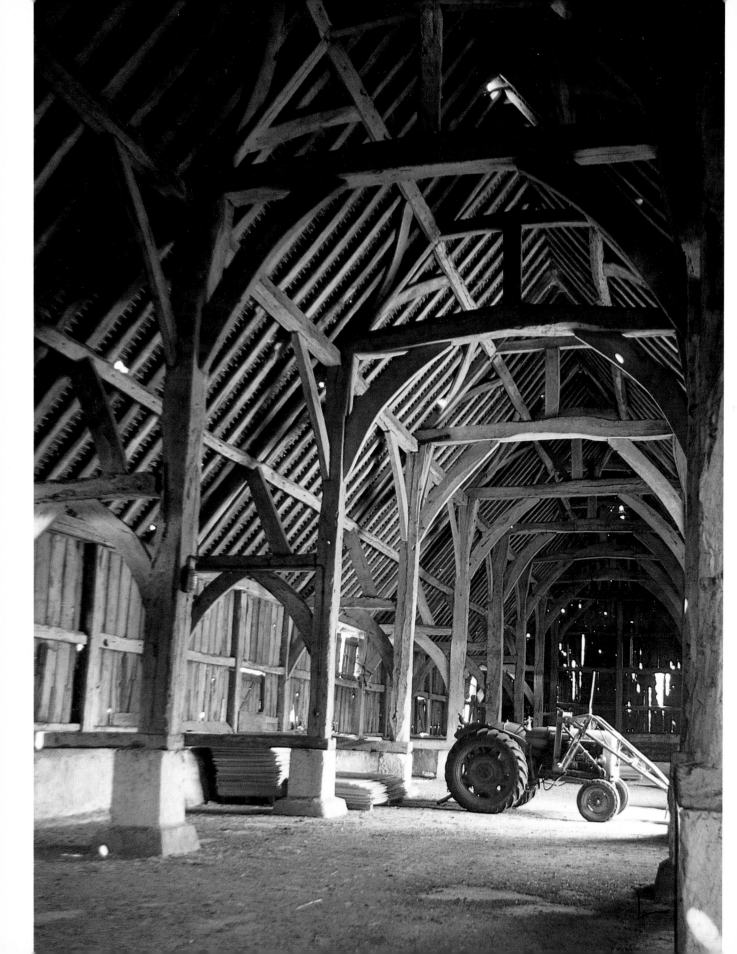

roofed but otherwise open building, now called a shelter shed. In some of the drier parts of the country, almost regardless of winter temperature, no more was needed. With plenty of straw from threshed corn, there was no lack of winter bedding or litter to make cattle comfortable in these draughty structures. Set around an enclosed yard, hovels could confine cattle away from the following summer's pasture. That was important as the amount of grass and hay the pasture produced could limit the size of a herd. Foldyards have a further use. Throughout the year cows could be brought here for milking. The less restful were stalled in the sheds, but, for the remainder, a bucket and a three-legged stool in the yard were enough.

Local fashion, materials and individual wealth determined how these shelter sheds were made, but their function was invariable. They could have mangers on the back wall, or a drinking trough. The construction could be flimsy and use whatever materials were to hand or be as solid as a barn. The rear wall might belong to another building or a boundary, the side walls likewise, with the shed no more than part of a range of varied buildings. There might be as few as two or three arcaded bays, each about 2.5 m (8 ft) wide and between 2.5 and 3 m (8 and 10 ft) in depth, or the bays could run like a cloister around two or even three sides of a foldyard.

In West Sussex these sheds are still called hovels, but the shelter shed from Lurgashall, rebuilt at the Weald and Downland Open Air Museum at Singleton, is anything but rudely built. Its oak framing follows the long-standing practice of using posts braced to a top-plate, and they support an overall hipped roof. The two posts at the front are tenoned into grooves in tall foundation stones, and the rest of the frame is similarly built a high stone plinth that kept the timbers clear of fouled litter, damp and the threat of rot.[39]

Later sheds had flagged or tiled floors, raised above the level of the fold-yard with a slope to facilitate drainage. These and troughs and mangers differentiate shelter sheds from implement sheds or cart sheds, and so does the width of their bays, which had to be well over the usual 2.5 m (8 ft) if carts were to be driven inside. Where there is good stone, occasional expensively built shelter sheds are supported by classical columns. At Edge Farm in Gloucestershire, the shelter shed has plain monolithic piers of Cotswold stone; and the fine shelter shed at Ryley's Farm, Grittleton, Wiltshire, sports round columns with capitals. The arcades of most sheds are seldom so lavish; brick or stone piers, round or square, are far commoner, the round ones having the advantage of lacking edges to hurt the cattle.

## LINHAYS

Similar shelter sheds, called 'linhays' or 'linneys' in local dialect, were built all over the West Country in the 17th century. In the centre of Devon hardly a farm is without its linhay; many farms have two of them, and the largest farms have several.[40] The main difference between them and ordinary shelter sheds is the provision of a loft for the storage of fodder and litter, which can be dropped down to the animals. Like shelter sheds, linhays have solid rear walls, and usually solid side walls as well, though rain can still blow through the open front. This is supported by an arcade of posts, and they carry the beams of the loft floor, which are often tongued into them. The shelter is of normal storey height, and the opening into the loft is usually half that or even less. As in

Harmondsworth barn, Hillingdon, London
*(left)*. One of the finest surviving barns built on the Bishop of Winchester's estates.

185

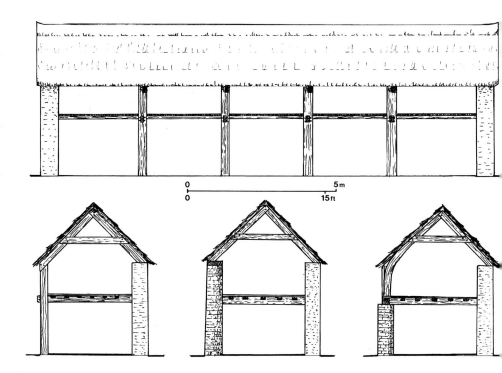

*Devon linhays. Front elevation and sections, showing* (left to right) *a typical linhay with cob side and back walls and timber posts at the front, a linhay from Braunton Marsh with circular stone piers at the front, and a linhay from Hatherleigh with half-height piers and crucks.*

shelter sheds, the arcade posts are mostly of wood, but in north Devon a few are of sandstone. A fine linhay on Braunton Marsh forms an isolated yard with lower buildings and has full-height stone piers. When only the lower part of the arcade is stone, the upper, timber part rests on the end of a cross beam. The walls are usually of cob or stone, or with cob or weatherboarding over a stone base. The roof structure is designed to allow the hay to be piled as high as possible, so the trusses are of simple design often with principal rafters joined by a collar, very occasionally with upper crucks, as at Deckport, Hatherleigh.

Like shelter sheds, linhays were built in yards, and occasionally in an isolated field. The small yard at Burnthouse Farm, Otterton, formed by a tall linhay opposite a cob barn, is typical of many, while the linhays forming the outer court at Bury Barton, Lapford, are on the grandest scale.[41]

**LAITHES** A more ingenious building specifically designed for cattle is the laithe, a type of barn common on the Pennines where the predominance of cattle over grain was fully recognized. Instead of the stalls being fitted into a barn, wherever this was convenient, half of the laithe was specifically designed for them. Laithes have a wagon entrance in a middlestead that acts as a threshing floor in the traditional way, then to one side is a space for crops, on the other the stalls, called a 'mistal'. They have their own entrance, and, over them, a loft for hay and the straw left behind after threshing.

186

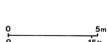

*Catherine Slack, Hebden Royd, West Yorkshire, one of the last laithe-houses, built in 1880. Plan, showing a four-room house at the right-hand end, with a living-room and scullery built over a small cellar, and direct access to the laithe, which has, traditionally, four stalls for milking cows on the right-hand side of the central middlestead and threshing floor, and an open stall for more cattle on the left; the corn and threshed grain and straw were all stored in lofts.*

This plan rationalized the accommodation provided for cattle in threshing barns, though the timing of the arrival of the first laithes and the adaptation of barns to take cattle cannot be disentangled. Both developed quickly as farming veered towards cattle and away from grain during the climatic decline of the 17th century. The laithe was already being built as a specialized combination of cow house and barn *c.*1600, at least by important yeomen.

Many laithes were like one at Greenhill, New Mill, on the Pennines above Holmfirth, which has two separate sets of stalls, five in all, and two loose-boxes and a barn in the upper part. This was one of the earliest laithes, if the four pairs of cruck trusses that frame it are any guide.[42] Gilberte Brokesbank's laithe of 1650 at Bank House, Luddenden, was divided equally between barn and mistal, and had four stalls for eight cows facing inwards. The majority of laithe-houses were built in the later 18th and 19th centuries on the newly enclosed commons of the Pennine heights at a time when the mills of the Industrial Revolution were pressing their way along the fast-flowing rivers of the valley bottoms and filling them with toil and soot, and an expanding market for meat and milk.

Further north the construction of various combinations of barns, byres, stables and granaries as continuations of farmhouses became commonplace in the later 17th century. In Teesdale, for instance, the thatched Grass Farm at Hunderthwaite, Romaldkirk, County Durham, was built in 1703 with a low room over a firehouse and an attached byre at each end, one of which had a sleeping room for a farm hand over it.[43]

**FIELD-HOUSES** In the Dales different topography brought a different settlement pattern. The wide glacial valleys are the most fertile parts, unlike the tight, tree-choked valleys further south, and they offered more shelter from the biting winter weather than the bleak moors that divided them. The aim of farming was still much the same, with cattle-rearing and dairying taking precedence, arable farming being principally to satisfy the local need for bread and cattle-feed. The moorland commons were too high and poor to sustain cattle in winter so these were confined to the curving valley bottoms, which were enclosed and

divided into numerous small fields bounded by stone walls. A large proportion of these fields, perhaps as many as one in three or four, contain a form of combined hay barn and byre called a field-house.

These small buildings are at least twice as long as their width and all of stone, with a low-pitched, slated, gabled roof. Most are ruggedly built of Carboniferous Limestone, which, because it readily splits, is easily laid in courses. Every so often these courses are interrupted by projecting 'through' stones which have the appearance of rough dripmoulds, but are used to bind together the inner and outer facings of stone with the rubble core. In a house they would be trimmed flush with the wall and not noticeable, but in these field-houses the stones project and so give them a character of their own.

The most basic field-house is half hay barn and half lofted byre. The byre is usually divided into stalls, and may contain a loose-box. The remainder is open from ground to roof and called a 'sinkmow'. Often field-houses are built on a slope, or with earth embanked against one side so that hay can be carted straight through a doorway into the loft. More elaborate field-houses have a proper wagon entrance to the sinkmow and two doorways to the byre, one for a feeding walk, another for the cattle and for mucking-out.[44]

The earliest field-houses, like laithes, were probably built in the 16th century. A field-house to the east of Keld church has a fine datestone of 1687, but it may be reused. Its plan is of the simplest, with two doorways on the west side, the larger leading into the sinkmow and the smaller into the byre, which is lofted and divided into stalls with a manger that can be replenished from the sinkmow; on the east side, a low opening opposite the larger door carries the datestone as its lintel, and two further openings at each end allow hay to be pitched into the loft and the upper part of the sinkmow. Like laithes, most surviving field-houses belong to the later 18th and 19th centuries. A fine double-ended field-house east of Muker dated 1887 is unlikely to be the last of the line, and their construction probably continued into the 20th century.

A larger version of the field-house built on northern farmsteads in the 19th century had five bays or more and included a stable as well as byres and a sinkmow. There is one on the lonely farm at Muddy Gill, south of Great Asby, another of seven bays on a farm at the south end of the village of Orton, and yet another, at Keld Head, is dated 1814.

**BANK-BARNS** The Cumbrian equivalent is the bank-barn, a larger, developed form of field-house which similarly could be built into the natural slope of the land or have an artificial bank raised against one side to provide access into an upper storey. This form is widespread in highland Europe, but in England is really only characteristic of the north. The bank-barn essentially is a corn barn placed over a combination of byre, cart shed and stable. The barn follows the standard pattern with a central threshing floor entered on the uphill side, with, opposite on the downhill slope, a winnowing door to provide a draught and an opening for pitching threshed straw down to the cattle beneath, although this is usually done through traps in the floor. The three-part division of the barn is reflected below in twin byres or a byre and a stable flanking a cart shed, and these have their entrances on the downhill side. In Furness the entrances on both sides have canopies, a single one in the form of a

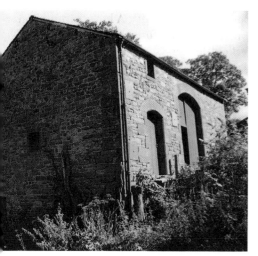

**Bank barn at Acorn Bank, Temple Sowerby, Cumbria; on the uphill slope is a large entrance to the barn, flanked by a lower entrance, unusually, for a stable.**

pentise roof extending the length of the downhill side to prevent rain blowing inside. A variation of the bank-barn widely found in Cumbria, but again especially in the south-east of the county, is aligned across the slope and the byres are entered from the downhill gable end instead of the downhill side.

The finest bank-barns were built on Daniel Fleming's Westmorland estates. One of them in the Rydall Hall farmyard, which could be Elizabethan, measures 17 by 7.5 m (55 by 25 ft); on its ground floor an entry passage led from one gable end between stalls that provided a standing for fourteen cows each side. Another one, rebuilt in 1659, had space for twenty-two cows in eleven stalls each side with a central passage for entry, feeding and mucking-out. The largest and most sophisticated was built on the Coniston Hall estate in 1688 with the end below the ramp to the upper storey divided into a stable and ox-house for a plough-team, and the rest into a cow-house with sixteen double stalls in rows of four and a large loose-box. Rows of stalls arranged in two groups run across the barn with an entrance and mucking-out passage between them, and access to feeding walks is on the further wall at the head of the stalls.[45] The earliest bank-barns may have been built at least two hundred years before this, but most of the survivors were erected long afterwards; one was built at Troutbeck in 1890 and another at Duddon Bridge, Cumbria, in 1904. The Great War finally put a seal on them.[46]

**DAIRIES**  Apart from the cattle used for draught purposes and cattle for breeding, they were kept for meat and milk. Stock for meat was generally reared on one farm, fattened on another, and driven to market and eventual slaughter somewhere else. With milking herds it was different. Milk could not travel, so either the cows had to be stalled close to where the milk was consumed or the milk had to be made into butter and cheese which could travel. The market for milk in towns grew so much that many cows lived their lives there in cramped stalls where they were fed and milked in conditions as squalid as those in which the urban poor found themselves. The stalls of these poor beasts have long since vanished, but the relics of their Victorian successors could be found until recently at the ends of many terraces of workers' houses in the industrial towns of the north. They were simple brick enclosures with a manger and a drain, and dark and fetid like the houses they served.

Large dairies were occasionally operated by monasteries and manors, but they only came to be built in any numbers in the 18th century when the size of the largest herds was increasing well beyond the dozen or two that had been common among important landowners. Yeomen usually built their smaller milkhouses or dairies into the service ends of their houses. In the Weald north-facing service rooms were commonly used as milkhouses, and once could be recognized from the outside by their louvered openings. Some dairies were substantial buildings in their own right, built out or completely detached from their farmhouses, such as the north-facing dairy house at Manor Farm, Cogges, Oxfordshire. At Alveston, in the good pastureland of the Vale of Berkeley, Whitehouse Farm at Earthcott Green and Manor Farm at Compton Green both had large single-storeyed dairies added to them in the late 17th century, and the detached dairy built at much the same time at Lynch Farm, Littleton, Aust, remained in use until the Second World War.[47] Many

Cumbrian farms had separate dairy houses where cows were stalled and butter and cheese made from their milk. In Dorset it was the same. One of the Havellands built a dairy house at Wilkswood Farm, Langton Matravers, about 1700 with a separate cheese room.[48] Like many other specialized farm buildings, the dairy was finally to come into its own in the later 18th century when large farms employed a number of dairymaids to manufacture butter and cheese rather than rely on the limited labour of the household, and these were designed with an uncommon degree of monumentality.

**STABLES** When tractors started arriving on farms in significant numbers after the First World War, horses had just about superseded oxen as draught animals everywhere in England. This had taken many centuries to achieve, and again it was the later 18th and 19th centuries that brought the greatest change.

From the start, horses were kept in stalls like draught oxen, though there were significant differences. Unlike riding horses, farm horses had buildings of lowly status, but ones that were eventually made superior to the general run of cattle houses. Owing to the length of their legs and necks, and to their less placid nature, horses needed higher and longer stalls than cattle to prevent them kicking and biting, and they had to be stalled individually, not in pairs. Often these stables would have a hayloft or granary overhead, because this was practical. A large stable would have a separate tack room too, either overhead or beside the stalls, with pegs for the tackle, and there might also be a binroom to store oats, a special reward for hard work. The implement sheds would either be nearby or even attached, and the largest stables had a heated room or even a set of rooms for the horse-man, on the model of the coach-houses and stables of grand country houses.

**PIG STIES AND HENHOUSES** Because of its omniverous appetite, a pig was the best way of converting household and farmyard waste into good meat. In the wild, this was satisfied by the pig's ability to root with its strong snout, so, when pigs were kept in captivity, they had to be confined. A ring through the nose would reduce their ability to root for food, but still pigs had to be kept from exercising their surprising strength and bursting into farm gardens and stripping them. A small but strong enclosure alleviated these problems, and a hovel gave much-needed shelter to this hairless animal.

These were probably no more than crude timber hutches with low enclosures set before them. Their swill was tipped over the low walls of the sty into a trough. Because the placid nature of these ferocious animals is an illusion, a wise precaution was to incorporate a slot in the wall of the enclosure so that swill could be put into the trough more safely, but these slots are known widely only in later pigsties.

Farmers' wives were responsible for farmyard fowl as well as pigs. Fowl and poultry traditionally had little in the way of buildings, and on most farms portable wickerwork coops were used for fattening the birds for the table or for taking them to market. Records of anything more substantial are rare, even when poultry were numerous, but sometimes they were housed in a loft built over a pig sty.

**DOVECOTS** In the Middle Ages, manorial privilege was symbolized by a distinctive building which stood apart and could be seen for what it was. This was the dovecot or pigeon-house. The Normans introduced the privilege of keeping feral pigeons, and this became the jealously guarded monopoly of monastic houses, manors and parsons. The fresh meat that pigeons provided all the year round was a welcome luxury at the lord's table, especially in winter, but there was a penalty: a major part of a pigeon's diet is grain, so no manorial lord would risk a peasant's pigeons raiding his fields.

Pigeons pair for life and live peaceably together in large numbers. They breed freely. Every six weeks a hen will lay a pair of eggs and she and the cock will fatten up the fledglings, and continue to do so nearly all the year round. A nesting place in a dry, warm and airy building promotes this production.

The commonest size of dovecot had about five hundred nesting spaces, and so could supply the demands of a community of about eighty with pigeon pie twice a week. The Benedictines, who were great consumers of pigeons, built simple, remarkably functional dovecots, immediately recognizable by their cylindrical shape. This is of great antiquity: Pliny the Elder described the Roman *columbarium* as a round building with a vaulted roof and nesting holes lining the walls (*Historia naturalis*). The Romans took this to France and the Normans brought it to England. Typically, English dovecots are 6 m (20 ft) in diameter and about the same in height, with stone walls about 1.2 m (4 ft) thick. Into these walls are set the nesting holes, tier upon tier, starting high enough above the ground to be safe from rodents, and continuing up to the eaves. The holes may be about 0.25 m (10 ins) in each direction, but often are deeper and sometimes L-shaped so that a pair of birds and their fledglings can tuck themselves away inside. The pigeons fly in through openings in the roof, sometimes under the eaves, more usually in a louver.

The higher nesting holes can only be reached by ladder. This was usually fixed to an ingenious device called a potence, again brought to England at the Conquest. It exploited the circular form of the dovecot, and comprised a pair of arms attached to a vertical rotating shaft at the centre of the dovecot with a ladder attached so that it remained about 0.2 m (8 ins) clear of the nests as it was turned round the circumference of the house. This allowed the eggs or squabs to be removed from any nest without all the fuss of climbing down the ladder to move it.

There is a fine potence, which may well be four hundred years old and probably replaces an earlier one, in the medieval dovecot at Dunster in Somerset. Another dovecot, built by the Knights Templars at their preceptory at Garway in Herefordshire, bears the date 1327 in Roman numerals – the oldest inscription on any surviving farm building in England. A huge circular dovecot complete with potence stood until the 1960s at Wick House Farm, Wick by Pershore, Worcestershire, and it contained 1300 nesting holes,[49] a number exceeded in the county only at Great Comberton with 1425 and at Leigh Court with 1380. Another unusually large dovecot at Sibthorpe, one of three medieval ones in Nottinghamshire, contains 1260 nesting holes in 28 tiers. It was probably built in the 14th century for a small college of priests founded at Sibthorpe in 1335. How they managed to consume the four hundred or so squabs it could have produced each week is hard to imagine.

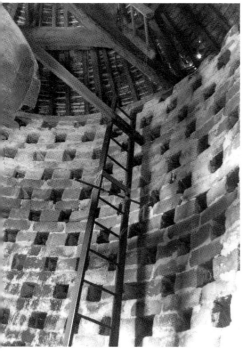

**Potence, Priory dovecot, Dunster, Somerset.**

Timber-framed dovecots could not be made circular, and their rectangular form did not lend itself to a potence so walkways and ladders were used instead, perhaps in the form of pegs fixed to a vertical timber as appears in the late 16th-century dovecot at Hawley Manor, Dartford, Kent.[50] Nevertheless most rectangular medieval dovecots are not of timber, but stone. In general they were built later than round ones, and seem to have superseded them. In Somerset the Augustinians built a tall, square dovecot at Bruton Abbey with gables like so many abbey barns, and the dovecot built by the Benedictines close to their great barn at Abbotsbury in Dorset again has the appearance of a diminutive barn. In East Sussex, the manorial dovecots at Berwick Court and Lullington Court both have hipped roofs in the south-eastern tradition, and the pigeons fly in and out through open gablets at each end of the ridges. Many monastic granges made do by incorporating dovecots into other buildings, especially barns, whose gabled wagon entrances particularly lent themselves to containing rows of flight holes, with the nests placed immediately behind and reached from a loft in the way still to be seen at Great Coxwell.

Most timber-framed dovecots are in the west Midlands. The small, cruck-framed dovecot built for a clergyman at Glebe Farm, Hill Croome, Worcestershire, was probably of the 15th century, but most are box-framed and date from after 1580. Their nesting holes were usually made of wattle and daub, and though fragile, these survive in the dovecot at Long Wittenham Manor, Oxfordshire.

The monastic and manorial monopoly of pigeon rearing weakened towards the end of the Middle Ages, and yeomen started to build dovecots. In Herefordshire yeomen copied manorial lords and built several in timber. The dovecot at Birdney Farm has framing, typically divided by studs into small panels which, unusually, are decorated by semicircles cut out of the studs to produce a highly ornate foiled effect. Most dovecots in Herefordshire are square, even the later, brick ones, thanks to the strong local tradition of building in timber.[51]

During the 18th century the heyday of the dovecot drew to a close. Other kinds of meat became plentiful and competed with pigeon meat, even in winter. Nevertheless many landowners built dovecots for their picturesque and symbolic effects, and farmers continued to include them somewhere round the farmyard, often as part of another building, to augment both their diet and the produce they sent to market. They became a feature of the Gloucestershire Cotswolds, notably in farms like Manor Farm, Culkerton, as a direct response to the increase in arable farming after the Middle Ages. This gave the great barn at Lowesmoor Farm, Cherington, its large tower for a dovecot. The small barn dated 1733 at Church Farm, Leighterton, has a gabled dovecot standing over the wagon entrance, and across the road at Drew's Farm nearly every building in sight is provided with nest holes for pigeons. Two houses at Duntisbourne Leer, a hamlet set in a fold of the Cotswolds, are liberally decorated with nesting holes in a picturesque way.

At Blythe House, Hayton, Nottinghamshire, a dovecot was built over a stable which now shelters geese and hens, so making a large aviary of the whole building. At Walkern Place in Hertfordshire, 420 nesting holes lined an octagonal dovecot inappropriately set over a granary,[52] and suggest a naive faith in poachers making the best gamekeepers. A dovecot at Burnt House

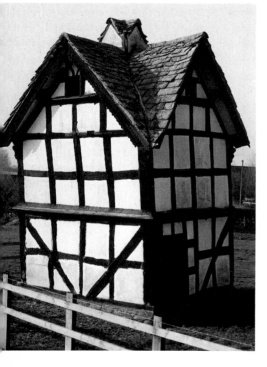

**Luntley Court dovecot, Dilwyn, Herefordshire.**

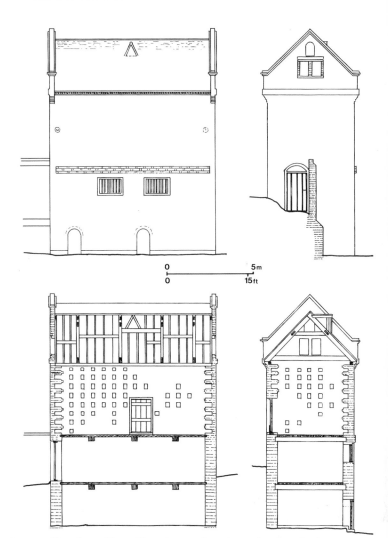

**Combined pigsty, henhouse and dovecot at Burnt House Farm, Chartham, Kent.**

*Burnt House Farm dovecot, Chartham, Kent. Elevations and sections, showing the dovecot built over a henhouse with a pigsty in the basement.*

Farm, Chartham, Kent, brings together pigeons, hens and pigs in a single building, all for the convenience of the farmer's wife. The low basement has twin entrances from the farmyard into the pigsty and, above it, an entrance in the gable wall leads into another low storey for the hens. Above this, the dovecot, reached by steps from an orchard, has 574 nesting holes set into the brickwork with entries in a louver overhead and through openings in the gables.[53]

By the time it was built in the 18th century, there were perhaps twenty-six thousand dovecots in Britain, accommodating enough pigeons to provide every man, woman and child in the kingdom with a monthly meal. Until 1800 pigeons were protected birds and farmers were still building dovecots fifty years later. Within thirty years the advent of refrigerators and fresh meat throughout the year changed all that. Pigeons are now classified as pests and shot, as perhaps they always should have been.

**WATER MILLS**  Like the rearing of pigeons, the milling of corn to make flour became a manorial prerogative in the early Middle Ages and a cause of much discontent. Peasants were forbidden to own hand mills or querns, which, if found, would be smashed by manorial agents. Mills consequently belonged to manors, but, unlike dovecots, there were restrictions on where they could be built.

The first recognizable corn mills in England were powered either by animals or by water. Oxen or horses attached to a harness could turn a millstone simply by pacing round a circular track. A track of this sort was excavated at the royal palace at Cheddar, where it was apparently placed for convenience between a granary and a bakery.[54] These date from the 10th century, but were not the last word in technology. However simple and convenient the arrangement may have been, the horse-drawn mill was slow. Water offered a far better source of power; it could be made to turn a millstone more quickly, and this enabled corn to be efficiently ground in large quantities.

Always it had to be placed where a stream of water was strong enough to power it, or where a stream could be especially channelled into a leat to provide the necessary head of water. Just occasionally, the tide was exploited by letting it rise into an enclosed pond and, when it had fallen enough to create a head of water, letting the water flow out through the mill. This limited the time when the mill could operate, but it was reliable. The tidemill at Woodbridge in Suffolk dates from 1793, but its origin goes back to 1170 when the site was first exploited in this way.

So, as can be seen to this day, only suitably placed manors, such as Michelham Priory in East Sussex and Mapledurham in Oxfordshire, could include a water mill within their own grounds, but monasteries, which had the same privileges, almost invariably had a stream flowing through their precincts, so they usually included a mill among their buildings to grind flour for the monks' bread. Just outside the walls of the Templars' preceptory erected between 1164 and 1185 at South Witham in Lincolnshire was a rectangular stone mill fed by a leat running off the river Witham.[55] Similarly, most villages in the corn-growing south and east had at least one water mill if there was a stream which could provide a good head of water, and these were invariably controlled by the lord of the manor.

Because of their economic importance to manors, the Domesday survey recorded water mills, indeed by the thousand. Some of their sites may have been used for milling in Roman times, and many mills can trace back their origins to well before Domesday. In Staffordshire, Burton Flour Mills have exploited the waters of the River Trent since 1004, although the earliest surviving building on the site dates only from 1715.

The wooden shafts and gears which transferred the power from the water wheel to the stones had to be protected from the weather, as did the grain and the finished flour, so some kind of building was needed. This might be built beside the millstream and have the millwheel built out from one side, or it might bridge the stream and the wheel would then lie inside. Either way, the mill had to be built on falling ground, with the picturesque contrast of low walls on the upstream side and high walls downstream. A single building could mount more than one wheel, and both methods of mounting the wheels could be employed. Even a single wheel could power more than one pair of millstones. Eventually, multi-purpose mills came into existence, and,

although they were not always used for grinding, they were still called mills. During the 12th century mills were adapted for fulling cloth and by about 1400 were also powering bellows in iron furnaces and several other kinds of industrial machine. Sometimes one water wheel turned different kinds of machine, and often mills were converted from one task to another as economic circumstances changed. The modestly sized Durseley Mill in Gloucestershire was built in the 17th century with a single wheel powering both a pair of fulling stocks and a pair of grinding stones, and the imposing Egypt Mill at Nailsworth was again designed for both fulling and grinding, but took power from two wheels, each with its own separate leat.[56] Their commonest task, nevertheless, remained the grinding of corn.

One of the earliest English mills was erected at Tamworth, Staffordshire, in the 9th century. Water rushed down a chute to turn the paddles of a horizontal wheel in the undercroft of the mill building. This was built of heavy timbers to counter the loading on the vertical shaft which transferred power from the wheel to the millstones. There were at least two floors, an upper one for the stones, and a lower one where the flour was bagged, both of them massively floored to withstand the vibration and the weight of the machinery.[57]

Many early water mills were powered by vertical wheels arranged so that the water would shoot down the race under them and strike the vanes set around its circumference. The wheels were set either in an undercroft, especially where there were more than one of them, or, singly, on the side of the building. The more efficient overshot wheel, which relied for its power on the mass of water fed from above into a series of buckets fitted around it, was already in use by the 12th century. Because it needed a greater head of water than an undershot wheel, provided either by a rapid fall in the ground or a long leat, it was less common in the flat cornlands of the south and east, where streams fall slowly.

Either way, a large geared wheel mounted on the main horizontal shaft engaged a smaller spur wheel on a vertical shaft, thus greatly increasing the speed of rotation, and this transmitted power upwards, either to drive the stones direct or to drive them through a further gear chain, increasing the speed once more. A hopper above fed grain into the eye at the centre of the stones, and, as it was ground, the grain worked its way outwards between the millwheels to spill over as flour and drop into another hopper and from there into a bin or a bag.

This gravity feed meant that a mill had to be at least two storeys in height, an upper one devoted to feeding the millstones, which were mounted on its floor, a lower one devoted to collecting the flour and packing it for transportation. The small timber-framed Abbey Mill at Campsea Ashe in Suffolk, which dates from the late Middle Ages, has two storeys, the upper one partly jettied, and most of the early stone and brick mills are no higher.

Milling caused great vibration, which, together with the need to withstand the sheer weight of the machinery, meant that a mill had to be soundly constructed. Because so many mills were built immediately beside the millstream or over their millraces, they were early candidates for construction in stone or brick, at least for their lower storeys. They nevertheless needed heavy internal timber framing to carry the bearings, so framed upper walls were no particular disadvantage. The overshot mills at Nether Alderley,

**Shore Mill, a water-powered carding mill, built about 1782 at Delph, Saddleworth, Greater Manchester.**

Cheshire, and at Worsbrough, South Yorkshire, built in local stone in 1581 and about 1625 respectively, both have their vertical shafts pivoting in bearings attached to massive floor-joists and tie-beams, which also carry typically northern low-pitched, king-post roofs.

It was comparatively easy to take power off one of the shafts to turn a hoist so that sacks of grain could be lifted up to the top storey. These were usually incorporated within the mill building until, in the later 18th century, millwrights realized that it was more efficient to lift the sacks of grain directly from the carts which delivered them. So mills either incorporated an internal standing for a cart beneath the hoist, or dormer roofs were jettied out over external hoists to protect them and the uncovered sacks from the weather. These so-called lucarnes or lucams were eventually designed to rise over the ground storey to the full height of the mill so that sacks could be hoisted into and out of any floor. They became one of the most characteristic features of later, multi-storeyed watermills. Baylham Mill in Suffolk has a prominent lucarne rising from the third storey above the eaves into the loft; this most attractive of mills lies beside a 14th-century millhouse, evidence of how long there has been a mill here, and across the road are stables and a cart-house, essential for sending grain to market. The grand Abbey Mill at Tewkesbury has a pair of lucarnes, one serving the top floor, the other all the upper floors, in a particularly picturesque ensemble made all the more pretty by the mill's dormer windows and its waterside site.

As the industries which mills served developed, the number of their storeys increased together with the complication of their machinery until they became nothing less than factories. However picturesque or monumental these seem today, they displaced Isaac Bickerstaffe's 'jolly miller' with the woeful slavery of William Blake's 'dark Satanic mills'.

**WINDMILLS** Windmills first came to Western Europe in the 12th century. This may have been yet another result of the Crusades. Significantly, the earliest documentary record of windmills in England is in a survey of the estates of the Knights Templars made in 1185, which mentions two windmills. One of these, at South Cave in Humberside, has been identified by a circular mound of earth. This stabilized a pair of horizontal cross-timbers, which were buried in it, and the massive upright post mounted on them, about which the mill was turned so that it faced into the wind.[58] Possibly this innovation demonstrates once again the Templars' ability to develop what they had seen in the Holy Land for the sake of profit. Furthermore, their advanced knowledge of carpentry would have been an essential element in the construction of a mill, which had to withstand the force of the wind at the same time as exploiting it.

Possibly these early windmills were a curiosity for a long while, since survivors date only from the 17th century. Survival cannot have been easy. Windmills were designed to be removable, and both this and the hazards of gusts catching them sideways were enemies of a long life. At all events, when Bourn Mill in Cambridgeshire and Nutley Mill in East Sussex were built in the 17th century, they were similar to windmills in medieval illustrations.

They were of the post-mill type in which the whole mill, the sails, shaft, machinery and its housing, could rotate around a central post so that they

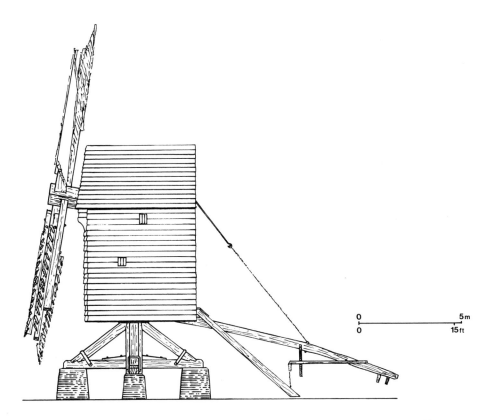

0        5m
0        15ft

*Bourn Mill, Cambridgeshire, possibly the earliest surviving windmill in England. Elevation.*

would face into the wind. The housing, a boxlike framed structure, which carried the sails and contained the machinery, was mounted on a massive upright post on which it turned. The post was made from an outsize oak: being about 0.6 m (2 ft) square and 6 m (20 ft) long, and consequently weighing some 2 tonnes, it was costly to buy – in the 14th century it might cost £1, an immense amount – and also to transport.[59] Its weight was carried by diagonal quarter-braces which were mortised into it about half way up and jointed to the two cross-trees at the base. Here, the post was quartered over the cross-trees to keep it steady. Initially these were buried in the ground, as at South Cave, but in surviving mills they simply rest on a plinth, usually in the form of four heavy piers. Socketed on top of the post like the top of a T was the rotating crown-tree from which the body of the mill was suspended; two horizontal side-girts rest on the ends of the crown-tree and carry a corner-post at each end. The sides and the roof of the housing were framed with uprights and braces, and two stout horizontal sheers ran fore and aft on either side of the central post below the bottom of the floor to steady the body of the mill by forming a bearing or carrying a collar which prevented the mill from swaying. The body was weatherboarded, occasionally plastered inside and often painted white outside. Early mills had a few shuttered openings to let in the light, but these were superseded by glazed windows. Access to the body of the mill was by a ladder running from a platform at the tail of the bottom floor to the ground. An inclined windshaft carried the sails, and the mill was turned

into the wind by means of a tail-pole fastened to the sheers and passing through the ladder.[60]

Sometimes the base of the central post, the quarter-braces and cross-trees were protected from the weather by a round house, which was used for storage. This might have an iron-faced curb on top which carried rollers fixed to the bottom of the mill's floor and prevented it from pitching; and sometimes, particularly in west Suffolk, the boarding of the mill was extended downwards to form an overlapping petticoat.

Early mills were small and had the plain gabled roof and wide, horizontal boarding of Bourn Mill, Cambridgeshire, which was in existence by 1637. Outwood Mill in Surrey, of 1665 and the oldest working mill in England, though with new sails, and the contemporary Nutley Mill in East Sussex have gracefully arched roofs continuing the line of the walls.

The milling machinery was similar to a watermill's except that the power was transmitted downwards, not upwards: a large geared wheel mounted on the windshaft and known as the brake wheel drives a smaller spur wheel known as the wallower and this drives the stones direct.

The other great difference lay in the need to turn the body of the mill. The great effort this needed was avoided by the tower mill, in which only a small cap carrying the sails, windshaft and brake wheel, turned to face the wind.

**Nutley windmill, East Sussex.**

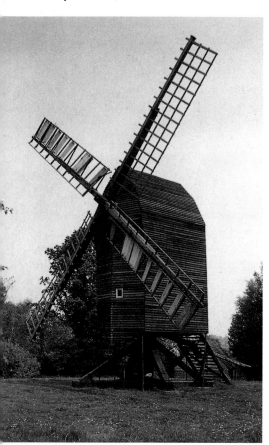

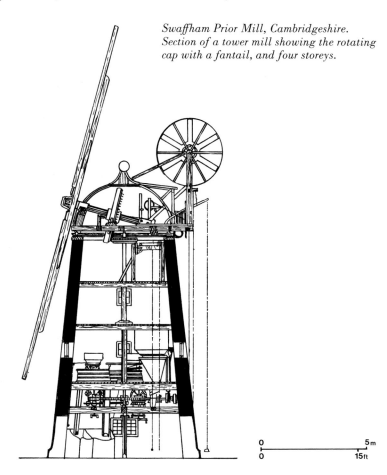

*Swaffham Prior Mill, Cambridgeshire. Section of a tower mill showing the rotating cap with a fantail, and four storeys.*

| 0 | | 5 m |
| 0 | | 15 ft |

This was mounted on a fixed tower which contained all the rest of the machinery and plenty of space for storage, usually with a dust floor, bin floor, stone floor and meal floor in descending order. They had possibly reached England from the Continent by the middle of the 15th century, but most survivors date from the 18th century and later.

Timber towers commonly built in the south-east, usually with eight sides, but sometimes with six, ten or even twelve, were known as smock mills from their tapering sides. They had brick bases which extended upwards, even to two storeys, and the top had a circular iron-faced curb, on which the cap turned. This was heavily framed and took various shapes, depending on the locality. A boat shape with flattened ends is commonest, but in East Anglia and the east Midlands many tower mills have a domical cap, often ogee and terminating in a decorative ball. At first, caps were made to face the wind by pushing on a tail pole, but this was cumbersome, and later, they were winched round. This was achieved automatically by a method patented in 1745 by Edmund Lee: when the wind veered, a fantail mounted on the back of the cap started to rotate and, through gear and chain, turned the cap back to face directly into the wind again. Fantails were also applied to post mills, and attached to the ladder or tail-pole and drove a carriage running on a track round the mill.

The earliest sails carried a simple wooden framework to which sail cloth was laced, but the Industrial Revolution brought various patent sails with hinged shutters, instead of cloth, which could be opened and closed to regulate the speed of the mill. Improvements in the way the stocks which carried the sails were mounted on the windshaft allowed it to carry up to eight sails. Five were the most efficient, but six had the advantage that up to half the sails could be inoperative but the remainder would still turn the shaft without it becoming unbalanced. Heckington Mill, removed from Boston in 1892, is the last remaining eight-sailer, but several other Lincolnshire windmills have five or six sails.

BREWING  Despite the manorial monopoly of milling, peasants were allowed to brew ale, even though the Church tried to licence the sale of alcoholic liquor. Grain, usually barley, was first malted, then mashed and brewed by fermenting it with yeast and water; finally, the brew was racked off into barrels, and the sludge used as manure. This was a big industry on monastic farms, which had to consider the needs of both the brethren and the travellers staying in monastic inns. A brewery was therefore expected to be a significant part of a monastic layout, as the remains of one built into the great woolshed of Fountains Abbey show. These breweries occasionally survived the Dissolution, especially those on abbey farms rather than within the precinct itself. In 1567, what had been the Cistercian Salehurst Abbey's farm still retained a stone cistern for steeping barley, two malting rooms, and an oast for drying the germinated grain over a kiln, and, adjacent to these, was a brewhouse with three water mills to mash the malt before it was fermented.

On farms, all this was done in a buttery, but, where large quantities were involved, separate brewhouses, malting chambers and even kiln houses were needed; occasionally a barn or granary served instead, and might have a kiln

at one end, such as the medieval ones found as far apart as Beer in Devon and Wintringham in Cambridgeshire.[61] A later, large granary at Manor Farm, Burwell, Cambridgeshire, included a malt-kiln with a conical roof tiled as a precaution against fire.[62] By the 18th century, independent breweries were becoming common. Invariably set beside a river whose water they needed both for production and for power, they combined a kiln house and water mill in various ways.

## CIDER HOUSES

Apples have been grown in England from Roman times, and in the Middle Ages came from numerous small orchards. Many monasteries had an orchard or two, and the mills, presses and barrels that enabled monks to make cider from their crops. The Wealden vales around Maidstone were especially good for apples, and the same held for the vales of the west. Every farm made apples and pears into cider and perry, especially in the inaccessible Weald, as there was no other way that all the fruit could be consumed.

By the later 17th century apples were often crushed in mills comprising a vertical stone wheel pulled round an annular trough by a horse. The crushed apples were pressed between straw mats in the ringer or cider press to extract the rest of the juice, which was then fermented in barrels. Being partly of wood, the mills and presses needed shelter, perhaps in a house of their own or in a corner of a barn or a room added to a farmhouse. The barrels needed most space of all, preferably in a cool, north-facing outhouse, with a loft for storing the apples and a cellar with a wide enough door to enable the barrels to be rolled inside. At Stoney Lane Farm, Crossway, Hartlebury, Worcestershire, a press exemplifies a once extensive local industry, and an outhouse at Rookery Farm, Pilning, probably built in 1678, contains a cider mill, together with the remains of a press, and is still in use. Pendick's Farm at Stidcot, Tytherington, has a cider room, typically about 4 m (12 ft) square, and Hill House at Olveston still has a cider mill and press in a separate building of around 1700, with an apple loft and a cellar for barrels.[63]

A favoured arrangement in Herefordshire was to house mill and press at ground level and use the upper storey as a granary or hop room.[64] The cider barrels often had their own house or an outshut of the farmhouse where the men could take their refreshment, but the master had a private supply in a cellar beneath his parlour. Cider houses were even attached to small cottages with an orchard, such as Pound Cottage at Upton Crews on the outskirts of Upton Bishop, whose 17th-century cider house is still complete with a horse mill, and the barrels are stored in a cellar reached from the parlour through a trap.

Cider houses took on all kinds of forms. Upper Norton, north of Bromyard, has a mill and press in an 18th-century continuation of the service end of the house, and the cider room at Old Plaistow, Ledbury, is in an addition with a hop room overhead and kilns to one side. Cider rooms were often added to barns, such as one at Croft Farm, Brimfield, or built within them. Upper Lye at Aymestrey had a mill and press in its barn, and Fairoaks Farm housed its equipment in a 17th-century timber-framed outbuilding.

Dunster Dovecot, Somerset *(right)*.

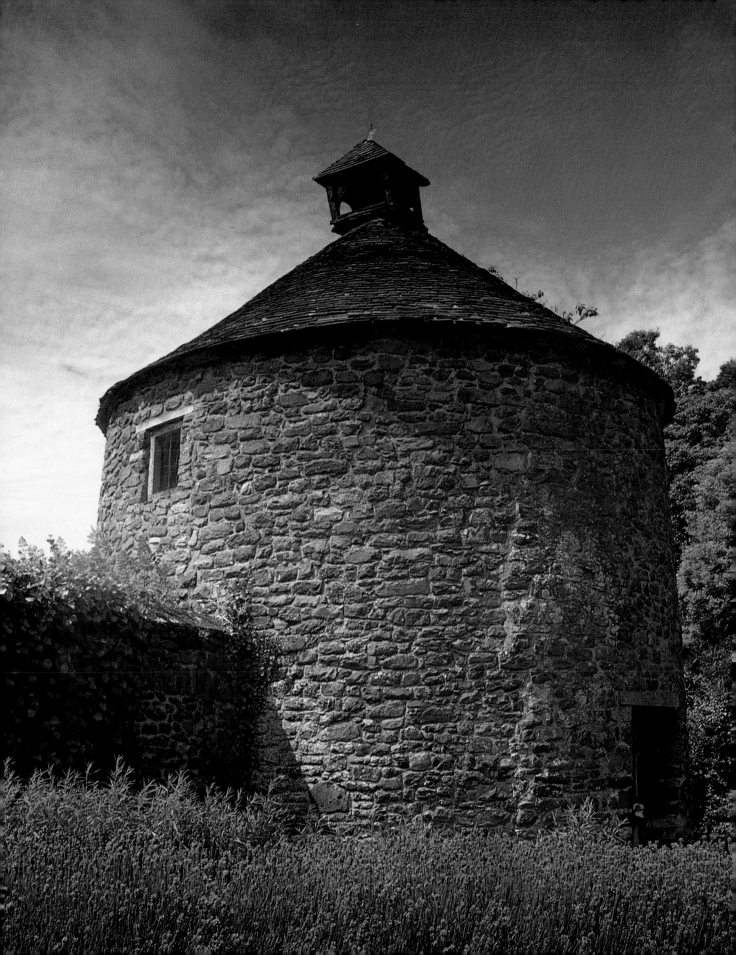

**HOPS**  Hops, like apples, are a crop widely grown in the Vale of Herefordshire, and in the vales of the Kent and Sussex Weald. Flemish weavers brought them to England in the 14th century and grew them in a small way. Then in the 16th century English brewers at last realized that hops could replace wormwood as a preservative to stop the liquor from souring, and also allowed economies in malted barley. The first extensive cultivation was in the Wealden vales around Maidstone, and soon extended to most of the Weald, the valley of the River Wey between Farnham and Alton, the downs around Wiltshire brewing towns such as Salisbury, Wilton and Bromham, and the vales of Hereford and Worcester.

Hops are picked in September, and must be dried and then tightly packed to preserve them, a process which should be completed by November. Mostly drying was done on an open floor, but this was not entirely satisfactory: a large crop needed to be dried quickly, so an oast or kiln was required.

Unlike malting, hop-drying remained in the hands of the farmers who grew them. Oasts came into ever greater use and by the early 18th century there was one on half the farms in the Kent and Sussex hop country. Some yeomen built oasts inside their farmhouses, and in the 17th century a medieval hall house at Robertsbridge was entirely converted to an oast-house.[65]

Some oasts were built within barns, and purpose-built oast-houses looked like barns too. They were two-storeyed and divided internally into a kiln room or plenum chamber and the stowage. The brick furnace in the plenum chamber lay beneath a drying floor made of closely set wooden laths. An oast-hair or mat was usually laid on the slats to support the hops and stop them from falling through. This let the slats be further apart and facilitated drying. The fire was stoked through a hole from the stowage, while above, in the upper storey, the green hops were received from the hop gardens to be raked on to the drying floor, and, after drying, and by now golden in colour, they were raked back again to cool before packing.

The small oast-house at Little Golford, Cranbrook, had two hearths in its plenum chamber set centrally beneath the drying floor and placed against a wall that divided the chamber from the stowage.[66] These small hearths warmed a floor of about 10 sq m (110 sq ft); as drying floors were on average two or three times as large as this, they normally had two or three times as many hearths rather than larger ones. A clever way of arranging them was to put them in two banks with a firing tunnel running between them. An 18th-century innovation was the provision of a cone-shaped vent rising above the roof to increase the draught of warm air through the hops. This allowed a greater quantity to be dried, and was far better than the old arrangement in which the warm, damp air drifted out through the tiles of the roof or from under the eaves. At some time between about 1740 and 1790 cowls placed on top of the cones came into use and improved the draught still further by turning away from the wind to improve the rate of extraction.

The cooling floor in the stowage or hop room never had windows, as light was thought to spoil the dried hops. Larger hop rooms were divided into spaces for hops awaiting drying and for those cooling and awaiting packing. Packing or 'bagging' was a bizarre job. Since hops had to be bagged tightly if they were to keep, the pockets were suspended through a circular 'treading hole', about 0.75 m (2.5 ft) wide in the hop room floor; a slim man – ironically those with

beer-bellies would not fit – climbed down through the hole into the sack and trod the hops firmly down as, little by little, they were shovelled in on top of him. As the pocket filled, the bagger rose back through the treading hole, gilded from head to foot by hop dust. The pocket was then sewn shut with two ears at the top for handles, and stored below the hop room until market time.

The earliest kiln-houses (or 'kells', to use the Herefordshire term) were like the oast-houses of the Weald. A pair of kilns at Tolmorithic, Bacton, were just under 1 m (3 ft) in each direction and sat beneath pyramidal hoppers that led the hot air up to slatted drying floors 2.5 m (8 ft) square. They were in one end of the kell, leaving the rest of the upper floor for fresh or cooling hops.[67]

By the end of the 18th century, farmers increasingly realized that the flow of hot air was crucial to the process of drying hops and that this could be made more efficient if the flow was increased.[68] So an inverted cone like a hopper was placed between the kiln and drying floor, and a conical ceiling was placed over the drying floor. This dramatic development, which gave rise to the characteristic roundels with their tall, conical roofs and cowled tops, is said to be due to John Read, whose monument in Horsemonden church also calls him the inventor of the stomach pump and other implements 'for the benefit . . . or relief of humanity'. Based on the fallacy that hops dried more slowly in the corners of a square floor, the roundel at least economized in bricks and made the construction of the cone over the kiln in the plenum chamber easier. These

*Oast at Court Farm, Brook, Kent. Section showing the stowage* (left) *and the roundel* (right)*: the stowage, which apparently predates the roundel, has its first bay devoted to unloading the fresh hops and pocketing them after drying; the remaining bays contain the cooling floor, but the central bay – currently with windows on both storeys – probably contained a kiln with a slatted drying floor over it, thus forming a plenum chamber, and so making a complete oast of the stowage before the roundel was built.*

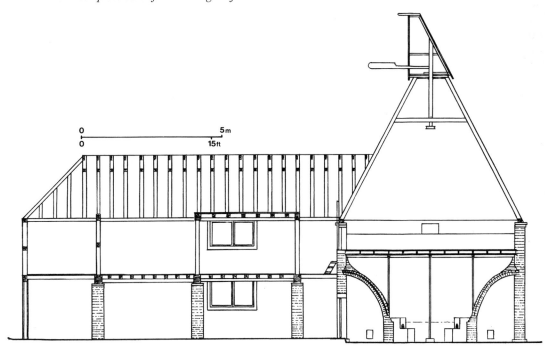

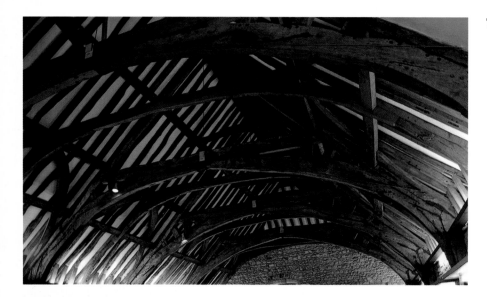

The Woolhouse, Southampton *(left)*.

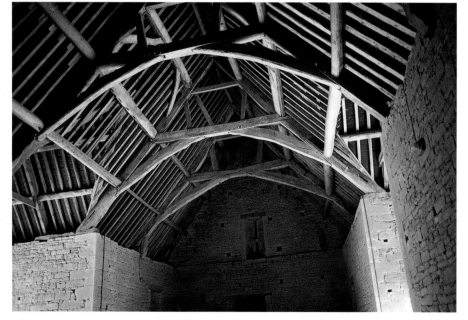

Ablington Manor barn, Gloucestershire *(left)*. A typical 18th-century Cotswold barn with arch-braces supporting collared rafters.

Higher Farm barn, Stockland, Devon *(left)*. A small Devon barn built with cob walls and crucks, each one made up from two pieces of timber jointed at the angle; a further cruck rises inside each gable wall to support a ridge-piece.

**Waxham barn, Norfolk.** This great 16th-century barn on the Norfolk coast, like the nearby Paston barn, has flint walls, and a roof with alternating hammerbeam and queen-post trusses; after decades of disrepair, it is now being restored.

were hardly advantages of great practical value, but their aesthetic merits gave the landscape one of its most picturesque elements.

The pivoting cowl that allowed wind-induced extraction was a barrier against rain. A vane kept the cowl turned away from the wind and, since failure to act might cause rain to reach the drying floor and ruin the hops, the cowl, its axle and mounting were made by wheelwrights to ensure their free rotation. Cowls became a common feature of Kentish oasts only in the 19th century. They were made in the form of a leaning cone with a flat top, though in the west Midlands the cowl continued to a point, and the vane protruded from the opening. These vanes were a great occasion for embellishment. Invicta, the rampant horse of Kent, was especially popular, and other animals or symbols denoted particular farms.

The earliest round oasts date from the second decade of the 19th century. One at Benenden was built about 1812 and the oast at Court Lodge Farm, Brook, is dated 1815. There are great numbers of round oasts in Kent and Sussex. Each one could serve a hop garden of about 6 acres, so Kent must have had six or seven thousand kilns. Most are single, but oasts with multiple roundels are common. A pair was added to one side of an old oast-house at Little Bewlbridge Farm. Stanford's End at Edenbridge has two roundels with a hop room between them, and, while single or double roundels remained commonest, groups of four like those built in 1876 at Maberhurst or the battery at Watersmeet Farm, Whetsted, Tudeley, were often built by farmers who specialized in hop-growing. The greatest of all specialists was E.A. White who built an immense house with five roundels in 1880 on his farm at Beltring, East Peckham, and, as his farm increased to 204 acres, he added three more houses with five roundels each in the 1890s. Operating since 1921 as the Whitbread Hop Farm, this is a factory in all but name. Many of these larger groups, especially those in the Medway valley east of Tonbridge, have two floors in the stowage, the second to receive the green hops above the cooling room. They can always be recognized by a hoist, often emerging from a gabled lucarne, to pull up the bags on arrival from the gardens. Many of these larger oasts did without specially made curved tiles for their conical roofs and instead the cones were built of brick, rendered and coated in a mixture of pitch and tar, their shiny black contrasting strikingly with the white cowls over them.

Round hop kilns reached Herefordshire later than Kent and Sussex, the first being built after 1835. The two at Little Cowarne Court are perhaps the earliest of a group that includes others at Stoke Lacy and ones at Ocle Pychard which, among the last, may date from the 1870s. Nevertheless Herefordshire kells are typically square, not round. They are found everywhere from Amberley Court at Marden, north of Hereford, down to Eastnor and Upton Bishop on the Gloucester border. In Worcestershire, Ham Castle Farm at Clifton on Teme has a kiln-house with three circular kilns built about 1840 and two square kilns added some while later. Bright red brick kells dot the Teme valley from Worcester up to Burford, often with pairs of square kilns, one at each end of a compact house. An unusual kiln-house beside the church at Stockton on Teme comprises two parallel ranges, one containing the hop room, the other the multiple kilns whose tall, slim cowls perch on the roof ridge like gaunt, white birds. In these Hereford and Worcester kells the flues

are narrower and thinner and the cowls consequently thinner than in the south-east, as well as pointed.

Square oasts were eventually built in Kent too. There are groups at Wellbrook Farm, Boughton-under-Blean, and Nashenden Farm on the southern outskirts of Rochester. Some square kilns in both areas dispensed with a cowl, as at Stone Cross, Ashurst, Kent, where a pair of square oasts with pyramidal roofs and square, louvered vents instead of cowls superseded a roundel. Others had a pitched roof with a louver built along the ridge, like two kells in Whitbourne, Herefordshire, and another at Cousley Farm, Wadhurst, East Sussex. They were just as efficient as cowls, as square kilns were just as efficient as roundels, but less attractive by far. Most of them were built not of local bricks but of others cheaply imported by rail. Nor did the straight walls of a square kiln require special skills in bricklaying.

They mark the end of a long tradition. Like everything else in English farming and industry, the processing of hops has radically changed. No longer do armies of pickers descend on the gardens, and just as machines have displaced them so have they also displaced the dryers and baggers who tended the oasts and trod the hops into the pockets. Coal superseded charcoal in the kilns, to be replaced in turn by oil, and in this century it became increasingly obvious that the whole process could be profitably mechanized in the brewers' factories. Again, typically of much English production, foreign hops are imported in great quantities and beer-drinking is in decline. Like so much on the farm, and, for that matter, in English factories too, oast-houses have been put to other uses. Maybe their day will come again and lager be banished for ever. Perhaps real ale is even better when the hops are hand-picked, dried over a charcoal kiln and trodden into a pocket to recapture that essence of Old England last known to our grandfathers.

A square kell at Eastnor, Herefordshire.

A windmill, Heckington, Lincolnshire *(left)*. With parts removed from a windmill at Boston, this is the last of Lincolnshire's eight-sailers.

A windmill, Outwood, Surrey *(left)*. Dated 1665, this is the oldest working windmill in England; the base is protected by a round house.

A windmill, Upminster, Havering, London *(right)*. One of the few survivors in Greater London, this smock mill is complete with its fantail.

# 8 THE END OF A TRADITION

The agriculture and trade which had filled the purses of English yeomen and merchants between the 14th and 17th centuries were less of a money-spinner in the depressed markets of the 18th century. The yeomanry soldiered on, still the backbone of English farming, but the campaign of building that would soon change the face of the English countryside originated higher in society among the gentry and aristocracy, and stayed there. They were well versed in architecture, and that meant more to them than tradition. When they enclosed their country estates, their new farms demonstrated architectural taste rather more than an understanding of agricultural economics. In town, it was increasingly the speculator with the capital to build on a large scale who called the tune. Architectural style, allied to economies in production, was what sold houses at a price tenants could afford. Tradition had little to offer.

As the 18th century gave way to the 19th, the increasing pace of change forced a new, hard world out of the old. For many who worked the land or tended the machines this was bleak in the extreme. The idyll of rustic life was only for those who could pay for it. As always, these were the landowners, not just any landowners now, but the greater ones and their entourage. Similarly, it was the same people who ultimately profited from the mills and the mines which equally scarred the English landscape and its inhabitants.

The first half of the 18th century was marked by a population whose size remained fairly static and by production that was generally greater than demand. With consequent low prices at market, the only way to a profit was through greater production and greater efficiency, however much these aggravated the problem of plenty. Out of this state of affairs sprang the Industrial Revolution. Improved efficiency could be measured in the reduction of labour needed to maintain output. New machines did not count for everything here: at the end of the 18th century one person engaged in farming could feed nearly half as many more mouths as at the start. With a basis of cheap food, the revolution thrived on invention applied to the pursuit of profit. The most significant social consequence was that, after 1750, the population began to increase dramatically. Old England, which for some two thousand years had had a population of just a few million and probably never more than five or six, was rapidly left behind. By 1801 there were already over nine million people living in England and Wales, and this number was all set to grow into tens of millions.

The old household structure of society in which a family of kin, servants and farmhands or apprentices lived together as a hierarchical though egalitarian unit faded away before a division that gave the head, his wife and children their separate lives, and the servants, farmhands and apprentices theirs. This was a division made concrete in the planning of houses, where the different classes kept to their floors in towns and to their front or back rooms in the country. Increasingly the poor were confined to rural cottages and crowded urban slums, well away from the polite residences of the affluent and the rich.

Despite the spirit of scientific enquiry which prompted the inventions of the Industrial Revolution, a romantic yearning for the old world affected society in many ways. This led the arbiters of taste to praise what they imagined to be the nobility and moral worth of ancient Greece and Rome. That, so far as polite architecture was concerned, brought a revival of classicism. More slowly, Gothic was revived, at first because it was redolent of the excitingly

mysterious Middle Ages, later because it was thought to be both Christian and English. That suited the moral consciousness of Victorian England, and was a better consolation than classicism for the degradation created amid all the new-found wealth.

Nevertheless, Gothic was an emphatic style, and rather hectic for ordinary buildings, particularly houses. Soon after the middle of the 19th century, there was a partial reaction in the plainer forms inaugurated by William Morris and the Arts and Crafts Movement. This took the form of an application of the rustic features of traditional buildings. They seemed to be more suitable for everyday purposes. If this was a romantic dream, it was in stark contrast to the age of the machine and mass production. While Morris's view of the past was unsound historically, his designs for wallpaper, textiles and furniture were touched with genius, and his Utopian vision of individual endeavour fuelling socialist egalitarianism inspired radically minded people with the belief that England must change.

> Forget six counties overhung with smoke,
> Forget the snorting steam and piston stroke . . .
> And dream of London, small and white and clean,
> The dear old Thames bordered by its gardens green.[1]

So the 'Old English' style of architecture came into being, with half-timbered houses such as J.L. Pearson's Roundwyck House at Kirdford (1868–70) and Norman Shaw's Leyswood at Groombridge (1870–72), both in the Sussex Weald. The style exemplified at once a kind of Christian morality and a social conscience by recalling a time, so Morris and the reformers supposed, when Christian craftsmen could inspire their work with the moral worth of their own powers of creation, and make it available to all. Needless to say, its revived forms and decoration were only skin deep. They could hardly be otherwise, since the old crafts of building were as dead as the men who had practised them. Yet the style was immediately taken up in grand country houses like Shaw's Cragside in Northumberland, designed, like many others, for a newly rich industrialist who wished to taste rural fruits away from the urban filth he had helped to create.

What was exclusive in the 1870s was everybody's property by the end of the century, and has remained so to this day. Reformers recognized how polluted towns had become, both through overcrowding and insanitary conditions, and through the tons of soot that belched from their chimneys into a once clear sky. The countryside increasingly appealed to these people as an ideal of cleanliness, health and sobriety which should benefit everybody. From this romantic vision the garden suburb was born.

Picturesque cottage estates had come into existence in the 18th century when rural landlords wished to improve the living conditions of their tenants. Then, early in the 19th century, the architect John Nash designed the self-consciously rustic cottages of Blaise Hamlet, near Bristol, and the two Park Villages close to London's Regent's Park as picturesque model suburbs with individual houses irregularly laid out in a rural manner. They were a special case, and it was not until efficient public transport made suburbs a practical home for city workers that these came into their own. The arrival of the garden suburb was heralded in the 1870s by Bedford Park in west London. Here,

One of the cottages designed by John Nash
at Blaise Hamlet, Avon *(right)*, built in
the early 19th century, at a time when a
desire for picturesque qualities meant
using a travesty of traditional forms.

The dairy, Blaise Castle *(above)*, is on the
same estate and is probably also
designed by Nash.

Norman Shaw's self-conscious revival of traditional styles of architecture brought a pleasing irregularity to purposefully leafy streets, even though sceptical conservatives condemned it as a place to lead 'a chaste correct Aesthetical existence'.

The idea of the model suburb designed with health in mind did not take immediate root. Its connotations of aestheticism and radicalism made it suspect. So, only at the start of the 20th century did the ideal of *rus in urbe* – the countryside in the town – inspire Letchworth Garden City, Hampstead Garden Suburb, and the cottage estates of the London County Council and a few other advanced housing authorities. In every sense they brought a breath of fresh air to the difficult problem of housing the urban masses. Their romantic use of traditional styles was a typically English response to the new problem of mitigating the worst effects of industrialization on housing – and it proved to be very expensive.

Nonetheless, the Old English style remained popular. It touched millions of semi-detached houses run up in the 1920s and 30s, and struck a louder chord among the grander houses of affluent commuters. While the architects of the Modern Movement, particularly Le Corbusier, set out from similar beginnings to the Arts and Crafts men, believing in plain forms to fulfil a Utopian vision, they soon took an ideological path which denied the past in the not entirely unfounded belief that the world had changed so much that history was irrelevant: only the liberating effects of modern materials such as reinforced concrete, steel and plate glass, used in an 'honestly' demonstrative way, could solve an industrial society's needs for mass housing. Their ideas and their pioneering buildings were so persuasive that the architects and planners responsible for reconstructing England after the Second World War followed their example. They would build a new Utopia of concrete towers.

They did not carry ordinary people with them, and, eventually, there was a comprehensive rejection of the harsher aspects of their brand of modern architecture. This has given a new lease of life to traditional styles. Even so modern a scheme as the Building Design Partnership's 1986 Broadway Centre in the London suburb of Ealing – integrated shops, offices and car parking – is dressed out with brick and tile, arches, gables and small window panes, all to put a smile on a friendly face. They seem to bring the story of traditional English architecture full circle. That cannot be. Only the mask of tradition remains. This now belongs to the image makers, but it has provided the point of departure for the best housing of the 20th century, as well as a fashion for the most sentimental.

As for traditional architecture itself, at the start of this century it was still often despised. Old houses were mainly for people who had owned their houses for generations, or were too poor to afford anything better; they were associated with slums and substandard amenities. Consequently many old houses fell at the insistence of Public Health Officers. Thankfully, it soon became clear that many old houses were stately in their associations and endowed with qualities of craftsmanship that no new house could achieve. Happily that view has largely prevailed. Like all traditional architecture, they are now treasured as living history, and protected by law. They do, after all, enshrine valuable practices of construction, planning and decoration which, however inappropriate to today's needs, are beyond everyday modern

capabilities. Those ancient qualities gently reproach us for our forgetfulness; they can also teach many lessons, which, very properly, question today's standards of architecture even though they do not provide the answers.

Kate Greenaway's House, Hampstead, designed by Norman Shaw in a consciously traditional rural style, and drawn to suggest that London was a million miles away.

**Old Oak Estate, Hammersmith, London. A corner of one of the London County Council's pioneering estates, begun shortly before the First World War.**

# GLOSSARY

AISLE-TIE – *tie-beam* spanning an aisle and connecting a wall-post to an *arcade*-post

ARCADE – row of posts or piers, usually supporting arches

ARCH-BRACES – pair of touching curved *braces*, usually supporting a *tie-beam* or *collar*, which together form an arch

BALUSTER – supporting post of a handrail

BANK-BARN – a barn built over a cattle-house and usually reached by an embankment or from an uphill slope

BARREL-VAULT – plain, arched roof running down the length of a building

BASE-CRUCK – one of a pair of short *crucks* which rise only a short way into the roof of a building and are linked by a *tie-beam* which carries a superstructure to support the upper part of the roof

BASTLE – small, defensive rectangular tower, built around 1600 along the Scottish border, usually of two storeys with a cattle-house on the ground floor and one or two domestic rooms above; also called a pelehouse

BOX-FRAME – timber frame comprising horizontal and vertical timbers, forming the walls of a building and directly supporting the roof

BRACE – triangulating piece, usually in a timber frame

BRESSUMMER – horizontal, intermediate structural timber, sometimes supporting the ends of floor *joists* or a chimney

BRIDGING-PIECE – horizontal timber spanning a building, for instance to support a series of floor *joists*

BUTTERY – a bottle store, from Fr. *bouteillerie*, hence a service room for liquid foodstuffs

CHIMNEY-HOOD – wide funnel-shaped chimney, usually made of timber and plaster, synonymous with firehood

CLOSE-STUDDING – *studs* set about as closely together as their own width

COB – building material comprising a naturally dried mixture of clay, earth, sand, pebbles and binding material such as cowhair, straw and brambles; in Buckinghamshire, wychert; Cumbria, dabbin

COLLAR – horizontal timber, usually joining a pair of rafters some way below their apex

COMMON RAFTER – one of a series of similarly sized rafters not forming part of a roof *truss*, i.e. not a *principal rafter*

CORBEL – piece of stone or timber projecting from a wall, usually to support an arch, post or beam

CORNICE – horizontal projection, particularly the topmost part of a classical *entablature*, designed to stop rain from running down the face of a building

CROSS-PASSAGE – passage running across a house, usually adjacent to a *hall*, between front and back entrance doors

CROSS-TREES – pair of crosswise timbers on which a *post-mill* is mounted

CROWN-PLATE – timber running down the length of a roof, carried by a series of crown-posts, to support the *collars* linking pairs of rafters

CROWN-TREE – rotating timber on top of a main post which carries the weight of the rotating body of a *post-mill*

CRUCK – curved timber, used in pairs to form a bowed A-frame which supports the roof of a building independently of walls

DAIS – raised floor, usually at the high end of a *hall* further from the entrance

DOVETAIL – reversed wedge-shaped timber joint designed to withstand tension, for instance between a *tie-beam* and a pair of *wall-plates*

DRAGON-POST – post at the corner of a building bearing a projecting diagonal beam, usually in association with *jetties* on adjacent sides

ENTABLATURE – classical lintel, comprising an architrave, or main structural element, decorative frieze, and *cornice*

GALLETTING – insertion of chips of stone into mortar between larger stones for decorative effect

GARDEROBE – archaic word for privy

GRUBENHAUS – German for sunken house; a form of Anglo-Saxon building characterized by a floor sunk to a depth of about 1 m (3 ft) below ground level

HALL – large public room, usually open to the roof and containing a hearth, used as a main living room in the Middle Ages; latterly, also an entrance vestibule; in the north, firehouse, house-body, housepart

HAMMER-BEAM – one of a pair of cantilevered beams which project from opposite walls to support a timber roof

HEARTH-PASSAGE – *cross-passage* partly backing a chimney-stack with a hearth in the adjacent *hall*

HECK – northern word for a short partition, usually shielding a hearth and ingle from a doorway or passage

HIP – slanting outward angle of roof, the opposite of a valley, the inward angle

HOODMOULD – projecting moulding over an opening or other feature of a building which needs protection from rainwater

HOVEL – southern dialect for an animal house, usually a shelter shed; Midland dialect for a raised store or granary, synonymous with helm

JETTY – projecting *joists* extending a floor beyond the external wall below

JOIST – horizontal supporting member, usually of timber, to carry a floor

KELL – western dialect for kiln-house, synonymous with oast

KEYSTONE – centre stone or voussoir at the head of an arch

KING-POST – vertical roof timber supporting a *ridge-beam*

LAITHE – combined barn and cattle-house, typical of the north

LAP-JOINT – joint between two timbers in which the thickness of each one is halved to allow them to fit or lap over each other

LINHAY – West Country dialect for a shelter shed with an open hayloft above

LOUVER – ventilation opening, usually slatted to reduce entry of rain and light

LUCARNE – dormer opening, sometimes jettied out, to protect a hoist and doorways on floors below it through which goods can be winched

MIDDLESTEAD – bay of a barn containing a main entrance for carts, and sometimes another doorway opposite; synonymous with midstrey

MISTAL – northern dialect for cattle stall, also synonymous with byre

MORTISE – hole in framework usually designed to receive a *tenon*

MULLION – vertical framing member of an opening such as a window

NETHER HOUSE – northern word for a room beyond the low end of a *hall*

NEWEL – stair which winds round a central newel-post

ORIEL – projecting window, often bracketed out from a wall

OUTSHUT – part of a building beneath a low continuation of the downward slope of a roof

PAD-STONE – flat stone acting as a plinth, usually for a single timber post

PASSING-BRACE – *brace* which, in one or two lengths, passes across the principal transverse members of a timber-framed building from an aisle-post on one side to a roof rafter on the other

PELEHOUSE – *see bastle*

PENTISE – single-pitched roof attached to the side of a wall

PLENUM CHAMBER – kiln room, particularly in an oast house

POST-MILL – windmill mounted on a post so that it can rotate into the wind

POTENCE – device which allows a ladder to pivot around the inside of a dovecot so that all the nest holes can be reached

PRINCIPAL RAFTER – stout rafter forming a structural part of a roof *truss*

PURLIN – longitudinal roof timber designed to support rafters

QUARTER-BRACES – *braces* supporting the post of a *post-mill* on the *cross-trees*

QUEEN-STRUT – one of a pair of struts which rise, usually from a *tie-beam*, to support the ends of a roof *collar*

RAIL – horizontal timber, such as in a wall or door

RIDGE-BEAM – longitudinal timber running along the ridge of a roof to support heads of rafters

SCARF-JOINT – joint connecting the ends of two timbers together

SCISSOR-BRACES – pair of *braces* which cross over each other, like a pair of scissors, below the apex of a roof

SHIELING – impermanent dwelling built on marginal land and temporarily occupied in the summer by herdsmen

SHIPPON – western dialect for cattle-house, synonymous with byre

SHORE – part of a timber frame acting as a buttress

SIDE-GIRTS – timbers attached to the *crown-trees* of a *post-mill* from which the body of the mill is suspended

SIDE STEAD – bay of a barn without a main entrance, as opposed to a *middlestead* which has one

SILL – base, e.g. of a wall or window

SINKMOW – northern dialect for part of a field-house or *laithe* left open as a hay store

SLING-BRACE – *brace* which rises across eaves line, usually as a substitute for a *tie-beam*, to counteract the outward thrust of a *trussed* roof

SMOCK-MILL – timber-framed *tower mill* with sloping polygonal sides

SOLAR – upper chamber in a medieval dwelling

SOLE-PLATE – timber serving as a *sill*-beam

SPERE – short partition, often fixed to a *truss* adjacent to a *cross-passage*

STADDLE-STONE – mushroom-shaped plinth stone designed to support a granary above the ground and deter rats

STRAINER-BEAM – beam fixed between two posts designed to keep them apart

STUD – secondary vertical timber

TAIL-POLE – pole projecting from the base of a *post-mill*, used to turn it into the wind

TENON – projecting piece of timber designed to fit into a *mortise* to form a joint

TIE-BEAM – transverse beam linking the tops of two walls, designed to counter the outward thrust of the roof above

TOWER MILL – windmill, with a rotating cap containing the *windshaft*, and a stationary body in the form of a multi-storeyed tower

TRANSOM – horizontal bar set across an opening such as a window

TRUSS – transverse timber frame designed to support a roof at bay intervals

WALL-PLATE – longitudinal timber framing the top of a wall

WIND-BRACE – *brace* joining a *purlin* and *principal rafter* of a roof to counteract the effect of wind pressure, and often to decorate the roof as well

WINDSHAFT – shaft to which the sails of a windmill are attached

# NOTES

## 1 The Making of a Tradition

1 Pevsner 1943, 10.
2 Mercer 1975, 1–2.
3 Brunskill 1971, 25–9.
4 Currie 1987.
5 Hawkes 1969.
6 Salway 1981, 542–52.
7 Postan 1944.
8 Bishop 1948.
9 A.J. Taylor 1961.
10 Tawney 1941.
11 Fletcher 1968.
12 Thirsk 1961.
13 Hoskins 1976.
14 Phelps Brown and Hopkins 1956.
15 Furnivall 1877, 241.
16 Kerridge 1953–4.
17 Airs 1975, 182–91.
18 C. Morris 1947, 220–21.
19 *Tour*, Vol. 2, 1726, Letter 8.
20 *Tour*, Vol. 1, 1724, Letter 2.
21 Fisher 1935.

## 2 Materials

1 *Cumberland Ballads* 1804.
2 McCann 1987.
3 Orme 1982.
4 Rackham 1976, 23, 76–7.
5 Weeks 1982.
6 Clifton-Taylor 1972, 336–48.
7 Peters 1977.
8 Machin 1977.
9 Clifton-Taylor 1969.
10 Clifton-Taylor 1972, 32 *et passim*.

## 3 Timber Framing

1 Rahtz 1979, 170–77, 178–85.
2 Bulmer-Thomas 1979.
3 J.T. Smith 1974.
4 Horn 1958.
5 Charles 1967, 16–25.
6 J.T. Smith 1964.
7 Alcock 1981, 5–24.
8 James *et al.* 1984.
9 Addyman 1981.
10 Algar and Musty 1969.
11 Alcock 1981, 28–36.
12 Rackham 1982.
13 Rackham 1972, 1982.
14 Currie 1983.
15 Hewett 1980, 23–4, 32–4.
16 Hewett 1971.
17 Fletcher and Tapper 1984.
18 Hewett 1969, 29–32.
19 J.T. Smith 1974.
20 Leggett *et al.* 1982.
21 Hewett 1962–3, 265.
22 J.T. Smith 1974.
23 Fletcher 1979.
24 J.T. Smith 1974.
25 Fletcher and Tapper 1984.
26 J.T. Smith 1974.
27 Hewett 1961.
28 Fletcher 1980.
29 Hewett 1961.
30 Hewett 1980, 91.
31 Fletcher and Spokes 1964.
32 Highfield 1971.
33 Morrey and Smith 1973.
34 Fletcher 1975.
35 Hewett 1980, 164–5.
36 Laxton *et al.* 1984.
37 Currie 1987.
38 Alcock and Barley 1972.
39 Hewett 1972; 1980, 87–8.
40 Fletcher *et al.* 1981.
41 Peters 1964.
42 Rigold 1968.
43 Hewett 1976.
44 Stell 1965.
45 J.T. Smith 1965.
46 Blair 1984a.
47 J.T. Smith 1965.
48 Rigold 1969a.

## 4 Medieval Houses

1 Ven. Bede, 2, 13.
2 Hope-Taylor 1977.
3 *Germania*, 12–15.
4 Cramp 1957.
5 Davison 1977.
6 Wood 1965, 35–40.
7 Webster and Cherry 1975, 250–51; 1978, 145–6; 1980, 220–21.
8 G. Beresford 1977.
9 Faulkner 1958.
10 Wood 1965, 16.
11 Wood 1965, 32–4.
12 Faulkner 1958.
13 Rigold 1962.
14 Blair 1984b.
15 VAG 1984.
16 VAG 1984.
17 Mason 1966.
18 Hewett 1976.
19 Sandall 1986.
20 McCann 1977.
21 J.T. Smith 1955; Hewett 1980, 53–5.
22 Hewett 1980, 108–9; Webster and Cherry 1977, 253–4.
23 Hewett 1976; 1980, 135–6.
24 J.T. Smith 1955.
25 Hewett 1966.
26 J.T. Smith 1955; Hewett 1980, 132–3.
27 J.T. Smith 1955.
28 Sandall 1975.
29 VAG 1982.
30 Bismanis 1977.
31 Fletcher 1979; Currie 1987, 29–33.
32 J.T. Smith 1958a.
33 S.R. Jones and Smith 1958.
34 Laxton *et al.* 1984.
35 Alcock 1982.
36 Alcock and Barley 1972.
37 Charles 1967, 38–9.
38 Barley 1961, 24–5.
39 VAG 1985.
40 Steane 1978.
41 Pantin 1957 (1).
42 Williams *et al.* 1987.
43 Pantin 1961.
44 Airs 1978; Pantin 1957, 1959 (5).
45 Wood 1965, 247–56.
46 Hewett 1973b.
47 Tonkin 1967–9b.
48 Hewett 1973a; 1980, 85–7.
49 Colman 1986.
50 Colman and Colman 1965.
51 J.T. Smith 1958b; Colman and West 1974.
52 Colman 1974.
53 Mason 1969, 20–25.
54 Field 1965.
55 B-Text, Book 17.
56 Barley 1963.
57 VAG 1984.
58 Field 1965; Dyer 1986.
59 Charles 1967, 26–32, 38–9.
60 Alcock *et al.* 1971–3; Alcock 1975.
61 Alcock 1965; 1968, 13–28; 1972, 35–36.
62 VAG 1982.
63 Ryder 1979, 47–55, 62–77.
64 Giles 1986, 27–36.
65 Martin and Mastin 1977–80, 18–20; 1980–86, 47–50.
66 Harris 1987.
67 Martin and Mastin 1980–86, 47–50.
68 Melling 1965, 23–4.
69 Bruce-Mitford 1956, 176.
70 Peate 1936.
71 G. Beresford 1979.
72 Field 1965.
73 Alcock *et al.* 1972.
74 S.R. Jones 1971.
75 Alcock 1969, 83–106.
76 Alcock and Laithwaite 1973.
77 Machin 1978, 34–43.
78 Austin and Hall 1972.
79 Rigold 1967.
80 C. Morris 1947, 136–7.
81 Rigold 1969b.
82 Cowper 1911.
83 J.T. Smith 1970a.
84 Rigold 1963.
85 Martin and Mastin 1980–86, 50–51.
86 Swain 1968.
87 Martin and Mastin 1977–80, 3–5.
88 Rigold 1969a.
89 Martin and Mastin 1974.
90 Gravett 1981.
91 Parkin 1962.
92 Sparks and Parkin 1974; Hayes 1981.
93 Slane 1984.
94 Mason 1953.
95 Lewis *et al.* 1988 (13–16).

## 5 New Houses for Old

1 Furnivall 1877, 239–40.
2 J.T. Smith 1970a; Mercer 1975, 61.
3 Cummings 1979, 4.
4 *Piers Plowman*, Book 10.
5 Machin 1977.
6 Hewett 1973c.
7 Melling 1965, 7, 9–10.
8 Martin and Mastin 1974, 23–8.
9 Gravett 1966; Quiney 1983.
10 Swain 1968.
11 Mason 1969, 77.
12 Alcock *et al.* 1971–3; Alcock 1975, 1.
13 Barley 1961, 96–7.
14 Alcock 1966.
15 Williams 1974a.
16 Barley 1961, 108–13.
17 Alcock *et al.* 1972.
18 S.R. Jones 1971.
19 Alcock *et al.* 1972.
20 S.R. Jones 1971.
21 Mercer 1975 (73).
22 Tonkin 1976–8.
23 R. de Z. Hall 1971.
24 Williams 1972, 1976.
25 Wood-Jones 1963, 55–9.
26 RCHM *Northants. N* 1984, lix–lxiii.
27 Parker 1975, 138–9.
28 Hoskins 1957, 285–94.
29 Tonkin 1967–9a and 1967–9b, 167.
30 J.T. Smith 1970b.
31 Williams 1974b.
32 Summers 1972.
33 Quiney 1984.
34 Hewett 1973c.
35 Johnson 1981.
36 C 6/1/7, 269–70.
37 Barley 1967, 738–9.
38 VAG 1982.
39 Elmhirst 1951; S.R. Jones 1980c.
40 Kenyon 1955.
41 Pantin 1957 (1), 1959 (5).
42 Machin 1978, 77–82.
43 Wood-Jones 1963, 107–38.
44 Barley 1961, 157–60.
45 Carson 1976.
46 VAG 1982.
47 Barley 1979.
48 Barley 1979.
49 Quiney 1974.
50 VAG 1984, 1985.
51 Stell 1965.
52 Giles 1986, 107–32.
53 Quiney 1986, 56–60.
54 S.R. Jones 1980a.
55 Raistrick 1976, 44.
56 Mercer 1975 (479).
57 Pearson 1985, 59–61 (19, 94).
58 Pearson 1985, 61–4 (59).
59 Pearson 1985 (14).
60 Quiney 1986, 60–67; W.J. Smith 1987.
61 Giles 1986, 137 (177).
62 Hutton 1973.
63 Hillam and Fletcher 1983.
64 S.R. Jones 1980a.
65 Mercer 1975 (513).
66 Stell 1965.
67 Hayes and Rutter 1972, 9–12.
68 Singleton 1955; Brunskill 1974, 56–9, 1977.
69 Hayes and Rutter 1972, 50–53, 66, 84–6.
70 Hayes and Rutter 1972, 32–4, 41–3, 46–7, 79.
71 C. Morris 1947, 196, 202.
72 Brunskill 1953.
73 Mercer 1975 (281).
74 Milner 1976.
75 Spence 1980.
76 Dixon 1979.
77 Ramm *et al.* 1970 (1, 13, 15, 29).
78 Ramm *et al.* 1970 (14, 39, 43).
79 Dixon 1979.
80 C. Morris 1947, 207.

## 6 Town Buildings

1 Pantin 1962–3b.
2 Schofield 1984, 28, 56.
3 Wood 1965, 81–98; Faulkner 1966.
4 Lawson and Smith 1958; Turner 1988.
5 Schofield 1984, 77–8.
6 Barley 1986, 69.
7 Faulkner 1966.
8 Pantin 1962–3b (14); VAG 1987.
9 Lawson and Smith 1958.

10 Grenville 1988.
11 Carter 1980.
12 Wood 1965, 3–4; S.R. Jones 1974.
13 Schofield 1984, 54–6.
14 Wood 1965, 1–15.
15 RCHM *York 5* 1981 (469).
16 Martin and Mastin 1987 (1).
17 Martin and Mastin 1974.
18 Pantin 1962–3b (9, 10).
19 Pantin 1962–3b (14–23).
20 Pantin 1962–3b (24); VAG 1987.
21 Pantin 1961.
22 Pantin 1962–3a.
23 Pantin 1962–3a.
24 Schofield 1984, 118–20.
25 Pantin 1962–3b (30–33); Faulkner 1966.
26 RCHM *York 5* 1981 (120).
27 VAG 1987.
28 Salzman 1952, 430; Short 1980; RCHM *York 5* 1981, lix (139, 222, 291, 471).
29 Bridge 1986.
30 Bailey 1980.
31 Pantin 1959.
32 Jones and Smith 1960–61.
33 Martin and Mastin 1987 (3).
34 Schofield 1984, 88–9.
35 Pantin 1961 (2–4).

36 RCHM *Stamford* 1977, l–lvii.
37 R. Taylor 1974.
38 Martin and Mastin 1980–86, 71; 1987 (17).
39 Laithwaite 1968.
40 VAG 1987.
41 Martin and Mastin 1987 (11).
42 Schofield 1984, 146, 165, 171.
43 Hewett 1980, 230–33.
44 Schofield 1984, 144, 158–62.
45 Kelsall 1974.

**7 Agriculture and Industry**
1 Platt 1969, 207–8.
2 Rigold 1966.
3 Castle 1973; Weaver 1970.
4 Hillam and Fletcher 1983.
5 Currie 1987.
6 Rigold 1971.
7 Hillam 1988.
8 S.R. Jones 1980b.
9 Michelmore 1974.
10 Ryder 1980.
11 Clarke 1973.
12 Le Patourel 1976.
13 Fletcher 1980.
14 Platt 1969, 187.
15 Currie 1987.
16 Faulkner 1965.
17 Christy 1903; VAG 1984.

18 Ebbage 1976.
19 Home 1912.
20 Webster and Cherry 1977, 257.
21 Mercer 1975 (283).
22 Ryder 1980.
23 Martin and Mastin 1977–80, 25–9.
24 Mercer 1975 (246).
25 Hewett 1962–3.
26 Wade 1981, 22.
27 Homes 1978.
28 Wade 1981, 23; 1983, 33–4.
29 Wade 1981, 23.
30 VAG 1975.
31 Woodward 1982; Airs 1983b.
32 Pantin 1962–3a.
33 Wade 1981, 15–21.
34 Martin and Mastin 1980–86, 75.
35 Alcock 1969, 83–106.
36 Martin and Mastin 1977–80, 25–9; 1982, 62–5.
37 Michelmore 1974; Ryder 1979.
38 Grundy 1970.
39 Armstrong 1971, 34.
40 Alcock 1963.
41 Alcock 1966.
42 Walton 1956.
43 Chapman 1978.
44 Brunskill 1975.
45 Tyson 1980.

46 Brunskill 1974, 82–7.
47 L.J. Hall 1983, 84.
48 RCHM *Dorset SE* 1970, Langton Matravers (6).
49 Bond 1974.
50 Caiger 1974.
51 Watkins 1890.
52 Mowat 1903–14.
53 Wade 1980, 9–11.
54 Rhatz 1979.
55 Wilson and Hurst 1967, 274–5.
56 Tann 1967.
57 Webster and Cherry 1972, 161.
58 Beresford and St Joseph 1979, 64.
59 Rackham 1976, 76.
60 Wailes 1948.
61 G. Beresford 1977.
62 RCHM *Cambs. NE* 1972, Burwell (6).
63 L.J. Hall 1983, 85 (224).
64 Homes 1973–5.
65 Martin and Mastin 1977–80, 99; 1980–86, 9–18.
66 Cronk 1978–9.
67 Tonkin 1973–5; Homes 1978.
68 Cronk 1978–9.

**8 The End of a Tradition**
1 *The Earthly Paradise* 1868–70.

## BIBLIOGRAPHY

ADDYMAN, P.V. 'Cruck buildings', in ALCOCK, 1981, 37–9
AIRS, M.R. *The making of the English country house 1500–1640*, London, 1975
——'Ewelme', *Archaeol. J.*, 135 (1978), 276–80
ALCOCK, N.W. 'Devonshire linhays', *Trans. Devon Assoc.*, 95 (1963), 117–30
——'The medieval cottages of Bishop's Clyst, Devon', *Med. Archaeol.*, 9 (1965), 146–53
——'A Devon farm, Bury Barton, Lapford', *Trans. Devon Assoc.*, 98 (1966), 105–31
——'Devonshire farmhouses', pts 1, 2, 4, *Trans. Devon Assoc.*, 100, 101, 104 (1968, 1969, 1972)
——*Stoneleigh villagers 1597–1650*, Warwick, 1975
——(ed.) *Cruck construction*, Council for British Archaeol. Research Rep., 42, London, 1981
——'The hall of the Knights Templar at Temple Balsall, W. Midlands', *Med. Archaeol.*, 26 (1982), 155–8
ALCOCK, N.W., and M.W. BARLEY 'Medieval roofs', *Antiquaries J.*, 52 (1972), 132–68
ALCOCK, N.W., J.G. BRAITHWAITE and M.W. JEFFS 'Timber-framed buildings in Warwicks.', *Trans. Birmingham Archaeol. Soc.*, 85 (1971–3), 178–202
ALCOCK, N.W., P. CHILD and M. LAITHWAITE 'Sanders, Lettaford', *Proc. Devon Archaeol. Soc.*, 30 (1972), 227–33
ALCOCK, N.W., and M. LAITHWAITE 'Medieval houses in Devon', *Med. Archaeol.*, 17 (1973), 100–25

ALGAR, D., and J. MUSTY 'Gomeldon', *Current Archaeol.*, 14 (1969), 87–91
ARMSTRONG, J.R. (ed.) *Weald and Downland Open Air Museum*, guide, Chichester, 1971
AUSTIN, C., and R. DE Z. HALL 'The medieval houses of Stocklinch', *Proc. Somerset Archaeol. and Natural Hist. Soc.*, 116 (1972), 86–100
BAILEY, J.M. 'Nos 26–32 Middle Row, Dunstable', *Beds. Archaeol. J.*, 14 (1980), 98
BARLEY, M.W. *The English farmhouse and cottage*, London, 1961
——'A glossary of names in houses of the 16th and 17th centuries', in Foster and Alcock, *Culture and environment*, London, 1963, 479–501
——'Rural housing in England', in Thirsk, *The agrarian history of England and Wales*, vol. 4, Cambridge, 1967, 696–766
——'The double-pile house', *Archaeol. J.*, 136 (1979), 253–64
——*Houses and history*, London, 1986
BERESFORD, G. 'Excavations of a moated house at Wintringham', *Archaeol. J.*, 134 (1977), 194–226
——'Three deserted medieval settlements on Dartmoor', *Med. Archaeol.*, 23 (1979), 98–158
BERESFORD, M.W., and J.K.S. ST JOSEPH *Medieval England*, 2nd ed. Cambridge, 1979
BISHOP, T.A.M. 'The Norman settlement of Yorks.', *Studies in medieval history*, ed. R.W. Hunt *et al.*, Oxford, 1948, 1–14
BISMANIS, M.R. 'An aisled hall at Withington, Herefs.', *Med. Archaeol.*, 21 (1977), 202–3
BLAIR, J. 'Posts or crucks?', *Vernacular*

*Archit.*, 15 (1984a), 39
——'Some developments in English domestic planning, 1100–1250', paper presented to 13th Annual Symposium of Soc. of Archit. Hist. of Great Britain, 1984b
BOND, C.J. 'A medieval dovecot at Wick', *Vale of Evesham Hist. Soc. Research Papers*, 3 (1974), 52–8
BRIDGE, M. 'Tree ring dates', *Vernacular Archit.*, 17 (1986), 53–4
BRUCE-MITFORD, R.L.S. 'A Dark-Age settlement at Mawgan Port, Cornwall', *Recent archaeol. excavations in Britain*, London, 1956, 167–96
BRUNSKILL, R.W. 'The development of the small house in the Eden valley', *Trans. Cumberland and Westmorland Antiquarian and Archaeol. Soc.*, new ser. 53 (1953), 160–89
——*A handbook of vernacular architecture*, London, 1971
——*Vernacular architecture of the Lake Counties*, London, 1974
——'Vernacular architecture of the northern Pennines', *Northern Hist.*, 11 (1975), 107–42
——'Traditional domestic architecture of S.W. Lancs.', *Folk Life*, 15 (1977), 65–8
BULMER-THOMAS, I. 'Euclid and medieval architecture', *Archaeol. J.*, 136 (1979), 136–50
CAIGER, J.E.L. 'Two Kent pigeon houses', *Archaeol. Cantiana*, 89 (1974), 33–41
CARSON, C. 'Segregation in vernacular buildings', *Vernacular Archit.*, 7 (1976), 24–9
CARTER, N. 'The Music House and Wensum Lodge, King Street, Norwich', *Archaeol. J.*, 137 (1980), 310–12

CASTLE, S.A. 'Parsonage Farm, Abbots Langley, Kingsbury Farm, St Albans, and Croxley Hall Farm', *Herts. Archaeol.*, 3 (1973), 131–8
CHAPMAN, V. 'Cruck-framed building in the Vale of the Tees', *Trans. Durham and Northumberland Archaeol. Soc.*, new ser. 4 (1978), 35–42
CHARLES, F.W.B. *Medieval cruck-building and its derivatives*, London, 1967
CHRISTY, M. 'Some old Roothing farmhouses', *Essex Rev.*, 12 (1903), 129–44
CLARKE, D.W. 'Pennine aisled barns', *Vernacular Archit.*, 4 (1973), 25–6
CLIFTON-TAYLOR, A. 'Building materials', in J.A. Newman, *The buildings of England*, Harmondsworth, 1969, 23–9
——*The pattern of English building*, 3rd edn., London, 1972
COLMAN, G., and S. COLMAN 'A 13th-century aisled house', *Proc. of the Suffolk Inst. of Archaeol.*, 30 (1965), 149–65
COLMAN, S. 'A late aisled house in Suffolk', *Vernacular Archit.*, 5 (1974), 14–17
——'Hales Farm, Fyfield, Essex', *Proc. of the Suffolk Inst. of Archaeol.* (1986)
COLMAN, S., and S.E. WEST *Edgar's Farm, Stowmarket*, East Anglian Archaeology, Report No. 1, Suffolk County Planning Dept., 1974
COWPER, H.S. 'Some timber-framed houses in the Kentish Weald', *Archaeol. Cantiana*, 29 (1911), 169–205
CRAMP, R. '*Beowulf* and archaeology', *Med. Archaeol.*, 1 (1957), 57–77
CRONK, A. 'Oasts in Kent and E. Sussex', *Archaeol. J.*, 94 (1978), 99–110; 95 (1979), 241–54

CUMMINGS, A.L. *The framed houses of Massachusetts Bay, 1625–1725*, Cambridge, Mass. and London, 1979
CURRIE, C.R.J. 'Timber supply and timber building in a Sussex parish', *Vernacular Archit.*, 14 (1983), 52–4
——*Harwell houses to 1700*, Vernacular Architecture Group, 1987

DAVISON, B.K. 'Excavations at Sulgrave, Northants, 1960–76', *Archaeol. J.*, 134 (1977), 105–14
DIXON, P.W. 'Tower-houses, pelehouses and border society', *Archaeol. J.*, 136 (1979), 240–52
DYER, C. 'English peasant buildings in the later Middle Ages', *Med. Archaeol.*, 30 (1986), 19–45

EBBAGE, S. *Barns and granaries in Norfolk*, Ipswich, 1976
ELMHIRST, E. *Peculiar inheritance*, London, 1951

FAULKNER, P.A. 'Domestic planning from the 12th to 14th centuries', *Archaeol. J.*, 115 (1958), 150–83
——'Sudeley Castle', *Archaeol. J.*, 122 (1965), 189–90
——'Medieval undercrofts and town houses', *Archaeol. J.*, 123 (1966), 120–35
FIELD, R.K. 'Worcs. peasant holdings', *Med. Archaeol.*, 9 (1965), 105–45
FISHER, F.J. 'The development of the London food market, 1540–1640', *Econ. Hist. Rev.*, 5 (1935), 46–64
FLETCHER, J.M. 'Crucks in the W. Berks. and Oxford region', *Oxoniensia*, 33 (1968), 71–88
——'The medieval hall at Lewknor', *Oxoniensia*, 40 (1975), 247–53
——'The bishop of Winchester's medieval manor house at Harwell, Berks.', *Archaeol. J.*, 136 (1979), 173–92
——'A list of tree-ring dates', *Vernacular Archit.*, 11 (1980), 32–8
FLETCHER, J.M., M. BRIDGE and J. HILLAM 'Tree-ring dates', *Vernacular Archit.*, 12 (1981), 38–40
FLETCHER, J.M., and P.S. SPOKES 'The origin and development of crown-post roofs', *Med. Archaeol.*, 8 (1964), 152–83
FLETCHER, J.M., and M.C. TAPPER 'Medieval artefacts and structures dated by dendrochronology', *Med. Archaeol.*, 28 (1984), 112–132
FURNIVALL, F.J. (ed.) *Harrison's Description of England*, London, 1877

GILES, C. *Rural houses of W. Yorks., 1400–1830*, London, 1986
GRAVETT, K.W.E. 'Whitehall, Cheam', *Surrey Archaeol. Col.*, 63 (1966), 138–50
——'The Clergy House, Alfriston', *National Trust Studies*, ed. G. Jackson-Stops, London, 1981, 103–8
GRENVILLE RAI Lecture: 'The Rows of Chester', 1988
GRUNDY, J.E. 'Notes on the relationship between climate and cattle housing', *Vernacular Archit.*, 1 (1970), 2–5

HALL, L.J. *The rural houses of N. Avon and S. Glos., 1400–1720*, Bristol, 1983

HALL, R. DE Z. 'A preliminary catalogue of curing chambers in Somerset', *Proc. Somerset Archaeol. and Natural Hist. Soc.*, 115 (1971), 45–7
HARRIS, R. (ed.) *Weald and Open Air Museum Guidebook*, Chichester, 1987
HAWKES, S.C. 'Early Anglo-Saxon Kent', *Archaeol. J.*, 126 (1969), 186–92
HAYES, D. 'Some hall-house plans in E. Kent', in WADE, 1981, 24–30
HAYES, R.H., and J.G. RUTTER *Cruck-framed buildings in Ryedale and Eskdale*, Scarborough, 1972
HEWETT, C.A. 'Timber building in Essex', *Trans. Ancient Monuments Soc.*, new ser. 9 (1961), 33–56
——'Structural carpentry in medieval Essex', *Med. Archaeol.*, 6–7 (1962–3), 240–71
——'Jettying and floor-framing in medieval Essex', *Med. Archaeol.*, 10 (1966), 89–112
——*The development of carpentry 1200–1700*, Newton Abbot, 1969
——*The barn at Grange Farm, Coggeshall, Essex*, Chelmsford, 1971
——'The tithe barn at Siddington, Glos.'. *Archaeol. J.*, 129 (1972), 145–7
——'The smaller medieval house in Essex', *Archaeol. J.*, 130 (1973a), 172–82
——'A medieval timber kitchen at Little Braxted, Essex', *Med. Archaeol.*, 17 (1973b), 132–4
——'The development of the post-medieval house', *Post-Med. Archaeol.*, 7 (1973c), 60–78
——'Aisled timber halls and related buildings', *Trans. Ancient Monuments Soc.*, new ser. 21 (1976), 45–99
——*English historic carpentry*, London and Chichester, 1980
HIGHFIELD, J.R.L. 'The Aula Custodis', *Postmaster*, 4, No. 4 (1971), 14–22
HILLAM, J. 'Tree-ring dates', *Vernacular Archit.*, 19 (1988), 44
HILLAM, J., and J.M. FLETCHER 'Tree-ring dates', *Vernacular Archit.*, 14 (1983), 61–2
HOME, G. 'Inscriptions on the beams of a barn at Effingham', *Surrey Archaeol. Col.*, 25 (1912), 144–7
HOMES, C.A.I. 'Industrial archaeology', *Trans. Woolhope Natural Hist. and Field Club*, 41 (1973–5), 9–13, 135–6, 271–2
——'The agricultural use of the Herefs. house and its outbuildings' *Vernacular Archit.*, 9 (1978), 12–16
HOPE-TAYLOR, B. *Yeavering*, London, 1977
HORN, W. 'On the origin of the medieval bay system', *J. Soc. Archit. Hist.*, 17 (1958), 2–23
HOSKINS, W.G. *The Midland peasant*, London, 1957
——*The age of plunder*, London, 1976
HUTTON, B. 'Timber-framed houses in the Vale of York', *Med. Archaeol.*, 17 (1973), 87–99

JAMES, S., A. MARSHALL and M. MILLETT 'An early medieval building tradition', *Archaeol. J.*, 141 (1984), 182–215

JOHNSON, I. 'Hill Farm, Laxfield', *Proc. Suffolk Inst. of Archaeol. and Hist.*, 35 (1981), 53–9
JONES, S.R. 'Devonshire farmhouses, pt. 3', *Trans. Devon Assoc.*, 103 (1971), 35–75
——'Ancient domestic buildings [in Lincs.] and their roofs', *Archaeol. J.*, 131 (1974), 309–13
——'Stone houses in the vernacular tradition in S. Yorks., 1600–1700', *Archaeol. J.*, 137 (1980a), 386–93
——'Whiston Hall barn, Whiston', *Archaeol. J.*, 137 (1980b), 431–3
——'Houndhill, Worsbrough', *Archaeol. J.*, 137 (1980c), 442–4
JONES, S.R., and J.T. SMITH 'Manor House, Wasperton', *Trans. and Proc. Birmingham Archaeol. Soc.*, 76 (1958), 19–28
——'The Wealden houses of Warwickshire', *Trans. and Proc. Birmingham Archaeol. Soc.*, 79 (1960–61), 24–35

KELSALL, A.F. 'The London house plan in the later 17th century', *Post-Med. Archaeol.*, 8 (1974), 80–91
KENYON, G.H. 'Kirdford inventories, 1611–1776', *Sussex Archaeol. Col.*, 93 (1955), 78–156
KERRIDGE, E. 'The movement of rent, 1540–1640', *Econ. Hist. Rev.*, 2nd ser. 6 (1953–4), 16–34

LAITHWAITE, M. 'A ship-master's house at Faversham, Kent', *Post-Med. Archaeol.*, 2 (1968), 150–62
LAWSON, P.H., and J.T. SMITH 'The rows of Chester', *Chester Archaeol. Soc. J.*, 45 (1958), 1–42
LAXTON, R.R., C.D. LITTON and W.G. SIMPSON 'Tree-ring dates', *Vernacular Archit.*, 15 (1984), 65–9
LEGGETT, P.A. *et al.*, 'Tree-ring dates', *Vernacular Archit.*, 13 (1982), 48–9
LE PATOUREL, H.E.J. 'Stank Hall barn, Leeds', *Thoresby Soc. Misc.*, 16 (1976)
LEWIS, E., and E. and K. ROBERTS *Medieval hall houses of the Winchester area*, Winchester, 1988

McCANN, J. 'Slade's farm, Beauchamp Roding', *Essex J.*, 12, No. 2 (1977), 35–7
——'Is clay lump a traditional building material?', *Vernacular Archit.*, 18 (1987), 1–16
MACHIN, R. 'The mechanism of the pre-industrial building cycle', *Vernacular Archit.*, 8 (1977), 15–19
——*The houses of Yetminster*, Bristol 1978
MARTIN, D., and B. MASTIN *An architectural history of Robertsbridge*, Robertsbridge, 1974
——*Historic Buildings in Eastern Sussex*, vols 1–4, Robertsbridge, 1977–87
MASON, R.T. 'Three medieval houses in E. Sussex', *Sussex Archaeol. Col.*, 91 (1953), 21–31
——'Old Court Farm, Limpsfield', *Surrey Archaeol. Col.*, 63 (1966), 130–37
——*Framed buildings of the Weald*,

revised edn., Horsham, 1969
MELLING, E. *Kentish sources: 5*, Maidstone, 1965
MERCER, W.E.R. *English vernacular houses*, London, 1975
MICHELMORE, D.J.H. 'Pennine aisled barns with king-post roofs', *Brigantian*, 3 (1974), 15–17
MILNER, L. 'Northumberland pele towers', *Archaeol. J.*, 133 (1976), 168–9
MORREY, M.C.J., and J.T. SMITH '"The Great Barn" at Lewknor', *Oxoniensia*, 38 (1973), 339–45
MORRIS, C. (ed.) *The journeys of Celia Fiennes*, London, 1947
MOWAT, G. 'Early pigeon-houses', *Trans. St. Albans and Herts. Archit. and Archaeol. Soc.*, new ser. 2 (1903–14), 29–32

ORME, B.J. 'Prehistoric woodlands and woodworking in the Somerset Levels', in McGrail, *Woodworking techniques*, Oxford, 1982, 79–94

PANTIN, W.A. 'Medieval priests' houses in south-west England', *Med. Archaeol.*, 1 (1957), 118–46
——'Chantry priests' houses', *Med. Archaeol.*, 3 (1959), 216–58
——'Medieval inns', in *Studies in building history*, ed. E.M. Jope, London, 1961, 166–91
——'The merchants' houses and warehouses of King's Lynn', *Med. Archaeol.*, 6–7 (1962–3a), 173–81
——'Medieval English town-house plans', *Med. Archaeol.*, 6–7, (1962–3b), 202–39
PARKER, R. *The common stream*, London, 1975
PARKIN, E.W. 'The vanishing houses of Kent, 1', *Archaeol. Cantiana*, 77 (1962), 82–90
PEARSON, S. *Rural houses of the Lancs. Pennines*, London, 1985
PEATE, I.C. 'Some Welsh houses', *Antiquity*, 10 (1936), 448–59
PETERS, J.E.C. 'The tithe barn, Arreton, Isle of Wight', *Trans. Ancient Monuments Soc.*, new ser. 12 (1964), 61–79
——'The solid thatch roof', *Vernacular Archit.*, 8 (1977), 825
PEVSNER, N. *An outline of European architecture*, Harmondsworth, 1943
PHELPS BROWN, E.H., and S.V. HOPKINS 'Seven centuries of the prices of consumables', *Economica* new ser. 23 (1956), 294–314
PLATT, C. *The monastic grange in medieval England*, London, 1969
POSTAN, M.M. 'The rise of a money economy', *Econ. Hist. Rev.*, 14 (1944), 123–34

QUINEY, A.P. 'Hatchett's Farm', *Post-Med. Archaeol.*, 8 (1974), 108–12
——'Whitehall, Cheam', *Surrey Archaeol. Col.*, 74 (1983), 135–40
——'The lobby-entry house', *Archit. Hist.*, 27 (1984), 456–66
——*House and home*, London, 1986

RCHM *Cambs. NE*, 2, London, 1972
RCHM *Dorset SE*, 2, London, 1970
RCHM *Northants N*, 6, London, 1984

RCHM *Stamford*, London, 1977

RCHM *York*, London, 1981

RACKHAM, O. 'Grundle House', *Vernacular Archit.*, 3 (1972), 3–8

——*Trees and woodland in the British landscape*, London, 1976

——'The growing and transport of timber and underwood', in McGrail, *Woodworking techniques*, Oxford, 1982, 199–218

RAHTZ, P.A. *The Saxon and medieval palaces at Cheddar*, Oxford, 1979

RAISTRICK, A. *Buildings in the Yorks. Dales*, London, 1976

RAMM, H.G., R.W. McDOWALL and W.E.R. MERCER *Shielings and bastles*, London, 1970

RIGOLD, S.E. *Temple Manor, Strood*, Ministry of Housing and Public Works Guidebook, London, 1962

——'The distribution of the "Wealden" house', in Foster and Alcock, *Culture and environment*, London, 1963, 351–4

——'Some major Kentish barns', *Archaeol. Cantiana*, 71 (1966), 1–30

——'Fourteenth-century halls in the E. Weald', *Archaeol. Cantiana*, 82 (1967), 246–56

——'The Cherhill barn', *Wilts. Archaeol. and Natural Hist. Mag.*, 63 (1968), 58–65

——'Timber-framed buildings in Kent', *Archaeol. J.*, 126 (1969a), 198–200

——'Yardhurst, Daniel's Water', *Archaeol. J.*, 126 (1969b), 267–9

——'The distribution of aisled timber barns', *Vernacular Archit.*, 2 (1971), 20–21

RYDER, P.F. *Timber-framed buildings in S. Yorks.*, Barnsley, 1979

——'Vernacular buildings in S. Yorks.', *Archaeol. J.*, 137 (1980), 377–85

SALWAY, P. *Roman Britain*, Oxford, 1981

SALZMAN, L.F. *Building in England down to 1540*, Oxford, 1952

SANDALL, K. 'Aisled halls in England and Wales', *Vernacular Archit.*, 6 (1975), 19–27

——'Aisled halls in England and Wales', *Vernacular Archit.*, 17 (1986), 21–35

SCHOFIELD, J. *The building of London from the Conquest to the Great Fire*, London, 1984

SHORT, P. 'The 14th-century rows of York', *Archaeol. J.*, 137 (1980), 86–136

SINGLETON, W.A. 'Traditional domestic architecture in Lancs. and Cheshire', *Trans. Lancs. and Cheshire Antiquarian Soc.*, 65 (1955), 33–47

SLANE, P. *Bayleaf Farmhouse*, unpublished dissertation, 1984

SMITH, J.T. 'Medieval aisled halls and their derivatives', *Archaeol. J.*, 112 (1955), 76–94

——'Medieval roofs', *Archaeol. J.*, 115 (1958a), 111–49

——'A 14th-century aisled house', *Proc. Suffolk Inst. Archaeol.*, 28 pt. 1 (1958b), 52–61

——'Cruck construction', *Med. Archaeol.*, 8 (1964), 119–51

——'Timber-framed building in England', *Archaeol. J.*, 122 (1965), 133–58

——'The evolution of the English peasant house to the late 17th century', *J. British Archaeol. Assoc.*, 3rd Ser. 33 (1970a), 122–47

——'Lancs. and Cheshire houses', *Archaeol. J.*, 127 (1970b), 156–81

——'The early development of timber buildings', *Archaeol. J.*, 131 (1974), 238–63

SMITH, W.J. *Saddleworth buildings*, Saddleworth, 1987

SPARKES, M.J., and E.W. PARKIN 'The Deanery, Chartham', *Archaeol. Cantiana*, 89 (1974), 169–82

SPENCE, R.T. 'The Graham clans and lands', *Trans. Cumberland and Westmorland Antiquarian and Archaeol. Soc.*, new ser. 80 (1980), 79–102

STEANE, J. 'Cogges', *Archaeol. J.*, 135 (1978), 301–4

STELL, C.F. 'Pennine houses', *Folk Life*, 3 (1965), 5–24

SUMMERS, N. 'Old Hall Farm, Kneesall', *Trans. Thoroton Soc.*, 76 (1972), 17–25

SWAIN, E.R. 'Divided and galleried hall-houses', *Med. Archaeol.*, 12 (1968), 127–45

TANN, J. 'Multiple mills', *Med. Archaeol.*, 11 (1967), 253–5

TAWNEY, R.H. 'The rise of the gentry, 1558–1640', *Econ. Hist. Rev.*, 11 (1941), 1–34

TAYLOR, A.J. 'Castle-building in Wales in the later 13th century', in *Studies in building history*, ed. E.M. Jope, London, 1961, 104–33

TAYLOR, R. 'Town houses in Taunton, 1500–1700', *Post-Med. Archaeol.*, 8 (1974), 63–79

THIRSK, J. 'Industries in the countryside', in *Essays in the economic and social history of Tudor and Stuart England*, ed. F.J. Fisher, Cambridge, 1961, 70–88

TONKIN, J.W. 'An introduction to the houses of Herefs.', *Trans. Woolhope Natural Hist. and Field Club*, 39 (1967–9a), 186–97

——'Vernacular buildings', *Trans. Woolhope Natural Hist. and Field Club*, 39 (1967–9b), 165–8, 374–9

——'Buildings', *Trans. Woolhope Natural Hist. and Field Club*, 41 (1973–5), 127, 262, 345–6

——'Buildings', *Trans. Woolhope Natural Hist. and Field Club*, 42 (1976–8), 105–6

TURNER, R.C. 'Early carpentry in the Rows of Chester', *Vernacular Archit.*, 19 (1988), 34–41

TYSON, B. 'Rydall Hall farmyard', *Trans. Cumberland and Westmorland Antiquarian and Archaeol. Soc.*, 80 (1980), 113–29

VAG *Surrey*, Vernacular Archit. Gp. Conference Programme, 1975

——*Salop*, Vernacular Archit. Gp. Conference Programme, 1982

——*Essex*, Vernacular Archit. Gp. Conference Programme, 1984

——*Warwicks.*, Vernacular Archit. Gp. Conference Programme, 1985

——*Oxon.*, Vernacular Archit. Gp. Conference Programme, 1987

WADE, J. (ed.) *Traditional Kent buildings*, No. 1, Maidstone, 1980

——*Traditional Kent buildings*, No. 2, Maidstone, 1981

——*Traditional Kent buildings*, No. 3, Maidstone, 1983

WAILES, R. *Windmills in England*, London, 1948

WALTON, J. 'Upland houses', *Antiquity*, 30 (1956), 142–8

WATKINS, A. 'Herefs. pigeon houses', *Trans. Woolhope Natural Hist. and Field Club* (1890), 9–23

WATSON, R.C. 'Parlours with external entrances', *Vernacular Archit.*, 6 (1975), 28–30

WEAVER, O.J. 'A medieval aisled barn at St Julian's Farm, St. Albans', *Herts. Archaeol.*, 2 (1970), 110–12

WEBSTER, L.E., and J. CHERRY 'Medieval Britain', *Med. Archaeol.*, 16, 19, 21, 22, 24 (1972–80)

WEEKS, J. 'Roman carpentry joints', in McGrail, *Woodworking techniques*, Oxford, 1982, 157–68

WILLIAMS, E.H.D. 'Corn drying kilns', *Proc. Somerset Archaeol. and Natural Hist. Soc.*, 116 (1972), 101–3

——'Poltimore Farmhouse, Farway', *Trans. Devon Assoc.*, 106 (1974a), 215–229

——'Some two-unit houses in Somerset', *Proc. Somerset Archaeol. and Natural Hist. Soc.*, 118 (1974b), 28–38

——'Curing chambers and domestic corn drying kilns', *Proc. Somerset Archaeol. and Natural Hist. Soc.*, 120 (1976), 57–61

WILLIAMS, E.H.D., J. and J. PENOYRE and B.C.H. HALE 'The George Inn, Norton St Philip, Somerset', *Archaeol. J.*, 144 (1987), 317–27

WILSON, D.M., and J.G. HURST 'Medieval Britain in 1966', *Med. Archaeol.*, 11 (1967), 262–319

WOOD, M. *The English medieval house*, London, 1965

WOOD-JONES, R.B. *Traditional domestic architecture of the Banbury region*, Manchester, 1963

WOODWARD, D. 'Identifying the helm', *Vernacular Archit.*, 13 (1982), 26–7

## ACKNOWLEDGMENTS

Information for the drawings has been taken from the following works:

**Page 13** Wilson and Hurst 1967, 274–5

**44** Addyman *et al.* 1972

**48** Hewett 1980, Figs 50 and 52

**49** Alcock 1981, Fig. 2

**51** The barns at Cressing Temple, Hewett 1967 Leigh Court barn, Alcock 1981 Siddington barn, conjectural reconstruction after Hewett 1971 Frindsbury and Nettlestead Place barns, Rigold 1966 Upper Lee barn, Stell 1965

**53** Hewett 1961

**54** VAG 1987

**57** Hewett 1976

**64** Mason 1966

**65** Hewett 1980

**68** J.H. Parker 1853

**72** Charles 1967, 38

**73** Pantin 1959

**76** Hewett 1973b

**80** Hewett 1973a

**84** VAG 1982

**85** Giles 1986, 29

**87** G. Beresford 1979

**88** Alcock *et al.* 1972

**90** Rigold 1969b

**96** Quiney 1983

**101** Williams 1978

**105** Williams 1974b

**115** Wood-Jones 1963, 122–3

**117** RCHM *Dorset SE* 1970, Lytchett Minster (8)

**119** Daisy Bank and Lower Birks, Stell 1965 Bradshaw, S.R.

**120** Jones 1980 W.J. Smith 1987, 28–30

**125** Ramm *et al.* 1970, 93

**128** Faulkner 1966

**129** Faulkner 1966

**133** VAG 1987

**137** Faulkner 1966

**144** Pantin 1962–3b

**145** No. 38 North Street, Laithwaite 1978 Leche House, Pantin 1962–3b

**147** Spon Street, S.R. Jones and Smith 1960–61 Upper Lake, Martin and Mastin 1987, 17

**148** Survey by F.W.B. Charles

**150** VAG 1987

**151** Laithwaite 1978

**152** VAG 1987

**153** No. 31 Mermaid Street, Martin and Mastin 1987 (17) The Broadway, survey by F.A. Evans

**154** 4 Watchbell Street, Martin and Mastin 1987 (11) Buckingham Street, Kelsall 1974 Albury Street, Quiney 1979b

**163** Survey by F.W.B. Charles

**182** Martin and Mastin 1982, 64

**183** S.R. Jones 1980d

**186** Alcock 1963

**187** Stell 1965

**193** Wade 1980, 9–11

**197** Wailes in RCHM *Cambs W.* 1968, Bourn (22)

**198** Wailes 1948, Fig. 8

**203** Wade 1980, 15

Photograph p. **7** Edwin Smith
Photographs pp. **14** and **62** Centre Guillaume le Conquérant, Bayeux